Slide Buyers' Guide

Visual Resources Association

SLIDE BUYERS' GUIDE

An International Directory of Slide Sources for Art and Architecture

Fifth Edition

Edited by

NORINE D. CASHMAN
Curator of Slides and Photographs
Brown University

Subject Index by

MARK M. BRAUNSTEIN
Head, Slide and Photograph Collection
Rhode Island School of Design

LIBRARIES UNLIMITED, INC.
Littleton, Colorado
1985

LIBRARIES UNLIMITED, INC.
P.O. Box 263
Littleton, Colorado 80160-0263

This is the first book in the Visual Resources Series.

Library of Congress Cataloging in Publication Data

Cashman, Norine D., 1949-
 Slide buyers' guide.

 (Visual resources series)
 At head of title: Visual Resources Association.
 Includes indexes.
 1. Art--Slides--Catalogs. 2. Art--Slides--Directories.
I. Braunstein, Mark Matthew, 1948- . II. Visual
Resources Association (U.S.)
N4040.V57C3 1985 702'.5 85-19857
ISBN 0-87287-471-0

Libraries Unlimited books are bound with Type II nonwoven material that meets and exceeds National
Association of State Textbook Administrators' Type II nonwoven material specifications Class A
through E.

To

Nancy DeLaurier,

editor of the first four editions

CONTENTS

Part I
North America

Part II
Asia, Australia, Britain, Europe, Ireland,
and the Middle East

Part III
Appendixes

Part IV
Indexes

PREFACE

The *Slide Buyers' Guide* is designed to assist slide curators, librarians, teachers, and scholars in identifying sources of slides depicting art and architecture. The vendors listed are evaluated, whenever possible, on the quality of the slides offered, the completeness and accuracy of the identification of the images, and the service rendered in filling orders. The guide is intended to enable purchasers of slides to make wise choices in allocating their acquisitions funds.

HISTORY

Four previous editions of this title, all edited by Nancy DeLaurier of the University of Missouri at Kansas City, appeared in 1970, 1972, 1976, and 1980. The first, second, and fourth editions were published by the Visual Resources Group of the Mid-America College Art Association (MACAA), and the third edition was published by the College Art Association. During the 15 years that have passed since the first edition, the *Slide Buyers' Guide* has come to be recognized as a standard reference tool for slide curators and librarians. Like many directories, however, it must be updated periodically to continue to be useful.

The preparation of a fifth edition of the *Slide Buyers' Guide* was therefore regarded as a high priority when the newly established Visual Resources Association (VRA) assumed responsibility for the MACAA publications in 1983. Because of my experience on the editorial board of the fourth edition, I was persuaded to accept the appointment as editor of the fifth edition. To prepare the subject index for the new edition, I enlisted Mark Braunstein, formerly assistant editor of *Art Index* and catalog editor for Rosenthal Art Slides. I also assembled an advisory board of ten VRA members presently engaged as professional visual resource administrators.

METHODOLOGY

A mailing list based on the fourth edition, supplemented by names and addresses from various other sources, was compiled in early 1984. An initial mailing to more than 1,000 presumed slide vendors (50 in Canada, 518 in the United States, and 450 abroad) was sent out in April. Follow-up mailings and telephone calls resulted in an eventual return of 208 completed questionnaires. When no other sources are stated, the reader may assume that the entry is based on a completed questionnaire. Slide vendors from whom no response could be elicited were included in the guide if information about them could be obtained from catalogs on file, the last edition of the guide, the Slide Market News column of the quarterly *International Bulletin for Photographic Documentation of the Visual Arts*, or recent ordering experience of the advisory board members. The source of information is specified in such entries. A third type of entry consists of

references from museums to commercial vendors who offer visual documentation of their permanent collections and/or exhibitions.

In all, this edition of the *Slide Buyers' Guide* includes 510 entries. Most of the data gathered reflect the slide market as it existed in mid-1984. When current information could not be obtained, old information was retained if it was deemed still useful. The most up-to-date information included is accurate as of the final revision of the manuscript in mid-1985. Subsequent changes will be reported in the previously mentioned Slide Market News column, which serves as a running update of the *Slide Buyers' Guide* between editions.

Two appendixes represent the mailings that did not result in entries. Appendix 1 is a short list of respondents who indicated that they no longer offer slides for sale. Appendix 2 lists names and addresses of presumed vendors who did not complete the questionnaire and about whom we could not discover enough useful information from secondary sources to compose an entry. Appendix 3 consists of a bibliography of art history textbooks for which slide sets have been developed, with references to the vendors who offer them.

The subject index was compiled by Mark Braunstein from catalogs and lists as they arrived from vendors. When not even an outdated catalog could be used for indexing, subject headings were assigned on the basis of statements on the returned questionnaires or in the previous edition. Rather than a classified arrangement of chronologic periods and media, as in previous editions, the fifth edition subject index consists of an alphabetical listing of subject headings. The flexibility of the latter system results in coverage of a greater variety of topics.

ARRANGEMENT

The entries are classified geographically, subdivided by types of vendors. A sequential numbering system allows for reference to any entry from the indexes and other entries.

The arrangement of data within an entry has been standardized. When the length of the entry warrants them, the following headings are employed as organizational devices:

Profile: scope of subject coverage

Photography: method of creating masters for slide production

Production: method of making copies for sale

Documentation: identification supplied in catalogs or with slides

Purchasing: prices and business practices

Rental: terms on which slides may be borrowed temporarily

Other sources: distributors or independent vendors

Evaluation: ratings on quality, documentation, and service

GENERAL INFORMATION

Conventions and assumptions observed in the entries are as follows:

Unless otherwise noted, a vendor offers slides for sale (rather than for rental or exchange).

Original photography is presumed to have been carried out in the presence of the depicted work of art or architecture unless reliance on secondary sources is indicated.

Production of copies is presumed to be directly from original transparencies or (inter)negatives. If copies are known to be more than one or two generations removed from the original, that fact is noted.

Documentation (catalogs, lists, brochures, slide identifications, labels, texts, and audiocassettes) is in English unless stated otherwise.

Payment in the currency of the country in which the vendor is located is preferred or required unless alternatives are stated.

All slides obtainable from sources listed in this guide are presumed to be copyrighted.

VALIDITY

The informational content of entries in this guide is derived primarily from the slide vendors' responses to the questionnaire. It was usually impractical, if not impossible, to verify the accuracy of their statements. Occasionally, when a vendor's reply contradicted evidence from sample slides or ordering experience, the discrepancy was noted parenthetically or in the evaluative comments. As a rule, when respondents left blanks on the returned questionnaires, we refrained from speculation, omitting that item from the entry unless the information could be derived from a brochure, catalog, or reliable secondary source.

EVALUATIONS

The "Statement on Slide Quality Standards" (1979), reproduced in the Introduction, represents an attempt by professional slide curators to define the criteria by which slides should be evaluated. The editor and advisory board applied these guidelines to the vendors listed in this guide whenever our experience provided substantial evidence. The user should bear in mind, however, that our evaluative ratings and comments are based, by necessity, on samples of the vendor's total production and service.

In the previous edition, slide vendors were rated according to a four-star system:

**** excellent

*** good

** acceptable

* usable within limitations

For this edition, this system was modified, and a number from one to four was assigned for each of the following:

Quality: photography and production

Documentation: completeness and accuracy of identification in catalog and/or on labels

Service: promptness and accuracy in filling orders, equity of policies, fairness in dealing with dissatisfied customers, and general helpfulness

The values of the numbers are:

4 excellent

3 good (generally above average)

2 fair (generally below average)

1 poor

In practice, a range of numbers was often assigned to reflect either variation in the vendor's quality/documentation/service or a difference of opinion among the evaluators. The extremes of 4 and 1 were used sparingly to preserve their significance. Most slides available are of "2 to 3" quality — good or having minor deficiencies that can be tolerated.

The numerical ratings (unless attributed to an individual advisor) are a composite of ratings submitted to the editor by the advisors, based on their experience as slide buyers. Whenever samples were submitted by vendors, their quality was rated by the editor alone. Comments by the advisors or the editor follow the ratings. Care has been taken to distinguish the comments of individuals from the ratings that express a group consensus.

Although the system of evaluation in this edition will be helpful to all readers, it is designed particularly to benefit experienced professionals who are discriminating slide buyers. For less experienced buyers, we recognized the need for designating a short list of major vendors who can be relied on to meet the basic needs of a small collection. Such vendors are marked by a large asterisk in the left margin. These vendors offer a large volume of slides generally covering the history of art and architecture. They produce slides of good quality that are adequately identified. In our experience, their business practices are reputable and reasonable, and their service is prompt and helpful.

We offer these recommendations with the following plea. We understand that small budgets and lack of staff compel some institutional purchasers to build their collections by making a few large purchases, minimizing the time and effort needed for selection. We encourage them, however, not to overlook the many smaller, more specialized, and less well known vendors who offer excellent slides. The subject index of this guide can be used to identify the vendors that will meet specific needs.

CONCLUSION

The *Slide Buyers' Guide* is more than a directory of slide sources, although the listing and evaluation of vendors are its primary functions. The guide has as a secondary mission the education of both vendors and consumers. Since 1979, when the "Statement on Slide Quality Standards" was first disseminated, the quality of slides on the market has improved significantly. The "Slide Quality Standards," which were published in the fourth edition of the *Slide Buyers' Guide*, informed vendors of the criteria by which visual resource professionals judge the quality of their productions. Slide purchasers have used the standards to develop their own critical skills, exerting a real influence on the slide market through discriminating allocation of their acquisitions funds.

Introductory matter follows that explicates the points briefly stated by the "Slide Quality Standards." It is hoped that this edition of the *Slide Buyers' Guide* will contribute to the further improvement of slide quality, documentation, and service.

ACKNOWLEDGMENTS

The Visual Resources Association has made possible the compilation of this guide by advancing sufficient funds for me to conduct the research thoroughly, both by mail and by telephone. My thanks are offered to Christine Sundt, president, and Nancy Schuller, treasurer, for their prompt responses to my every request. Other individual members of the association have contributed substantially to this edition. I am especially grateful to the 10 members of the Advisory Board, who made suggestions for the design of the questionnaire, supplied names of vendors for the mailing list, evaluated vendors with whom they were familiar, reviewed a draft of the introduction, and continually offered their support and encouragement during the long process of collecting and organizing information about slide vendors.

Three VRA members assisted with the several mailings of questionnaires, which totaled more than 1,500: Joy Alexander, editor of the *International Bulletin for Photographic Documentation of the Visual Arts* and curator of slides, University of Michigan, Ann Arbor; R. I. H. Charlton, publications officer, Ashmolean Museum, Oxford; and Dr. Walter Krause, assistant professor, Institut für Kunstgeschichte der Universität Wien. I thank them and members of their staffs for relieving me of carrying out that chore on my own and also for the fact that their assistance resulted in substantial savings on the cost of postage. For contributing names and addresses of Canadian slide vendors to the mailing list, I am indebted to Hélène Boivin of Ottawa University, author of *Sources of Slides for Canadian Art* (Universities Art Association of Canada, 1980).

Although I took responsibility for writing the entries, I was assisted in drafting some of them by two colleagues at the Rhode Island School of Design: Laurie Averill, readers' services librarian, and Elinor Nacheman, cataloger. The portion of the introduction concerning photography and production methods was revised by Nancy DeLaurier from the introduction to the fourth edition.

My debt to Nancy DeLaurier is so large I fear I cannot offer a complete list of her contributions. Her work in producing the earlier four editions laid the foundation for this one. My experience in assisting her with the fourth edition was particularly valuable. From the time I commenced work on this edition, Nancy has always been a reliable source of sound advice. As a member of the board of advisors, she responded to every communication from me. As the manuscript began to take shape, she read every section for accuracy of content, a task no one was better suited to perform. This edition is, therefore, modeled on her earlier efforts and bears her mark throughout.

Others have read parts of the manuscript, offering valuable comments that I have heeded in most instances. I am especially grateful to Zelda Richardson, slide curator at the University of New Mexico, Albuquerque, for the suggestions she and her staff made for revision of the introduction. Mark Braunstein, in addition to compiling the subject index, has served on the board of advisors and has read the entire manuscript. His proofreading skill has ferreted out almost every error, from simple typographic mistakes to awkward sentence structure.

Finally, I would like to thank those who, although they have not contributed to the *Slide Buyers'* *Guide* directly, have relieved me of other routine responsibilities so that I might devote my time to this project. Brown University, at the request of Roger Mayer, chairman of the Art Department, gave its approval to my acceptance of the appointment as editor. My co-workers, Kathleen James and Linda Mugica, have cheerfully tolerated the diversion of my attention from the routine administration of our visual collections. The understanding and patience of my husband David and daughter Eleanor have likewise been a source of support throughout the year and a half it took to prepare this manuscript.

<div align="right">Norine D. Cashman</div>

INTRODUCTION

Few of the vendors listed in this guide are companies whose sole or major production consists of 35 mm slides of art and architecture. Some companies supply slides of art as well as other subjects. The intended audience for these slides may be educational institutions (often at the secondary level) or tourists. Still other companies produce 35 mm slides among various audiovisual formats, especially films and/or filmstrips. Art and architectural subjects may be emphasized or may be merely one of many subjects offered. One vendor is best known for sales of art supplies to practicing artists. Some commercial entities issue slides as a sideline to their major activity, for example, architectural firms, publishers, and commercial photographic studios. A number of companies are exclusively or primarily distributors of slides produced by others.

All these vendor types have in common a profit motive; they are businesses with slides as their products. Slides also may be purchased from individuals. Artists, scholars, and teachers often make available slides they have taken of their own work or the subjects they study, especially slides shot while traveling abroad. Although this group of vendors is classified as commercial in this guide (for lack of sound criteria to distinguish them), their photography may not in many cases be primarily a business venture.

Nonprofit institutions comprise the other large category of slide vendors. Foremost among them are art museums, which usually sell slides of selected works in their permanent collections as part of their educational mission. Some have their slides photographed and produced in-house. Others contract with outside firms for photography and/or production. Slides are usually sold in the museum shop and by mail order. Exhibitions are sometimes documented, but the necessity of obtaining permissions from lending institutions and/or copyright holders frequently discourages museum personnel from offering this service.

Museums will often carry out "special photography," making a new slide of a previously unphotographed work to satisfy a particular request. Prices for this service are usually much higher than for slides kept in stock. Galleries may offer slides of work by artists they represent. Even if slide sales are not a routine activity, a gallery may be willing to lend slides for duplication.

Some nonprofit institutions without permanent collections of art sell slides documenting exhibitions, architecture, or works in various collections. Staff members of visual collections in educational institutions sometimes carry out photographic documentation projects, making slides available to other institutions without profit. There are even a few nonprofit institutions committed primarily to visual documentation.

The preceding survey of vendor types is offered to demonstrate that slides on the market come from such diverse sources that variation in quality is only to be expected. The method of obtaining master slides is the point at which vendors first make choices that distinguish their products from those of others. Although certain deficiencies in an original transparency or negative can be corrected in production, in general, high-quality slide copies depend on setting and adhering to high standards in the original photography. The following outline revised from the fourth edition explains the various means by which originals can be obtained to serve as masters for the production of slides.

1. The slide vendor or an employee may photograph directly from the work of art. Extensive travel may be required in this instance, the cost of which is passed on to the consumer. On-site photography is conducted by two types of vendors:

 a. Professional art photographers who arrange in advance to shoot in museums during hours when the museums are closed to the public. These photographers pay fees and/or royalties to the museums. They are allowed to use tripods and professional lighting equipment. Their results are on the whole the best that can be obtained.

 b. Traveling scholars or tourists may photograph in museums during regular hours, in available light, and hand-holding their cameras. Some of these slides are excellent, but others may suffer from any of the following deficiencies: glare, deep shadows cast by the frame, inadequate or uneven lighting, color distortion caused by a mismatch of film type and lighting conditions, fuzzy focus, perspective distortion, image size too small or cropped, poor selection of views of architecture and sculpture.

2. Vendors may borrow or rent transparencies (35 mm slides or larger format) from the owner of the work of art, paying a flat fee or royalties from sales. This method is standard procedure for some suppliers; others use it only when photography in person is not possible. Even when a substantial fee is paid, this method is usually less costly, and certainly requires less effort, than traveling to photograph on site. The disadvantage of this method, however, is that the vendor is dependent on museums and galleries to supply images of good quality.

3. A vendor may purchase outright or pay royalties for slides shot by a variety of individuals (see 1,b above). Slides with flaws can be improved at the professional production facilities of large, established slide dealers. Vendors of this type are usually selective in their acquisition of slides from individuals, which likewise contributes to higher quality overall.

4. A few vendors sell slides shot on a copystand from secondary materials—books, periodicals, printed ephemera, photographic prints, and other slides. In such cases, consumers should be made aware of the source of the slides, or they will probably assume that the original images were photographed on site. Some secondary materials (plates from rare books, for instance) are legitimate sources for slides as long as permission has been obtained from the owner and/or copyright holder of the work photographed.

EVALUATION

Judging the quality of slides is no easy task. It is an endeavor in which experts may sometimes disagree over particular examples. Some general principles can be agreed on, however. The following document, issued in 1979 by a committee of professional visual resource administrators, defines the criteria by which slides should be evaluated. The statement was subsequently endorsed by the Art Libraries Society of North America and by the Visual Resources Association.

Statement on Slide Quality Standards

COLOR: The color should be as true as possible to the original work of art, neither over- nor under-exposed, nor off-color due to the lighting or the film type.

FILM: The film should have fine-grained resolution, and color should be stable with a minimum shelf-life of ten years. Duplicate slides should be newly printed as far as possible to maximize their shelf-life. High contrast in duplicate slides should be controlled. The film should be clean with no dirt or scratches on the surface nor duplicated onto the film from the master transparency or negative. The size 24 × 36 mm is preferable; the supplier should indicate other sizes if used.

PHOTOGRAPHY: The slides must be in focus and full-frame as far as possible without being cropped. Lighting should be adequate and even throughout and without glare or reflections. In photographing paintings and buildings, distortion should be avoided.

INFORMATION: Accurate and complete information is necessary: artist's full name, nationality and dates, title of the work, medium, date and dimensions if known, and location. Cropped slides should be identified as such, and details should be described. An indication of the orientation is important, especially on details and abstract works of art. It should be clear which is the front of the slide.

It is important to indicate whether the slide will be an original or a duplicate; specific information on the source of the slide, film type, and processing would be appreciated. Return and replacement policies should be spelled out.

PRICE: The price of the slide should fairly reflect the costs of production and distribution.

Carol Terry, Committee Chairman
Stanford University (formerly)

Nancy DeLaurier
University of Missouri at Kansas City

Eleanor Fink
NCFA/NPG
Smithsonian Institution

Stanley Hess
Cleveland Museum of Art (formerly)

Linda Bien
Concordia University, Montréal

The standards outlined in this statement are those against which vendors have been measured in the evaluation section of the entries in this guide.

PHOTOGRAPHY

The choice of film type for photography of the masters has a profound effect on quality, although factors such as equipment (especially lenses), lighting conditions, and skill in framing the subject are also important. Permanence of color is a concern when choosing a film for the production of copies.

A thorough discussion of the advantages and disadvantages of particular films cannot be undertaken in this space. Readers may consult back issues of the *International Bulletin* for Ask the Photographer columns by Patrick Young if the following general remarks are not sufficiently technical.

Kodak films predominate in the slide market today. Both Kodachrome and Ektachrome yield excellent results and are relatively stable in retaining their colors. Kodachrome lasts longer if kept in dark storage, but Ektachrome suffers the least damage from projection.

Films with a high ASA (200 or 400, for instance) may be chosen to enable the photographer to shoot in available daylight rather than artificial light. Although natural light is often preferable, the disadvantage of films with a high ASA is that their resolution (sharpness) is not as fine as that of films with a low ASA. When a slide is to be reproduced in copies for sale, maximum sharpness in the original is desirable because the reproduction process will inevitably cause some loss of resolution.

PRODUCTION

The quality of the slide copy actually purchased by the consumer is further determined by how the master image is reproduced and processed. Some vendors are extremely concerned and careful about this important step. Several major vendors have in-house production facilities so that they can exercise complete control through personal supervision. A few others are personally involved, although production takes place in an independent laboratory; results may be equal to those achieved in-house. Most vendors use independent laboratories, assigning them full responsibility for production. Kodak laboratories are, in general, consistently dependable for film cleanliness and care in processing. Unless the vendor works closely with them, however, Kodak laboratories do not take special measures to control contrast. Local laboratories can be directed to color-correct slides and to control contrast, but they are often more careless about dirt and scratches on film.

A brief explanatory outline of production methods follows, also based on the fourth edition.

1. "Camera originals" are slides cut from the actual roll of film that was in the camera as it was set up in front of the work of art. In this method, which is relatively rare, photographers take as many shots of each work of art as they think they can sell. When stock is exhausted, they must return to the site to reshoot or use their last originals as masters from which to reproduce slides.

 a. Advantages: With proper match of film and lighting, correct exposure, and filtration to balance color, this method results in the most accurate slides possible. Maximum stability of film is attained in originals, which are always on reversal film, assuming that the film is later processed correctly. The whole range of color values is present. Contrast is neither too high nor too low. Sharpness of detail, assuming proper focus, is at its best; any reproduction would be slightly softer.

 b. Disadvantages: Correction cannot be made in the original for any of the following faults: poor lighting, mismatch of lighting to film, wrong exposure, or failure to balance color. A slide with any or all of these flaws would probably be improved in the reproduction process. Originals are also the most expensive slides available, unless their cost is subsidized by an institution. Photographers can recoup their expenses, often including travel, only by dividing their total costs by the number of originals shot. A photographer's expenses are all incurred "up front," with reimbursement occurring gradually over several years as slides are sold.

2. Original slides or larger transparencies may be reproduced by duplication (rephotography) on reversal film. Stock can be replenished in accordance with demand, and the production cost per copy does not vary greatly whether a few or many duplicates are made.

a. Advantages: Color and exposure faults in the original can be corrected. Because the film used for duplication is also a reversal film, duplicates are as stable as originals (i.e., color dyes will fade slowly).

b. Disadvantages: The subtle intermediate values of the original are lost in the process of rephotographing, resulting in a high-contrast duplicate. Detail is lost in deep shadows and brightly lit areas. Special measures can be taken by the producer to control contrast during duplication, but the duplicate almost always lacks the richness of the original. Commercial laboratories, including Kodak, seldom attempt to control contrast unless specifically directed to do so. Kodachrome duplicating film is especially high in contrast. Ektachrome #5071, which has become increasingly popular as a duplicating film, has a built-in low-contrast emulsion. Another problem with duplication is that if the original is dusty or scratched, these flaws will be rephotographed onto the duplicates. Finally, some film types are not compatible for duplication; that is, color distortion will occur unless filtration is skillfully employed to minimize it.

3. Another method of production involves "printing" slides from negative film. If the original transparency was a positive image, an internegative is made from it. Vendors who use this method extensively may shoot master negatives on site rather than positive transparencies. As in the case of reversal duplicates, stock of printed slides can be replenished easily.

a. Advantages: Color accuracy is comparable to duplicates. Most print film is lower contrast than reversal duplicating film, although the full range of values in an original transparency cannot be reproduced. The cost for printed slides is low because they are produced only in large quantities.

b. Disadvantages: Color correction is often done per batch of images rather than image by image. Color stability may be of short duration, depending on the film type. Kodak's Eastmancolor motion picture print film (#5381 and #5383) should be avoided. It has long been the most popular with large-volume producers because of its initial beauty and low cost. Experience has proved, however, that the blue dye in this film fades within four to five years, followed by the yellow dye, resulting in an all-magenta image. This film is responsible for the many slides in established collections purchased in the 1960s and 1970s, which are now pink or purple. The unstable versions of this film are no longer manufactured, but many vendors still have old stock on this film to produce slides for sale. Kodak has replaced this product with several new "low-fade" Eastmancolor films (most commonly, #5384), which accelerated aging tests show to be stable for 50 years *if* processed with ECP-2A chemistry. An alternative print film, Kodak Vericolor slide film, is predicted by Kodak to have a 20-year life span. It is more expensive than Eastmancolor films.

MOUNTING AND PACKAGING OF SLIDES

Most slides are mounted in glassless binders of plastic or cardboard. Glass-binding is occasionally offered, usually as an option, at greater cost. Unmounted slides (i.e., a strip of film) sometimes are available at reduced cost. Slides should be stored by the vendor in a manner that protects them from dust and scratches, and they should be packed carefully to prevent damage during shipment. Some vendors insert slides into plastic sleeves or shrink-wrap small sets; although this solution provides excellent protection during shipment, long-term storage in this condition is not advisable unless the plastic is of archival quality.

DOCUMENTATION

Identification of images is necessary to slide buyers, first to select and purchase slides, and later to classify, label, and file them into an existing collection. Most slides are keyed to the catalog or to a list sent with the order; some arrive labeled or accompanied by labels to be applied to the slides after binding. The completeness of identification varies among vendors. Desirable elements of a full identification are enumerated in the "Statement on Slide Quality Standards."

The text of booklets supplied with slide sets is of variable quality. A few vendors offer scholarly commentaries that are truly valuable. Most texts are not oriented to a scholarly audience, however, and many are virtually useless. Chatty "lecture notes" are no substitute for full identification of the images.

PURCHASING

Business practices are usually explained in a vendor's catalog. Instructions for placing orders should be followed carefully to avoid delay in filling the order. In some cases, delivery time may be shortened by ordering from a distributor. Purchase of slides from distributors usually results in higher prices for the consumer but eliminates the inconvenience of placing multiple orders, corresponding in foreign languages, paying in foreign currencies, and waiting for overseas shipments to arrive.

Most vendors require prepayment from individuals but will invoice institutions. Unless prepayment is required, slide buyers are wise to withhold payment until the slides are received and evaluated. If the slides are satisfactory, payment should be processed promptly.

When purchasing from a vendor for the first time, it is wise to consider in advance what can be done if the slides prove to be unsatisfactory. Each vendor has a policy on accepting returned slides if a customer is not pleased. Some vendors send slides "on approval" for a specified period, usually not exceeding 30 days. Within this time, the purchaser may return some or all (depending on the particular vendor's policy) of the slides—provided, of course, that the slides have not been damaged by the customer. An invoice will then be issued for the number of slides actually kept. From the consumer's point of view, approval orders are highly desirable. Not only can materials that do not meet quality standards be rejected but the views ordered can be compared with those already in a collection to verify that the new slides are truly needed.

Unfortunately, some slide buyers, including institutions, have abused this privilege. Therefore, many vendors are reluctant to trust new customers and will not send orders on approval. A few vendors will accept no returns whatsoever, a policy that should alert slide buyers to order with caution. In such an instance, a small test order is advisable.

Legitimate reasons for returning slides include poor photographic technique, production flaws, fading from film deterioration already evident at the time of receipt, unremovable dirt or scratches, and damage during shipment. Some of these problems can be rectified by the vendor sending another copy of the same slide. In other cases, a refund or credit toward substitute slides is needed. A vendor also should be willing to exchange slides that were sent erroneously; that is, the slides shipped are not those requested.

A few general hints on ordering are offered here for inexperienced slide buyers.

1. Test new vendors with a small initial order, especially if prepayment is required and/or returns are forbidden.

2. When ordering slides from a museum, specify a maximum price you are willing to pay for special photography if you are not sure a "ready-made" slide is available.

3. Place orders for an economically profitable number of slides. Shipping charges are proportionally higher per slide on small orders, to say nothing of the cost in effort by the buyer and vendor and perhaps the intermediary purchasing department.

4. Proofread orders carefully, especially if slides are designated by numbers. Ask the purchasing department to photocopy your list to avoid errors in retyping. If the purchaser makes a mistake, the vendor has no obligation to rectify it.

5. Designate a specific recipient and address to whom the slides should be sent.

6. Check orders as soon as possible on receipt for accuracy and quality. Generally, returns should be mailed within two weeks of the date of receipt unless a longer period of review has been agreed on.

7. Insure returned merchandise.

COPYRIGHT CONSIDERATIONS

Most contemporary works of art are copyrighted, as are many others produced in the twentieth century. Permission from the copyright owner and, if requested, payment of fees are required by law when copies of the image are distributed. Compliance with copyright law is time consuming and adds to the expense of slide production. Most professional art slide companies obtain permissions as standard procedure.

A slide produced from a work of art may itself be copyrighted by the photographer or producer. Most slides obtainable today are indeed copyrighted. Slide vendors regard the copying of their productions without permission as an infringement of copyright law. Their statement issued in May 1983 is reproduced below. The Visual Resources Association has not endorsed the statement. Slide buyers, however, need to be informed of the position of the vendors on this issue.

Clarification on Copyright[†]

From the Slide Producers' Association
May 1983

The vendors of slides in the field of education relating to art and art history wish to publish the following statement in keeping with United States, Canadian, and International Copyright Law:

All slides of art or architecture—whether originals or duplicates—are the original creation of the company producing them and are thus protected under International Copyright Laws. Such slides are sold under the express condition that they are to be used for teaching and studying purposes only and may be projected via normal slide projector for classroom and lecture use. No purchased slide may be reproduced or transmitted by any other means, electronic or mechanical, including photocopy, slide duplicator, video recording, or any information storage and retrieval system now known or to be invented, without permission in writing from the producer.

As a further clarification, since these slides are produced for the specific purpose of teaching, scholarship, and research, the normal "fair-use" clause allowing single copies to be made for these purposes does *not* apply. Since virtually the only market for these slides is comprised of the very teachers, students, scholars, and visual-resource people who would be interested in copies, any copying activity whatsoever is a form of direct damage to the producer of the original image. Therefore, any unauthorized copying of slides must be considered in violation of copyright law and in violation of professional ethics. Any authorized copying must be agreed upon in writing.

The matter of professional ethics is especially important, since the production of high-quality slides for teaching and research purposes can occur only if there is close cooperation based on trust between the artist and/or owner of the object being photographed and the photographer on the one hand, and between the photographer and the purchaser of the image on the other. If directors of museums or historic buildings believe that the conditions under which they granted permission to photograph their objects are being violated, they will not grant such permission in the future. If photographers (who incur large up-front expenses) have the already limited potential for sales undermined—or their efforts at achieving maximum quality subverted—through the production of pirated duplicates, the delicate network of trust and cooperation breaks down. In the interest of scholarship it is therefore crucial that every

[†]Reprinted by permission.

person involved—in the production, the curating, and the use of visual images—exercise ethical responsibility in meticulously honoring and protecting all copyright provisions.

Slide Producers' Association

Budek Films and Slides
Dunlap Society
Hartill Art Associates
KaiDib Films International
Miniature Gallery
Rosenthal Art Slides
Saskia, Ltd.
Scala/Art Resource
Ed Teitelman, Photography

NOTE TO USERS OF THIS GUIDE

Many of the larger commercial vendors, as well as a few museums, maintain mailing lists to keep regular customers informed of new offerings. Requests to be added to mailing lists are welcomed by vendors, who routinely send out mailings to promote their products. Most museums, some smaller companies, and individuals, however, often prefer not to mail information unless it is requested by a customer who seriously intends to place an immediate order. If a vendor keeps a mailing list, this fact has been noted at the beginning of the documentation section of the entry. Users of this guide are asked please to refrain from soliciting catalogs from vendors indiscriminately simply to have the catalogs on file. Small vendors are able and willing to correspond with buyers who will actually do business with them but cannot afford to mail ten catalogs for every one that results in a sale. Continued response by such vendors to questionnaires for future editions of this guide depends on whether the correspondence generated by the guide is helpful to their business or merely a nuisance.

BOARD OF ADVISORS

Elizabeth D. Alley
Curator of Slides and Visual Aids
School of Architecture
University of Maryland

Mark M. Braunstein
Head, Slide and Photograph Collection
Rhode Island School of Design

Helen Chillman
Librarian, Slide and Photograph Collection
Art and Architecture Library
Yale University

Nancy DeLaurier
Curator, Slides and Photographs
Art and Art History Department
University of Missouri at Kansas City

Nancy Kirkpatrick
Head, Slide Department
Ryerson and Burnham Libraries
Art Institute of Chicago

Marybeth Koos
Slide Curator
Northern Illinois University

Dr. Walter Krause
Assistant Professor
Institut für Kunstgeschichte der Universität Wien

Brenda MacEachern
Slide Curator
Department of Visual Arts
University of Western Ontario

Dr. Sara Jane Pearman
Slide Librarian
Cleveland Museum of Art

Nancy S. Schuller
Curator of Visual Arts
Department of Art
College of Fine Arts
University of Texas at Austin

Part I
NORTH AMERICA

CANADA

COMMERCIAL VENDORS

1 **Alphabets Co.**
455 Spadina Avenue, Suite 209
Toronto, Ontario M5S 2G8
(416) 593-5534
attn: John Negru

Profile: Offers 1,000 slide titles of art and architecture in Burma, Central America, China, Hawaii, India, Japan, and Thailand. Offers 200 slides of textiles. New titles continually added (50 in 1984).
Photography: Slides shot by J. Negru and a colleague, both professional photographers, on Kodachrome ASA 64. Nikon equipment used with polarizing and color-correction filters. Architecture shot with wide-angle lens and hand-held camera.
Production: Duplicated by Colour Collaborators on Ektachrome. Color corrected and contrast controlled. Mounted in plastic, cardboard, metal, or glass.
Documentation: Free catalog, updated annually. Full information provided. Slides keyed to catalog. Orientation marked.
Purchasing: Slides sold singly or in sets, $2.50 each (Canadian funds). This price applies to slides that will be "for archival use" only. Publication and broadcast rates negotiable. No discounts. Minimum order $50.00. Prepayment required. Slides duplicated to order and shipped within two weeks. Rush orders filled within four days; surcharge of 100 percent. Slides not sent on approval and no returns accepted.
Evaluation: No current information available.

2 **Boulerice, Yvan/Centre de Documentation**
C.P. 292, Succ. "E"
Montréal, Québec H2T 3A7
(514) 524-7141
attn: Yvan Boulerice

Profile: Offers 10,000 color slide titles of Canadian art, chiefly contemporary. Works in Canadian museums represented, and gallery exhibitions in the vicinity of Montréal documented. Some slides of Canadian architecture also available. New titles continually added (500 to 1,000 in 1984).
Photography: Slides shot on Ektachrome #5018 by Y. Boulerice and his staff, using Leica equipment, quartz lights, and color-correction filters. Ektachrome #6118 transparencies (4 by 5 inches) and black-and-white negatives also shot.
Production. Duplicated in-house on Ektachrome #5071. Color corrected and contrast controlled. Mounted in cardboard or glass.

Documentation: Mailing list kept. Free catalog in French/English, updated annually. Complete identifications given. Slides keyed to catalog. Orientation marked (black spot designates upper right corner).
Purchasing: Slides sold singly and in sets ranging in size from 10 to 500 slides. No minimum order. Per-slide cost in sets $1.60 or less (Canadian funds). Postage included. No discounts. Payment in Canadian funds requested. Slides kept in stock and shipped within two weeks. Rush orders filled in 24 hours; surcharge of 100 percent. Slides not sent on approval. Returns accepted for exchange only if damaged in shipment.
Evaluation: Four-star rating in fourth edition. Two samples sent, one of flatwork and one of a three-dimensional object in an environment: quality 3, documentation 3.

3 Désy, Léopold
 2425 Boulevard Hamel
 Québec, Québec G1P 2H9

Profile: No response to questionnaire. Entry based on fourth edition and H. Boivin's *Sources for Slides of Canadian Art*. Approximately 15,000 color slide titles offered of architecture, featuring religious and public buildings in Québec, New Brunswick, and Nova Scotia. Canadian sculpture also represented, and some slides produced from museum transparencies.
Photography: Slides shot on Ektachrome by L. Désy, art historian and photographer, using professional equipment and techniques.
Production: Duplicated by Kodak on Ektachrome duplicating film.
Documentation: Catalog (231 pp.) $15.00. Free lists of sets also available on request. All information provided in French. For architecture in Québec, identifications consist of location, building name, architect, date, and view. For New Brunswick and Nova Scotia, only location and building name provided.
Purchasing: Slides sold in large sets or singly. Duplicates approximately $2.00 each. Originals available by special order; cost varies. Prepayment required on first order. Returns accepted when accompanied by a letter of explanation.
Evaluation: "Excellent slides" (H. Boivin). "Mr. Désy is very responsive to clients' special problems and needs" (fourth edition).

*** 4 Hartill Art Associates**
 181 St. James Street
 London, Ontario N6A 1W7
 (519) 433-7536
 attn: Alec and Marlene Hartill

Profile: Several thousand color slide titles offered of architecture, sculpture, mosaics, frescoes, and stained glass in Europe (especially France, Italy, Germany, and northern Spain), Canada, and the United States. Monasteries and cathedrals as well as some ancient Roman sites documented in depth. New titles continually added. Slides usually available that are not in catalog (up to 1,000 in 1984). Suggestions welcomed for subjects to be covered in future travels.
Photography: Slides shot on Kodachrome ASA 64 (occasionally high-speed Ektachrome) by A. Hartill using Nikon equipment. When necessary, electronic flash or quartz lights employed. "Mostly we use available lighting for natural effects; we try to avoid extraneous subjects and show the subject alone without distractions. We often have the kind assistance of our Embassy in order to gain approval from authorities; this requires much forethought, scheduling, and planning."
Production: Duplicated on Ektachrome #5071 and Kodachrome ASA 25 professional film (PKM135) by a custom in-house laboratory. Color corrected and contrast controlled. Mounted in cardboard.
Documentation: Mailing list kept. Catalog $6.00 plus postage, prepaid. French version of catalog available on request. Annual supplements issued, and catalog revised at approximately five-year intervals. Full information provided. Slides keyed to catalog. Orientation marked.
Purchasing: Original slides sold in sets only. Set prices based on per-slide cost of $3.50. Single slides available only as duplicates, $2.50 each. Minimum order 20 slides. Quantity discount of 5 percent for 50-99 slides, 10 percent for 100-499 slides, and 15 percent for more than 500 slides. Additional 2 percent discount given for payment within 10 days of invoice date. Postage added. Prepayment required only from

customers who have not paid promptly on past orders. Originals shipped within three days. Duplicates made to order on fresh film stock and shipped within 12 days. Rush orders of original slides filled within 24 hours; charge for delivery passed on to customer. Slides not sent on approval. Returns accepted only from customers with whom "a relationship of trust has been developed over a period of time."

Evaluation: Quality 3 to 4, documentation 4, service 4. "Both originals and duplicates are very good. Much effort put into documentation. Stained glass outstanding" (Brenda MacEachern). "The very best architectural photography available" (Norine Cashman).

5 Import Graphics
30 Hillhouse Road
Winnipeg, Manitoba R2V 2V9
(204) 338-7426
attn: Jeff Morry, President

Entry based on letter received in late 1984. Set of 80 slides offered of "Contemporary Polish Fine Art Posters" for $130.00 plus postage (U.S. dollars). More than 50 artists represented, including five Soviets. For an additional charge of $5.50, slides packaged in a carousel, arranged in categories. Names of artists provided on "contents sheet." Quality of sample slides 2 to 3.

6 McIntyre Educational Media, Ltd.
30 Kelfield Street
Rexdale, Ontario M9W 5A2
(416) 245-7800

Canadian office of McIntyre Visual Publications, Inc. (60).

7 Scholastic Slide Services
605 Blair Road
Ottawa, Ontario K1J 7M3
(613) 749-0862
attn: Hellmut W. Schade

Profile: Offers 37,000 color slide titles of architecture in Canada, the United States, Mexico, Jamaica, France, Germany, Greece, Italy, Spain, and Switzerland. Some slides of sculpture included. Eighteen hundred slides available that are not listed in catalog. New titles continually added (2,000 in 1984). Professor Schade is an art historian teaching in the School of Architecture, Carleton University.

Photography: Slides shot by H. Schade on Kodachrome ASA 25 and 64 using Nikon equipment and various lenses, including a perspective-correcting lens. Some 2¼-inch transparencies shot as well.

Production: Duplicated by H. Schade on Ektachrome #5071 and processed by Techniphoto, Ltd., Ottawa. Color corrected and contrast controlled "to some extent." Mounted in plastic. Slides obtained through Rosenthal Art Slides (76) produced by Rosenthal.

Documentation: Mailing list kept (Canada, mostly). Free lists in English, revised biennially. City, building name, and number of slides given. *A Gateway to Canadian Architecture*, 2d ed., 182 pp., $10.00. Price of this catalog deductible from first slide order over $100.00. Slides labeled (or accompanied by a photocopy of the labeled original slide) and keyed to catalog. Identifications consist of location, name of building, architect/builder, and date. Orientation marked by label position.

Purchasing: Slides sold singly, $2.50 each (Canadian funds). Postage added. Discount of 25 percent given if all slides of a particular location are ordered. No minimum order. Slides duplicated to order and shipped within four to six weeks. No rush orders accepted. Slides not sent on approval. Returns accepted for refund "only in cases of bona fide ordering mistakes." Slides guaranteed "unconditionally for 10 years. Should the slides fade within this period, return the slides, and you will receive new slides free of charge. . . . Slides which start to fade after the guarantee period will be replaced at 50 percent of the prevailing catalog price."

Other Sources: Some slides also available from Rosenthal Art Slides (76): one hundred and eighty-five of Canadian architecture and 250 of Greek architecture.

Evaluation: Quality 2 to 3, documentation 2 to 3, service 2 to 3. "Requests for information are answered very slowly" (Nancy Kirkpatrick). "We obtained some very good slides from this source. Prof. Schade sent more slides than those specifically requested, and he willingly took back those that did not meet our needs or quality standards" (Norine Cashman).

MUSEUMS

8 **Art Gallery of Ontario**
 317 Dundas Street West
 Toronto, Ontario M5T 1G4
 (416) 977-0414
 attn: Photographic Services or Audio-Visual Centre

Profile: Approximately 600 color slide titles offered by Photographic Services. Western art represented primarily: Canadian (historical and contemporary), United States (twentieth century), and European (nineteenth and twentieth centuries). Large group of slides of Henry Moore's work available. Slides of Inuit culture featured: artifacts, sculpture, prints, and drawings. Slide sets of special exhibitions offered. New titles continually added (180 in 1984). Black-and-white photographs also sold by Photographic Services, and 4-by-5-inch color transparencies rented for reproduction. Collection of the Audio-Visual Centre composed of 35,000 archival slides and 75,000 circulating slides. Five thousand slides to be added to Audio-Visual Centre collection in 1984: Oriental art (Chinese, Japanese, and Indian) and photography.
Photography: Slides shot on Ektachrome by staff photographer in studio. When required, Speedoron flash system used.
Production: Duplicated in-house on Ektachrome #5071. Color corrected and contrast controlled. Slides mounted in cardboard or plastic. Some slides produced from Ektacolor #5028 negatives by Eberhard Otto onto Ektachrome SO 566-SE for commercial sale.
Documentation: Free catalog in English available from Photographic Services, frequently updated. Full information provided in catalog and on labels. Slides for public sale are fully labeled (English or French). Other slides keyed to information provided. Orientation marked on duplicate slides but not on originals. Catalog of Audio-Visual Centre outlines collection arrangement and lists artists whose works are represented.
Purchasing: Both originals and duplicates offered by Photographic Services. Slides listed in catalog sold singly at $1.00 each (Canadian funds). Order form provided in catalog. Limited-edition sets also offered; prices vary, depending on actual production and promotion costs. Per-slide cost is lower in sets. Postage added. Prepayment required from individuals and purchase orders from institutions. All orders totaling less than $10.00 must be prepaid. Slides duplicated to order. Orders filled on a first-come, first-served basis. Rush orders accepted at no surcharge. Slides not sent on approval. Returns accepted for exchange or refund. Special photography carried out: first original costs $5.00, each additional original costs $2.00. Duplicates made from master slides in the Audio-Visual Centre's collection, each $2.00.
Rental: Slides from the Audio-Visual Centre loaned within Canada only for two-week period.
Evaluation: Quality 3 to 4, documentation 3 to 4, service 3 to 4. Five samples received, two originals and three slides reproduced from negatives: originals rated 4 on quality, duplicates 3. "Slides vary from excellent to just okay. Fast service and full information" (Nancy Kirkpatrick). "Special exhibition coverage is usually well chosen and of excellent quality" (Brenda MacEachern).

9 **Carmen Lamanna Gallery**
 840 Yonge Street
 Toronto, Ontario M4W 2H1
 (416) 922-0410

Profile: No response to questionnaire. Entry based on H. Boivin's *Sources for Slides of Canadian Art*. Duplicate color slides offered of works by contemporary Canadian artists.
Production: Duplicated on Ektachrome #5071.
Documentation: No list available. Complete information supplied with slides.

Purchasing: According to Brenda MacEachern, the gallery "has no actual organized slide sales program. They just duplicate slides they have [on file]." Specific requests filled, or gallery will prepare a selection based on the purchaser's expressed needs of works by particular artists. Slides $4.50 each (Canadian funds). Gallery prefers to receive orders during the summer.
Evaluation: No information available.

10 **Montréal Museum of Fine Arts**
3400 Avenue du Musée
Montréal, Québec H3G 1K3
(514) 285-1600
attn: Slide Library Administrator or Boutique

Profile: No response to questionnaire. Entry based on fourth edition and H. Boivin's *Sources for Slides of Canadian Art*. Subjects represented in museum's collection include Canadian art (especially twentieth century painting); Inuit and Amerindian art (especially graphics and sculpture); Latin American art (particularly Peruvian textiles); ancient art of the Near East, Greece, Etruria, and Roman Empire; medieval art; Renaissance through nineteenth century European art; African art; Oceanic art; pre-Columbian art; Islamic art; Oriental art; and Mediterranean glass.
Photography: Slides shot on Ektachrome ASA 50 by staff photographer in studio.
Production: Duplicated on Ektachrome #5071 by a local laboratory. Color accuracy checked.
Documentation: No list available from Slide Library. Full identifications provided with slides in English or French. Orientation marked. List of Sandak (77) slides available from Boutique; full information supplied on slide mounts.
Purchasing: Small orders for specific works filled by Slide Library. Some originals available at $2.50 each (Canadian funds). Duplicates made to order, $1.25 each. Approximately 40 Sandak slides offered for sale by Boutique, $1.00 each. No returns accepted.
Other sources: Set of 59 slides, also offered singly, available directly from Sandak (77). Slides also offered by Boulerice (2).
Evaluation: No information available on Slide Library slides. See Sandak (77) for evaluation of Boutique slides.

11 **National Gallery of Canada**
Ottawa, Ontario K1A 0M8
(613) 996-6497
attn: Slide Sales, Reproduction Rights and Sales

Profile: More than 2,000 color slide titles offered of works in the permanent collection and special exhibitions. Canadian art emphasized. Slides also available of Chinese art, Indian and Eskimo art from Canada, Canadian silver, and European painting. Exhibition sets include "Art and the Courts: France and England from 1259 to 1328" and "Fontainebleau: Art in France 1528-1610." New additions to holdings temporarily suspended due to lack of staff.
Photography: For the most part, slides shot on Ektachrome by staff photographers in studio.
Production: Duplicated on Ektachrome #5071 by the National Film Board of Canada. Color corrected and contrast controlled. Mounted in cardboard or plastic. Some sets available unmounted.
Documentation: Mailing list kept. Catalog in French or English distributed free to "best customers." New catalog issued in 1984, priced $10.00 (Canadian funds), postpaid. Slides keyed to catalog. Orientation marked by number placement.
Purchasing: Slides sold only to educational institutions, singly or in sets. Slides in stock $1.70 each (Canadian funds). Slides duplicated to order $2.75 each. Per-slide cost discounted in sets. Otherwise, no discounts given. Minimum order 10 slides, unless order is prepaid. Orders filled from stock within a few days. Duplicates made to order shipped within two weeks. On request, slides sent by courier service at customer's expense. Slides usually not sent on approval, and no returns accepted. "We have seldom ever had slides returned."
Other sources: Slides also offered by Boulerice (2).
Evaluation: Quality 3 to 4, documentation 4, service 3 to 4. " '300 Years of Canadian Art' set is a standard tool for Canadian courses" (Brenda MacEachern).

12 **Robert McLaughlin Gallery**
 Civic Centre
 Oshawa, Ontario L1S 2Z5
 (416) 576-3000
 attn: Slide Librarian

Profile: Offers 194 color slide titles of contemporary Canadian art.
Photography and production: Duplicated from 35 mm originals on Ektachrome #5071. Some originals sold.
Documentation: Free list; many slides listed are out of stock. Artist, title, and date provided. Sets announced on single sheets. Full identifications supplied with sets. Orientation marked.
Purchasing: Single slides $2.00 each (Canadian funds). Set prices vary. No minimum order. Orders shipped within one to two days. Slides sent on approval.
Evaluation: Only one advisor able to rate (Brenda MacEachern): quality 3 to 4, documentation 4, service 4.

13 **Royal Ontario Museum**
 100 Queen's Park
 Toronto, Ontario M5S 2C6
 (416) 978-3660
 attn: Programs and Public Relations Department

No response to questionnaire. Entry based on H. Boivin's *Sources for Slides of Canadian Art* and information from advisory board members. Duplicate slides available of most of the artifacts in the museum's collection. No slide list exists, but published catalogs of the collections may be used as a guide in ordering. Identifications provided on request. Duplicates produced on Ektachrome #5071, $1.25 each (1981). "Slow response to orders" (Sara Jane Pearman). "In our collection, we have some very useful slides from the Royal Ontario Museum of models of ancient sites such as the Acropolis in Athens" (Norine Cashman).

OTHER INSTITUTIONS

14 **Jack Chambers Memorial Foundation**
 St. John's College
 400 Dysart Road
 Winnipeg, Manitoba R3T 2M5
 (204) 474-9605 or 8531 or 0491

Profile: A set of 1,000 duplicate color slides is in production. Contemporary Canadian art is to be documented from 1965 to 1980, with works of 100 artists represented. Painting, sculpture, printmaking, ceramics, video, and conceptual media included. Artists were selected by regional committees of artists; 10 works each selected by artists themselves. This foundation is "a charitable trust established [in 1978] to support research and educational projects in the Canadian visual arts." The slide set is the foundation's first project. Additional support for it received from private individuals, corporations, and federal and provincial governments.
Photography and production: Original photography coordinated by Eberhard Otto. No information available on production. Slides available unmounted or in Gepe mounts. Packaged in loose-leaf notebook with documentation.
Documentation: Extensive biographical and bibliographical information on each artist provided in English and French.
Purchasing: As of early 1985, 200 slides actually available. Current price for complete set $2,000.00 ("loose but identified") or $2,500.00 (in Gepe mounts). On receipt of a purchase order, the slides presently available will be shipped, with subsequent groups to follow as soon as they are produced.
Evaluation: No information available.

15 **National Film Board of Canada**
 Photothèque, Tunney's Pasture
 Ottawa, Ontario K1A 0M9
 (613) 593-5826

Profile: More than 250,000 images in black-and-white and color offered of Canadian subjects (social, economic, and cultural), of which 33,000 are available in slide format. Principal use of archive is for editorial and commercial reproduction. The arts category emphasizes performing arts, but several categories include images useful for the study of architecture.
Photography: Slides shot by professional and amateur photographers.
Production: Duplicated on Ektachrome #5071. Color corrected and contrast controlled only if requested (see purchasing information below). Mounted in plastic.
Documentation: Mailing list kept. Free catalog (#7, 1981) available on request, illustrating 700 black-and-white and 32 color images of 14,000 additions since catalog #6. Previous catalogs may be consulted at National Film Board offices and at Canadian public libraries. Catalog information is in English and French; identification consists of a brief caption for each image. For architecture, city and building name provided. New slide titles continually added, but catalogs issued infrequently. Slides labeled in English, keyed to the catalog, and accompanied by a photocopy of the caption card. Orientation marked.
Purchasing: Slides sold singly. Price list available on request. Prices (1984) for educational use (no reproduction rights) are $3.50 for a color-corrected duplicate slide, $1.70 for a "projection quality" slide (Canadian funds). Prepayment required from individuals. Minimum invoice amount $5.00. Duplicated to order and shipped within four days. Rush orders filled in one day; 100 percent surcharge. Images not reproduced in catalogs may be selected in person, or a search may be requested and materials acquired on 60-day approval. Approval service prices: Color slide duplicates $5.50, black-and-white slides $7.95.
Other sources: National Film Board prefers to have orders sent to address above, but its slides are available also from Miller Services, 45 Charles Street, Toronto.
Evaluation: No information available.

16 **Ontario Crafts Council**
 346 Dundas Street West
 Toronto, Ontario M5T 1G5
 (416) 977-3551
 attn: Craft Resource Centre

Profile: Offers 195 sets of duplicate color slides documenting crafts exhibitions. Media represented are fiber, wood, clay, metal, glass, leather, and mixed media. New titles continually added (four sets in 1984).
Photography: Slides shot by a professional photographer on Kodak film.
Production: Duplicated on Kodak film by BGM Colour Labs, Toronto. Mounted in plastic.
Documentation: Mailing list kept. Free list in English only, updated biennially. Identification sheet supplied with each set. Orientation marked.
Purchasing: Slides sold in sets only, each comprised of 20 or more slides. Prices based on $1.50 per slide (Canadian funds). Postage added. Quantity discounts negotiable. Prepayment required. Slides duplicated to order and shipped within one month. Rush orders filled in two weeks; 15 percent surcharge. Slides sent on approval.
Rental: Sets rented for two weeks within Canada only. Members charged $10.00, others $15.00.
Evaluation: No information available.

17 **Public Archives of Canada**
 395 Wellington Street
 Ottawa, Ontario K1A 0N3
 (613) 995-1300
 attn: Picture Division, Room 326

Profile: Archives comprised of approximately 100,000 items, "primarily of historical interest to Canada, including landscapes, urban views, original and engraved portraits, historical events, posters, costume designs, medals, and heraldic devices." Ten slide sets available representing this material.

Photography: Originals are 4-by-5-inch Ektachromes, 35 mm Ektachrome slides, or 4-by-5-inch black-and-white negatives, all shot by in-house reprographic services. Nikon, Sinar, Combo, and Durst cameras employed with professional lighting techniques (direct, reflected, and polarized).

Production: Duplicates made in-house on Ektachrome #5071 or Eastman Fine Grain Release Positive film #5302 (for black-and-white slides). Color corrected. Contrast controlled in black-and-white slides. Mounted in plastic or cardboard.

Documentation: No list. Free brochure available describing sets. Information provided in booklets in English and French. Orientation marked.

Purchasing: Ten sets, 20 to 40 slides each, available from Public Archives of Canada or McIntyre Educational Media, Ltd. (6). Single slides offered only by Public Archives of Canada; originals $4.75 each (Canadian funds), duplicates $2.10 each. Prices same for black-and-white or color. No minimum order. All orders invoiced. Duplicates made to order and shipped within three months. No rush orders accepted. Slides not sent on approval, and no returns accepted.

Evaluation: Only one advisor able to rate (Brenda MacEachern): quality 2, information 3. "We only have the 'Images of Canada' set, acquired in 1972. Many are off-color but are only available from this source."

UNITED STATES

COMMERCIAL VENDORS

18 aatec publications
P.O. Box 7119
Ann Arbor, MI 48107

No response to questionnaire. Entry based on brochure. Slide sets offered on nine topics, all concerning aspects of solar energy. Sets comprised of 20-80 slides, accompanied by printed narration. Cassette ($7.00 extra) available with three sets. Priced $90.00 for 80 slides, $58.00 for 50 slides, and $12.95 for 20 slides. Six sets, each 20 slides, on "Solar Energy Technology" by Stephen Cook, priced $70.00 plus postage.

19 American Library Color Slide Co.
P.O. Box 5810, Grand Central Station
New York, NY 10017
(212) 255-5356

Profile: No response to questionnaire. Entry based on recent brochure. Duplicate color slides offered of all periods and media: sixty-five thousand singles and approximately 4,000 sets. (Because of its all-encompassing coverage, ALCS is not included in the subject index of this guide.) Twenty sets coordinated with art history textbooks.
Production: Current production reported to be on Ektachrome #5071.
Documentation: Mailing list kept. Free 85-page brochure, *Surveys of World Art*, available on request; also, free *Color Slide Catalog of World Painting*, more than 300 pages. General catalog sold for $14.95 under the title *Color Slide Source and Reference of World Art*, 685 pages, indexed (7th ed., 1980). Slides labeled with name of artist, title of work, dates, and location. Citations of museums abridged. No nationalities indicated for artists/architects. Identifications not always complete or accurate.
Purchasing: Sets composed of 10 slides or more. Series of units offered, ranging in size from 520 to 30,000 slides, each of which is a "totally self-sufficient unit in a continuous, fully interlocking system. . . ." Per-slide cost in sets is $2.10 if cardboard-mounted, $3.00 if glass-mounted. Minimum order $25.00. No discounts. Official purchase order required. Shipments invoiced 30 days net, FOB New York City. Delivered within three to four weeks. "No return of merchandise [is] accepted without written permission. Cancellations will not be honored after work has started on any order. All claims of any nature must be made within 30 days after receipt of merchandise. Slides will be replaced if defective in manufacture or lost in transit. Except for such replacement, the sale of such slides or film is without other warranty or liability. Since color dyes may in time change, there is no warranty against change of color, and such slides will not be replaced."
Evaluation: Quality 1 to 2, documentation 2, service 1. Film formerly used proved to be unstable.

20 **Andrews, Wayne**
 521 Neff Road
 Grosse Pointe, MI 48230
 (313) 886-2719

Profile: Annual series of photographs issued by photographer who has documented architecture, chiefly in the United States, since about 1945, publishing half a dozen books illustrating American architecture. Black-and-white slides available from his archive of approximately 4,200 negatives. In addition to buildings in the United States, architecture in Europe, the Soviet Union, and Mexico represented. Nineteenth and twentieth centuries emphasized.

Photography: All negatives shot by W. Andrews on 4-by-5-inch Tri-X film.

Production: Slides made at a Long Island laboratory. Mounted in cardboard.

Documentation: Mailing list kept. Catalog (1976; Supplement A, 1980) $3.00, deductible from first order. Images identified by geographical location, name of building, architect (name often abbreviated, no nationality or dates given), and date of building. Views arbitrarily described as "A," "B," and so forth. Annual list of new offerings (approximately 100) issued free to customers on mailing list. Slides keyed to catalog or list. Orientation not marked.

Purchasing: Sale in sets preferred. Minimum order 10 slides. Price per slide $5.00. Prepayment required. Shipping charge added. Discounts on orders larger than 40 indicated on price list dated 1976. Slides made to order within one month. Rush orders accepted. Slides not sent on approval, and no returns accepted.

Evaluation: Quality 2 to 3, documentation 2, service 1 to 2. "In sets, I find unnecessary duplication of views and too many views of minor buildings. When ordered selectively, however, some excellent, often unique images can be acquired from this source" (Norine Cashman).

21 **Architectural Color Slides**
 187 Grant Street
 Lexington, MA 02173
 (617) 862-9431
 attn: Franziska Porges

Profile: Offers 30,000-40,000 color slide titles of architecture and related arts; international scope. Works in the Greek museums and the Boston Museum of Fine Arts represented. New titles continually added.

Photography: Slides shot with Leica and Nikon equipment. According to the fourth edition, photography done by Mr. Porges, an architect, on Kodachrome and Ektachrome.

Production: Duplicated by Kodak.

Documentation: Mailing list kept. Catalog (16 lists) $3.00, deductible from first order. Slides identified by location, building name, architect, and view; few dates given. Slides keyed to catalog.

Purchasing: Slides sold in sets only. Duplicated to order. Rush orders filled within one week.

Evaluation: Quality 2, documentation 2, service 2. "Very old slides (1966) in our collection have been weeded out as better slides were acquired. Some were too dark with murky color" (Norine Cashman).

22 **Architecture of the World**
 20 Waterside Plaza, Suite 25F
 New York, NY 10010
 (212) 889-4672
 attn: Ernest Burden

Profile: Formerly Architectural Delineations. Over 5,000 color slide titles offered of architecture, emphasizing ancient and modern (especially in the United States, Canada, and South America). Approximately 2,000 slide titles available now besides those listed in catalog, and 1,000 more to be added in 1984.

Photography: Slides shot by E. Burden (50 percent) or by traveling scholars (50 percent) on Ektachrome using Nikon equipment, including wide-angle, zoom, and perspective-correcting lenses. "Each site was photographed from an overall view, followed by closer general views and terminated by several close-ups and detail shots. Thus, you can order slides offering a general overview of a specific building or site or, in some cases, as many as 36 views covering every detail of a temple."

Production: Duplicated in-house on Ektachrome ER with E-6 processing. Color corrected and contrast controlled. Mounted in cardboard.

Documentation: Mailing list kept. Free catalog, revised every two years. Slides keyed to catalog. Orientation marked by label position.

Purchasing: Slides sold singly or in sets. Minimum order 30 slides. Quantity discounts. Postage included in price except for foreign orders or orders sent by priority mail. Duplicated to order and usually shipped within two weeks. Rush orders filled within one week; no surcharge. Prepayment required from individuals and private companies. Purchase order required from educational institutions. Slides not sent on approval and no refunds given. Returns accepted for exchange only.

Evaluation: Quality 2, documentation 2, service 2. "Samples sent in 1974 have turned brown" (Norine Cashman). Twenty samples sent for this edition: all very high contrast, and color inaccurate in three slides. Several views of buildings cropped, and perspective distorted in two cases. One excellent slide included. Identifications incomplete; dates and architects inconsistently given. Many misspellings noted.

23 **Art in America**
 c/o Brant Art Publications
 980 Madison Avenue
 New York, NY 10021
 (212) 734-9797
 attn: Richard Loyne

Profile: Set of approximately 200 duplicate color slides offered annually, selected by the editors of *Art in America* magazine from the year's 10 issues. Paintings, sculpture, drawings, and photography featured. Coverage predominantly contemporary, but exhibited works of all periods included as well. Most major galleries and museums in United States and abroad represented.

Photography: Slides shot by professionals.

Production: Duplicated on Ektachrome #5071. Color corrected. Mounted in cardboard.

Documentation: Free list issued annually. Slides keyed to list. Identifications consist of artist, title of work, date of work, medium, dimensions, collection, and page reference. No dates given for artists. Orientation marked (asterisk on list indicates vertical image).

Purchasing: Slides sold only as a set, at a price of $295.00. Duplicates kept in stock and shipped within 30 days. Rush orders accepted. Prepayment required from individuals. Slides sent on approval. Returns accepted for exchange or refund.

Evaluation: Quality 3, documentation 3, service 3. "Both Brown and Rhode Island School of Design ordered the 1983 set and returned it because of poor quality. The 1984 set, however, shows great improvement. Problems with color fidelity, focus, and resolution have been rectified. Greater care to eliminate dust and scratches on the originals is still needed. Production delays occurred on both the 1983 and 1984 sets" (Norine Cashman).

24 **Art Now, Inc.**
 144 North 14th Street
 Kenilworth, NJ 07033
 (201) 272-5006

Profile: More than 2,200 color slide titles offered, with emphasis on contemporary work: paintings, watercolors, drawings, graphics, collages, and crafts. Exhibitions at museums and approximately 80 galleries in New York documented. Company in business since around 1970. New slides continually added.

Photography: Slides shot by independent professionals using tripod and professional lighting to photograph exhibitions.

Production: Duplicated on Ektachrome #5071 at Van Chromes Corporation. Color corrected and contrast controlled. Mounted in cardboard.

Documentation: Mailing list kept. Well-designed free catalog, revised every two years. Identification in catalog consists of artist's full name, title of work, date of work, and medium. Dimensions not given nor nationalities and dates of artists. Slides listed in catalog by sets, but indexed by artist. Slides labeled with full catalog identification. Orientation marked.

Purchasing: Slides sold in sets or as singles (except as noted). Single slides $1.75 each; in sets, per-slide cost $1.50. Minimum order $20.00. Duplicates kept in stock and shipped within six weeks via United Parcel

Service at customer's expense. At present, rush orders not accepted; future change of policy on this point planned. Prepayment required from individuals, purchase orders from institutions. Slides not sent on approval, and no returns accepted.

Evaluation: Quality 2 to 3, documentation 3, service 2. "Have discovered that early productions are turning pink. Sometimes orientation is doubtful and slides are dirty" (Brenda MacEachern). "Sometimes poorly photographed but mostly the only thing available" (Sara Jane Pearman).

25 **Art on File**
 312 Prospect
 Seattle, WA 98109
 (206) 284-3955
 attn: Colleen Chartier or Robert Wilkinson

Profile: Formerly Chartier Photography. One set of 56 color slides offered of "Public Art in Context," representing 26 projects carried out in the vicinity of Seattle by nationally renowned contemporary artists. Two additional sets documenting public art in America to be announced in June 1985.
Photography: Slides shot by Colleen Chartier.
Production: Duplicated on Ektachrome #5071. Mounted in plastic.
Documentation: Free brochure, with sample slide and annotation. All 26 projects listed and briefly described in brochure. Slides accompanied by extensive, well-organized annotations. Introductory text and bibliography included with set. Slides keyed to annotations. Orientation not marked.
Purchasing: Order form included in brochure. Slides sold singly, $4.00 each, or as a complete set for $125.00. Postage added to orders of single slides ($2.50) but included in price of set. Minimum order five slides. Prepayment requested. Slides delivered within 30 days. Rush orders accepted.
Evaluation: Based on sample order quality is 3 to 4, documentation 4, service 3.

26 **Art Slides of India and Nepal**
 1684 Preyer
 Cleveland Heights, OH 44118
 (216) 321-9476
 attn: Thomas Donaldson

Profile: Offers 12,000 color slide titles of art and architecture in India and Nepal, with particular emphasis on Orissa. Monuments covered that are not available from other sources. New titles continually added.
Photography: Slides shot by Thomas Donaldson on Kodak film (Ektachrome according to the fourth edition). Lighting generally natural, occasionally by flash.
Production: Duplicated in-house on Kodak film or at the Kodak laboratory in Findlay, Ohio. Color correction and contrast control not attempted. Mounted in cardboard.
Documentation: Mailing list kept. Free lists, updated every two years. Set titles listed, with number of slides and price, followed by single slide titles. Almost 800 slides grouped into 31 sets by iconographical motif on separate listing. Slides labeled. Orientation not marked.
Purchasing: Slides sold singly or in sets. No minimum order. Prepayment required from individuals ordering for the first time. Per-slide cost in sets $1.60 or less. Single slides $2.00 each. Quantity discounts given to $1.50 per slide for more than 100 slides. Prepaid orders discounted 10 percent. Postage paid within United States on orders of $25.00 or more. Duplicated to order and mailed within three weeks. Rush orders filled within two weeks; no surcharge. "All slides are on 30-day approval provided a purchase requisition is included." Returns accepted within 30 days for exchange or refund.
Evaluation: "Quality excellent of slides I've seen" (Helen Chillman). "Mixed quality"; three-star rating (fourth edition).

27 **Bonanza Group, Inc.**
 220 East 54th Street, 4B
 New York, NY 10022
 (212) 751-2473
 attn: Judith Sandoval

Profile: Archive accumulated by photographer J. Sandoval of the following black-and-white negatives, from which she usually sells 8-by-10-inch prints but can also produce slides: five thousand Mexico (sixteenth to nineteenth centuries) and 1,800 Costa Rica, Nicaragua, and Honduras (including 300 of Copán). Architecture, ruins, and sculpture featured. For a large order (several thousand dollars' worth), Ms. Sandoval is willing to select and print from the archive of 29,000 negatives at the Centro de Estudios de Historia de Mexico Condumex. Such orders previously carried out for the Fogg Museum (15,000 prints) and the National Gallery of Art (16,000 prints). New titles continually added.

Photography: Black-and-white negatives shot in 35 mm and 120 mm formats by J. Sandoval using Olympus and Minolta equipment, including Olympus perspective-correcting and telephoto lenses, on Ilford FP4 or Kodak Plus-X or Tri-X.

Production: Slides made from negatives by Roffi, New York, New York. Contrast controlled. Film type and mount type subject to customer preference.

Documentation: Mailing list kept. Catalog $10.00, listing sites but not individual buildings. Slides fully labeled in English or Spanish as requested.

Purchasing: Slides sold in sets or singly. Minimum order 100 slides. Price per slide approximately $13.50. Quantity discounts. Slides made to order from negatives within three to six months, depending on order size. Rush orders filled within one month; surcharge 50 percent. Slides not sent on approval, and no returns accepted.

Evaluation: "The main virtue of her work is that she documents buildings that are unavailable elsewhere. . . . She has been a prompt and conscientious person to deal with. . . . I would give service and completeness of information high marks and place the quality of the photographs as good to adequate" (Helene Roberts, Harvard). "We have found it advisable to make the selection of photos ourselves from her proof sheets, since numerous views of the same subject are included, as are many non-art-related shots. . . . The information Ms. Sandoval provides for each photo is minimal—location (site, building) only. However, she has compiled an index that has much more information on each building. This book of "field notes" (475 pp.) is available for $500.00" (Ruth Philbrick, National Gallery of Art).

28　**Boutin, Allan**
　　76 Franklin Street
　　New York, NY 10013
　　(212) 925-4867

Profile: Offers 300 color slide titles of architecture: Chicago School, New York, and H. H. Richardson. No expansion of holdings planned.

Photography: Slides shot on Kodachrome and Ektachrome by A. Boutin. Perspective-correcting lens used.

Production: Duplicated by Kodak.

Documentation: Photocopied list $5.00, deductible from first order. Identifications consist of place, building name, style, architect, and date. Views described briefly if at all. No revision of list anticipated. Slides keyed to list. Orientation not marked.

Purchasing: Minimum order 20 slides. Priced $2.00 per slide, with quantity discount: $1.75 each for 50 or more slides; $1.50 each for 100 or more slides. Purchase order required. Duplicated to order and shipped within two weeks. No rush orders accepted. Slides sent on approval within the United States. Returns accepted for exchange.

Evaluation: No samples sent; comments based on slides in Brown University's collection since 1970. Quality good, although color slightly bluish and contrast rather high. Details of Chicago School buildings well chosen and well shot.

29　**Budek Films & Slides**
　　73 Pelham Street
　　Newport, RI 02840
　　(401) 846-6580
　　attn: Elizabeth Allen, Director

Profile: More than 30,000 color slide titles offered of art, architecture, and archaeology; scope international, from all time periods. Many museum objects represented; for a listing, consult the two pages of

"Sources and Credits" in catalog. New titles continually added. This company formerly owned by Herbert E. Budek, later by Avid Corporation, then by Mr. Allen, and since around 1981, by Mrs. Elizabeth Allen. Slide equipment, filmstrips, and microfiche also stocked by Budek.

Photography: Slides shot by independent professionals (75 percent), traveling scholars (15 percent), and staff photographers (10 percent). Film used is "almost exclusively Kodak—Kodachrome or high-speed Ektachrome if necessary." Available light preferred when possible.

Production: Printed by Color Film Corporation, Stamford, Connecticut on Eastmancolor #5384; recommended ECP-2A processing used. Produced since around 1979 on low-fade film; all unstable stock to be replaced by the end of 1985. Color corrected by group. Mounting options offered: unmounted (coiled in film canister), cardboard mounts, Gepe glass mounts.

Documentation: Mailing list kept. Free catalog of set titles. Catalog listing individual slides within sets $3.00, deductible from first order. Supplements issued quarterly. Slides keyed to catalog or list.

Purchasing: Sale in sets preferred. No minimum order. Standard sets average 10 slides, super sets 40 slides. Both available unmounted ($6.00 and $21.00, respectively), cardboard-mounted ($9.00 and $32.00), or Gepe glass-mounted ($12.50 and $42.00). "Ten percent discount is applied to any series ordered in its entirety. All prices are FOB[†] Newport, Rhode Island, and are effective January 1, 1983. Please add 7 percent to total of order to cover postage and handling for United States and Canada shipments. All others, please state shipping preference. Slide sets are available for 30-day approval if ordered on institutional stationery. Only cardboard and unmounted formats are shipped for preview purposes. There is a 10 percent restocking charge for orders returned due to customer error, and a 10 percent surcharge for any orders needed prior to our normal 14-day ARO (after receipt of order). Shipping and receiving claims must be made within 10 days of receipt of order." Prepayment required from individuals, overseas customers, and delinquent accounts. Duplicates kept in stock and sent approximately two weeks after receipt of order. Rush orders sent out within three days. Single slides available on request. Returns accepted for exchange or refund. Special discounts periodically announced in mailings. Orders for sale slides must be prepaid, and no returns are accepted. "If anyone would like to replace slides in their collection that may have deteriorated over the 40 years that Budek Films has been in existence, please write or call and we will give you an outstanding quote for replacement."

Other sources: Slides distributed by overseas agents, chiefly in Asia.

Evaluation: Quality 1 to 2, documentation 2, service variable. Sample set of 20 slides (Christo) sent: high contrast noted, but views well chosen and definition quite sharp. Two slides badly warped by mounts. "Sent back the only slides I ever ordered from them because they were off-color, out of focus, and dirty" (Nancy Kirkpatrick). "Scratches on film" (Mark Braunstein). "Very cooperative about return of a whole set of old pink slides" (Nancy DeLauner). "We received prompt service on a rush order. Also, someone kindly took the time to mark all sets in the catalog that were at that time available on new film. The new management appears sincerely committed to improving quality, and the service we have been given in recent years has been excellent" (Norine Cashman).

✳ 30 Burstein, Barney
 2745 East Atlantic Boulevard, #305
 Pompano Beach, FL 33062
 (305) 781-5260

Profile: Approximately 7,000 color slide titles offered of painting, sculpture, decorative arts, and archaeological artifacts from 179 museums, galleries, and private collections in the United States and abroad. Coverage of non-Western art included.

Photography: Slides shot on Kodachrome and Ektachrome by B. Burstein using Nikon and Canon equipment.

Production: Duplicated on Ektachrome. Color corrected and contrast controlled. Mounted in cardboard.

Documentation: Mailing list kept. Catalog and two supplements $2.00. Supplements issued as new slides become available. Dimensions included in the second supplement but not in the earlier supplement and general catalog. Dates provided when known, but many works listed without dates. Slides keyed to catalog. Orientation marked.

†FOB stands for free on board or freight on board.

Purchasing: Slides sold singly, as originals until stock is depleted and thereafter as duplicates. Quantity discounts given from top price of $2.25 (one to nine slides) to lowest price of $1.40 (more than 100 slides). Postage added. Minimum order $10.00. Prepayment required on foreign orders. Duplicated to order and shipped within two weeks. Rush orders filled within one week if slides in stock. Slides sent on approval. Returns accepted within two weeks for exchange or refund.

Evaluation: Quality 3 to 4, documentation 3, service 3. "Underexposure of some slides noted, but in general quality is excellent" (Norine Cashman). "Have not used recently; always considered slides good to excellent; good information, helpful dealer" (Helen Chillman).

31 **Center for Humanities, Inc.**
Communications Park, Box 1000
Mount Kisco, NY 10549
(800) 431-1242
(914) 666-4100 (New York, Alaska, Hawaii — call collect)

Profile: No response to questionnaire. Entry based on 1985 catalog. Slide sets, filmstrips, video, and computer software offered for sale to educational institutions. Many subjects other than art covered.

Documentation: Free catalog, issued annually, illustrated and indexed. Sets briefly described. Teacher's guide and audiocassette included with each set.

Purchasing: Order forms available in catalog; toll-free telephone orders accepted as well. Slides sold in sets only, packaged in carousels. Orders sent on 30-day approval to educational institutions. Returns accepted. Preview period extension and special deferred payment can be arranged. Sets priced $99.50 per carousel tray of slides. Series prices discounted 10 percent. Postage charged at 5 percent. Damaged or lost slides replaced free of charge as long as the program is offered for sale.

Other sources: Distributed by McIntyre Educational Media, Ltd. (6) in Canada.

Evaluation: No information available.

32 **Color Slide Enterprises**
Box 150
Oxford, OH 45056
attn: Marvin H. Puckett

Profile: No response to questionnaire. Entry based on information in fifth edition of this company's catalog, as well as on a July 1983 order. Three hundred sculptures represented by more than 1,400 color slide titles of various views and details. Ancient and Renaissance works emphasized. Formerly (mid-1960s) known as Color Slide Encyclopedia.

Photography: "Our original transparencies were all taken with Kodachrome in available light only. Some are not as professional as we would have liked. However, there are some very good ones."

Production: Duplicated from original slides. Binding in glass mounts offered for surcharge of $0.50 per slide.

Documentation: Fifth edition of catalog, "Sculpture in 2 × 2 Color Slides" $1.00. Works grouped by artist; anonymous pieces listed by museum. Very useful index by title included. Each work illustrated in black-and-white by one view. Other views systematically described. Identification consists of artist, title, collection, view description, and sometimes material. No dates or dimensions given.

Purchasing: Single slides priced $1.00 each, with quantity discounts to $0.75 for 250 or more slides. Slides sent on approval to institutions.

Evaluation: Quality extremely varied. Sculptures photographed in galleries with no backdrop, so background often appears cluttered. Some duplicating film unstable. "Old slides in our collection have turned pink, purple, and green. Five of 15 slides ordered in 1983 were pink when received" (Norine Cashman). Documentation fairly complete and very consistently presented. Service 2 to 3.

33 Creative Concepts of California
P.O. Box 649
Carlsbad, CA 92008
(619) 270-6138
attn: Robert L. Goddard

Profile: Small sets of duplicate color slides offered of ancient architecture (Egyptian, Greek, Roman), Mexican ruins, early American architecture, California missions, modern architecture and sculpture, architecture in Europe, and Oriental art and architecture. Company in business since 1969. New slides continually added.
Photography: Slides shot by Robert L. Goddard on Kodachrome ASA 64. Currently, Nikon camera and lenses used. Mostly shot with natural light. Processed by Kodak.
Production: Duplicated in a Kodak laboratory in Los Angeles. Film type not specified. Quality controlled by careful selection of originals (one-half to one stop overexposed). Mounted in cardboard.
Documentation: Illustrated catalog $0.50, deductible from first order. Mailing list kept and catalogs sometimes sent free of charge. Catalog revised annually. Slides keyed to information sheet supplied with each set.
Purchasing: Slides sold in sets only, but set sizes small (3 to 25 slides). Small stock kept, but some duplicates made on receipt of order. Eighty percent of orders filled within two weeks. Rush orders accepted if slides in stock; no surcharge. Set prices based on $2.00 per slide. Discount of 10 percent given on more than 50 slides; 20 percent on more than 100 slides; 25 percent on more than 1,000 slides. United States orders postpaid. Foreign postage charged to customer. Minimum order $25.00. Purchase order required from institutions; slides sent on approval. Prepayment required from all others. Returns accepted for exchange or refund.
Evaluation: Quality 2, documentation 2, service 3. Set on Pitti Palace sent as samples: of five slides, three views marred by perspective distortion, one badly; two slides overexposed. Identification scant.

34 DeMarco, Nicholas
Box 148, Vassar College
Poughkeepsie, NY 12601
(914) 452-7000, x2655

Profile: Duplicate color slides offered of originals shot by slide curator while traveling in Europe covering architecture, sculpture, and painting from ancient Greek and Roman to modern. Many views available of sculpture in the Pergamon Museum, East Berlin. Some works in the Kunsthistorisches Museum, Vienna documented. Architecture in Chicago and Minneapolis also offered. New slides continually added.
Photography: Slides shot by N. DeMarco with Nikon camera, using 55 mm and 50 mm lenses and occasionally a 26 mm wide-angle lens. Films used include Kodachrome ASA 25 and 64 and Ektachrome ASA 400 and 160 tungsten.
Production: Duplicated by Kodak laboratory at Fair Lawn, New Jersey.
Documentation: Computer-generated list available of subjects covered. Views of architecture not specifically described.
Purchasing: Groups of slides sent on approval for selection of desired views. Orders usually filled within one week.
Evaluation: Quality variable, including some excellent slides. Documentation sketchy.

35 DeMartini Educational Films
414 Fourth Avenue
Haddon Heights, NJ 08035
(609) 547-2800
attn: Alfred DeMartini

Profile: Audiovisual programs, chiefly sound filmstrips, produced for secondary and college levels. One hundred thousand color slide titles offered. "Silkscreen" set available in slide format for $695.00, illustrating works by 100 artists whose prints are in the collection of the Philadelphia Museum of Art (960

frames). Other works in the Philadelphia Museum of Art and other museums and galleries also represented in archive. Approximately 1,000 new slide titles to be added in 1984.

Photography: Slides and Ektacolor negatives shot by A. DeMartini and a staff photographer using Nikon equipment.

Production: Copies made by VI-TECH laboratory in Camden, New Jersey, and Kodak in Rockville, Maryland. Color corrected and contrast controlled. Mounted in cardboard or plastic.

Documentation: Free brochures. No catalog available. Slides keyed to identification lists. Orientation not marked. "Silkscreen" set accompanied by teacher's manual, with brief commentary for most frames.

Purchasing: Slides sold singly. Quotations made for quantity purchases. Minimum order $25.00. Some slides kept in stock, but duplicates usually made to order and shipped within five days to two weeks. No returns accepted.

Evaluation: No information available.

36 **Dick Blick Co.**
P.O. Box 1267
Galesburg, IL 61501
(800) 447-8192

Profile: Company dealing in art and educational supplies offers 160 sets of duplicate color slides. Art and architecture covered from prehistory to the present. Approximately 12 new sets to be added in 1984. (Because of its all-encompassing coverage, Dick Blick Co. is not included in the subject index of this guide.)

Photography and production: No film type specified. In catalog, low cost credited to "production overruns (not factory seconds)."

Documentation: Slide sets listed on five pages of general catalog, available for $2.00. New catalog issued annually. Identification of individual slides not provided in catalog, but slides themselves labeled.

Purchasing: Slides sold in sets only, ranging in size from 25 to 800 slides. Quantity discounts figured into price structure: twenty-five slides for $14.50, 50 slides for $37.50, 100 slides for $78.80, 400 slides for $274.80, 800 slides for $448.80. Postage added. Special prices quoted for very large orders. Minimum order $10.00. Prepayment required except from institutions or companies with Dunn & Bradstreet rating. Four mail-order centers located in United States: Galesburg, Illinois; Emmaus, Pennsylvania; Henderson, West Virginia; and Plainville, Connecticut. Each has toll-free number for ordering. Retail store located in Dearborn, Michigan. Slides shipped within two to three weeks. Rush orders filled within one week; no surcharge. Returns accepted within 10 days. "All sales guaranteed."

Evaluation: No information available on quality of slides. Several misspellings of artists' names noted in catalog.

37 **Educational Audio Visual, Inc.**
Pleasantville, NY 10570
(800) 431-2196 or (914) 769-6332
attn: Jeanne Nelson, Promotion Manager

Profile: No response to three mailings of questionnaire, but continued existence verified by telephone. Distributor for color slides produced by other companies (names withheld at request of EAV). Educational Audio Visual, Inc. is no longer an authorized distributor of Scala (421) slides. Other audiovisual materials sold as well—filmstrips, records, audiocassettes, tapes, overhead transparencies, and so forth. Subjects covered include art appreciation, design, graphic arts, photography, crafts, art processes, architecture, and art history.

Production: Cardboard mounts standard; some sets mounted in glass.

Documentation: New catalog issued annually. Contents of sets listed in catalog. Identifications consist of artist, title, collection.

Purchasing: The following information extracted from the 1980 EAV catalog. Slides sold in sets only, priced approximately $2.00 per slide if glass-mounted, less than $1.00 each if cardboard-mounted. Minimum order $25.00 unless prepaid by check or money order. Slides sent on 10-day approval. Returns negotiated by customer service department.

Evaluation: Quality 2, documentation 2, service 2.

38 **Educational Dimensions Group**
Box 126
Stamford, CT 06904
(800) 243-9020 or (203) 327-4612

Profile: Educational filmstrip company in business for more than 15 years, oriented toward high school and college audiences. Archive of 300,000 color slides available, "mostly outtakes shot for our filmstrips." Sets of slides packaged in carousels. Individual slides sold as "stock photos" for reproduction. Art and architecture covered among other subjects. Techniques, art appreciation, and art historical survey emphasized. Works in New York museums and galleries represented. New titles continually added. Black-and-white prints also made from slides on request.
Photography: Slides and some large-format transparencies shot by staff photographers on Kodachrome and Ektachrome using Nikon equipment.
Production: Duplicated on Kodachrome ASA 25 with Bowens Illumitran. Color corrected and contrast controlled. Packaged in carousels or sleeves.
Documentation: Mailing list kept. Free catalog of filmstrips issued annually; slide sets included. Sets accompanied by teacher's guides and sometimes by cassettes. Some slides labeled, others keyed to booklet. Orientation not routinely marked but may be requested on "stock photo" orders.
Purchasing: Toll-free number available for placing orders; order form included in catalog. Sets sent on approval to institutions for 30-day preview. Prepayment required from individuals and businesses. Shipping covered on prepaid orders or added at 2½ percent to invoices. Twenty-slide sets $36.50. Sets in carousels approximately $1.00 per slide; two sizes offered, 160 and 320 slides (i.e., two or four carousel trays). Guarantee: "You may replace absolutely free any component of your . . . slide set if it becomes damaged or defective." "Stock photo" orders sold according to A.S.M.P. (American Society of Magazine Photographers) price list. Originals can be mailed out on day of request. Picture researchers invited to visit archive by appointment.
Evaluation: "Two sets previewed in 1976 and returned. Problems noted with focus and exposure in one set. Other set acceptable but duplicated subjects already in our collection" (Norine Cashman).

39 **Elliott Faye Media**
4614 Prospect Avenue
Cleveland, OH 44103
(216) 431-0549

Profile: No response to questionnaire. Entry based on "Slide Market News," *International Bulletins* of December 1982 and March 1983. Archive compiled of 2,000 color slides shot since 1972 by E. Faye for publication or multimedia presentations. Ancient sites and artifacts featured in Turkey, Greece, Crete, Cyprus, Malta, Israel, and so forth. Early Christian and medieval churches included in Greece, Turkey, Israel, Italy, Germany, and Spain. Some icons and manuscripts offered.
Photography: Slides shot by Elliott Faye on Kodachrome, Ektachrome, and Agfachrome. Professional equipment and methods used.
Production: Duplicated by local laboratory on Kodak duplicating film, usually Ektachrome #5071. Quality supervised closely by E. Faye.
Documentation: List $1.00, arranged by region, period, and medium.
Purchasing: Single slides priced $3.50 each. Quantity discounts. Sets of 20 slides $35.00. Postage included in prices. Minimum order $10.00. Slides duplicated to order and shipped within two weeks.
Evaluation: No information available.

40 **European Art Color Slides**
(Peter Adelberg, Inc.)
120 West 70th Street
New York, NY 10023
(212) 877-9654
attn: Mrs. Greta Adelberg

Profile: All media, prehistoric to modern times, covered by 6,000 color slide titles. Many museum collections represented. Company in business for more than 30 years but no longer expanding holdings.
Photography: Slides shot by Peter Adelberg on Kodak film using Pentax equipment.
Production: Duplicated at Kodak laboratory, Fair Lawn, New Jersey. Mounted in cardboard.
Documentation: Mailing list no longer kept. Catalog $5.25, prepaid. No revision planned. Slides available, however, that are not listed in catalog. Minimal identifications given in catalog, to which slides are keyed by number. Orientation not marked.
Purchasing: Slides sold singly, $3.50 each. No discounts. Postage added. Minimum order 40 slides. Order of at least one-third more advised because many items are no longer available. Prepayment or official purchase order required. Some slides kept in stock (a few originals, mostly duplicates). If necessary, duplicates made to order. Orders shipped within four weeks. Rush orders accepted and filled within one week; no surcharge. Slides not sent on approval. Return of up to 10 percent accepted for "valid reasons."
Evaluation: Quality 2 to 3, documentation 1 to 2, service 1. "Many old slides are excellent even after years of heavy use. Slides ordered in 1978, however, varied widely in quality. Some, evidently on unstable film, were so discolored that they were discarded immediately" (Norine Cashman).

41 **Frieze Frame Images**
126 Commonwealth Avenue
Boston, MA 02116
(617) 353-0570
attn: Samuel B. Frank

Profile: Offers 8,000 color slide titles of architecture, landscape, and urbanism in France, England, and the United States. "In our urban and landscape slides, special care has gone into describing complex spaces and sequences through series of images." New titles continually added.
Photography: Eighty to ninety percent of slides shot by S. Frank on Kodachrome or Ektachrome.
Production: Slides duplicated by Subtractive Technology, Boston, Massachusetts. Color corrected and contrast controlled. Mounted in cardboard.
Documentation: Catalog in progress, to be issued free. Slides keyed to catalog. Color Xerox contact sheets sent on approval to aid in selection of slides. Orientation marked.
Purchasing: Slides offered singly or in sets. Minimum order $25.00. Slides $2.50 each, with discounts for quantities greater than 100, purchase in sets, and/or prepayment. Postage added to orders under $100.00, included on orders over $100.00. Prepayment required except from institutions. Some slides kept in stock. Orders filled within one to two weeks. Rush orders filled in two days if items are in stock. Returns accepted for exchange.
Evaluation: Only Mark Braunstein at Rhode Island School of Design, where Mr. Frank teaches, was able to rate this source: quality 3 to 4, documentation 1 to 2. "Excellent views, well-edited selection but information scant."

42 **GAF Slides**
Viewmaster International
P.O. Box 490
Portland, OR 97200

Profile: Also known as Panavue Slides. Slides of museum objects produced to be distributed by some U.S. museums.
Photography: Color transparencies (4 by 5 inches) supplied to GAF by each museum.
Production: Film type not specified. Produced as "superslides"; that is, film frame is larger than that of normal 35 mm slides. Mounted in plastic mounts with ¼-inch border on all four sides.
Documentation: Identification printed on mounts. Lists may be available from the individual museums.
Purchasing: Offered only by museums. Prices usually quite low, no more than $1.00 per slide.
Evaluation: Original colors are quite rich, even garish when film is fresh. Unstable film fades to pink or orange. Because of the odd size of the film, these slides cannot be glass-mounted in the usual Gepe or Perrotcolor mounts, nor can standard-sized labels be applied along the narrow borders.

43 **Geological Education Aids**
17 Leisure Drive
Kirksville, MO 63501
attn: A. J. Copley

Profile: Approximately 10,000 images offered as filmstrips or slides; 90 percent color, 10 percent black-and-white. Art covered among other topics, all scientific. Museum objects represented. New titles continually added.

Photography: Kodachrome slides and Kodak #5247 negatives shot mostly by A. J. Copley, who teaches geology at Northeast Missouri State College.

Production: Printed by a commercial movie laboratory on Eastmancolor #5384; recommended ECP-2A processing used. Color corrected. Copies kept in stock; some may still be on Eastmancolor #5381 (unstable). Sold unmounted only, coiled in film canister. Brochure mentions option of plastic mounts at $0.55 per slide or glass mounts at $0.95 per slide.

Documentation: Mailing list kept. Free brochures, updated annually. Sets accompanied by information sheets (five to eight sheets per 80-100 slides). Some identifications given in Spanish or French; most in English.

Purchasing: Slides sold in sets only. Price per frame of film approximately $0.22. Minimum charge $4.00. Prepayment required from individuals. Postage paid on prepaid orders. Stocked slides shipped within three days. Slides sent on approval. "Our slides have a satisfaction guarantee. Return within five days for exchange or cancellation of order if not satisfied for any reason." Periodic sale prices announced in mailings.

Evaluation: Quality 1 to 2, documentation 1 to 2, service 3. Two sample strips sent: one of flat art very good; one of painting and sculpture poor to fair. Lighting uneven, paintings not level or square, several frames pinkish-orange overall. "Odd slide sets/filmstrips with very sketchy information. Some slides already off-color when sent" (Nancy Kirkpatrick).

44 **Gould Media, Inc.**
44 Parkway West
Mount Vernon, NY 10552-1194
(914) 664-3285
attn: Anthony E. Mellor

Profile: Distributor for Colorvald (419), Focal Point (273), Woodmansterne (278), Audiovisual Productions (Chepstow), Diapofilm (327), KaiDib Films (56), and Diana Wiley (London). Slides formerly sold by Audio-Learning, Inc. included. All slides are duplicates, 99 percent on color film. Art history covered among other subjects: history, music, biology, geography.

Production: Woodmansterne and KaiDib slides produced on Eastmancolor #5384 (low-fade). Other slides printed on Eastmancolor #5381 (unstable). Mounted in cardboard or plastic.

Documentation: Free catalog, updated twice a year. Sets described, but only Woodmansterne slides listed individually. Identification provided either on slides or in accompanying notes.

Purchasing: Slides sold singly or in sets. No minimum order, but service charge of $5.00 added to orders under $50.00. Per-slide cost in sets varies; set prices listed in catalog. Single slides $2.75 each (available only from KaiDib and Woodmansterne sets). United States orders sent postpaid. On orders from Canada, $4.00 added for postage and insurance. On overseas orders, postage and insurance charged at cost. If in stock, slides sent one day after receipt of order; otherwise, shipped within three weeks. Slides sent on 30-day approval after submission of a purchase order. Returns accepted for exchange.

Evaluation: For quality and documentation ratings, see entries for producers listed in Profile. Slides on stable film designated in catalog. Handsome, well-organized catalog, but artists' names and place names occasionally misspelled.

45 **Grimm, Douglas**
2524 Sycamore
Route 7, West Rattlesnake
Missoula, MT 59802
(406) 543-7970

Profile: No response to questionnaire. Entry based on fourth edition, updated by telephone call. Approximately 1,500 color slide titles offered of works by contemporary artists and craftsmen. Many museum objects documented.
Photography: Slides shot mostly by D. Grimm, with a few by other commissioned photographers. Camera hand-held. Ektachrome used with available light. Museum photography carried out during regular hours.
Production: Duplicated in commercial laboratory on Ektachrome. Frames masked. Color corrected. No contrast control attempted.
Documentation: Catalog $1.50, deductible from first order. Additional slides available that are not listed in catalog. Identifications supplied on slides as well as in catalog. Orientation marked by position of title at top.
Purchasing: Approximately 20 of each slide title kept in stock. Price for 50 slides is $45.00; additional slides $0.79 each. No smaller orders accepted. Prepayment required from individuals.
Evaluation: Two-star rating in fourth edition.

46 **Haeseler Art Publishers**
Technical Center
710 Park Avenue
Iowa Falls, IA 50126
(515) 648-3014
attn: John A. Haeseler

Profile: Offers 3,000 color slide titles of art and architecture in France and Spain. Coverage of Italy and Great Britain anticipated. Medieval architecture and architectural sculpture featured. New slides continually added.
Photography: Slides shot by John Haeseler, producer of more than 100 films, using Leicaflex equipment. Tripod always employed for interiors and often for exterior close-ups. Slides shot on Kodachrome ASA 25, bracketing for optimal exposure.
Production: Duplicated at Haeseler's Technical Center on Ektachrome #5071, with processing by Kodak laboratories in Chicago and Hollywood. Color corrected. Slides of a series copied together on same emulsion and processed simultaneously to ensure consistency. Mounted in cardboard.
Documentation: Mailing list kept. First catalog available listing 1,000 slides, illustrated in black-and-white. Second catalog in progress (2,000 slides). Both free. Third catalog to be issued featuring English subjects. Slides keyed to identification sheets accompanying sets. Commentaries on each set provided. Orientation marked.
Purchasing: Slides sold in sets and singly. Minimum order 20 slides with at least four slides per set. Sets kept in stock and shipped within one week (first class), but singles made to order (two to four weeks extra). Per-slide cost $1.50 in sets of more than 30 slides, $1.60 in sets of less than 30 slides. Single slides $2.00 each. Postage added at cost, plus $3.00 handling. All slides sent on approval. Returns accepted.
Evaluation: Quality variable (2 to 4), documentation 2 to 3, service 2. Six samples sent: some cropping and distortion noted on slides of paintings. Architecture slides generally better than art slides. Identifications minimal and in some cases inadequate for full cataloging. For instance, portraits included as "documentation" are identified only by sitter, not by artist.

47 **Hart Slides World Wide**
224-A Alhambra
San Francisco, CA 94123
(415) 921-8549
attn: Neil Hart

Profile: Established 1975. Offers 7,000 color slides taken in Iran, Afghanistan, Pakistan, India, Malaysia, Thailand, Greece, Turkey, Spain, Latin America, and so forth to "document architectural and historical subjects, urban settlements, and the relation of public space to public life." New slides continually added (four sets totaling almost 300 slides in 1985).
Photography: Slides shot by Neil Hart, architect and urban designer, on Kodachrome (and in the past occasionally on Agfachrome and Ektachrome) using a hand-held 35 mm camera, natural light, and various lenses, including wide-angle and telephoto.

Production: Duplicated at Faulkner Color Lab on Ektachrome #5071. Color corrected and contrast controlled. Mounted in cardboard.

Documentation: Mailing list kept. Computer-generated catalog (1981) $6.00, deductible from first order. Identification consists of site, building name, view description, date, and references to subject index. Supplements issued as new slides become available. Slides keyed to catalog or supplementary lists. Orientation marked by index number at top.

Purchasing: Order form included in catalog. Slides sold singly and in sets. Single slides $3.25 each. Per-slide cost in sets discounted. Additional quantity discounts given on very large orders. Postage and handling charged at 10 percent to maximum of $10.00. Minimum order $50.00. Prepayment required from individuals and foreign accounts. Purchase order required from institutions. Slides duplicated to order and shipped within three to four weeks. Sets (*only*) sent on approval. Returns accepted within five days for exchange or refund. Requests considered for slides shot to order.

Evaluation: Quality 3, documentation 3, service 3 to 4. Two samples sent: beautifully composed views of an architectural interior, both slightly soft in definition. Catalog well organized and easy to use, greatly improved from earlier lists. Information that does not fall into an established category, however, has been dropped. For instance, architects are not listed.

48 Heaton-Sessions
P.O. Box 376
Stone Ridge, NY 12484
(914) 687-0656
attn: Adria Heaton-Sessions

Profile: General coverage of art history offered in approximately 2,000 slide titles. Sets coordinated with 15 texts: color slides of color plates, color slides of black-and-white illustrations, and black-and-white slides of illustrations not available in color. (This source not indexed by subject in this guide.)

Photography: Slides shot by Adria Heaton-Sessions (30 percent) and her husband, Edward Picard (70 percent). Color slides (80 percent of total) shot on Ektachrome ASA 160 and 400. Electronic flash used where possible.

Production: Duplicated in-house on Ektachrome #5071. Color corrected and contrast controlled "as much as possible." Black-and-white slides produced on Kodak Fine Grain Release Positive film #5302. Mounted according to customer choice: cardboard, Gepe glass (regular), or Gepe glass (anti-Newton ring). Sets available unmounted.

Documentation: Mailing list kept. Free catalog, revised annually, listing only the plate numbers available for each book. Supplements issued when new slides become available. Slides keyed to textbook. Orientation marked.

Purchasing: Slides sold singly or in sets. Minimum order 20 slides. Single slides priced from $1.06 to $1.98 each, depending on film type and mount type. Per-slide cost in sets less than $1.00 for unmounted and cardboard-mounted slides. Postage added. Slides duplicated to order and shipped within four weeks. Rush orders filled within one to two weeks, depending on size of order. Purchase order required. Prepayment of 50 percent required from foreign customers. "To preview, ask for representative group of slides for two-week loan." Returns accepted for exchange or refund "only when the slides are defective." No unmounted slides may be returned.

Evaluation: Quality 1 to 2, service 2. Faults mentioned by advisors include dirty film, graininess, poor color, and cropping of image. Many slides are obviously shot from secondary sources (books, and so on). Documentation not rated because no identification provided other than reference to textbook.

49 Honart Slides
49 Church Street
Westborough, MA 01581
(617) 366-0860
attn: Linda Honan

Profile: Approximately 1,000 color slide titles listed of architecture and architectural sculpture from Europe and North America. Among the special sets now offered: "Romanesque Pilgrimage Route

Architecture," "Urban Spaces in Europe," "Antonio Gaudí," "Monet's Giverny: An Artist's Garden," "Shaker Community Architecture," and "New England Gravestones." Five hundred other slides available, and 1,500 more to be added in 1984.

Photography: Slides shot by traveling scholars using Olympus camera with various lenses and a tripod. Photographed on Agfachrome ASA 200 and Ektachrome ASA 100 and 400 (formerly on ASA 64) with available light. "Very little use of flash."

Production: Duplicated on Ektachrome #5071 at Kodak's Rochester laboratory. "We are in the process of setting up our own laboratory." No color correction or contrast control attempted: "We aim for an exact duplication of the original." Mounting options: unmounted, cardboard-mounted, or Gepe glass-mounted.

Documentation: Mailing list kept. Free catalog, updated annually. Slides keyed to information sheet. Orientation marked.

Purchasing: No minimum order. Price per slide unmounted or in cardboard mounts $1.80, in Gepe glass mounts $2.80. Ten percent discount given on orders of more than 15 slides. Sets discounted 10 percent from price of singles. Postage added at 5 percent within North America. Other customers billed for shipping at cost. Duplicated to order; slides shipped within three weeks. Rush orders filled within one week; cost of $5.00 per slide. Prepayment required from unknown individuals. Returns accepted for exchange or refund if sent back within ten days. Requests considered for slides shot to order.

Evaluation: Five samples sent: two architectural views marred by perspective distortion. Details of sculpture very good. Color appears natural, contrast high on only one slide. Information in catalog brief; few specific dates given.

50 Indian Culture
P.O. Box 724
Hadley, MA 01035

Profile: No response to questionnaire. Entry based on the December 1981 *Bulletin*. Offers 900 color slide titles of art, architecture, and related religious and social activities of India, Sri Lanka, Thailand, Kampuchea, Indonesia, Korea, Japan, Afghanistan, Iran, and Egypt.

Photography: Slides shot on Kodachrome and Ektachrome.

Production: Duplicated by a Kodak laboratory.

Documentation: Eighteen sets of 50 slides each described in catalog. Label information for each slide provided with set.

Purchasing: Slides sold singly or in sets. Per-slide cost from $1.95 to $1.60, depending on discount for quantity.

Evaluation: No information available.

51 Inky Press Productions
P.O. Box 3849
Champaign, IL 61821
(217) 352-1958

Profile: Entry based on 1984 brochure. Six sets totaling 165 color slide titles offered of the work of Bea Nettles, artist-photographer. Books also published and exhibitions circulated.

Production: Five sets plastic-mounted, one unmounted.

Documentation: Free brochure describing sets and the work of Bea Nettles.

Purchasing: Slides sold in sets only. Purchase orders requested from institutions. Prepayment required from individuals. Prepaid orders postpaid. Set prices based on $1.00 per slide. With the exception of one set of 15 slides, each set comprised of 30 slides.

Evaluation: No information available.

52 **International Structural Slides**
 P.O. Box 466
 Berkeley, CA 94701

Profile: Principles of structural and architectural engineering illustrated by 680 color slide titles. First two volumes consist of seven chapters, each treating one type of structure. Volume 3 is entitled "Structures of Leonhardt, Andrä, and Partners." Volume 4 is entitled "Earthquake Engineering." New slides continually added (120 in 1984).

Photography: Volumes 1 and 2 photographed by Professor W. G. Godden, Department of Civil Engineering, University of California, Berkeley. Volume 3 photographed by German professional photographers. Volume 4 photographed by Professor V. V. Bertero, Division of Structural Engineering, Berkeley. Slides shot on Kodachrome ASA 25 and 64 and Ektachrome ASA 400. Leica and Nikon cameras used with various lenses.

Production: Duplicated on Ektachrome #5071 by Frank Holmes Laboratories, San Fernando, California, with no color correction or contrast control. Mounted in cardboard.

Documentation: Mailing list kept. Free brochure. "Information Package" for Volumes 1 and 2 available for $5.00 within the United States, $6.00 overseas. Catalog revised or supplement issued annually. Slides keyed to descriptive manual accompanying set. Orientation marked.

Purchasing: Slides sold in sets only. Per-slide cost $1.50 in United States, $1.62 overseas. Postage included in prices. No discounts. Prepayment required on all noninstitutional orders and overseas orders. Purchase order required from institutions. Duplicated to order and shipped via United Parcel Service within two to three weeks. Foreign orders shipped Air Freight. No rush orders accepted. Slides not sent on approval, and no returns accepted. "The price includes projection rights within the (purchasing) institution only. Wider use may be possible with further negotiation." Requests considered for slides shot to order.

Evaluation: One sample sent: color bluish, but building well photographed and resolution sharp. Black-and-white images reproduced on promotional sheet appear excellent. Volumes 1 and 2 "currently used in over 50 universities."

53 **Islamic Perspectives**
 76a Sparks Street
 Cambridge, MA 02138
 (617) 661-0205
 attn: Kendall Dudley

Profile: Offers 7,000 color slide titles of Islamic architecture, cities, villages, and aspects of daily life. "Current collection focuses on Iran, Turkey, India, and Spain but is continually expanding through trips to areas of Islamic influence." Substantial additions (probably Sicily and/or Egypt) planned for 1985 or 1986. A few museum objects represented. Black-and-white prints also supplied.

Photography: Slides shot by K. Dudley (70 percent) and independent professionals (30 percent). Kodachrome used for 90 percent of originals; remainder shot on Agfachrome ASA 125. Nikon cameras used with variety of lenses. "Tripod used wherever possible and necessary. Vivitar 285 flash used where permitted. Vast majority of slides and black-and-white are taken with available light. Work done primarily in early morning and late afternoon."

Production: Duplicated by Kodak at Rochester or Fair Lawn, depending on client's preference. No color correction or contrast control attempted. Mounted in standard Kodak cardboard mounts.

Documentation: Mailing list kept. Free catalog of sites and sets, including price list. Comprehensive catalog listing all slides $6.00, deductible from first order. Catalog revised every two years. Slides keyed to catalog. Orientation marked only as necessary.

Purchasing: Slides sold singly or in sets. Single slides $2.95 each. Per-slide cost in sets approximately $1.75. Special prices quoted on large orders of single slides and on combinations of sets. Postage added. Minimum order five slides. Duplicated to order and shipped within one to two weeks. Rush orders filled in two days (local laboratory) or one week (Kodak); possible surcharge on small orders. Prepayment requested on large orders: 50 percent on U.S. orders, 100 percent from overseas customers. Sample slides sent on request, but slides duplicated to order not sent on approval. Returns accepted for exchange "if slide is defective or poorly exposed." Requests considered for slides shot to order. "Shooting itineraries can be designed to include requests for particular sites, and orders will be taken for original slides and negatives."

Also, documentation of New England architecture arranged at hourly rate of $45.00, "total cost subject to negotiation."
Evaluation: Quality 3, documentation 3 to 4, service 4. "Originals viewed in office in Cambridge, Massachusetts are good, but Kodak duplicates from these lose much. Some views completely worthless—obscured by sharp, dark shadows or close-ups with no distant views to accompany. . . . This minor complaint I voice about only a few slides. The vast majority are absolutely beautiful and probably unavailable anywhere else" (Mark Braunstein). Nine sample slides sent: good color, sharpness fair, interesting views.

54 **James L. Ruhle and Associates**
 P.O. Box 4301
 Fullerton, CA 92634
 (714) 526-6120

Profile: Offers 57 sets of color slides on energy and environmental subjects.
Photography: Slides shot mostly (80-90 percent) by James L. Ruhle on Ektachrome ASA 200.
Production: Printed by CFI on Eastmancolor #5384; processing unknown. Most duplicates made from originals, some from duplicates. Some Eastmancolor #5381 (unstable) still stocked. Mounted in plastic.
Documentation: Free list, revised every five years. Sets accompanied by booklets with printed narration. Orientation marked by number placement.
Purchasing: Sale in sets preferred. Single slides sometimes sold. Price for 50 slides is $27.50. Quantity discount of 10 percent given on orders totaling $1,000.00. Prepayment required from individuals. Slides kept in stock and shipped within two to three days. Rush orders filled in one day with no surcharge. Returns accepted "only if there is something wrong with our shipment."
Evaluation: Based on slides in the collection of Rhode Island School of Design the quality is 2 to 3.

55 **Johnson Architectural Images**
 P.O. Box 5481, Hilldale Station
 Madison, WI 53705
 (608) 238-4453
 attn: Don Johnson

Profile: More than 1,800 color slide titles offered in 46 sets of architecture from Roman times to the present. Work of several individual architects featured: Thomas Jefferson, Robert Maillart, Pier Luigi Nervi, Filippo Brunelleschi, V. Horta, H. P. Berlage, and Willem M. Dudok. Large set on Chicago architecture available. New slides continually added (two to four sets per year).
Photography: Slides shot by Don Johnson using Nikon camera, perspective-correcting lens, 70-210 mm zoom lens, and tripod. Kodachrome ASA 25 and 64 used in available light.
Production: Duplicated on Ektachrome #5071 in a California laboratory. Color corrected, contrast controlled "when possible." Mounted in cardboard or plastic. "On rare occasions, we will mount in glass."
Documentation: Mailing list kept. Free catalog, revised annually. Selection of available sets described in catalog. Slides keyed to list accompanying set. Orientation marked by label position.
Purchasing: Per-slide cost in sets $1.50. Single slides $2.00. Postage included in price. No discounts. No minimum order. Prepayment required from individuals. Sets kept in stock and shipped within one to two days. If customer dissatisfied, return of part or all of order accepted for exchange or refund. Slides sent on approval to institutions for 21-day review period; single slides may be selected from sets and remainder returned.
Evaluation: Quality variable, including some excellent slides; documentation 2 to 3, service 2 to 3. "Architect on faculty who asked us to order felt coverage of buildings was unimaginative, shots not well selected" (Helen Chillman). "All his Dutch architecture slides are horizontal. Many tall buildings and towers are cut off at the top" (Mark Braunstein). Twelve samples sent: most quite sharp, color generally muted, contrast rather high.

56 **KaiDib Films International**
 P.O. Box 261
 Glendale, CA 91209-0261
 (818) 249-9643
 attn: Tom Dibble

Profile: Company in business more than 20 years. Offers approximately 12,000 color slide titles in ancient art, Oriental art, Gothic architecture in Europe, modern architecture in the United States and Europe, urban planning in Europe, clothing in the United States and Europe, and theater arts, among others. Exhibitions documented include 250 slides from the Beijing Museum's "Archaeological Finds of the People's Republic of China" and 100 slides from the Shanghai Museum's "6,000 Years of Chinese Art." New slides continually added. Slides formerly sold by Dr. Block Color Productions acquired by KaiDib in 1982, to be reedited and issued as sets (several already available).

Photography: Slides shot, in equal proportions, by staff, independent professionals, and traveling scholars, usually on Kodachrome. Some objects photographed without being removed from museum cases.

Production: Printed by Frank Holmes Laboratories, San Fernando, California on Eastmancolor #5384; recommended ECP-2A processing used. Color corrected and contrast controlled. Mounted in cardboard. Packaged in plastic sleeves.

Documentation: Mailing list kept. Free catalog describing sets; individual slides not listed. Catalog revised annually. List of contents of any set sent free on request. Slides labeled and keyed to booklet accompanying set. Slides keyed to lecture notes, as well as to list of slide identifications at back of booklet. Identifications often incomplete. Orientation not marked.

Purchasing: Slides sold singly or in sets. Sets sent on approval for 30 days to institutions on receipt of a purchase order. Singles may be selected and the remainder returned. Booklet included in price whether whole set or selections kept. No minimum order. Single slides $2.65 each. Set prices discounted 25 percent (i.e., 100 slides for $198.75). Postage added at cost: United Parcel Service within United States, airmail to Canada, and surface mail overseas (unless airmail requested). Prepayment required from private organizations, individuals, and overseas customers unless credit previously established. Duplicates kept in stock and shipped within one week. Rush orders filled within two days at no extra charge. Slides accepted for exchange within six months or for refund within 30 days. "Our slides are also unconditionally guaranteed: if any color deterioration occurs within 10 years of your purchase, replacements will be made free of charge. If color shifts after 10 years, replacements will be made at 50 percent of our sales price in effect at the time replacements are requested."

Other sources: KaiDib slides also distributed by Gould Media (44).

Evaluation: Quality 2 to 3, documentation 2, service 3 to 4. "Slides varied in quality and usefulness. Texts in lecture-note format are virtually useless and often fail to identify the image sufficiently for full cataloging. Business policies and service are ideal from the consumer's point of view, however. An excellent source if acquisitions are selective" (Norine Cashman). "Good for basic material, particularly architecture. Have no complaints on anything we've purchased" (Helen Chillman). "Information provided is insufficient for cataloging. The brightly colored backgrounds detract from the image" (Marybeth Koos). "Service is always excellent" (Nancy Kirkpatrick). See Fall 1983 *International Bulletin* for more detailed evaluation.

57 **Kautsch, Capt. Thomas N.**
 (The Master's Tripod)
 955 Alla Avenue
 Concord, CA 94518
 (415) 682-8738

Profile: Offers 20,000 color slide titles of architecture, emphasizing cities, ruins, and temples. The countries documented include Burma, Cambodia, Egypt, India, Italy, Japan, Sri Lanka, Taiwan, and Thailand. Angkor covered extensively. Objects in New York's Metropolitan Museum of Art represented. New titles continually added.

Photography: Slides shot by Capt. Kautsch on Kodachrome. Negatives also shot on Kodacolor ASA 64 and Plus-X. Tripod used for most photography.

Production: Copies made commercially in several laboratories. Film type unknown but not Eastmancolor. Mounted in cardboard.
Documentation: Mailing list kept. Free single sheet listing sites. Slides keyed to information provided. Orientation marked.
Purchasing: Slides sold singly; some are originals. No minimum order. "Market price." Duplicates made to order, shipped within one week. Slides sometimes sent on approval. Returns accepted for exchange only.
Evaluation: No information available.

58 **Landslides**
77 Conant Road
Lincoln, MA 01773
(617) 259-8310
attn: Alex S. MacLean

Profile: Company founded 1975. Archive accumulated of 70,000 original color slides of aerial views. Duplicate slides of urban and rural subjects offered, useful for teaching about architecture, urban planning, land use, environmental issues, geology, and so forth. Sites and cities from 33 states represented. Approximately 10,000 slides added per year to archive. New sets offered periodically.
Photography: Kodachrome slides shot by Alex MacLean from both fixed-wing planes and helicopters using Nikon and Canon 35 mm equipment and a Kenyon KS4 Gyro Stabilizer. Pre-1975 slides on Agfachrome.
Production: Duplicated in-house on Ektachrome #5071; E-6 processing by a local laboratory. Color corrected and contrast controlled. Unmounted or mounted in plastic.
Documentation: Mailing list kept. Of 4,500 slides available, approximately 1,800 fully cataloged. Catalogs computer-generated. Catalogs listing more than 500 slides each, $5.00 apiece. Volume 1 on California; Volume 2 on southern Great Lake Cities; Volume 3 from Baltimore to Orlando. Slides labeled with brief information, also keyed to list and/or catalog.
Purchasing: Slides sold singly or in sets. Prices for institutions $2.50 per slide in sets, $3.75 per single slide. Minimum order $25.00. Duplicated to order and shipped within three to four weeks. Rush orders accepted, price negotiable. Slides made to order for $3.75 each plus $20.00 research fee. Slide sets sent on approval for five days; single slides may be selected. Refunds made for defective slides.
Evaluation: Quality 3 to 4, documentation 3, service 3. Unique offerings.

59 **Logos Signum Publications**
19122 Lindsay Lane
Huntington Beach, CA 92646
(714) 848-5401
attn: Robert Johnson, Publisher

Profile: Established 1975. Offers 25 sets of color slide titles in anthropology, classics, history, and, to a lesser extent, art history, philosophy, and theater. Artifacts from more than 50 museums represented. New sets in preparation include "Greek and Roman Sports," "Irish Prehistory," and "Portugal's Golden Age."
Photography: Slides shot by traveling scholars using Olympus, Canon, and Nikon cameras, 25 mm to 400 mm lenses, and tripod when necessary. Photographed with available light, occasionally with flash, on Kodachrome and Ektachrome.
Production: Duplicated at Frank Holmes Laboratories, San Fernando, California, using Ektachrome with E-6 processing. Color corrected and contrast controlled. Mounted in cardboard.
Documentation: Mailing list kept. Free catalog, updated twice a year. Slides keyed to booklets prepared by college-level instructors. Orientation marked by number in lower left corner.
Purchasing: Slides sold in sets only (60-240 slides), except for individual replacement slides ($3.50 each). No minimum order. Per-slide cost $1.25-$1.45. Postage included for U.S. orders (except rushes); from Canada $0.03 added per slide; from overseas $0.06 added per slide. Prepayment required from individuals, purchase orders from institutions. Duplicates kept in stock, shipped within one week, library rate. Sent on approval for 21 days; 15 percent rental charge assessed if not returned on time. Returns accepted for refund.

Evaluation: Quality 1 to 2, based on 16 samples sent: five very soft focus; color muted on three; six judged to be useful images of good quality. Documentation 3 to 4. Sample booklet for "History of Greek Theater" well organized and carefully printed. Commentaries substantial, and slide identifications adequate, although lacking materials and dimensions.

60 **McIntyre Visual Publications, Inc.**
 716 Center Street
 Lewiston, NY 14092
 (416) 245-7800

Profile: Filmstrips, some accompanied by cassettes, produced for the educational market. Also, approximately 100 sets of 40 slides each offered. Subjects featured include ancient art (prehistoric to Byzantine), painting (Renaissance to modern), modern sculpture and architecture, and Canadian art, including native arts. New slides continually added. Sixteen sets of 40 slides on painting (Renaissance to 1900) to be added in 1984. Distributor of slides by Visual Publications (277) and National Film Board of Canada (15). In Canada, address orders to McIntyre Educational Media, Ltd. (6).
Photography: Slides and large-format transparencies shot by staff photographers and independent professionals, mostly on Ektachrome.
Production: Copies made via internegative #6011 on Eastmancolor #5384. Eastmancolor #5381 no longer stocked. Produced by Advance Film, Toronto and Filmstrip Services, London, England. Color corrected and contrast controlled. Mounted in cardboard or plastic. Packaged in sleeves or carousel trays.
Documentation: Mailing list kept. Free catalog, updated annually. Slides labeled with main heading plus a number, keyed to descriptive guide. Some sets accompanied by cassettes. Orientation marked by number placement.
Purchasing: Slides sold in sets only. Prices based on per-slide cost of $1.00 to $1.50. Quantity discounts. Payment accepted in U.S. or Canadian funds. Prepayment required from individuals. Postage added at approximately 5 percent of invoice. Telephone orders accepted; call collect and ask for customer service. Orders filled within three days. Rush orders filled in two days if item is in stock. Slides sent on approval for 30 days. Returns accepted for exchange or refund.
Evaluation: Quality variable (from 1 to 3), documentation 2, service 3. "Occasionally too contrasty or blue" (Sara Jane Pearman). "Good coverage" (Nancy Kirkpatrick).

61 **Mayer, Francis G./Art Color Slides, Inc.**
 235 East 50th Street
 New York, NY 10022
 (212) 753-0053
 attn: Peter H. Mayer

Profile: Offers 16,000 color slide titles of art and architecture of all historical periods. Many museum objects included, as well as some objects in private collections. Company in business since 1943. No growth anticipated in present size of holdings.
Photography: Slides shot on Kodachrome by F. G. Mayer and more recently by Peter H. Mayer.
Production: Duplicated on Kodak positive film at a Kodak laboratory and mounted in cardboard.
Documentation: Catalog #8 and supplements all out of print. Complete original catalog plus supplement $45.00. Complete photocopied catalog plus supplement $30.00. Free list of catalog contents available. Single photocopied pages of catalog $0.15 each, plus $0.50 postage per 10 pages, prepaid. No revision of catalog planned. Identification of each image minimal. Slides keyed to catalog. Orientation marked.
Purchasing: No minimum order. Single slides $3.00 each. Postage added at 5 percent. Prepayment required on all orders. Duplicates usually made to order and shipped within four days. Slides made to order for $10.00 each, with possible quantity discounts. No returns accepted.
Evaluation: Quality 2, documentation 1 to 2, service 1. "Some Mayer slides in our collection, admittedly old and much used, are very faded. Recent acquisitions were of acceptable quality but were not as sharp as duplicates can be" (Norine Cashman). "Our slides date from 1974. Part of one order was returned due to cropping and [poor] focus" (Brenda MacEachern).

62 **Media Loft, Inc.**
10720 40th Avenue N.
Minneapolis, MN 55441
(612) 831-0226

Profile: More than 1,700 color slide titles in 21 sets offered of photo communications: art, documentary, photojournalism, commercial photography, and illustration. Works of an individual photographer featured in some sets. Photographic techniques documented in other sets. New titles continually added (three or four sets annually).
Photography: Slides shot by more than 50 different photographers on various films.
Production: Copies made by Allied Lab, Chicago, or Color Film Corporation. "In many cases we do our own 'master' set from the original and another laboratory does the duplications from our master." Color corrected and contrast controlled. Mounted in plastic or cardboard. Packaged in carousels, oriented correctly.
Documentation: Free catalog issued annually. "The series was conceived and produced by R. Smith Schuneman, B.F.A., M.F.A., Ph.D." Audiocassette (18-30 minutes) included with each set. Printed information provided as well (biographies, and so on).
Purchasing: Slides sold in sets only. Set consists of 80-120 slides. Minimum order one set. Eighty-slide sets $125.00 each. Postage included for U.S. orders; from Canada, add $5.00. Discount of 5 percent given on orders over $400.00, 10 percent on orders over $600.00. Payment accepted in U.S. currency only, by way of check, money order, or credit card. Purchase order with 30-day term also accepted. Prepayment required from new individual customers unaffiliated with a college and from any customer who has previously been delinquent in paying. Copies kept in stock and shipped within two weeks. Rush orders filled next day if possible; no surcharge. Slides sent on two-week approval; returns accepted for exchange or refund.
Evaluation: Based on eight samples sent: quality 3 to 4. No labels provided on slides.

63 **Media Tree**
2675 Windsor Avenue, N.E.
Salem, OR 97301
(503) 364-3906
attn: Karl Rehm

Profile: Offers 30 sets of 80 color slide titles each, representing art and architecture, ancient and non-Western, in Egypt, Greece, the Roman Empire, Mexico, China, Japan, and India. Also available: Islamic and some architecture of medieval Europe. Sixteen 80-slide sets on photographic techniques offered. Approximately 10 new sets added per year (around 200 slides).
Photography: Slides shot 90 percent by Karl Rehm, 10 percent by staff. Nikon and Leica equipment used. Films varied: Ilford Pan F, Kodachrome ASA 25 or 64, and Fujichrome ASA 50 or 100.
Production: Duplicated at Color Film Corporation, Stamford, Connecticut, onto Kodak Vericolor using internegative #6011. Color corrected by group. Contrast controlled. Mounted in plastic.
Documentation: Free catalog, revised yearly. Slides keyed to catalog. Orientation marked by number placement.
Purchasing: Slides sold in sets only. Twenty slides with guide $34.50, 80 slides with guide and synchronized cassette $59.95. Postage added: $2.00 within the United States. Prepayment required from individuals. Duplicates kept in stock, and orders filled within 30 days. No rush orders accepted. Slides sent on approval to institutions. Defective slides exchanged. No refunds given after payment.
Other sources: Distributed by Kenneth E. Clouse, 333 Quail Hollow Road, Felton, CA 95018.
Evaluation: No information available.

64 **Michel Studio, Inc.**
2710 Oxford Road
Lawrence, KS 66044
(913) 842-4664
attn: Lou Michel

Profile: Offers 2,500 color slide titles of architecture and sculpture in Europe, North Africa, and the United States, from ancient through modern times, including images appropriate for urban studies. Company founded 1964 by Lou Michel, Professor of Architecture at the University of Kansas. New titles continually added (1,000 in 1984).

Photography: Slides shot on Kodachrome ASA 64 by Lou Michel using Nikon equipment on a tripod and under ideal natural lighting.

Production: Duplicated on Ektachrome #5071 by Custom Color Corporation, Kansas City, Missouri. Color corrected and contrast controlled. Mounted by laboratory.

Documentation: Mailing list kept. Two free catalogs (1982 and 1985). Full identifications given. New catalog to be issued in 1985, featuring twentieth century architecture in the United States. Slides listed in sequence to approximate experience of walking through a space. Supplement to catalog issued approximately every three years. Slides keyed to catalog. Orientation marked.

Purchasing: Slides sold singly, $2.00 each. Minimum order 10 slides. Discount of 10 percent given on more than 100 slides if invoice paid within 30 days. Shipping charges from $4.00 to $6.00 per invoice. Prepaid orders sent postpaid. Prepayment required from individuals. Slides duplicated on order and sent within two weeks. Rush orders filled within three days; surcharge of $20.00. Slides sent on approval for 30-day review period. Returns accepted for refund or exchange. Requests considered for slides shot to order, travel and expenses to be covered by client.

Evaluation: Quality 3, documentation 4, service 3 to 4. "Excellent slides shot with the teacher in mind. Comprehensive listing of views and details is appreciated. Prompt service" (Nancy Kirkpatrick). Ten samples sent: excellent compositions, expert use of a perspective-correcting lens, good color, and better than average sharpness for duplicate slides.

65 **Mini-Aids**
 177 Webster Street
 Box A261
 Monterey, CA 93940
 (408) 373-7018
 attn: Joan Longdon or Felice Wild

Profile: Color slides imported from Europe. Art and architecture covered, emphasizing works that are difficult to obtain from other slide sources. Slides produced by Diapofilm (327), Stoedtner (373), Jünger Audio-Visuell (370), and others. Many works of art in European museums obtainable through this source.

Production: Copies made from internegatives or interpositives on various films. Mounts varied: paper, cardboard, plastic.

Documentation: Mailing list kept. Free monthly newsletter. Many slides available that are not mentioned in mailings. "We translate the pertinent information into English (and we research at Brand Art Library with the hope of filling in data when it is sketchy). When we are asked for 'anything' by a particular artist or architect, we compile a list from our catalogs (resources), send it to the requestor, and then order from the supplier as requested." Some sets accompanied by cassette as well as printed matter. Orientation marked (method varies by producer).

Purchasing: Slides sold singly or in sets. "Mini-Aids imports art slides from abroad. Since we are primarily a custom service, we buy in small quantities as requested." Slides usually shipped within four weeks. "Our policy is 'within six weeks'—to accommodate special orders and unforeseen delays." Rush orders accepted; surcharge to cover telephone call to Europe. Minimum order $30.00. Slides in sets $2.20 each. Single slides $2.65 each. Special orders $3.50 or more each. Shipping by United Parcel Service added at cost. Prepayment required from individuals. All orders (except custom-made slides) sent on approval for 10-day preview. Returns accepted within 10 days for exchange or refund. Discounted 5 percent for payment within 15 days of invoice date.

Evaluation: Quality variable (from 2 to 4), documentation 3, service 3 to 4. "Quality varies according to original source (as does information). Excellent, personalized service" (Nancy Kirkpatrick). "Stability of film from some sources doubtful" (Norine Cashman).

66 **Miranda, Dan**
P.O. Box 145
Brookline, MA 02146
(617) 739-1306 (after 6:30 p.m.)

Profile: Antique picture postcards (1890-1930) in the personal collection of Dan Miranda reproduced as slide sets. Subjects include "Anti-Semitic Picture Postcards, 1890-1920," "Black Stereotypes, 1900-1920," "Stereotypes of Women, 1890-1930," "Boston, 1900-1920." In all, 854 color slide titles offered in seven sets. Expected to add 1,000 slides in seven sets in 1984.
Photography: Slides shot on copystand with photo floods by Dan Miranda using Ektachrome tungsten ASA 50 professional film #5018. Processed by a commercial laboratory.
Production: Most slides sold are originals. Occasionally, duplicated on Ektachrome #5071 by Subtractive Technology, Boston. Color corrected and contrast controlled. Mounted in plastic.
Documentation: Mailing list kept. Free brochure describing sets. List revised at six-month intervals. Slides keyed to "full descriptive information" supplied with each set. Orientation marked by copyright name and date at top on front side.
Purchasing: Slides sold in sets only. Most are originals, 2 percent duplicates. Slides kept in stock and shipped within three days. Priced from $1.11 to $2.60 per slide, with the majority $1.60. Prepayment required. Quantity discounts. Shipping, handling, and insurance included in prices. Rush orders filled in three days; no surcharge. Slides made to order within three days. Sample slides (*only*) sent on approval. No exchanges or refunds accepted.
Evaluation: Quality 3, based on two samples sent: good color and sharpness; lighting uneven, noticeable mainly in background framing the postcard.

67 **Moorhead/Schmidt Slide Collection**
3400 Montrose Boulevard, No. 302
Houston, TX 77006-4334
(713) 526-3403
attn: Gerald Moorhead, Architect

Profile: Approximately 15,000 color slide titles offered, primarily of architectural subjects. Countries most extensively covered are Italy, the United States, France, and West Germany. Buildings from ancient to modern times included.
Photography: Slides shot by practicing architects during their travels. Various films used.
Production: See Purchasing.
Documentation: Free index, arranged geographically. City, building name, architect, and date provided but no descriptions of views.
Purchasing: Slides sold singly, as duplicates. Selection of originals sent postpaid on approval for 25 days, during which time the customer may make one copy of each slide desired for $1.00 each. Insurance required on return shipment. Charge of $30.00 assessed per slide if damaged. Slides also duplicated to order, in which case the customer pays the actual cost of duplication plus $1.00 per slide copied.
Evaluation: Based on a sample order: quality 3 to 4, documentation 3, service 3. "The most recently shot slides seem to be of the highest quality" (Norine Cashman).

68 **Murvin, H. L./Architectural Books, Slides & Seminars**
500 Vernon Street
Oakland, CA 94610
(415) 658-7517
attn: H. L. Murvin, AIA

Profile: Mesoamerican and South American subjects covered by 1,200 color slide titles, including pre-Columbian art, architecture, and artifacts (69 sites); indigenous architecture; markets and people; and Amazon tribes. Objects from museum collections in Mexico, Guatemala, Colombia, Peru, and Brazil represented. Presently, some 2,000 slides available beyond those listed in catalog. Approximately 500 new titles to be added in 1984.

Photography: Slides shot by H. L. Murvin, architect, on Kodachrome using tripod and zoom and wide-angle lenses.

Production: Duplicated by Kodak laboratory in Palo Alto, California. Color corrected and contrast controlled. Mounted in cardboard.

Documentation: Mailing list kept. Catalog $3.95, deductible from first order. Annual revisions or supplements issued. Slides keyed to catalog. Orientation marked by "X" in upper right-hand corner.

Purchasing: Single slides $2.25 for institutions, $4.00 for individuals or private firms. Minimum order 50 slides. Sets also offered. Shipping cost added. Purchase order or prepayment required. Duplicated to order and shipped within two to three weeks. Rush orders filled within 10 days; 10 percent surcharge plus special delivery charges. Slides not sent on approval, but "slides may be returned within two weeks of date of receipt for a full refund if color or focus is determined to be unacceptable or if a mistake is made in filling the order."

Evaluation: One sample sent of a sculpture: overall yellow-orange color, dramatic lighting from above, detail obscured by high contrast.

69 **Nicklas, Steven D.**
 Central Avenue
 Avis, PA 17721
 (717) 769-6416

Profile: Offers 52 sets of color slides of ancient art and architecture in Egypt, Palestine, other Near Eastern countries, and Roman Britain. Sets other than those described in catalog include "Byzantine Empire," "Ottoman Empire," "Arab Culture and Islam," "Crusades," "Rome and Pompeii," and "Coinage of Late Antiquity."

Photography: Slides shot on site by S. Nicklas, an archaeologist specializing in the Near East, using Kodachrome ASA 64. Wide-angle and telephoto lenses employed but not a perspective-correcting lens. Tripod used for 10-20 percent of shots; remainder shot with hand-held camera. Flash apparently used to light interiors.

Production: Duplicated on Ektachrome #5071 by Center County Photo Lab, State College, Pennsylvania. Color corrected and contrast controlled. Mounted in plastic and inserted in clear plastic sleeves.

Documentation: Mailing list kept. Four-part catalog $1.00, deductible from first order. Issue of German-language catalog planned within two years. Revisions/supplements anticipated at six-month intervals. Eleven sets offered that are not presently described in catalog, and addition of 11 more sets planned for 1984. Slides keyed to catalog (one page of text per set, plus brief description of each view). Orientation not marked.

Purchasing: Per-slide price in sets ranges from $1.10 to $1.45. Single slides available, but no price indicated. Flat rate of $2.00 charged for shipping. Discount of 10 percent offered on two or more complete series. Duplicates kept in stock (10 copies). Orders filled in most cases on day of receipt. Rush orders filled within 12 hours with no surcharge. Two weeks required for restocking. Slides sent on approval. Orders invoiced within 30-day term. Payment accepted in U.S. dollars or pounds sterling at the current exchange rate. Returns accepted for exchange or refund within 10 days.

Evaluation: Quality 2, documentation 2, service 3. Some distortion noted on sample slides, as well as variation in color accuracy and a tendency toward overexposure (at least on interior shots).

70 **Palm Press, Inc.**
 27 Gold Smith Street
 Littleton, MA 01460
 (617) 486-8448
 attn: John Laurenson, Jr.

Profile: No response to questionnaire. Entry based on 1984 letter and 1980 brochure. Firm specializes in custom photographic service to industry, institutions, artists, and photographers. Slide sets feature work of prominent photographers, mostly contemporary. As of 1980, 23 sets (905 slides) offered, some color and some black-and-white. Additional sets planned.

Production: "To assure the highest quality, the entire slide production process takes place at our shop. Our production involves the use of internegatives for both black-and-white and color, which we believe optimally bridges the gap between the original and the screen image." Mounted in cardboard and inserted in plastic sleeves.

Documentation: Catalog was scheduled to be issued in fall of 1980. Order form provided in brochure. Checklist with biographical information included with each set.

Purchasing: Sets of 30 to 40 slides $60.00 (1980). Discounted 20 percent if entire holdings purchased in one order. Prepayment or institutional purchase order required.

Evaluation: No information available.

71 **PDA Publishers Corp.**
1725 East Fountain
Mesa, AZ 85203
(602) 835-9161
attn: Theodore D. Walker

Profile: Books published on design graphics, architecture, and landscape. Eleven slide sets on site design offered as well. Most geographical areas in the United States represented. Titles include "Fences," "Pools and Fountains," "Steps and Ramps," "Play and Recreation Equipment," and "Site Furniture and Fixtures."

Photography: Slides shot on Kodachrome ASA 25 by an independent professional, Theodore D. Walker, former Professor of Landscape Architecture at Purdue University.

Production: Duplicated in-house on Ektachrome #5071. Color corrected and contrast controlled. Processed by Kodak laboratories. Mounted in standard Kodak mounts. Sets packaged in carousel trays.

Documentation: Mailing list kept. Free brochure, revised annually. Slides keyed to script for set. Most slides identified by city and state. Also available for $19.00, *Instructor's Manual for Site Design and Construction Detailing.*

Purchasing: Slides sold in sets only. Minimum order one subset. Per-slide cost approximately $1.00. Set sizes vary from 31 to 116 slides. Discount given only for entire collection—653 slides for $595.00 (savings of $65.00). Shipping by United Parcel Service available (6-12 days), charged to customer. Prepayment required from individuals who have not previously ordered or customers with poor credit rating. Duplicated to order and shipped book rate within three to six weeks. No rush orders accepted. Preview samples sent (approximately 20 slides) on receipt of a $15.00 refundable deposit. Returns accepted only if sent back within 24 hours of receipt.

Evaluation: No information available.

72 **Photo-America**
205 South Maple
Bowling Green, OH 43402
(419) 354-1727
attn: Andrew Gulliford
 or
Box 305
Silt, CO 81652

Profile: Images offered of the American West—historic sites, landscapes, nature scenes, people; also, views of urban America. Special strength: one-room country schools. Three thousand color slide titles available; 500 more to be added in 1984. Images offered for publication, educational use, or commercial use.

Photography: Slides shot by A. Gulliford or his associate, Randall Teeuwen, using Minolta, Nikon, Mamiya, and Hasselblad equipment. Slides and negatives shot on Kodak films: Kodachrome, Ektachrome, Tri-X, and Plus-X. Fifty percent shot on color film.

Production: Duplicated on Kodak film by Pallas Labs, Chicago. Color corrected and contrast controlled. Mounted in cardboard or plastic.

Documentation: Catalog with computer-generated index in progress. Slides labeled. Orientation not marked.

Purchasing: Slides sold singly. Minimum order 10 slides. Sets also offered. Prices vary according to intended use. Postage added. Rentals possible. Duplicates kept in stock, sometimes made to order. Orders sent within 30 days. Rush orders accepted; surcharge of 50 percent. Requests considered for slides shot to order. Prepayment required for slides made to order and for rush orders. Sample slides sent on approval. No returns accepted on ordered slides.

Evaluation: Fourteen sample slides sent, three of which represented architecture. Of these three, two were excellent and one was fair. Sharpness extraordinary for duplicates. Other slides of people, nature, etc., varied in quality.

73 **Pictures of Record, Inc.**
119 Kettle Creek Road
Weston, CT 06883
(203) 227-3387
attn: Nancy Hammerslough, President

Profile: Offers 46 sets of color slides of archaeological sites, including maps and diagrams, and of related museum objects. Two survey sets available of Mesoamerican archaeology. New sets continually added.

Photography: Eighty percent of slides shot by Nancy Hammerslough. Remainder shot by traveling scholars and archaeologists. Slides shot on Kodachrome ASA 64 and occasionally on ASA 400 film. Variety of lenses and lighting techniques used. Tripod sometimes employed.

Production: Printed on Eastmancolor LF print film #5378 by Insight Labs, Cineffects Visuals, or Color Film Corporation. Master slides are occasionally duplicates rather than originals. Color corrected and contrast controlled. Mounted in cardboard. Packaged in 8½-by-11-inch loose-leaf binders for bookshelf storage.

Documentation: Mailing list kept. Free catalog of brief set descriptions, revised twice a year. Each set accompanied by introductory text, detailed annotations keyed to slides, and a bibliography. Orientation marked (not so on two samples).

Purchasing: Slides sold in sets only. Minimum order one set. Sets vary in size from 42 slides ($66.00) to 110 slides ($150.00). Discount of 10 percent given on two or more sets. Prepayment required from individuals and foreign accounts. Payment accepted in U.S. dollars only. Slides kept in stock and orders filled one day after receipt. Sent via United Parcel Service. Presently, shipping outside United States charged to customer, but shipping within United States included in set price. Slides not sent on approval but may be returned for refund within 10 days (or within a longer time span if previously agreed on).

Evaluation: Quality 2 to 3, documentation 2 to 3, service 2 to 3. "Extremely garish and bright-colored backgrounds" (Marybeth Koos). Two samples sent: one slide was very good, the other was out of focus.

74 **Prothmann Associates, Inc.**
650 Thomas Avenue
Baldwin, NY 11510
(516) 223-1420
attn: John Middents

Profile: Color slides offered of architecture, fine arts, graphic arts, costume, textiles, furniture, ceramics, among others. Most slides imported from overseas, for instance from Hannibal (403), Sanz Vega (473), Diapofilm (327), and Bildarchiv Foto Marburg (402). Prothmann is no longer an authorized vendor of Scala (421) slides. Slides produced by Prothmann as well, often documenting exhibitions; subjects covered include ceramics, drawing, Afro-American and African art, Victorian art, and architecture in the United States and Europe.

Photography and production: Varied according to source of slides. Prothmann's own slides duplicated by Kodak.

Documentation: Free catalog, last issued in 1979 (#8), which lists more than 650 titles (25,000 slides). Some items listed are no longer available. Sources of slides not indicated. Contents of sets sometimes, but not

usually, listed slide by slide. Prothmann productions accompanied by printed identification and commentaries; completeness of identification variable.

Purchasing: Inquiries welcomed regarding subjects not listed in catalog. Mr. Middents will respond personally, describing the available materials and quoting prices. In general, prices increased 25 percent over those listed in the 1979 catalog. Slides sold primarily in sets, but Prothmann-produced architecture slides sold singly. Prepayment required from individuals. Returns accepted only if slides sent back within seven days of receipt.

Evaluation: Quality variable (from 1 to 3), documentation variable, service 3 to 4.

75 **ROLOC Color Slides**
 326 South Pickett Street
 Alexandria, VA 22304
 (703) 751-8668
 attn: Donald Kent Smith

Profile: Offers 40,000 color slide titles of tourist sites worldwide, including many major architectural monuments. Some paintings and sculptures available as well. Washington, DC, sites featured in set of 140 slides, accompanied by 17 pages of lecture notes. Custom title slides produced. Established 1947. "ROLOC slides are produced by Lt. Col. M. W. Arps, U.S. Army, retired, who turned his hobby into a business." New slides continually added.

Photography: Slides shot by various photographers, including Mr. Smith, his staff, and independent professionals. Film types varied.

Production: Duplicated at Colorfax Lab on Ektachrome #5071. Color corrected and contrast controlled. Mounted in cardboard.

Documentation: Catalog listing more than 6,000 slides of U.S. sites $1.00. Lists of subjects in more than 100 other countries offered for $0.37 each (cash or stamps). List of art subjects issued separately (12 pp.). Slides labeled with brief identification. Orientation not marked.

Purchasing: Slides sold singly. Quantity discounts given to $0.45 each for 200 or more slides. Minimum order $1.00. Postage included. Duplicates kept in stock and shipped within 24 hours. Telephone orders filled on date of call; no surcharge. Returns accepted for exchange or refund. "We do not require a deposit or official school purchase order. Invoices are sent with orders or, if desired, billing is delayed pending final selection of slides sent and determination of number retained by instructor or department initiating the order. . . . If for any reason you are not satisfied, please tell us about it. Color slides are still a hobby with us." Slides distributed through dealers at tourist sites in Washington, DC, and Virginia.

Evaluation: Quality 2, based on 12 sample slides sent of Washington, DC, architecture. Buildings mostly well photographed, but duplication only fair. Color garish on four slides; definition slightly soft on all; light surfaces overexposed. For the price, however, these slides judged a good buy.

* 76 **Rosenthal Art Slides**
 5456 South Ridgewood Court
 Chicago, IL 60615
 (312) 324-3367
 attn: John Rosenthal

Profile: More than 30,000 color slide titles of art and architecture offered, covering all time periods. Works in many major U.S. museums represented, as well as some in European collections. Selected holdings of 15 U.S. museums documented by sets of slides (also available singly). Slides of architecture from the Frank Lloyd Wright Foundation, Skidmore Owings & Merrill, and the Mies van der Rohe slide collection included. Special exhibitions documented such as "Manifestations of Shiva" (Philadelphia Museum of Art), "Women Artists, 1550-1950," and "Two Centuries of Black American Art" (both at Los Angeles County Museum of Art). Many contemporary artists listed in Volume 2 of catalog. New slides continually added.

Photography: Slides and large-format transparencies shot by traveling scholars (40 percent), museum staff (40 percent), John Rosenthal (10 percent), and miscellaneous persons (10 percent). Approximately 25 percent of originals are large-format transparencies supplied by museums. Kodachrome and Ektachrome

film used. In museums, studio lighting used with Nikon 35 mm equipment or view cameras. For shooting architecture, Nikon cameras on tripods employed. Perspective-correcting lenses used where applicable.

Production: Duplicated in-house on Ektachrome #5071. Ektachrome E-6 type #5018 sometimes used for increased contrast. To decrease contrast, flashing technique used. Mounted in 1.4 Loersch Quickpoint glassless plastic mounts with reduced glueline.

Documentation: Mailing list kept. Annual newsletters issued. Three-volume catalog $12.00, postpaid in United States. From overseas, add $5.00 for surface mail, $15.00 for airmail. Supplements issued approximately every two years. Listings in 1981 and 1983 supplements consolidated in Volume 3 of catalog, with new listings included as well. Supplements and new catalog volumes mailed free to customers who have purchased more than 50 slides during the previous two years. Slide titles in catalogs cross-referenced to related items in earlier volumes. Slides listed in Volumes 1 and 2 keyed to catalog. Slides in Volume 3 labeled as well. Orientation marked. Staff includes full-time slide curator employed to conduct research on images for catalogs.

Purchasing: Terms are 1-10 percent, 30-day net. In United States, FOB destination; foreign, FOB Chicago. All slides sold singly with the exception of two sets: manuscripts from the Pierpont Morgan Library (1,200 slides, $1,500.00) and "European Pedestrian Malls" (140 slides, $200.00). Single slides $2.00 each, with quantity discounts to $1.70 for more than 1,000 slides. Prepayment required from individuals and foreign purchasers (except Canada). "Institutions which expect that payment may take more than 60 days should contact us for terms." Minimum order $5.00 prepaid, $10.00 billed. Shipping charges included for U.S. orders. Orders shipped by insured airmail to overseas customers. Slides kept in stock and shipped within one week. Rush orders accepted; no surcharge, except for additional $5.00 if shipped via United Parcel Service Blue Label air service or if fewer than 25 slides are shipped via special delivery. "We will issue a refund, exchange, or credit for defective returned slides when valid criticism accompanies each slide returned."

Other sources: Rosenthal slides may be purchased directly from the following museums:

Albright-Knox Art Gallery, Buffalo, NY

Cincinnati Art Museum, Cincinnati, OH

Hirshhorn Museum, Washington, DC

Metropolitan Museum of Art, New York, NY

National Museum of American Art, Washington, DC

Phillips Collection, Washington, DC

Stanford University Art Museum, Stanford, CA

Terra Museum of American Art, Evanston, IL

Toledo Museum of Art, Toledo, OH

Walters Art Gallery, Baltimore, MD

Evaluation: Quality 4, documentation 4, service 4. "His slides get better and better. Excellent quality now; prompt service; information also more complete in recent years" (Nancy Kirkpatrick). "Not all slides perfect, but on average would rate as one of the best dealers" (Helen Chillman). "Excellent duplication" (Sara Jane Pearman).

✱ 77 **Sandak, Inc.**
 180 Harvard Avenue
 Stamford, CT 06902
 (203) 348-3721
 attn: Harold J. Sandak, President

Profile: Approximately 20,000 color slide titles offered of art and architecture, ancient through contemporary. Permanent collections and special exhibitions of U.S. museums extensively documented. "Arts of the United States" set (2,500 slides), compiled with funding by the Carnegie Corporation, still available, as is "Monastery and Cathedral in France." Other sets coordinated with textbooks offered, as well as numerous survey sets and art appreciation sets. New slides continually added.

Photography: Original works photographed by staff photographer (50 percent) and independent professionals (50 percent). Some original photography supplied by museums. All museum photography done by

special arrangement after public hours with tripod and professional lighting. Preferred film and format: 4-by-5-inch Vericolor negatives.

Production: Film used is Eastman Vericolor slide film #5072. Slides produced in-house. Color corrected and contrast controlled. "We probably are the only slide producers that really do not make duplicates in 80 percent of our production work. We prefer to shoot an original negative of the work of art and make 'first-generation' positives from that negative. However, there are times when it is not possible to shoot an original negative. When that occurs, we make an 'internegative' from the original transparency supplied by the museum and produce our slides frame-by-frame from the internegative. We believe that there is superior quality control in the laboratory with this method." Slides not subject to fading of color as in the past. "All Sandak slides are produced on Kodak film having a 'shelf-life' of 20-30 years and possibly longer with proper storage at 70 degrees Farenheit and a relative humidity of 40 percent." Mounting options: patented plastic and glass or cardboard. "We are gradually phasing out plastic and glass and will eventually only offer cardboard."

Documentation: Mailing list kept. Free catalog of sets. Lists of contents of particular sets available on request. Supplements issued annually. Identifications fully and systematically presented. *Arts of the United States* text (illustrated) still available for $10.50—useful as a reference tool and/or as a catalog for ordering slides. Slides labeled and keyed to list. Orientation marked (on plastic mount, edge marked with felt-tipped pen).

Purchasing: Slides sold in sets or singly. Singles may be selected from most sets. Single slides $1.95 each. Sets discounted. Postage added. Slides kept in stock. Rush orders "sometimes can be filled within a few days." Orders usually filled in two to three weeks (see Evaluation). Prepayment required from individuals. Slides sent on approval. "Approval orders must be explicitly indicated as such." Returns accepted for exchange or refund within 30 days. Slides purchased before change to stable film replaced at half price; old slides must be sent to Sandak on receipt of replacements.

Other sources: Sandak slides distributed by Educational Audio Visual (37) and also by the following museums:

Baltimore Museum of Art, Baltimore, MD

Cleveland Museum of Art, Cleveland, OH

Corcoran Gallery of Art, Washington, DC

Guggenheim Museum of Art, New York, NY

Hyde Collection, Glen Falls, NY

Indianapolis Museum of Art, Indianapolis, IN

Metropolitan Museum of Art, New York, NY

Montréal Museum of Fine Arts, Montréal, Québec, Canada

Museum of Fine Arts, Boston, MA

Museum of Fine Arts, Houston, TX

Museum of Modern Art, New York, NY

National Galley of Art, Washington, DC

New Orleans Museum of Art, New Orleans, LA

Ringling Museum of Art, Sarasota, FL

San Francisco Museum of Modern Art, San Francisco, CA

Toledo Museum of Art, Toledo, OH

Whitney Museum of American Art, New York, NY

Yale Center for British Art, New Haven, CT

Yale University Art Gallery, New Haven, CT

Requests considered for slides shot to order.

Evaluation: Quality variable (from 2 to 4), documentation 3 to 4, service variable (from 1 to 4). "New slides appear to be satisfactory and durable" (Elizabeth Alley). "The quality and longevity of Sandak slides keep improving" (Nancy Kirkpatrick). "Some mistakes occur in filling orders, especially those placed by phone, but are promptly corrected. Some slides on the new film come out too dark" (Helen Chillman).

"Letters of inquiry are answered very slowly. Coverage of European architecture needs to be updated" (Brenda MacEachern). "Large orders of single slides and replacement orders take several months to be filled" (Norine Cashman).

* 78 **Saskia, Ltd.**
 P.O. Box 621109
 Littleton, CO 80123
 (303) 978-9393
 attn: Renate Wiedenhoeft

Profile: Approximately 15,000 color slide titles offered of art and architecture of Western Europe, dating from ancient Greece through early twentieth century, with emphasis on the Italian Renaissance, Italian and northern Baroque painting, and nineteenth century French and German painting. Objects in approximately 46 European museums represented, as well as some in the Metropolitan Museum of Art in New York, the Cleveland Museum of Art, and the Nelson-Atkins Museum in Kansas City. Slides keyed to four textbooks (see Volume 2 of catalog). Photographers have 20 years of experience documenting museum objects. Color slides offered as originals and some as duplicates. "Original color slides are offered to educational institutions only, with some exceptions made under special conditions to qualified professionals." New slides continually added. Black-and-white prints and 4-by-5-inch color transparencies also available of selected items. Color microfiche set of 1,800 Old Master paintings in the Kunsthistorisches Museum, Vienna, produced from master Saskia slides by Chadwyck-Healey, Inc., 623 Martense Avenue, Teaneck, NJ 07666.

Photography: Slides shot by Dr. Ron Wiedenhoeft, Professor of Humanities at the Colorado School of Mines, and his wife, Renate Wiedenhoeft. Films used are Agfachrome 50L and 50S, and Agfachrome CT18 (daylight). Kodak color scale often photographed with work of art. "Lamps and corrective filters are used for most museum work, which is generally done on Mondays, when museums are closed to the public. . . . With a collapsible studio comprised of tripods, lamps, cables, filters, umbrellas, background materials, and a host of gadgets made to solve specific problems, we travel from place to place, using motor drives and bulk-film backs to shoot self-loaded ten-meter strips of film through our cameras. These need to be rewound every night and taken back to the main Agfa laboratory in Munich (via overnight train) for processing once a week. Special sources of Agfa professional film, extensive testing, and one-day development under constant conditions at the same laboratory assure consistency of results."

Production: Processed and duplicated by Agfa-Gevaert, Agfacolor Umkehrdienst, Munich, Germany. Duplicated on AP 44 film. Originals inserted in windows of 3-by-5-inch index cards or (formerly) mounted in thin paper masks. Duplicates color corrected and mounted in cardboard or plastic. No effort made to control contrast in duplicates. Frames, etc. not masked.

Documentation: Mailing list kept. Comprehensive catalog: Volume 1, 1977, $3.00; revised Volume 2, 1983, $4.00; Volume 3, 1984, $3.00. Volume 3 consists of slides of architecture and urbanism, most of which are also listed in Volumes 1 and 2. A 1985 supplement issued, as well as a separate listing of slides of ancient art and archaeology. Prepayment or purchase order required to obtain catalog. Prepaid orders postpaid. Other orders, $1.75 added for one volume, $2.75 for two volumes, or $3.50 for three volumes. Foreign shipment $3.00 per volume. Free lists available of women artists and self-portraits. "Complete information is supplied with all slides, including dates, medium, and dimensions when these are supplied by the museum." Label information printed on slide mount or pasted on 3-by-5-inch index card. Slide curator employed to conduct research for catalogs. Orientation not marked.

Purchasing: Educational institutions not familiar with Saskia slides may receive a number of original slides on approval for one week." Slides sold singly except one set of Michelangelo drawings. Order form included in catalogs. Slides $4.00 each, duplicates $2.00 each. Postage added. Quantity discounts. Billed minimum $10.00. Prepayment required from individuals, also from foreign accounts unless credit established previously. Prepaid orders postpaid. Order form included in catalogs. In addition to originals, 6-20 duplicates kept in stock of items marked with a single or double asterisk in catalogs. Orders filled within 10 days. Rush orders filled on day of receipt or next day; no surcharge, but Federal Express charges passed on to customer. Returns accepted within two weeks for exchange or refund. Requests considered to photograph to order (during summer). Subscription plan available; several hundred slides sent on approval four to five times annually, from which selections may be made.

Evaluation: Quality 3 to 4, documentation 3 to 4, service 3 to 4. "Especially fine photography of paintings; slides of architecture and sculpture slightly less distinguished but improving. Details well chosen. Duplicate slides much inferior to their originals and only fair in comparison to duplicates available from other sources. Information occasionally inaccurate, but sincere effort is made to provide full and correct identifications; corrections issued periodically" (Norine Cashman). "Be sure to specify originals only when ordering, otherwise they substitute inferior quality duplicates when originals are depleted. . . . Be sure to specify to send details ordered only when full views ordered are also shipped; otherwise they send just details for which you have no use without full views" (Mark Braunstein). "Have found Agfa redness disappointing—especially in heavily used slides, but Agfa has promised improvement in their new film" (Nancy DeLaurier). "Catalog extremely difficult to search through, and the chaotic typography only makes matters worse" (Mark Braunstein). "The Rolls Royce of slides. Costly but worth the price for superb originals, good information, great service" (Nancy Kirkpatrick). "Sensitive to needs of art historians" (Brenda MacEachern).

79 **Savoy Slides**
25 Grace Court
Brooklyn, NY 11201
(212) 852-2367
attn: John F. Pile

Profile: Approximately 10,000 color slide titles offered of 2,115 subjects representing architecture in the United States and Europe. "Interiors and details included wherever possible." New titles continually added.

Photography: Slides shot by J. Pile for his own use in teaching. Various 35 mm cameras employed (Alpa, Nikon, Leica), "hand-held or on tripod as appropriate. Wide-angle and perspective-correcting lenses used as required. All interiors by existing light. No flash." Kodachrome ASA 25 and 64 used.

Production: Duplicated by Kodak's Rochester laboratory. Mounted in cardboard.

Documentation: Mailing list kept. Free series of lists represent only partial holdings. Number of slides per monument indicated, broken down by exteriors, interiors, and details, but no description of views given. "A special list will be prepared on a particular topic on request." Slides keyed to lists or to identification card provided for each building covered (city, building name, architect, date). Orientation marked only if not obvious.

Purchasing: Single slides only, $1.65 each, postpaid. No minimum order. Discount of 10 percent if more than 25 slides ordered. Prepayment required from individuals. Institutional purchase orders requested. Slides not sent on approval, but returns accepted for refund or exchange if customer is genuinely dissatisfied. Slides duplicated on receipt of order and shipped within 10 days. Rush orders accepted; usually filled within five days. Requests considered for slides shot to order of subjects in the New York City area.

Evaluation: Based on 20 samples sent: quality 2, documentation 2. Typical Kodak duplicates with heightened contrast and loss of resolution.

✳ 80 **Scala Fine Arts Slides**
c/o Art Resource, Inc.
65 Bleecker Street (ninth floor)
New York, NY 10012
(212) 505-8700
attn: Joanne Greenbaum, Scala Slides Supervisor, or
 Dr. Theodore Feder, President

Profile: Color slides imported from Italy by Art Resource, Inc. Offers 7,000 slide titles in 335 sets. Art history of all periods covered, with emphasis on works in Italian collections. See entry 421 for further details.

Production: Old stock on unstable film no longer distributed by Art Resource.

Documentation: For new sets, documentation on contents available on request from Art Resource. List of slide sets in preparation also available.

Purchasing: Slides sold in sets only. Set prices based on per-slide cost of $1.00. Sets comprised of 6, 12, 18, 24, 36, 60, 64, 80, 96, 112, 120, or 240 slides. Minimum order $25.00. Slides not kept in stock in U.S. office but must be obtained from Italy. However, U.S. orders not handled directly by Italian office; orders must be channeled through Art Resource, Inc. in New York. Time interval between receipt of order and shipment is usually four to six weeks. Rush orders accepted; usually no surcharge. Slides not sent on approval, but "we will accept returns for exchange if the client if not satisfied with the quality of the slide set." Requests considered for slides shot to order; partial advance payment required.

Evaluation: Quality 3, documentation 3, service 2 to 3. "Views well chosen and original photography usually excellent, but duplication is only fair" (Norine Cashman). "Slides of same item may vary in exposure. Data for obscure works can be minimal. Very long shipment time. New listings often not available or cancelled" (Brenda MacEachern). "A reliable standby, especially for Italian materials. Slide longevity is improving of late" (Nancy Kirkpatrick). "Once you establish contact, service is good" (Helen Chillman).

81 **Siggraph Slides**
 A.C.M. Order Department
 P.O. Box 64145
 Baltimore, MD 21264

Profile: Annual set of color slide titles issued by the Association for Computing Machinery. Computer graphics represented from the year's "Art Show" at the Siggraph International Conference exhibition. No response to questionnaire. Entry based on information supplied by Marybeth Koos and on an April 1984 order by Brown University.

Documentation: Identification sheet supplied with set, according to M. Koos; no sheet received with Brown's order. Artist's name in copyright notice superimposed on image. List reported to include title, date, size, media (hardware, software, and computer), and location of production. Brown University unable to procure information about contents of set prior to ordering.

Purchasing: Slides sold in sets only. Specify "Art Show" slides because slides of machinery and nonart graphics are also offered. Prices for 1983 Art Show slides $30.00 for 78 slides. Prices for 1982 Art Show slides $25.00 for 74 slides. Prepayment required. Orders filled within one month.

Evaluation: Quality 3, service 1 to 2. See Documentation.

82 **Slide Presentations**
 175 Fifth Avenue
 New York, NY 10010
 (212) 677-2200
 attn: Stephen Sbarge

Profile: No written response to questionnaire. Entry based on telephone conversations with salesperson, as well as on brochures. Approximately 3,000 color slide titles offered in two large sets, elaborately packaged: "Architecture, Interiors, and Furniture, 2800 B.C.-1975" and "History of Costume, 3100 B.C.-1930."

Photography: Slides shot extensively, if not exclusively, from secondary sources (book reproductions, etc.). Copystand photography by S. Sbarge using Kodachrome.

Production: Duplicated by Kodak. Slides inserted in sleeves, packaged in loose-leaf binders with text.

Documentation: Mailing list kept. Free brochures. Slide-by-slide commentaries provided in texts: more than 500 pages for architecture set and 350 pages for costume set.

Purchasing: Slides sold in sets only. Purchase of subsets (single volumes) may be arranged. Architecture set comprised of approximately 1,900 slides in eight volumes, $3,540.00. Costume set consists of 1,200 slides in five volumes, $2,400.00. Shipping and insurance costs added. "Prepayment or partial prepayment is requested. By special arrangement, deferred payment plans are available." Delivered within two to six weeks.

Evaluation: Quality 2 to 3 based on sample volumes from both sets. Texture of printed page clearly visible when architecture slides viewed under magnification. Apparent sharpness when viewed with naked eye due to very high contrast. In fact, definition noted to be rather soft. Colors muted, with little variation from slide to slide. Aside from some interesting fashion plates, slides in costume set include many details of paintings that art slide collections may already possess. "On the costume set, the text is useless for lectures

by anyone but the author, and while information on paintings is supplied, next to nothing or nothing is said about the costume's material, weave, etc." (Mark Braunstein). "This seems a case where attractive packaging and professional marketing take precedence over substance. Commentaries are quite elementary and do not always provide all the basic facts of identification. Quality of slides is average for copystand production but not comparable to results obtainable from original transparencies" (Norine Cashman). "Good selection but all seem to be from books — with a good library, you can do your own. Presentation text and books unnecessary for our type of collection" (Helen Chillman).

83 **Slides for Education**
5574 Lakewood Avenue
Detroit, MI 48213
(313) 821-6619
attn: Joseph P. Messana

Profile: In business since around 1964. More than 50,000 color slide titles offered of architecture and art in the United States, Canada, Mexico, South America, and Europe. Architecture emphasized, also monumental sculpture, parks, landscaping, gardens, and public areas. Historical and modern works available. New slides continually added (2,000 in 1984).

Photography: Original photography (slides, negatives, and large-format transparencies) carried out by J. P. Messana, a full-time photographer since 1962. Most slides shot on Kodachrome ASA 64, some on ET-tungsten Ektachrome, using Leica, Olympus, or Mamiyaflex equipment. Variety of lenses employed: wide-angle, zoom, telephoto, micro. Tripod used at all times. Natural light preferred; flood lights used on some interiors and art objects when necessary.

Production: Printed on Eastmancolor #5384; ECP-2A processing used. Stock of slides on Eastmancolor #5381 (unstable) soon to be exhausted. Most orders duplicated to order on fresh film. Privately produced by custom laboratory. Color corrected and contrast controlled. Available unmounted, in cardboard or plastic mounts, or in Weiss plastic and glass mounts.

Documentation: Mailing list kept. Set of catalogs $4.00 postpaid in United States or Canada. Supplement issued annually. Slides labeled and keyed to catalog. Orientation indicated by position of label.

Purchasing: Slides sold singly or in sets. All slides $2.75 each except Weiss-mounted slides, which are $3.75 each. Orders of more than 500 slides discounted 5 percent. Postage added. Prepayment required from individuals and foreign accounts. Purchase order required from institutions. Some slides stocked; most duplicated to order. Shipped within 30 days. Rush orders filled within two weeks; surcharge of 20 percent. Slides not sent on approval, and no returns accepted. Requests considered for slides shot to order.

Evaluation: Quality variable, documentation 2, service 2 to 3. "Have never ordered. Was not very pleased by impression of samples, nor by aggressive salesmanship" (Elizabeth Alley). "Mr. Messana is willing to please, but his information is sometimes incomplete, and his shots often too 'arty' and not sensitive to art historical needs" (Nancy Kirkpatrick). "In 1976, Mr. Messana visited our collection to show his samples. While some of them were very good, his apparent inability to distinguish and weed out poor slides made me cautious about leaving selection to his judgment" (Norine Cashman).

84 **Soleri Slide Series**
6433 East Doubletree Road
Scottsdale, AZ 85253
(602) 948-6145
attn: Ivan Pintar

Profile: Six sets of color slide titles offered of the work of Paolo Soleri: Arcosanti, Cosanti, Arcology. Objects owned and exhibited by the Cosanti Foundation included.

Photography: Slides shot by Ivan Pintar on Kodachrome ASA 25.

Documentation: Free brochure. Audiocassette included with "Two Suns Arcology" set. Set accompanied also by printed transcript and booklet.

Purchasing or rental: Slides sold singly or in sets. Sets of 36 slides $36.00. Single slides $1.00 each. Larger set of 120 slides, "Soleri: Two Suns Arcology," accompanied by 15-minute narration on cassette, sold for $100.00 or rented for one week for $20.00 prepaid or $25.00 C.O.D. rush. Make checks payable to Ivan

Pintar. Second edition of this set consists of 80 slides plus 12-minute cassette, $100.00. Duplicates kept in stock and mailed within two weeks. Rush orders accepted. Slides sent on approval.
Evaluation: Quality variable, including some very good slides; documentation 3, service 3. Focus problems related to depth of field noted on slides of models. Some drawings tinted overall blue or green.

85 **Streetscape Slides**
 2701 East Vassar Avenue
 Denver, CO 80210
 (303) 692-9261
 attn: Peter Dulan

Profile: More than 2,000 color slide titles offered of architecture and public sculpture in the United States. Extensive coverage of Chicago architecture and Frank Lloyd Wright houses. New titles continually added (300-500 slides in 1984).
Photography: Shot by Peter Dulan, slide curator and photographer for the University of Denver, using Kodak Ektachrome in 35 mm, 2¼-inch, and 4-by-5-inch formats, mostly ASA 64.
Production: Duplicated by Pro-Lab, Denver, on Kodak slide duplicating film (presumably Ektachrome #5071). Color corrected and contrast controlled. Mounted in plastic or cardboard.
Documentation: Mailing list kept. Catalog $2.50, deductible from first order. Architecture identifications written by Ellen Micaud, architectural historian. Slides keyed to catalog. Orientation marked.
Purchasing: Slides $2.50 each, 25 for $50.00. Sets offered. Minimum order $10.00. Orders greater than $25.00 postpaid. Duplicates kept in stock, made to order when necessary; shipped within 10 days. Slides sent on approval to United States and Canada. Purchase orders required. Returns accepted for exchange. "Quality guaranteed." Requests considered for slides shot to order.
Evaluation: One sample slide sent of an architectural interior: well composed, naturally lit, one area overexposed. Detail in this sample not sharply defined.

86 **Taurgo Slides**
 154 East 82nd Street
 New York, NY 10028
 (212) 879-8555
 attn: Thomas Rayner Todd

Profile: Offers 32,000 color slide titles of art and architecture. Western art covered from ancient Greece to the eighteenth century. Some slides available of Egypt, the Near East, and Islamic sites. Catalogs to be issued soon on United States, modern, tribal, and Oriental art and architecture. Greek and English catalogs to be augmented. In 1984, 15,000 new slides to be added. Company established 1949. Approximately 100,000 black-and-white negatives available from which slides can be made.
Photography: Slides shot by T. R. Todd or staff photographers on Kodachrome. A few (approximately 200) slides shot by others. Flash used where possible, tripod where needed.
Production: Duplicated by Kodak at Rochester or Fair Lawn laboratory. No color correction or contrast control attempted. Mounted in cardboard or Perrotcolor.
Documentation: Mailing list kept. Free series of lists, continually revised. Greek and English lists to be reissued soon. Identifications brief; few dates given. Slides keyed to lists. Orientation marked.
Purchasing: Single slides $1.50 each in cardboard mounts, $2.00 each in Perrotcolor mounts. Minimum order 10 slides. Postage added. Duplicated to order and shipped within two weeks ("Perrotcolor a little longer"). Small rush orders accepted, filled in one week with 10 percent surcharge. Prepayment required on foreign orders. Slides not sent on approval. Returns accepted for exchange, "but we cannot accept for exchange a large order sent for 'sampling' (or copying). . . ." Slides made to order from books or photographs on request; orders filled within two weeks, and prices charged as above.
Evaluation: "Of 10 color slides ordered in 1979, we returned four. Two images were cropped, and one was unevenly lit. The fourth slide we criticized for glare, poor color, and focus. The slides requested in exchange were finally received three months later" (Norine Cashman).

87 **Teitelman, Edward/Photography**
 305 Cooper Street
 Camden, NJ 08102
 (609) 966-6093

Profile: Approximately 1,800 color slide titles offered of architecture, covering the United States, Great Britain, Mexico, and Europe, with emphasis on the nineteenth and twentieth centuries. Both originals and duplicates sold. All slides produced on color film, although a few are black-and-white images (old photographs, plans, etc.). In business almost 25 years. New titles continually added. Philadelphia material almost all recently rephotographed. Black-and-white and color prints custom made on request; reproduction rights available.

Photography: Slides shot on Kodachrome ASA 25, mostly by E. Teitelman, some by a traveling scholar. Processed by Kodak. Perspective-correcting lens used. Interiors shot with available light when possible.

Production: Duplicated by Atkinson/Stedco, Hollywood, California, onto Ektachrome. Color corrected and contrast controlled. Mounted in cardboard.

Documentation: Free catalog, indexed by architect and building type. Supplements issued. Identifications consist of building name, location, architect, and completion date. Slides keyed to catalog. "Supplementary descriptions will be sent with sets involving items not identified fully in the catalog. We are always available to further aid if these identifications do not suffice." Orientation marked by number in upper right corner.

Purchasing: Extra originals sold until exhausted. Slides sent in groups for selection, sold singly at $2.00 each. No minimum order. Postage added to orders under $50.00. Some slides kept in stock; others duplicated to order. Shipped within three to six weeks. Rush orders accepted, preferably by telephone; filled within seven to ten days with no surcharge. Slides sent on approval for 10 days. Returns accepted for exchange or refund.

Evaluation: Quality 2 to 3, documentation 3, service 3.

88 **Tipi Shop, Inc.**
 Box 1542
 Rapid City, SD 57709

Profile: Brochure sent in response to questionnaire. Questionnaire not completed. Entry based on brochure. Two sets of color slides offered of American Indian art and crafts: "Contemporary Indian and Eskimo Crafts" (74 slides) and "Contemporary Sioux Painting" (77 slides). (Several black-and-white slides included in Sioux set.)

Documentation: Sets described in the "Fact Sheet" (Government Printing Office, 1978, Publication #0 - 277-817) of the Indian Arts and Crafts Board of the U.S. Department of the Interior, Room 4004, Washington, DC 20240. Sets each accompanied by a 32-page booklet with lecture text. Slides keyed to text.

Purchasing: Each set $50.00.

Evaluation: No information available.

89 **Universal Color Slide Co., Inc.**
 65A Mathewson Drive
 Weymouth, MA 02189
 (617) 337-5411
 attn: Coletta M. Rodi, President

Profile: Offers 30,000 color slide titles of art and architecture from prehistoric times to the present. (This source not indexed by subject in this guide because it would appear under most headings.) The following fields emphasized, with 2,000 to 5,000 slides each: painting of the Renaissance; painting of the seventeenth, eighteenth, and nineteenth centuries; twentieth century painting; architecture of the fifteenth through twentieth centuries; sculture of the fifteenth through twentieth centuries; and drawings and prints. Non-Western art and ancient art also offered. Sets correlated to textbooks available. "Complete Library" of 800 slides offered in 100-slide increments. Company in business more than 50 years, changed management in 1983 and again in 1985. Addition of 200 new slides planned for 1984.

Photography: Slides shot by Sam Marcus, previous owner, as well as by traveling scholars and independent professionals. Information on film type, equipment, and techniques not available. Some slides apparently shot from secondary sources rather than from the actual works of art.

Production: Duplicated in-house on Kodak Ektachrome #5399. Color corrected and contrast controlled. Cardboard mounts standard; Gepe glass mounts available on request.

Documentation: Mailing list kept. Free catalog of sets published 1983. Catalog of individual slides in preparation to replace 1979 catalog. Catalog published in 1979 $1.00, deductible from an order over $10.00. Annual revisions or supplements planned. Special listings available of most topics mentioned on pages 10 and 11 of set catalog. Inquiries in writing or by telephone welcomed. Identifications printed on slide mounts. Orientation not marked on sample slides.

Purchasing: Single slides $2.00. Per-slide cost in sets $0.50 to $0.75. Price increase to be effective February 1, 1985. Shipping by United Parcel Service, charged to customer. No minimum order. Prepayment required from individuals and foreign accounts. Purchase orders required from institutions; invoices payable within 30 days. Copies kept in stock and shipped within three days. Rush orders filled on day of receipt; no surcharge except for express mail if requested. Slides sent on approval "when required by state/city purchasing regulations, preview subject to 15 percent charge on items returned. . . . All defective slides exchanged, other returns exchanged up to 15 percent of order (individual slides only). Refunds subject to 15 percent charge." Money-back guarantee offered on sets only (excluding large sets available for preview) if returned within 10 days and accompanied by a written criticism.

Evaluation: Quality rated in second edition as unsatisfactory, and catalog described as "confusing and inaccurate—many errors, misplacings, and misspellings." With that word of caution, we decline to assign numerical ratings to this company so soon after its change of ownership. Of 35 samples sent, 12 slides judged of reasonably good quality. Remainder suffered from poor resolution, soft focus, high contrast, and/or poor color fidelity. Information printed on mounts sparse, in many cases lacking name of collection. Catalog improved, but some artists' names still misspelled.

90 **Visual Education, Inc.**
 4546 Via Maria
 P.O. Box 6039
 Santa Barbara, CA 93111
 (805) 967-6919 or (805) 964-5226
 attn: Dr. Herbert Budek

Profile: Approximately 10,000 slide titles offered in 250 sets, covering predominantly architecture and sculpture. Some sets on painting available, some of them including mosaics, frescoes, and illuminated manuscripts. New sets (approximately 10) to be added in 1984 on Mexican art and architecture. Company also produces filmstrips and covers other subject areas such as history, religion, anthropology, geography, and science. Brochure received in spring 1985 states that "I, Herbert Budek, now plan to retire. . . . This may be our last offer."

Photography: Slides shot on Kodachrome ASA 25 by staff or independent scholars. Architectural exteriors photographed with hand-held camera, "except in shadow areas where tripod is used." Interiors always shot with tripod.

Production: Copies printed from continuous internegative loops at Frank Holmes Laboratories, San Fernando, California. Film used since 1980 is Eastmancolor #5384 (low-fade). "We presume that the laboratory uses the recommended [ECP-2A] processing." Color corrected (by group) and contrast controlled. Slides sold unmounted, cardboard-mounted, plastic-mounted, or Gepe glass-mounted.

Documentation: Mailing list kept. Free brochures, frequently updated. Sets accompanied by printed guides ("lecture notes"), to which slides are keyed. "Since ours are architectural slides, the orientation is obvious." Optional cassettes available; specify audible signals or inaudible pulses for automatic projection.

Purchasing: Slides sold in sets only, averaging 40 slides each. Singles no longer offered. Sets $15.00 unmounted, $30.00 cardboard-mounted, or $60.00 glass-mounted. Billed minimum $10.00. Shipping added at 5 percent. Prepayment required from some foreign accounts. Duplicates kept in stock and shipped within three days. Rush orders accepted. Slides sent on approval to institutions. Returns accepted.

Evaluation: Quality 1 to 2, documentation 2, service 2 to 3.

91 **Visual Media for the Arts and Humanities**
Box 737
Cherry Hill, NJ 08003

Profile: No response to questionnaire. Slides produced for ArchiCenter, Chicago (102), the Metropolitan Museum of Art, New York (159), and the National Gallery of Art, Washington, DC (174). No information available on photography, production, documentation, or direct purchase from above address.
Evaluation: Contrast not controlled during duplication.

92 **VRI Slide Library**
P.O. Box 1208
Imperial Beach, CA 92032
(619) 429-5533

Profile: "Thousands" of color slide titles offered of contemporary visual and performing arts and contemporary architecture. Exhibitions in major New York, California, and European galleries documented. Approximately 300 slides available documenting the projects developed and funded by Creative Time, 1974-1984. Sets totaling 4,000 new slides now in preparation. Company formerly called Visual Resources, Inc.
Photography: Slides, negatives, and large-format transparencies shot on various films by diverse photographers.
Production: Duplicated at the Kodak laboratory in Fair Lawn, New Jersey. Mounted in cardboard.
Documentation: Mailing list kept. Free brochures. Slide sets accompanied by "scholarly catalogs," to which slides are keyed. Number printed at top of image to mark orientation.
Purchasing: Singles, sets, and subscription series available to educational institutions only. Minimum order $30.00. Quantity discounts given on complete volumes. Postage added to invoice. Prepayment required only from "institutions which have been delinquent in payment previously or who have duplicated our slides illegally." Duplicated on order and shipped within four weeks. Rush orders accepted by telephone after receipt of written purchase order and filled within one week at no additional cost. Sample set (*only*) of a series sent on approval. "Returns are accepted only for defective slides, never for duplicate orders. . . . Complete sets are not returnable."
Evaluation: Quality variable, documentation 3, service 2. Sample catalogs contained full identifications of images.

93 **Wolfe Worldwide Films**
1541 J Parkway Loop
Tustin, CA 92680
(714) 544-0622

Profile: Offers 15,000 color slide titles covering 118 foreign countries. Art and architecture included among other subjects (people, scenery, etc.). Some museum objects represented—54 from the Prado, 22 from the Louvre, etc. Company is a division of Photo Network.
Photography: Slides shot by traveling photographers (40 percent professional and 60 percent amateur). Film used is primarily Kodachrome.
Production: Duplicated by International Color Labs, Burbank, California. Questions on film type not answered.
Documentation: Mailing list kept. Catalog $1.50, revised every seven years. Supplements issued every six months. Slides labeled. Orientation not marked.
Purchasing: Slides sold in sets or singly. Slides $0.75 each with quantity discounts to $0.53 each for 250 or more. Postage of $0.50 added for fewer than 100 slides, $1.00 for more than 100 slides. Minimum order (on charges only) $10.00. Duplicates kept in stock, mailed one day after receipt of order. Slides sent on approval at $0.20 each. Returns accepted for exchange.
Evaluation: No information available. Slides evidently intended for tourists.

MUSEUMS

94 **Abby Aldrich Rockefeller Folk Art Center**
 and Colonial Williamsburg Foundation
 AV Distribution Section
 P.O. Drawer C
 Williamsburg, VA 23185
 (804) 229-1000

Profile: No response to questionnaire. Entry based on fourth edition, 1980 catalog, and recent brochure. Approximately 750 color slide titles offered of architecture, furnishings, decorative arts, folk art, textiles, and prints of Colonial America.
Photography and production: "Photographed, produced, and sold exclusively by the Colonial Williamsburg Foundation." According to the fourth edition, 4-by-5-inch original transparencies shot by staff photographer and slides produced in-house. Mounted in cardboard.
Documentation: Mailing list kept. Free catalog lists full information for single slides. Texts included with sets. Cassettes offered with some sets. Identifications printed on slide mounts.
Purchasing: Slides sold singly or in sets. Order form included in catalog. Slides $0.50 each; per-slide cost in sets $0.40 (1980). Postage added at $1.75 per set. Returns accepted for exchange.
Rental: Several sets also offered for three-day rental ($10.00 plus postage).
Evaluation: No information available.

95 **Addison Gallery of American Art**
 Phillips Academy
 Andover, MA 01810
 (617) 475-7515

No response to questionnaire. Single slides offered by Burstein (30). Slides included in sets available from the Dunlap Society (243).

96 **Albright-Knox Art Gallery**
 1285 Elmwood Avenue
 Buffalo, NY 14222
 (716) 882-8700

Profile: Permanent collection (chiefly twentieth century painting and sculpture) documented by several suppliers. Inquiries directed to the museum are referred to University of Michigan Slide Distribution (252) for complete sets or to Rosenthal Art Slides (76) for single slides. Works covered by two sets are 93 paintings (260 slides) and 48 sculptures (87 slides).
Photography: Slides shot by Patrick Young of the University of Michigan.
Production: Sets produced by the University of Michigan Slide Distribution. Single slides from these sets duplicated by Rosenthal Art Slides for distribution by gallery shop as well as by Rosenthal.
Documentation: All slides keyed to list or catalog available from each supplier.
Purchasing: Full sets distributed by the University of Michigan Slide Distribution. Single slides from painting set offered by Rosenthal Art Slides. Five additional paintings sold by Rosenthal. A limited number of small sets (produced by Rosenthal) to be sold by the gallery shop commencing in 1985.
Other sources: Slides also available singly or as a set of 58 from Sandak (77). Single slides offered by Burstein (30).
Evaluation: See entries for suppliers mentioned above.

97 **Allen Memorial Art Museum**
Oberlin College
Main and Lorain Streets
Oberlin, OH 44074
(216) 775-8665 or 8668
attn: Sales Desk

Profile: Offers 154 color slide titles of works in the permanent collection: paintings, sculptures, works on paper, and decorative arts. New titles continually added (five in 1984).
Photography: Slides shot on Kodak film by an independent professional photographer using Nikon equipment. Objects lit by quartz lamps.
Production: Duplicated on Ektachrome by an independent professional laboratory. Color corrected and contrast controlled. Mounted in cardboard.
Documentation: Free list, revised more or less annually. Slides labeled on mounts. Orientation marked by label placement.
Purchasing: Single slides $1.50 each. No discounts. No minimum order. Postage added if greater than $1.00. Duplicates kept in stock, and orders usually shipped within five days. Rush orders filled same day with no surcharge if items in stock. Slides shot to order within one to three weeks of works not previously photographed; fee of $15.00 per slide charged. Prepayment required on all orders. Returns accepted for exchange or refund if slides are of unacceptable quality. Single slides of works in this museum's collection also offered by Burstein (30).
Evaluation: Quality 3, documentation 3 to 4, service 3 to 4.

98 **American Antiquarian Society**
185 Salisbury Street
Worcester, MA 01609
(617) 755-5221

Response to questionnaire: special photographic orders only. Single slides of works in this collection offered by Burstein (30).

99 **American Craft Museum**
44 West 53rd Street
New York, NY 10019
(212) 397-0630

Permanent collection (works of American craftsmen since 1900) and special exhibitions documented in slides by the American Craft Council (235).

100 **American Museum of Natural History**
Central Park West at 79th Street
New York, NY 10024
(212) 873-1300

No response to questionnaire or follow-up letter. Entry based on fourth edition and 1984 brochure entitled "Programs for Schools in New York City." According to the latter, "Slides on many school subjects are sold by the Museum's Photograph Collection. Each slide costs $0.85. Sets also available. Send request for catalogs to Photograph Collection." As of 1980, approximately 5,000 slides were offered, of which some 40 percent were field photographs. Slides of items in this museum included in sets offered by Pictures of Record (73).

101 **Amon Carter Museum**
P.O. Box 2365
Fort Worth, TX 76113
(817) 738-1933
attn: Mary Lampe, AV Coordinator

Profile: Approximately 800 color slide titles offered of works in the permanent collection: nineteenth and twentieth century paintings and sculpture of the American West. New slides continually added.
Photography: Transparencies shot by staff photographer using Sinar 8-by-10-inch camera, Linhof 4-by-5-inch camera, and Leica 35 mm camera. Ektachrome used for all color work (EPY 50 for 35 mm camera, #6118 or #6117 for 4-by-5-inch and 8-by-10-inch cameras). Studio lighting conditions employed.
Production: Duplicated on Ektachrome by Meisel Photochrome Corporation or the Color Place. Color corrected and contrast controlled. Mounted in cardboard.
Documentation: Free list of major paintings. Catalog (1972) of permanent collection $12.50. Slides labeled. Orientation not marked.
Purchasing: Address orders to Registrar's Office. Slides sold singly, usually as duplicates; some originals available. Price per slide $1.50, postpaid. No minimum order. Prepayment required. Slides kept in stock and shipped within one week. No rush orders accepted. Slides not sent on approval, and returns accepted for exchange only. Special orders carried out within four to six weeks; charge of $35.00 for photography, plus $1.50 for duplication. In addition, a limited selection of slides produced by Scala (421) offered by the museum's bookstore.
Evaluation: No information available.

102 **ArchiCenter**
Chicago Architecture Foundation
330 South Dearborn Street
Chicago, IL 60604
(312) 922-3134

Profile: Sixty-five color slide titles offered of Chicago architecture. More slides to be made available in the future. Set of five filmstrips also offered.
Photography: Original photography by independent professionals as well as by staff photographer.
Production: Duplicated by Visual Media (91) and Curt Teich & Co. Mounted in cardboard. Small sets encased in clear plastic.
Documentation: Mailing list kept. Free list of titles. Slides labeled with building name, date, location, and photographer. Orientation marked by label position.
Purchasing: Set of 55 recent Chicago buildings $85.00, also available singly for $1.75 each. Two five-slide sets each $3.50. Prices discounted 10 percent for ArchiCenter members. Minimum order $5.00. Prepayment required from individuals. Shipping charge of $3.50 added for large set sent via United Parcel Service, $2.50 for orders of single slides. Slides kept in stock and sent within one to two days. Rush orders filled same day if slides in stock; surcharge to cover special shipping. No returns accepted.
Evaluation: Six samples sent. Quality of five-slide set of Richardson's Glessner House produced by Curt Teich & Co. was very good. One slide from large set produced by Visual Media had very high contrast, although original photography appears excellent (no distortion noted). "We recently purchased a set of 'Recent Chicago Buildings' slides and were very pleased" (Nancy Kirkpatrick).

103 **Art Institute of Chicago**
Michigan Avenue at Adams Street
Chicago, IL 60603
(312) 443-3536
attn: Slide Sales

Profile: Color slides available of selected items from the museum's collection. Production of new slides planned to document the most important holdings.
Photography: Slides and large-format transparencies shot by staff photographers in studio using Ektachrome ASA 64.

Production: Duplicated on Ektachrome #5071 by U.C. Color Laboratories, Chicago. Contrast controlled and color sometimes corrected. Duplicates occasionally made from other duplicates rather than from originals. Mounted in plastic.

Documentation: No comprehensive list of offerings available. Catalog to be issued in the future. Slides currently imprinted with identifications or keyed to list. Orientation marked by asterisk or slide number.

Purchasing: Slides sold singly or in sets. Slides made to order by Rights and Reproductions Department. If new photography is required, $12.00 charged per transparency. Slides made from existing transparencies $1.50 each.

Other sources: Many slides of items in the Art Institute offered by Rosenthal Art Slides (76). Set of 50 slides sold by Dick Blick Co. (36). Single slides offered by Burstein (30). Slides of Art Institute works included in sets produced by the Dunlap Society (243).

Evaluation: Quality 2 to 3, documentation 3, service 2 to 3. Sample set (12 slides) sent of series produced by the Textile Department: very good slides, ample information.

104 **Asia Society**
Asia House Gallery
725 Park Avenue
New York, NY 10021
(212) 288-6400

No response to questionnaire. Set of 48 slides, also offered singly, available from Sandak (77) of the collection of Mr. and Mrs. John D. Rockefeller 3rd.

105 **Asian Art Museum of San Francisco**
Avery Brundage Collection
Golden Gate Park
San Francisco, CA 94118
(415) 558-2993
attn: Photographic Services

Profile: Entire collection of Asian art covered in color slide titles. Sets offered include "The Buddha Image in Asian Art," "Man and Nature in Asian Art," and "Animals in Chinese Art." In-house exhibitions documented.

Photography: Original photography carried out by staff photographer using 8-by-10-inch and 4-by-5-inch view cameras or 35 mm camera with 55 mm macro lens and studio lighting. Kodachrome ASA 40, Type A, used for 35 mm color slide titles. Larger Ektachrome transparencies and black-and-white negatives also shot.

Production: Duplicated by Kodak. No attempt made to correct color or control contrast. Mounted in cardboard.

Documentation: No list or catalog available. Order by referring to accession numbers (obtainable in published catalogs of the collection). Some slides labeled.

Purchasing: Slides sold in sets or singly, $1.00 each. No minimum order. Postage added. Slides kept in stock, and orders shipped within two weeks. Rush orders accepted and filled, if possible, within one week. Returns accepted for exchange only. Special photography carried out within two to three weeks; fees from $100.00 to $150.00, depending on dimensions of the object. Color transparencies also available for three-month rental.

Other sources: Slides of two exhibitions ("Archaeological Finds From the People's Republic of China" and "6,000 Years of Chinese Art—Treasures From the Shanghai Museum") available from KaiDib (56).

Evaluation: Three-star rating in the fourth edition.

106 **Baltimore Museum of Art**
Art Museum Drive
Baltimore, MD 21218
(301) 396-7101

No response to questionnaire. According to the *American Art Directory*, slides sold by museum shop. Set of 104 slides available from Sandak (77), including paintings, prints and drawings, sculpture, American quilts, American furniture, and the art of Africa, the Americas, and the Pacific. These slides also offered individually. Single slides of works in this museum also sold by Burstein (30).

107 **Boston Athenaeum**
 10 1/2 Beacon Street
 Boston, MA 02108
 (617) 227-0270

Single slides of works in this collection offered by Burstein (30).

108 **Bowdoin College Museum of Art**
 Walker Art Building
 Brunswick, ME 04011
 (207) 725-8731, x275
 attn: Museum Shop

Profile: Offers 51 color slide titles of works in the permanent collection: forty-two of paintings (mostly American) and nine of ancient artifacts. New titles added from time to time (approximately 18 in 1984).
Photography and production: Slides shot and duplicated by Dennis Griggs, Tannery Hill Studio. Color corrected and contrast controlled.
Documentation: Mailing list kept. Free list of offerings, periodically revised. Slides labeled. Orientation marked.
Purchasing: Slides sold singly, $2.00 each. No minimum order. Duplicates kept in stock, and orders shipped within one week. Rush orders filled same day. No special photography available. Slides not sent on approval, and returns not accepted.
Other sources: Slides of objects in this museum also offered by Burstein (30) and the Dunlap Society (243).
Evaluation: Two samples sent; excellent quality.

109 **Brooklyn Museum**
 188 Eastern Parkway
 Brooklyn, NY 11238
 (718) 638-5000
 attn: Photoservices

Profile: Color slides offered of some works in the permanent collection. One hundred and seven slides listed in brochure, mostly produced by Sandak (77): African and Oceanic art, Egyptian and classical art, Oriental art, Western painting and sculpture, decorative arts, and costumes and textiles. Other slides available, duplicated from study collections of the museum's departments. New titles continually added.
Photography: Slides for department study collections shot by staff photographer.
Production: Commercial slides produced by Sandak (77). Other slides duplicated by Berkey or Kodak's laboratory at Fair Lawn, New Jersey. Mounted in cardboard.
Documentation: Free list available, incomplete. "Catalog is for commercially developed slides only. Additional works from all departments available." Slides labeled. Orientation not marked.
Purchasing: Slides sold singly. No minimum order. Commercial slides $1.00; others $2.00 each. Postage added. Educational discount of 15 percent given to institutions and libraries on receipt of an authorized purchase order. Duplicated to order and shipped within two weeks. Rush orders filled within three days; surcharge of $7.00. Special photography carried out for $15.00 per image; allow one month at least. Slides not sent on approval, and returns accepted only if slides are damaged.
Other sources: A set of 181 slides recently issued by Sandak (77), from which single slides may be ordered. Slides of objects in this museum also offered by Burstein (30), F. G. Mayer (61), and the Dunlap Society (243).
Evaluation: See entries for the producers just mentioned. "We received two slides in 1983 that were duplicated from departmental study collections. On the basis of those samples, I would rate quality as 3" (Norine Cashman).

110 **Butler Institute of American Art**
524 Wick Avenue
Youngstown, OH 44502
(216) 743-1107

No response to questionnaire. According to the *American Art Directory*, slides sold by museum shop. As of 1980, the fourth edition of this guide reported 50 slides available at $1.00 each (list, $1.50). Single slides also available from Burstein (30). Slides of works from this museum also included in sets produced by the Dunlap Society (243).

111 **Cahokia Mounds Museum**
7850 Collinsville Road
East St. Louis, IL 62201
(618) 344-5268
attn: Mail Order Sales

No response to questionnaire. Entry based on brochure received in 1981. Slide set offered: "Cahokia: Indian Culture and Archaeology."

112 **California Palace of the Legion of Honor**
Lincoln Park
San Francisco, CA 94121
(415) 750-3642
attn: Museum Shop

As of February 1985, slide sales being phased out by the museum shop. Few slides available at this time, and stock will not be replenished when exhausted. Single slides of works in the museum's permanent collection offered by Burstein (30).

113 **Carnegie Institute, Museum of Art**
4400 Forbes Avenue
Pittsburgh, PA 15213
(412) 622-3200

No response to questionnaire. Single slides of works in this museum offered by Burstein (30). Slides included in sets produced by the Dunlap Society (243). A set of slides will be released in 1985 by the University of Michigan Slide Distribution (252).

114 **Chrysler Museum**
Olney Road and Mowbray Arch
Norfolk, VA 23510
(804) 622-1211

No response to questionnaire. According to the *American Art Directory*, slides sold by museum shop. Single slides of selected works in this museum offered by Burstein (30). Slides also included in sets available from the Dunlap Society (243).

115 **Cincinnati Art Museum**
Eden Park
Cincinnati, OH 45202
(513) 721-5204, x266
attn: Photographic Services

Profile: Fifty slides of paintings (25 each, American and European) produced by Rosenthal Art Slides (76), available from Rosenthal or the museum. Another 178 color slide titles offered (in 11 sets) of works in the

museum's permanent collection: ancient art, Near Eastern art, Far Eastern art, prints, drawings, photographs, decorative arts, American Indian art, African art, sculpture, and period rooms. Some 5,000 additional images available by special order.

Photography: Slides shot by staff photographer on Ektachrome ASA 50 in studio.

Production: Duplicated on Ektachrome #5071 by a local laboratory. Color corrected and contrast controlled. Mounted in plastic. Slides of paintings produced by Rosenthal.

Documentation: Mailing list kept. Free catalog (1981). Slides keyed to list and labeled as well. Orientation marked.

Purchasing: Slides sold singly and in sets. No minimum order. Slides from catalog $1.30 each, discounted 5 percent on orders over $5.00 by educational institutions. Per-slide cost in sets $1.20. Order form included in catalog. Postage added at $1.25 for 1-15 slides, $2.50 for 16-50 slides, $3.50 for 51-100 slides (United States); rated doubled for foreign orders. Prepayment required. Duplicates kept in stock and shipped within two weeks. No rush orders accepted. Special order duplicates $2.00 each. Slides shot to order within three weeks for $10.00 each. Slides not sent on approval, and returns accepted only if error was made by museum in filling request.

Evaluation: Quality 3, documentation 3, service 3. "Good selection for a smaller museum" (Nancy Kirkpatrick). Three samples sent; excellent quality.

116 **Cleveland Museum of Art**
 11150 East Boulevard
 Cleveland, OH 44106
 (216) 421-7340
 attn: Slide Library or Sales Desk

Profile: Several thousand museum objects documented in original slides; duplicates may be ordered from the Slide Library. New acquisitions routinely photographed. Exhibitions occasionally documented. Slides produced by GAF (42), Sandak (77), and Saskia (78) sold by the Sales Desk.

Photography: Slides in Slide Library collection shot by staff photographers in studio using Kodachrome or Ektachrome. Original transparencies for GAF and Sandak slides provided by museum. Saskia slides shot by Ron and Renate Wiedenhoeft.

Production: Slide Library originals duplicated in-house on Ektachrome. No attempt made to correct color. Duplicates processed locally or by Kodak. Mounted in cardboard or plastic. Sales Desk slides produced by GAF, Sandak, and Saskia. Note that Saskia slides are duplicates.

Documentation: No catalog or list available of Slide Library holdings. The museum handbook can be used to request slides by accession number. Slide Library duplicates keyed to handbook for identification. Labeling information also provided on sales form. List available from Sales Desk of 56 GAF slides, 102 Sandak slides, and 83 Saskia slides.

Purchasing: Slide Library slides sold singly for $2.00. Postage of $0.35 added for each four slides. Prepayment required. No minimum order. Slides usually duplicated to order and shipped within two to four weeks. Rush orders filled in one day; surcharge of $7.00 plus express mail charge if desired. Requests for special photography should be addressed to the curator of the department concerned. GAF, Sandak, and Saskia slides may be ordered from the Sales Desk, but the museum prefers to have orders directed to Sandak or Saskia. Slides $0.50 for GAF, $1.00 for Sandak, and $1.50 for Saskia. Postage of $0.50 added, $1.00 on orders over $10.00.

Other sources: Slides of objects in this museum also offered by Burstein (30), Rosenthal Art Slides (76), Asian Art Photographic Distribution (240), and the Dunlap Society (243).

Rental: Slides offered for circulation, for a service fee, in the Cleveland area only.

Exchange: The museum will exchange slides with other museum libraries.

Evaluation: See entries for the producers named in Other Sources. For Slide Library duplicates the quality is variable, documentation 3, service 2 to 3. "Slides are duplicated and sold by the Cleveland Museum of Art Slide Library as a service to scholars and teachers. . . . No guarantee is made for quality, color, or availability. These slides are often not of a commercial quality but may serve as an adequate image" (Sara Jane Pearman).

117 **The Cloisters**
 Fort Tryon Park
 New York, NY 10040
 (212) 923-3700

No response to questionnaire. According to the *American Art Directory*, slides sold by museum shop. Single slides also offered by F. G. Mayer (61), Rosenthal Art Slides (76), and Sandak (77). Several sets (not available as singles) also sold by Sandak that include many works from the Cloisters collection: "Stained Glass of the Middle Ages and the Renaissance" (60 slides) and "The Year 1200" (150 slides—subsets available).

118 **Columbus Museum of Art**
 480 East Broad Street
 Columbus, OH 43215
 (614) 221-6801
 attn: Resource Center

Profile: Offers 600 color slide titles of works in the permanent collection: sixteenth to twentieth century European paintings, drawings, prints, sculpture, and decorative arts; nineteenth and twentieth century American paintings; and Chinese and Japanese ceramics and sculpture. New slides continually added. One hundred and fifty slides available that are not listed. Sets currently available: "Introduction to the Museum," "French Art," "Sculpture," and "Elijah Pierce."
Photography: Slides shot on Ektachrome ASA 50 by an independent professional photographer in a professional lighting set-up.
Production: Duplicated on Ektachrome #5071 by Comsci. Color corrected and contrast controlled. Mounted in cardboard or plastic.
Documentation: Free catalog, revised as necessary. Slides labeled. Orientation marked on some slides. Sets accompanied by script.
Purchasing: Slides sold singly and in sets. Single slides $1.50. Sets, composed of at least 20 slides, $20.00. Prepayment required on orders of sets. Postage added. Duplicated to order and shipped within three weeks. Rush orders and special orders not accepted. Returns accepted if customer is dissatisfied.
Other sources: Single slides of objects in this museum offered also by Burstein (30), and slides included in sets available from the Dunlap Society (243).
Evaluation: Insufficient information available.

119 **Cooper-Hewitt Museum**
 (Smithsonian Institution)
 2 East 91st Street
 New York, NY 10128
 (212) 860-6868
 attn: Photo Services

Profile: Original and duplicate color slides offered of objects in the permanent collection, which includes more than 300,000 objects from 3,000 years of design history: paintings, drawings, prints, textiles, furniture, metalwork, ceramics, glass, woodwork, and wallcoverings. At present, 12 kits offered.
Photography: Slides shot by a professional photographer.
Documentation: Free single-page list of set titles. Slides in sets keyed to identification list and accompanied by brief text. Information of holdings of the museum available in Russell Lynes, *More Than Meets the Eye* (Smithsonian, 1981).
Purchasing: Slides sold singly and in sets. No minimum order. Kits of 20 slides $30.00 plus $2.40 postage for the first kit and $0.50 for each additional kit. Prepayment required. Slides shipped within two weeks. Rush orders accepted. Special photography carried out on request.
Other sources: Slides of works in this museum included in sets offered by the Dunlap Society (243).
Evaluation: Quality 3, documentation 3, and service 3.

120 **Corcoran Gallery of Art**
 17th Street and New York Avenue, N.W.
 Washington, DC 20006
 (202) 638-3211
 attn: Corcoran Shop or Registrar's Office

Profile: Color slides offered of works in the permanent collection, which consists mostly of American art and photography. Some nineteenth century European paintings, drawings, prints, and decorative arts included. New titles continually added.
Photography: Slides, negatives, and large-format transparencies shot on Kodak film by an independent professional photographer.
Production: Duplicated on Kodak film. Mounted in cardboard or plastic. Slides sold by gallery shop apparently produced by Sandak (77).
Documentation: Free list. Slides fully labeled. Orientation not marked.
Purchasing: Slides sold singly. No minimum order. Seventy-seven slides, predominantly American paintings, sold by shop for $0.75 each. Postage of $0.50 added for up to four slides. Duplicates kept in stock by shop and shipped within one week. Rush orders filled in one day; surcharge for special shipping. Slides made to order within three to four weeks by Registrar's Office at per-slide cost of $1.50 for a duplicate, $13.00 for new photography. Shipping (by United Parcel Service) added: $0.50 for up to 11 slides, $1.50 for more than 12 slides, $3.00 for foreign delivery. Order form available with list. Prepayment required by both shop and Registrar's Office. Returns accepted by shop for exchange only. Returns accepted by Registrar's Office if customer is dissatisfied.
Other sources: Set of 154 slides, sold singly and in subsets of 123 (American) and 31 (European), offered by Sandak (77). Slides of works in the Corcoran Gallery also available singly from F. G. Mayer (61) and in sets from the Dunlap Society (243).
Evaluation: See Sandak (77). No information available on slides from Registrar's Office.

121 **Corning Museum of Glass**
 Corning Glass Center
 Corning, NY 14381
 (607) 937-5371
 attn: Sales Department

Profile: No response to questionnaire. Entry based on fourth edition, updated by letter of March 1984. Approximately 1,300 slides offered of glass objects in the museum: European, English, American, contemporary, Indian, and Far Eastern pieces, as well as glass from ancient times in Egypt, the Near East, the Roman Empire, and the Islamic world.
Documentation: Catalog $5.00, lists full information for each slide.
Purchasing: Slides $0.75 each.
Evaluation: Three-star rating in the fourth edition. "Rhode Island School of Design has a set; I'd give it top rating" (Mark Braunstein).

122 **Cranbrook Academy of Art Museum**
 500 Lone Pine Road
 P.O. Box 801
 Bloomfield Hills, MI 48103
 (313) 645-3312

Slides offered by Rosenthal Art Slides (76), listed in Volume 3 of catalog, featuring the architecture, art, and design of the Saarinens and their circle.

123 **Dallas Museum of Fine Arts**
1717 North Harwood
Dallas, TX 78201
(214) 922-0220
attn: Mary Mills

Duplicates of master slides of selected items from the permanent collection available on request. No catalog available.

124 **Delaware Art Museum**
2301 Kentmere Parkway
Wilmington, DE 19806
(302) 571-9590
attn: Museum Store

Profile: Offers 112 color slide titles of the permanent collection, chiefly, pre-Raphaelite art and American illustration. No expansion of slides holdings planned.
Photography: Transparencies (35 mm or larger) shot by staff photographer on Ektachrome ASA 50.
Production: Duplicated on Kodak slide duplicating film (probably Ektachrome #5071) by Chan Davies Photo Lab, Wilmington, Delaware. Contrast controlled, but color not corrected.
Documentation: Free list, to which slides are keyed for identification.
Purchasing: Slides sold singly, $1.00 each plus $0.25 postage. Prepayment required on foreign orders. Slides kept in stock and shipped within two weeks. No rush orders accepted. No minimum order. Returns accepted for refund or exchange. No special photography carried out.
Evaluation: Quality 2 to 3 based on several samples sent.

125 **Denver Art Museum**
100 West 14th Avenue Parkway
Denver, CO 80204
(303) 575-2793
attn: Sales Desk

Profile: No response to questionnaire. Sale of slides by shop confirmed by telephone. Entry based on fourth edition. Limited selection of slides (approximately 50) offered of the permanent collection, featuring paintings, pre-Columbian art, Spanish Colonial art, and American Indian art.
Photography: Slides shot by staff photographer in studio.
Production: Duplicated on Ektachrome by a commercial laboratory. Color corrected and contrast controlled.
Documentation: Free list. Orientation marked.
Purchasing: Slides sold singly, $0.50 each. Prepayment required on first order. No returns accepted.
Evaluation: No information available.

126 **Des Moines Art Center**
Edmundson Art Foundation, Inc.
Greenwood Park
Des Moines, IA 50312
(515) 277-4405
attn: Reception Desk

No response to questionnaire. According to the fourth edition, 50 slides sold by museum. List available. Slides also offered singly or in a set of 62 by Sandak (77): European painting and sculpture and U.S. painting and sculpture, plus four ancient or primitive objects.

127 **Detroit Institute of Arts**
 5200 Woodward Avenue
 Detroit, MI 48202
 (313) 833-9161
 attn: Photo Service Department

Profile: Offers 9,000 color slide titles of the permanent collection. "All of the accessioned pieces are photographed, and at least three to six slides are taken of each view at that time, with black-and-white and color photography." New slides continually added. Exhibitions documented, but slides not available for public use.
Photography: Slides shot by staff photographers in studio on Ektachrome.
Production: Duplicated in-house on Ektachrome #5071; color corrected in batches. Some slides produced by Frank Holmes Laboratory, California. Mounted in cardboard.
Documentation: Mailing list kept. New computer-generated catalog in preparation, to be revised continually. New catalog $1.00, deductible from first order. Identification consists of period/nationality, slide number, artist, title, artist's dates, and museum accession number. No information provided about specific media, dimensions, or date of work. Orientation not marked.
Purchasing: Order form included in catalog. Slides sold singly and in sets. No minimum order. Single slides $1.00. Quantity discounts of 10 percent on 100-250 slides, 20 percent on 251-1,000 slides, and 25 percent on more than 1,000 slides. Orders over $5.00 by educational institutions discounted 10 percent. Prepayment required on foreign orders. Postage of $1.25 to $4.00 added, depending on quantity of slides; these rates doubled for foreign airmail shipment. If in stock, slides shipped within three to seven days. If duplicated to order, shipped within two weeks. Rush orders accepted; orders totaling fewer than 100 slides sent within two days. No returns accepted. Special photography carried out within one to two months at a cost of $15.00 per image.
Rental: Slides rented by research library to educational organizations in the Detroit area. Four-by-five-inch transparencies rented for reproduction.
Other sources: A set of 33 slides, also sold singly, of painting and sculpture in this museum offered by Sandak (77). Single slides also available from Burstein (30), and slides included in sets produced by the Dunlap Society (243).
Evaluation: Quality variable, documentation 2, service variable (2 to 4). "In our experience, a substantial number of slides we have ordered have been out of stock" (Norine Cashman).

128 **Dumbarton Oaks**
 (Harvard University)
 1703 32nd Street, N.W.
 Washington, DC 20007
 (202) 342-3246
 attn: Photoarchivist, Byzantine Photograph Collection

Profile: Four sets of 10 slides each offered of objects in the Byzantine collection. Sets documenting the pre-Columbian collection to be offered in the near future, as well as slides of the house and gardens.
Photography: Shot by staff photographers.
Production: Duplicated by Colorfax Laboratory, Washington, DC.
Documentation: Free list. Sets accompanied by full documentation. *Handbook of the Byzantine Collection* (1967) available from Publications Department for $5.00 plus $1.50 postage.
Purchasing: Sets priced $10.00 each plus $1.50 postage. Slides in sets not sold singly. Slides of objects not included in sets available through special orders directed to either the Byzantine collection or the pre-Columbian collection. If original photography required, curatorial fee charged. Current price list available on request.
Evaluation: Quality 3 to 4, documentation 3 to 4, service 3 to 4.

129 **Field Museum of Natural History**
Roosevelt Road at Lake Shore Drive
Chicago, IL 60605-2496
(312) 922-9410, x248
attn: Photography Department

Profile: Black-and-white and color slides offered of works in the museum's collection, including archaeology and ethnology of North and South America, Europe, the Near East, the Middle East, Africa, Oceania, Malaysia, the Philippines, China, Japan, and Tibet. Slides of botanical, zoological, and geological exhibits also available, as well as museum views and special exhibits. Prints and transparencies rented for publication. Approximately 10,000 color images included in archive.

Photography: Black-and-white and color photography in 35 mm and 4-by-5-inch formats carried out by two museum photographers using Kodak and Fuji films.

Production: Duplicated by Astra Photo Service.

Documentation: No list available. Captions not routinely included on slide mounts. Captions provided on request. Orientation not marked.

Purchasing: Mail order preferred; telephone orders accepted if confirmed in writing. "Please supply as much information as possible about the desired images. Wherever possible, please send a photocopy or detailed description of the images and always cite the source that the information was derived from." Slide sets sold by the museum store, single slides by the Photography Department. No minimum order. Duplicates $2.00 each for either black-and-white or color. Prepayment required. Slides duplicated to order. Small orders (fewer than 15 slides) shipped within two to three weeks. Rush orders accepted if work schedule permits. Special photography undertaken on request; orders filled within four to six weeks. "In the event that there is a specimen in a case that cannot be removed, a photograph will be taken through the glass case. If the specimen is in storage, it can be removed and photographed in our studio. . . . Museum will retail all original transparencies and negatives." Returns accepted for exchange or refund if image is damaged ("scratched before shipment").

Other sources: Slides of some works in this museum, especially African artifacts, offered by Rosenthal Art Slides (76).

Evaluation: No information available.

130 **Freer Gallery of Art**
12th and Jefferson Drive, S.W.
Washington, DC 20560
(202) 357-1432
attn: Museum Shop

Profile: Color slides offered of virtually the entire collection. Separate lists available entitled "Chinese Figure Painting," "Ukiyo-e Painting," "Chinese Pottery," "Japanese Pottery," "Korean Pottery," "Chinese Art," "Japanese Art," "Islamic Art," and "J. M. Whistler," as well as a short general list of major works. The following areas covered by slides not included on lists above: art of the ancient Near East, Egypt, China, Japan, and India, as well as early Christian and Byzantine art and nineteenth century American painting. Black-and-white photographs and 4-by-5-inch color transparencies available for reproduction.

Photography: Slides shot by staff photographer on Kodak film.

Production: Duplicated on Kodak film by the Smithsonian Institution. Color corrected and contrast controlled.

Purchasing: Slides sold in sets or singly, $1.00 each. No minimum order. No discounts. Postage added. Prepayment required on new accounts, large orders, and special orders. No returns accepted. Duplicates kept in stock; shipped within two to three weeks. Rush orders accepted and filled immediately. Special photography carried out at $6.00 per slide, possibly within four weeks.

Other sources: Slides of works in the Freer Gallery also offered by F. G. Mayer (61) and the Islamic Teaching Materials Project (246).

Evaluation: Variable (2 to 4) on quality, documentation, and service. "Whistler slides ordered recently were good to excellent" (Norine Cashman).

131 **Frick Collection**
1 East 70th Street
New York, NY 10021
(212) 288-0700

Profile: Approximately 100 color slides, duplicates and originals, offered of works in the museum's permanent collection — primarily paintings, with details; also, room views, sculpture, and porcelain. New titles occasionally added.
Photography: Slides shot by staff photographer on Ektachrome ASA 160 using Nikon camera in studio.
Production: Duplicated by Van Chromes, New York, New York, on Ektachrome #5071. Color corrected and contrast controlled. Mounted in plastic.
Documentation: Free list. Slides labeled with name of artist, artist's dates, title, and collection (same information as on list).
Purchasing: Single slides only. No minimum order. Originals $1.00 each, duplicates $0.75. No discounts. Postage added. Payment accepted by international postal money order. Slides kept in stock; shipped within five days. Rush orders filled if slides are in stock. No special photography offered. Slides not sent on approval, and returns accepted for exchange only if damaged. GAF Panavue slides no longer sold.
Other sources: Slides of works in the Frick Collection available from F. G. Mayer (61).
Evaluation: Quality 3 to 4, documentation 3, service 3. "Selection not as comprehensive as I could wish" (Helen Chillman). "Slides accompanied by minimal information, but it is readily available in the library" (Brenda MacEachern).

132 **Galleries**
Boston, MA

Single slides of art works shown in Boston galleries offered by Burstein (30). Inquiries also may be addressed directly to specific galleries.

133 **Galleries**
Chicago, IL

Single slides of art works shown in Chicago galleries offered by Rosenthal Art Slides (76). Inquiries may be directed to individual galleries as well.

134 **Galleries**
New York, NY

Approximately 80 galleries represented in holdings of Art Now (24). Other vendors offering slides of works shown in New York galleries include Art in America (23), Burstein (30), Educational Dimensions (38), F. G. Mayer (61), and VRI Slide Library (92). Mayer useful as a source of images of works exhibited in the 1950s and 1960s.

135 **Gallery of Prehistoric Art**
220 Fifth Avenue
New York, NY 10001
(212) 689-7518
attn: Douglas Mazonowicz

Profile: A set of 40 color slides offered of cave paintings in France and Spain, including maps, cave entrances, interiors, lighting, and pigments. According to the fiftieth edition of the *American Art Directory*, the gallery's resources include a collection of 2,000 slides. Black-and-white photographs available also, and color transparencies lent for reproduction.
Documentation: Free brochure. Slides accompanied by a taped lecture and printed script by Douglas Mazonowicz, artist and director of the gallery.
Purchasing: Set $75.00, postpaid. Price is $68.00 without the cassette.
Evaluation: No information available.

136 **Georgia Museum of Art**
University of Georgia
Jackson Street
Athens, GA 30602
(404) 542-3255

No response to questionnaire. Forty-four slides available in set or singly from Sandak (77). Single slides also offered by Burstein (30).

137 **Harvard University Art Museums**
Cambridge, MA 02138
(617) 495-2389
attn: Photographic Services, Fogg Art Museum

Profile: Duplicate and original color slides offered of selected objects in the Fogg Art Museum and the Busch-Reisinger Museum. Included in the former collection are some 50,000 items—Western paintings, drawings, prints, and sculpture, as well as Oriental and Islamic art and the Harvard University portrait collection. Approximately 5,000 objects representing twentieth century German art and architecture (1910-1956) featured in the Busch-Reisinger Museum. Black-and-white photographic prints also sold, and color transparencies rented for reproduction.
Photography: Slides shot by staff photographers on Ektachrome and Kodachrome. Professional techniques employed in studio.
Production: Duplicated by Master Color Services. Color corrected and contrast controlled. Mounted in plastic.
Documentation: Free lists. Many unlisted items available on request. Slides labeled and keyed to lists. Orientation not marked.
Purchasing: Slides sold singly, $1.50 each. No minimum order. Postage added. Prepayment required. Some slides kept in stock, others made to order. Slides shipped immediately on receipt of payment. Rush orders filled with 50 percent surcharge. Special photography carried out within seven to ten days; original slides $15.00 each. Slides not sent on approval, but returns accepted for refund.
Other sources: Slides offered by Asian Art Photographic Distribution (240) of the Winthrop collection of bronzes, jade, stone, and wood. Single slides available from Burstein (30) of items in both museums.
Evaluation: Quality 2 to 3, documentation 2 to 3, service variable (2 to 4).

138 **High Museum of Art**
1280 Peachtree Street, N.E.
Atlanta, GA 30309
(404) 892-3600

No response to questionnaire. According to the *American Art Directory*, slides sold by the museum shop. Set of 156 slides offered by University of Michigan Slide Distribution (252), including views of the museum building. Slides of works in this collection also included in sets issued by the Dunlap Society (243).

139 **Hill-Stead Museum**
Box 353
Farmington, CT 06034
(203) 677-4787

Profile: Offers 21 color slide titles of works in the collection and museum views. New slides added infrequently.
Photography: Slides shot by independent professional on Ektachrome EPY 50 using Nikon camera and professional lighting techniques.
Production: Duplicated on Ektachrome #5078 by Arthur Brown Photo Services, Hartford, Connecticut. Color corrected and contrast controlled. Mounted in cardboard.
Documentation: Free list, revised yearly. Artist's name, title of work, and date provided. Slides labeled. Orientation marked.

Purchasing: Slides sold singly or in sets. No minimum order. Priced $1.10 per slide, discounted 10 percent for educational institutions and 10 percent for quantities over 10. Postage included. Prepayment required. Duplicates kept in stock and shipped within three to ten days. Rush orders filled in one to three days; surcharge of 20 percent. Special photography carried out on application to the museum office. Returns accepted only if slides damaged during shipping.
Evaluation: Quality 3, documentation 3.

140 **Hirshhorn Museum and Sculpture Garden**
 Eighth and Independence Avenues, S.W.
 Washington, DC 20560
 (202) 357-3091

No response to questionnaire. Slides sold by shop are produced by Rosenthal Art Slides (76). These 168 slides available also from Rosenthal as a set or singly. The Hirshhorn collection also has been photographed by F. G. Mayer (61), Slides for Education (83), and the Dunlap Society (243).

141 **Hispanic Society of America Museum**
 Broadway near 155th Street
 New York, NY 10032
 (212) 926-2234

No response to questionnaire. Slides available from sales shop at $1.00 each. Prepayment required. Three-page list available; minimal information given. "Several slides received during fall 1984 were on unstable film that had already begun to fade" (Norine Cashman).

142 **Honolulu Academy of Arts**
 900 South Beretania Street
 Honolulu, HI 96814
 (808) 538-3693
 attn: Academy Shop

Profile: Offers 100 slide titles, all color originals, of works in the permanent collection.
Photography: Slides shot by staff photographer on Kodachrome ASA 40 Type A 5070 using Nikon cameras and lenses. Professional lighting techniques employed. Processed by Kodak and mounted in cardboard.
Documentation: Free list. Each slide accompanied by identification slip. Orientation not marked.
Purchasing: Single slides only, $1.00 each. No minimum order. No discounts. First-class postage added. Slides kept in stock and shipped within three to five days. Orders invoiced; payment due on receipt of invoice. Rush orders accepted at no surcharge if items are in stock. No back orders maintained. No special photography undertaken. No returns accepted.
Other sources: Set of Chinese painting offered by Asian Art Photographic Distribution (240).
Evaluation: Rated by one advisor (Sara Jane Pearman): quality 3, documentation 3, service 3. Two samples sent: one Kodachrome of a painting was excellent; one Ektachrome of a three-dimensional object was good but overexposed.

143 **Huntington Library and Art Gallery**
 1151 Oxford Road
 San Marino, CA 91108
 (818) 405-2100
 attn: Bookstore

Profile: Duplicate color slides of selected works in the collections available: eighteenth and nineteenth century British art and American art from 1750 to 1930. One set of 23 slides offered of Chaucer's *Canterbury Tales*. New titles added infrequently.
Photography: Slides shot by staff photographers on Ektachrome ASA 100 daylight film.

Production: Duplicated on Ektachrome by Frank Holmes Laboratories, San Fernando, California. Mounted in cardboard.

Documentation: Thirty-six titles listed on single sheet (free); minimal information given. Slides labeled. Dates added by hand to sample slides. Orientation not marked.

Purchasing: Duplicates kept in stock and shipped within one to two weeks. No rush orders accepted. Slides $0.50 each. No minimum order. Prepayment required. No returns accepted. Special photography undertaken at $25.00 per hour plus $5.00 for each slide; address request to Curator, Art Collections. Special orders filled in two to three weeks. A few slides in Curator's collection available as duplicates for $2.50 each.

Evaluation: Ratings apply only to commercial slides sold by bookstore: quality 3, documentation 3, service 2 to 3. Eight samples were sent of paintings: several were slightly overexposed.

144 **Hyde Collection, Hyde House**
161 Warren Street
Glens Falls, NY 12801
(518) 792-1761

No response to questionnaire. Slides may be ordered from Sandak (77): set of 69 slides, also available singly. Burstein (30) also has photographed items in the Hyde Collection, which features paintings, drawings, sculpture, furniture, and books dating from the fifteenth to the twentieth centuries. Works from this collection also included in sets from the Dunlap Society (243).

145 **Indianapolis Museum of Art**
1200 West 38th Street
Indianapolis, IN 46208
(317) 923-1331
attn: Alliance Museum Shop

Questionnaire not returned, but memo received from shop announced availability of "Sandak slide sets plus 30 singles." List available on request. According to the fourth edition, the 30 singles are produced by GAF (42). Price stated in memo was $0.60 per slide.

Other sources: Set of 103 slides offered by Sandak also may be purchased singly from Sandak (77). Slides of works in this museum also included in sets produced by the Dunlap Society (243).

146 **Institute of Contemporary Art**
955 Boylston Street
Boston, MA 02115
(617) 266-5151

Single slides available from Burstein (30).

147 **International Museum of Photography**
George Eastman House
900 East Avenue
Rochester, NY 14620
(716) 271-3361, x249
attn: Photographic Print Services

Profile: Extensive collection of photographic prints documenting the history of photography housed by museum.

Photography: Slides shot by staff photographers.

Documentation: No list available. Printed works may serve as a reference.

Purchasing: Single 35 mm color transparencies (duplicates) sold to nonprofit customers for $3.00 each. Postage of $2.00 added in United States, $5.00 overseas. Prepayment required. Allow four to six weeks for

delivery. Rush orders accepted if possible; surcharge of 100 percent. Special photography carried out at $25.00 per hour. When ordering, provide as complete an identification of each image as possible. (Photographs are cataloged by photographer, not by subject matter.)
Other Sources: Sets of slides are available from Light Impressions, 439 Monroe Avenue, P.O. Box 940, Rochester, NY 14603.
Evaluation: Insufficient information available.

148 **Isabella Stewart Gardner Museum**
 2 Palace Road
 Boston, MA 02115
 (617) 566-1401
 attn: Museum Shop

No response to questionnaire. Entry based on 1985 list and telephone call. Excellent original slides available in the 1960s no longer offered. The only slides now sold by museum shop are produced by GAF (42). List of 46 titles available. Slides $1.00 each. Discount of 40 percent given to educational institutions. Many single slides may be purchased from Burstein (30).

149 **Jefferson National Expansion Memorial**
 11 North Fourth Street
 St. Louis, MO 63102
 (314) 425-4472
 attn: Museum Education Office

Profile: No response to questionnaire. Entry based on brochure received in 1981. Offers 21 slide sets on topics of regional history and culture, including several sets on St. Louis architecture, "Louis Sullivan in St. Louis," "Navajo Blankets," "Thomas Hart Benton: Illustrations from Mark Twain," and graphic art by George Catlin and Thomas Moran.
Photography and production: Slides duplicated on Ektachrome #5071.
Documentation: Free brochure lists set titles only.
Purchasing: Slides sold in sets of 20 ($10.00) or 40 ($20.00). Prepayment or purchase order required.
Evaluation: No information available.

150 **John and Mable Ringling Museum of Art**
 5401 Bayshore Road
 P.O. Box 1838
 Sarasota, FL 33578
 (813) 355-5101

Profile: Offers 97 color slide titles of paintings and drawings in the permanent collection, and 45 slides of buildings and grounds.
Photography: Negatives shot by staff photographer.
Production: Slides produced by Sandak (77) and GAF (42). Mounted in cardboard.
Documentation: List of Sandak slides available from museum or from Sandak (77). Mounts of Sandak slides imprinted with full identification.
Purchasing: Slides sold singly, $0.75 each. No minimum order. No discounts. Postage added. Prepayment required only from customers who have not paid for previous orders. Slides kept in stock; shipped within one to two days. No special photography available. Returns accepted only for exchange.
Other sources: Set of 75 slides available from Sandak; single slides also may be purchased.
Evaluation: See Sandak (77) and GAF (42). "Sandak slides purchased around 1982 from museum were old stock, not on stable film" (Norine Cashman).

151 **Joslyn Art Museum**
 2200 Dodge Street
 Omaha, NE 68102
 (402) 342-3300
 attn: Museum Shop

Profile: Offers 134 color slide titles of painting, sculpture, and decorative arts in the permanent collection. In addition, seven slides available of the museum architecture. Of special interest are 48 tableaux and 33 vignettes by Karl Bodmer (aquatints from *Travels in the Interior of North America in the Years 1832-34*).
Photography: Slides shot by an independent photographer.
Production: Duplicated by Midwest Photo. Mounted in plastic.
Documentation: Free list; artist, artist's nationality, and title provided. Slides labeled.
Purchasing: Slides sold singly, $1.00 each. No minimum order. Postage of $0.50 added per five slides. Prepayment required from individuals. Duplicates kept in stock and shipped within three weeks. Rush orders accepted; no surcharge. No special photography offered.
Evaluation: No information available.

152 **Kelsey Museum of Ancient and Medieval Archaeology**
 University of Michigan
 434 South State Street
 Ann Arbor, MI 48104
 (313) 764-9304

No response to questionnaire. Single slides offered by Burstein (30).

153 **Kimbell Art Museum**
 Will Rogers Road West
 P.O. Box 9440
 Fort Worth, TX 76107
 (816) 332-8451
 attn: Bookstore or Slide Curator

Profile: Color slides (originals and duplicates) offered of the museum building by Louis Kahn, the permanent collection, and exhibitions initiated by the museum (to date, "Jusepe de Ribera," "J.-B. Oudry," and "Wealth of the Ancient World"). Included in the permanent collection, in addition to European art, are objects from Africa, Asia, and ancient cultures.
Photography: Slides shot by museum photographer on Ektachrome ASA 50 or Fujichrome ASA 50, usually in studio, occasionally in galleries. Four-by-five-inch photography also carried out.
Production: Duplicated by Color Place or Superior Slides, Dallas, Texas. Color corrected by film lot. Contrast controlled. Mounted in plastic or cardboard.
Documentation: Free list. Slides labeled and keyed to list, which provides accession number, artist, title, and date. Orientation marked only when necessary.
Purchasing: "Most slides sold by the bookstore are original slides; increasingly, duplicates are sold." Slides sold singly. No minimum order. Slides ordered from bookstore $1.25 each plus postage. Prepayment required. Slides kept in stock and shipped within several weeks. Rush orders handled by slide curator, as are special orders for slides not stocked by the bookstore. "If a duplicate is needed, the charge may run $5.00 a slide." Special photography carried out within one week. "Exhibition documentation is usually by subscription to lending institutions, a few other institutions who have loaned works previously, and a few universities (mostly local)." Slides not sent on approval, but "bookstore has made exchanges for flawed slides."
Exchange: Slide curator is also interested in exchanging slides with other institutions.
Other sources: A set of 200 slides to be offered in 1985 by University of Michigan Slide Distribution (252).
Evaluation: Quality 3 to 4, documentation 3 to 4, service 3 to 4. "Nice exhibition sets" (Sara Jane Pearman). One sample sent: very good quality.

154 **Laumeier International Sculpture Park**
 12580 Rott Road
 St. Louis, MO 63127
 (314) 821-1209
 attn: Education Department

Entry based on brochure received in 1981. Two slide sets offered: "Sculptures at Laumeier" and "Ernest Trova."

155 **Los Angeles County Museum of Art**
 5905 Wilshire Boulevard
 Los Angeles, CA 90036
 (213) 857-6126
 attn: Rights and Reproductions

Profile: Slides available of approximately 50 percent of the permanent collection. Exhibition of German expressionist sculpture documented by Rosenthal Art Slides (76).
Photography: Color 35 mm and larger format transparencies shot by staff photographer. Nikon F3 camera and lenses used for 35 mm work, with electronic flash and Ektachrome ASA 64 professional film.
Production: Three hundred and ninety-three slides produced by Rosenthal Art Slides from 4-by-5-inch transparencies supplied by the museum. In addition, other duplicates are available from the museum, produced by Newell Color Lab on Ektachrome duplicating film #6121. These latter duplicates sometimes made from duplicates. Slides mounted in plastic.
Documentation: See Volume 3 of Rosenthal (76) catalog. No other list available. Slides keyed to catalog or identification sheet.
Purchasing: When possible, direct orders to Rosenthal Art Slides (76). Slides from Rights and Reproductions $5.00 each. No minimum order. If a slide must be duplicated to order, it is usually shipped within two to three weeks. Rush orders filled within five to seven days; surcharge. Special photography carried out at $100.00 per object. Returns accepted if slide damaged or wrong one sent.
Other sources: Slides of the Los Angeles County Museum of Art collection also available from Burstein (30) and the Dunlap Society (243).
Evaluation: See entries for Rosenthal and other suppliers named. No information available about slides from Rights and Reproductions.

156 **M. H. DeYoung Memorial Museum**
 Lincoln Park
 San Francisco, CA 94121
 (415) 750-3642
 attn: Museum Shop

As of February 1985, slide sales being phased out by shop. Very few slides available at this time, and stock will not be replenished when exhausted. Single slides of works in this museum offered by Burstein (30).

157 **Meadows Museum and Gallery**
 Southern Methodist University
 Dallas, TX 75275
 (214) 692-2516
 attn: Registrar

Profile: Offers 85 color slide titles of the permanent collection of Spanish art, as well as slides of the sculpture court. New slides added only of new acquisitions.
Photography: Slides shot by independent professional photographers.
Production: Duplicated by B&W Photolabs, Dallas, Texas, on Ektachrome #5071. Contrast controlled. Color corrected on request. Mounted in plastic.
Documentation: Free list; information complete. Slides keyed to list. Orientation marked by number placement.

Purchasing: Slides sold singly, $0.75 each, plus $1.00 postage. No minimum order. Prepayment required. Duplicates kept in stock and shipped within one day. Slides accepted for exchange only; "special reasons would be considered, but generally we do not refund." Special photography undertaken only with approval of director; fee variable.

Evaluation: Quality 2, documentation 4, service 3. "Paintings are photographed from too great a distance, so the image does not fill the film frame" (Norine Cashman).

158 **Memorial Art Gallery**
University of Rochester
490 University Avenue
Rochester, NY 14607
(716) 275-5694
attn: Asst. Registrar

Profile: Offers 913 color slide titles (originals and duplicates) of objects in the permanent collection. New titles continually added.

Photography: Slides shot on Ektachrome by staff photographer using Olympus camera and tungsten quartz lights.

Production: Duplicated by Color Methods, Inc. on Ektachrome #5071. Color corrected and contrast controlled. Mounted in plastic or in Gepe mounts with anti-Newton ring glass (for $1.00 extra per slide).

Documentation: No list available. Slides labeled. Orientation marked.

Purchasing: Slides sold singly for $3.50 each (new photography) or $2.50 each (duplicates). Postage included. No discounts. No minimum order. Slides kept in stock; usually shipped within three days. New photography completed within seven days. No rush orders accepted, and no returns accepted.

Other sources: Slides of works in this collection included in sets produced by the Dunlap Society (243).

Evaluation: No information available.

159 **Metropolitan Museum of Art**
Fifth Avenue at 82nd Street
New York, NY 10028
(212) 879-5500
attn: Institutional Sales

Profile: No response to questionnaire. Entry based on fourth edition and recent order by Brown University. Slides sold in the museum's gift shop. Mail order slides available from the Institutional Sales Department. Sets often available of current exhibitions.

Photography and production: Varied. Some 250 slides sold in shop are produced by Rosenthal Art Slides (76) from transparencies supplied by the museum. Many Sandak (77) slides also carried by museum shop. Other slides available in shop and/or through mail order are produced by independent firms from original slides or transparencies shot by staff or independent professional photographers. Some slides produced by Visual Media (91) for mail order sales. Valerie Troyansky, Assistant General Merchandise Manager, reports that as of spring 1985, more slides are being produced by Rosenthal and Sandak and that slides by Visual Media are being phased out as stocks are depleted. Slides mounted in cardboard or plastic.

Documentation: Free catalog (ca. 1980): "Color Slides and Sound-Slide Sets." Approximately 1,100 single slides listed, as well as 20 sets. Twelve sets accompanied by cassette tapes. Identification for single slides consists of artist, title, date (when known), and museum accession number. Contents of sets not specified slide by slide. Sets accompanied by identification sheets.

Purchasing: Slides sold singly and in sets. Prices vary; generally, slides are quite inexpensive. Prepayment required on orders totaling less than $25.00. Discounts given to educational institutions. Postage added.

Rental: Holdings of the museum's Slide Library may be rented in person (*not* by mail) for educational use.

Other sources: Slides of objects in the Metropolitan Museum of Art can be ordered from the following companies:

Asian Art Photographic Distribution (240): approximately 1,000 slides of Chinese paintings

Burstein (30): single slides

Dick Blick Co. (36): set of 50 slides

Dunlap Society (243): included in sets

Islamic Teaching Materials Project (246): included in large set

Kautsch (57): slides of objects in Asian collection

F. G. Mayer (61): single slides

Rosenthal Art Slides (76): 250 slides

Sandak (77): large holdings, as sets or singly. The following lists may be requested:

 "Slides From the Permanent Collection"—single slides

 "Masterpieces of 50 Centuries"—three sets or singly

 "Italian Painting: Florentine School"—set of 25 or singly

 "The Cloisters"—63 single slides

 "Stained Glass of the Middle Ages and the Renaissance"—set of 60 or singly

 "The Year 1200"—set (four sizes)

 "Before Cortez: Sculpture of Middle America"—set (two sizes)

 "19th Century America"—set of 100 or two 50-slide subsets

 "New York Painting and Sculpture, 1940-70"—set (two sizes)

Saskia (78): single slides of ancient Near Eastern art, Greek and Roman sculpture, Medieval and Renaissance sculpture, and European painting, fifteenth century to twentieth century

Slides for Education (83): single slides

Evaluation: Quality variable, depending on producer. The museum is presently trying to upgrade the quality of its slide offerings. In the recent past, slides obtained directly from the museum by mail order have included some slides marred by high contrast, poor color fidelity, and soft definition of detail. Documentation of slides listed in museum's own catalog rated 2 to 3; no dimensions or specific media given for paintings. Service 1 to 2.

160 **Milwaukee Art Museum**
 750 North Lincoln Memorial Drive
 Milwaukee, WI 53202
 (414) 271-9508
 attn: Slide Library

Profile: Duplicate color slides offered of 718 paintings, 109 sculptures, 308 graphic works, and 71 photographs. Included are works from the Bradley collection (twentieth century American and European), the Layton collection (nineteenth century American), the Flagg Tanning Corporation collection (Haitian), and the von Schleinitz collection (nineteenth century German). New titles continually added.

Photography: Slides shot on Ektachrome ASA 50 by staff photographer.

Production: Duplicated by Kolor Krome on Ektachrome #5071. Color corrected and contrast controlled. Mounted in cardboard.

Documentation: Catalog $3.00. Identification consists of artist, artist's dates, title, date, and sometimes medium. Slides labeled. Orientation marked.

Purchasing: Slides sold singly and in sets. Single slide $1.75, postpaid. Set prices vary. No minimum order. Duplicates made to order and shipped within two weeks. No returns accepted.

Evaluation: No information available.

161 **Minneapolis Institute of Arts**
 2400 Third Avenue South
 Minneapolis, MN 55404
 (612) 870-3196
 attn: Slide Library

Profile: Approximately 725 color slide titles offered of works in the permanent collection, covering the following subject categories: African, Oceanic, Asian, New World, decorative arts, paintings, sculpture, and photography. New titles added periodically, especially to document new acquisitions.
Photography: Slides shot by staff photographer on Ektachrome using professional lighting techniques (quartz lights). Flat objects placed on black velvet ground; three-dimensional objects placed against seamless background papers of various colors.
Production: Duplicated by Procolor, Minneapolis, on Ektachrome #5071. Color corrected and contrast controlled.
Documentation: Mailing list kept. First catalog (1980) lists 522 slides. Supplement listing 200 slides issued in 1984. Both catalogs free. Contents of set of Chinese bronzes listed separately, available by special request. Slides keyed to catalog, which provides full information. Orientation marked by number placement.
Purchasing: Except for one set of 71 Chinese bronzes from the Pillsbury collection ($90.00), slides sold singly, $1.50 each. Pillsbury collection slides sold individually as well. No minimum order. Quantity discounts to $1.05 for more than 100 slides. Postage added (maximum $2.00 in United States). Prepayment required from individuals. Duplicates kept in stock and shipped within two weeks. Rush orders filled, if possible, within four days. No special photography offered. "We do not have a policy of sending slides on approval. However, if slides are found to be inadequate, they can be returned for a refund."
Other sources: Single slides of objects in this museum also available from Burstein (30).
Evaluation: Quality 3 to 4, documentation 4, service 3 to 4. Eleven samples sent: three-dimensional objects particularly well photographed; slides of one painting and one drawing not sharply focused.

162 **Munson-Williams-Proctor Institute**
310 Genesee Street
Utica, NY 13502
(315) 797-0000, x23
attn: Art Reference Library

Profile: Approximately 500 color slide titles offered of works in the permanent collection, plus several hundred slides of Fountain Elms architecture and furnishings. Slides also sold of the Tillou collection of American folk paintings and architecture in the vicinity of Utica. New titles continually added.
Photography and production: No data provided except that originals are 35 mm slides and that duplicates are mounted in cardboard. According to the fourth edition, slides shot by a commercial photographer in the galleries and duplicated by Kodak.
Documentation: Free list, revised quarterly; full information provided. Slides labeled. Orientation marked.
Purchasing: Slides sold singly, $1.50 each, postpaid. No discounts. No minimum order. Prepayment required on orders over $5.00. Duplicates kept in stock and shipped within one week. Slides not sent on approval, and returns accepted only for exchange.
Other sources: Single slides available from Burstein (30), and slides of works in this museum included in sets produced by the Dunlap Society (243).
Evaluation: No information available.

163 **Museum of American Textile History**
800 Massachusetts Avenue
North Andover, MA 01845
(617) 686-0191
attn: Photographic Services

Profile: Formerly Merrimack Valley Textile Museum. Offers 15,000 color slide titles from the curatorial/ library collections, including images of textiles. Other holdings documented include prints and photographs of textile technology, mills, and labor and industrial and preindustrial machinery. New titles added infrequently.

Photography: Slides shot by independent professional photographers (50 percent), staff members (25 percent), and scholars (25 percent) on various films. Approximately 10 percent of images are black-and-white.

Production: Duplicated by local firm from originals or duplicates. Color corrected and contrast controlled.

Documentation: Catalog available on premises only. Slides labeled. "$25.00 per hour research time (per staff member) may be charged in situations where staff time is extensively utilized."

Purchasing: Slides sold in sets and singly. Duplicates $1.00 each. New slides (minimum 10) $5.00 each. Slides duplicated to order and shipped within two weeks. Rush orders filled within four days; surcharge. Slides not sent on approval, and returns not accepted.

Rental: Slide programs rented on subjects related to the history of the textile industry. Four slide/tape presentations available for rental fee of $10.00 each: "Daily Work," "Bleak Prospects," "Machine Shop Village," and "Life in Turn-of-the-Century Lawrence."

Evaluation: No information available.

164 **Museum of Contemporary Art**
 237 East Ontario Street
 Chicago, IL 60611
 (312) 280-2600
 attn: Photography Archives

Profile: Duplicate color slides offered of items in the permanent collection. Major strengths: Dada, Surrealism, and Chicago art. "We also have a representative collection of European contemporary art and an important collection of artists' books." As of mid-1984, 297 slides available. New titles continually added, approximately 100 new acquisitions annually.

Photography: Slides shot by staff photographer on Ektachrome professional film.

Production: Duplicated in-house or by Pallas Photo Lab. Kodak film SO 366 used. Mounted in cardboard.

Documentation: Catalog $2.75. Supplements issued annually. Slides labeled and keyed to catalog. Orientation marked. Identifications consist of accession number, artist, title, and date.

Purchasing: Slides sold singly, $2.00 each. Postage added. "Not-for-profit organizations please include a letter showing tax-exempt status." Duplicated to order; shipped within one week. Slides not sent on approval, and returns not accepted.

Other sources: Some single slides of objects exhibited at the Museum of Contemporary Art also offered by Rosenthal Art Slides (76).

Evaluation: Quality 3, documentation 3, service 3 to 4. "We get slides of all their shows on a standing order basis, and we're very pleased with the coverage and service" (Nancy Kirkpatrick).

∗ 165 **Museum of Fine Arts, Boston**
 465 Huntington Avenue
 Boston, MA 02115
 (617) 267-9300, x317
 attn: Photographic Services Department/Slide Library

Profile: Approximately 10,000 color slide titles offered for sale of objects in the permanent collection. Some 8,000-10,000 slides available in addition to those listed in catalog. Another 5,000 or more to be added in 1984. Slides not listed in catalog may be duplicated to order. Exhibitions documented; slides usually sold in limited-edition sets. Black-and-white photographs of the museum's holdings available from more than 150,000 negatives.

Photography: Slides shot by staff photographer in studio using Nikon camera and lenses, strobe lighting, and various Kodak films. Black-and-white negatives and color transparencies in 8-by-10-inch format shot with Sinar view camera.

Production: Duplicated on Ektachrome #5071 by Subtractive Technology, Boston. Color corrected and contrast controlled, if necessary. Mounted in cardboard.

Documentation: Catalog $5.00, deductible from first order if over $50.00. Full information given for each slide. Slide identifications arranged by sets, however, which makes looking up a specific item arduous; catalog is not indexed, but table of contents lists set titles in classified arrangement. Catalog revised every three to four years. Slides keyed to catalog. Orientation marked by Museum of Fine Arts logo or dot.

Purchasing: Slides sold usually are duplicates; originals occasionally offered. Slides available in sets or singly. No minimum order. Sets available in several sizes. Order forms provided in catalog. Single slide $2.00, whether from stock or by special order. Per-slide cost in sets approximately $1.00. Postage added. Prepayment required on overseas orders and orders under $25.00. New photography $15.00 to $40.00, depending on complexity of object. Special orders filled within three to six weeks of receipt of written request. Approximately 5,000 slides (160 set titles) kept in stock. Orders usually filled within 10-20 days. Rush orders filled in two to four days; surcharge of 100 percent plus express shipping charges. Slides not usually sent on approval. Returns accepted for exchange or refund within two weeks.

Rental: Slide Library collection—150,000 images, of which 50 percent represent Museum of Fine Arts objects—available for rental. Slides rented to lecturers, graduate students, college and university professors, and Massachusetts schoolteachers. The latter are not charged, but others pay $10.00 to borrow up to 40 slides for two weeks.

Exchange: Exchange of slides with other museums desired.

Other sources: Slides offered by Burstein (30) and Architectural Color Slides (21).

Evaluation: Quality variable (2 to 4), documentation 3 to 4, service variable (2 to 4). "Excellent slides for the price when purchasing sets" (Mark Braunstein). "Duplicates sometimes too dense, dark" (Helen Chillman). "Slides are rather contrasty" (Brenda MacEachern). "Have had wrong slides sent and reversals, but slides are always cheerfully exchanged and corrections confirmed" (Nancy DeLaurier). Approximately 20 samples sent: contrast generally too great, and some slides were too dark. "This museum deserves commendation, however, for photographically documenting such a large proportion of its collection" (Norine Cashman).

166 **Museum of Fine Arts, Houston**
1001 Bissonet
P.O. Box 6826
Houston, TX 77005
(713) 526-1361
attn: Museum Shop

No response to questionnaire. Slides sold by museum shop are apparently both Sandak slides (77) and slides produced locally by or for the museum. Lists formerly available (1978-79). Rush order in 1982 was filled within nine days. Slides at that time $0.50 each plus $0.50 postage per order. Slides can be ordered directly from Sandak as well. Single slides offered by Burstein (30).

167 **Museum of Modern Art**
11 West 53rd Street
New York, NY 10019
(212) 956-6100
attn: Department of Publications

Profile: No response to questionnaire. Slides sold in bookstore and by mail order.

Production: Produced by Sandak (77) and mounted in cardboard.

Documentation: List of 355 items available from museum, providing artist, title, date, and MOMA item number. Slides fully labeled. Comprehensive list available from Sandak: "Slides From the Permanent Collection and Exhibitions of the Museum of Modern Art, New York."

Purchasing: As of 1981, price remained $0.75 per slide. On orders of 15 or more slides, 20 percent discount given to educational institutions, 25 percent to museum members. Postage added. Prepayment required.

Other sources: The following exhibition sets offered by Sandak (most individual slide titles in these sets included in comprehensive list as well):

"American Art Since 1945"—102 slides or 41 slides

"Art of the Twenties"—158 slides

"Big Pictures by Contemporary Photographers"—32 slides

"Contemporary Sculpture"—43 slides

"International Survey of Recent Painting and Sculpture"—119 slides

"New American Painting and Sculpture: The First Generation"—41 slides

"One Hundred Master Photographs"—100 slides

"Painting and Sculpture of the 60s"—26 slides

"Prints from Blocks, Gauguin to Now"—62 slides

"Revolution: The Russian Avant-Garde"—77 slides

"School of Paris: Drawing in France"—80 slides

Single slides offered by Burstein (30). Craft exhibitions documented in sets produced by the American Craft Council (235). Slides of Latin American art exhibited at Museum of Modern Art available from the Museum of Modern Art of Latin America (168).

Evaluation: See Sandak (77). "Our last order (in 1981) contained slides badly damaged by careless storage and handling. We had to return 8 of 31 for exchange. I would recommend ordering directly from Sandak" (Norine Cashman).

168 **Museum of Modern Art of Latin America**
Organization of American States
1889 F Street, N.W.
Washington, DC 20006
(202) 789-6021
attn: Audiovisual Unit

Profile: Offers 221 sets of duplicate color slides of pre-Columbian and contemporary culture in Latin America. Museum's own permanent collection documented, as well as special exhibitions of works by Latin American artists there and elsewhere, including the Museum of Modern Art, New York. Series titles: "Culture in Latin America," "Scenery of Latin American Countries," "Pre-Columbian Art," and "Art in Latin America." New titles continually added (approximately 20 sets in 1984). Films, filmstrips, and videocassettes also available.

Photography: Slides shot by staff photographer on Ektachrome professional film ASA 160 using Nikon equipment.

Production: Printed by Consolidated Visual Center on Eastmancolor #5384; ECP-2A processing used. Color corrected and contrast controlled. Mounted in cardboard and packaged in plastic sleeves.

Documentation: Mailing list kept. Free catalog in English, revised biennially, lists set titles only. Sets accompanied by descriptive pamphlets in English (a few also available in Spanish). Slides keyed to pamphlets. Orientation marked by number placement.

Purchasing: Sold in sets of 10, $6.00 per set. Minimum order one set. Postage included. Discount given for purchase of an entire series (36-49 sets). Prepayment preferred. Slides kept in stock or made to order if necessary. If in stock, slides shipped within two days. If produced to order, slides shipped within four to six weeks. Requests considered for slides shot to order. Slides sent on approval to researchers and publishers. Returns accepted ("rarely") "if the slides do not meet curriculum needs or are defective."

Other sources: Same slide sets may be available from the Pan American Development Foundation, 17th and Constitution Avenue N.W., Washington, DC 20006.

Evaluation: "Most of their slides are mediocre to poor quality. 'Documentation' takes the form of chatty discourses, not proper identification" (Nancy Kirkpatrick).

169 **Museum of New Mexico**
113 Lincoln Avenue
P.O. Box 2087
Santa Fe, NM 87503
attn: Museum Shop

Slides produced by Rosenthal sold by museum shop and Rosenthal Art Slides (76). American Indian arts and crafts represented, as well as works by artists from the southwestern United States.

170 **Museum of the American Indian**
Heye Foundation
Broadway at 155th Street
New York, NY 10032
(212) 283-2420
attn: Photography Department

Profile: Questionnaire not returned, but letter of response received. "For the time being, we sell slides, a few at a time, in our gift shop and also accept mail orders, with the understanding that a number of slides may be unavailable. It is on our part a service we offer to researchers, students, and foreign visitors." Museum's permanent exhibits composed of artifacts of aboriginal peoples of North, Central, and South America.
Photography and production: According to the fourth edition, slides shot by staff photographer in studio and duplicated by a commercial laboratory.
Documentation: No current list available as of September 1984. Many slides on old list now out of stock; more than 1,000 others not listed but actually available. Eventual revision of list planned. Casual inquiries discouraged because the staff can serve only those who seriously intend to purchase slides for educational purposes.
Evaluation: No information available.

171 **Museum of the City of New York**
1220 Fifth Avenue
New York, NY 10029
(212) 534-1672

Single slides of objects in this museum offered by Burstein (30) and F. G. Mayer (61).

172 **National Academy of Design**
1083 Fifth Avenue
New York, NY 10028
(212) 369-4880

Profile: Slides, 4-by-5-inch color transparencies, and black-and-white photographs offered for rental covering the academy's collection of nineteenth and twentieth century American art. Four hundred black-and-white and 100 color images available.
Photography: Independent photographer hired by National Academy of Design on freelance basis.
Production: Originals usually lent, but duplicates occasionally made by Color Pro Lab or National Reprographics, both in New York City. No attempt made to correct color or control contrast.
Documentation: No list. Images labeled with artist, title, and collection. Orientation not marked.
Rental: Images offered individually; no minimum order. Prices based on actual costs for each job. Time to fill order varies, depending on photographer's current work load.
Other sources: Slides of works in the National Academy of Design collection included in sets available from the Dunlap Society (243).
Evaluation: No information available.

173 **National Archives and Records Service**
 General Services Administration
 Washington, DC 20408
 attn: Cashier or Still Picture Branch

Profile: Offers 1,507 slides in eight sets: "Indians in the United States," "The American West, 1848-1912," "Pictures of the Civil War," "Pictures of the Revolutionary War," "U.S. Navy Ships, 1775-1941," "Negro Art from the Harmon Foundation," "Contemporary African Art from the Harmon Foundation," and "The American City."

Documentation: Eight leaflets—"Select Audiovisual Records"—available, corresponding to the eight slide sets offered. Each slide fully described in leaflet.

Purchasing: Slides sold in large sets (140-245 images). All sets offered on black-and-white film, $30.00 per set. Last three sets previously listed are optionally available partly on color film, $45.00 per set. Prepayment required. Make checks payable to NATF (NNVP). Price list for single slides available from the Still Picture Branch (NNVP).

Other sources: Same sets (all black-and-white film only) offered by Geological Education Aids (43) at discount prices. Slides of images relating to architectural history of Washington, DC, available from the Dunlap Society (243).

Evaluation: No information available.

174 **National Gallery of Art**
 Constitution Avenue at 4th Street, N.W.
 Washington, DC 20565
 (202) 842-6462 or 6455
 attn: Publications Service

Profile: Offers 500-600 color slide titles of works in the permanent collection of European and American art. Information about slides of temporary exhibitions available on request.

Photography: Slides, 8-by-10-inch color transparencies, or color negatives shot by National Gallery of Art staff. Ektachrome usually used for slides, with E-6 processing.

Production: Duplicated on Ektachrome #5071 by Visual Media (91). Color corrected. Mounted in cardboard or plastic.

Documentation: Free catalog of publications, including slides. New catalog scheduled for late 1984. Information in old catalog (#5) consists only of artist and title. Slides labeled and keyed to catalog. Orientation marked.

Purchasing: Order form included in catalog. Slides sold in sets or singly. Minimum order $4.00. Single slides $0.75 each. Sets contain nine slides accompanied by text. Discount of 20 percent given to educational and religious organizations and other museum shops. Postage added. Prepayment required. Duplicates kept in stock and shipped within three weeks. Rush orders not accepted. Slides not sent on approval, and no returns accepted. For slides made to order, contact Photographic Services.

Other sources: Set of 90 slides offered by Sandak (77), also available singly. Set of 100 slides available from Aguilar (469). Other sources of slides of National Gallery of Art objects include Burstein (30), Dick Blick Co. (36), Dunlap Society (243), Geological Educational Aids (43), F. G. Mayer (61), and Slides for Education (83).

Evaluation: Quality 2, documentation 2, service 2. "In recent years, many items ordered have been out of stock. Some slides received were badly scratched. Errors were made in filling several orders; wrong slides were sent. Duplicate slides are very high in contrast. Especially in comparison to the excellent original slides formerly offered, the slides presently available are a disappointment" (Norine Cashman).

175 **National Museum of African Art**
 Smithsonian Institution
 318 A Street, N.E.
 Washington, DC 20002
 attn: Eliot Elisofon Archives

Profile: Offers approximately 40,000 color slide titles of African art in the museum's collection and other public and private collections, as well as field slides of African culture. About 500 new slides added annually.

Photography: Photographed by Smithsonian Office of Printing and Photographic Services, independent peofessionals, and Eliot Elisofon (*Life* magazine photographer). Most museum objects shot on Kodachrome.

Production: Duplicated on Ektachrome #5071 by Colorfax Lab or Asman Lab. Color corrected and contrast controlled, if necessary. Mounted in cardboard.

Documentation: Free general guide to the collection and price list. Identification handwritten in English on mounts.

Purchasing: Slides sold singly, $0.80 each. No minimum order. Postage added at 15 percent (minimum $2.00). Publication quality duplicates $1.60. Prepayment or purchase order required. Slides usually duplicated to order; a few kept in stock. Shipped within three weeks. Rush orders filled in 10 days; surcharge of 100 percent. No rush orders over 50 slides accepted. No special photography offered. Slides not sent on approval, and returns accepted for exchange only when damaged.

Evaluation: Rated by one advisor (Nancy DeLaurier): quality 4, documentation 4, service 4. "They also sent much helpful material on their cataloging system." Two samples sent: resolution not sharp.

176 **National Museum of American Art**
Smithsonian Institution
Eighth and G Streets, N.W.
Washington, DC 20560
(202) 357-1626
attn: Office of Research Support

Profile: Formerly National Collection of Fine Arts. Offers 243 color slide titles of works in the permanent collection of American art, Colonial era to the present. Approximately 50 new titles added in 1984. Sets of four exhibitions also available: "Daniel Chester French," "Paintings of Charles Bird King," "George Catlin," and "The Harmonious Craft: American Musical Instruments."

Photography: Four-by-five-inch color transparencies shot on Ektachrome #6118 by staff photographers using a view camera and professional lighting techniques in a studio. Paintings and graphic works usually photographed unframed.

Production: Single slides produced by Rosenthal Art Slides (76) on Ektachrome #5071. Mounted in plastic or cardboard. Sets from exhibitions produced by the Office of Printing and Photographic Services, Smithsonian Institution.

Documentation: Mailing list kept. Free slide list, revised biennially, gives full information. Slides labeled and keyed to list. Orientation marked. Listed also in Rosenthal catalog, Volume 3. Sets accompanied by checklist giving full identifications.

Purchasing: Slides sold singly, $1.25 each, postpaid. No minimum order. Slides kept in stock and shipped within three weeks. Rush orders filled within three days; no surcharge. Slides not sent on approval. Returns accepted for exchange or refund if damaged. Prices on exhibition sets vary but all are based on per-slide cost of less than $1.00. Original photography carried out within two to three months for $50.00 fee. "If available, we lend 4-by-5-inch transparencies for three-month periods, free of charge, from which 35 mm slides may be made. This is only possible for works on our slide list that will not be reproduced, published, or used for other commercial purposes."

Exchange: "We are happy to exchange slides with other museums, generally those with American collections. This is usually negotiated on a slide-for-slide, or even exchange, basis."

Other sources: Slides of the "Art of Elihu Vedder" exhibition available in a set from the Dunlap Society (243).

Evaluation: See Rosenthal Art Slides (76) for quality. Documentation 4 (recent list), service 3. Smithsonian sets received three-star rating in fourth edition.

177 **National Portrait Gallery**
 Smithsonian Institution
 F Street at Eighth, N.W.
 Washington, DC 20560
 (202) 381-5380
 attn: Office of the Curator

Profile: No response to questionnaire. Entry based on fourth edition. Entire collection documented in slides.
Photography: Shot by staff photographer in studio. Frames of paintings removed.
Production: Duplicated by Kodak's Rochester laboratory.
Documentation: "Checklist of Permanent Collection," stock #4706-00009, available from Superintendent of Documents, U.S. Government Printing Office, Washington, DC 20402, for $1.60 postpaid. List arranged by sitters' names. Other information supplied includes artist's name and dates, dates of subject, date of work, medium, size, accession number, and donor. Indexed by artist. Full information also provided on slides.
Purchasing: Slides sold singly, $1.00 (1980). Prepayment required. No returns accepted.
Evaluation: Three-star rating in fourth edition.

178 **Nelson-Atkins Museum of Art**
 4525 Oak Street
 Kansas City, MO 64111
 (816) 561-4000
 attn: Sales Desk

Profile: Duplicate slides offered of objects in the museum's permanent collection. Many slides of Oriental art included. Western art, ancient through twentieth century, also represented. New titles added (25 in 1984).
Photography: Slides (in recent years) shot by professional photographers on Ektachrome. Pentax camera used, with professional studio and lighting. Most paintings now photographed without frames.
Production: Duplicated by Kodak. Color corrected and contrast controlled. Mounted in cardboard or plastic.
Documentation: Extensive list of slides available from sales desk. Also, the slide librarian has a list of Chinese subjects available, including most sections and details of Chinese paintings. List of remainder of slides available from the slide librarian. Supplements issued by sales desk as new acquisitions are photographed. Some slides labeled, others keyed to information sheets. Orientation marked.
Purchasing: Slides sold singly, $1.50 each (from both sources). No minimum order. No discounts. Postage added $2.00 per order (United States). Slides kept in stock by sales desk. Slides from slide library duplicated to order and shipped within three weeks. No rush orders accepted. Slides not sent on approval. Returns accepted if there is an error in filling the order or a defect in the slide. Special photography undertaken at $50.00 per slide; orders filled within four to six weeks.
Rental: Slides rented to publishers for reproduction.
Other sources: Slides of works in this museum offered also by Burstein (30), Miniature Gallery (275), Sandak (77), and Saskia (78). A set of 225 slides is available from the University of Michigan Slide Distribution (252). Sandak offerings consist of a few items in a Chinese painting set. Slides from Miniature Gallery included in Poussin set and "Sacred Circles" set (American Indian artifacts).
Evaluation: One sample slide of a painting sent: color murky, contrast high, definition soft. "The image in the sample, like other slides we have received in the past, was cropped" (Norine Cashman).

179 **New Britain Museum of American Art**
 56 Lexington Street
 New Britain, CT 06052
 (203) 229-0257

Profile: Original color slides, black-and-white photographs, and color transparencies offered of items in the collection of American art, 1740 to the present.

Photography: Shot by a professional museum photographer on Kodak film.
Production: Original slides mounted in plastic.
Documentation: No list.
Purchasing: Slides sold singly, $1.75 each. No minimum order. Slides kept in stock. No returns accepted.
Evaluation: No information available.

180 **New Orleans Museum of Art**
 Lelong Avenue
 P.O. Box 19123
 New Orleans, LA 70179
 (504) 488-2631

No response to questionnaire. A set of 150 slides, representing 80 paintings and five sculptures, offered by the University of Michigan Slide Distribution (252). A set of 74 slides, also available singly, may be purchased from Sandak (77); American and European painting, Spanish Colonial painting, Japanese painting, and African, Oceanic, and pre-Columbian art included. Additional slides offered by Rosenthal Art Slides (76).

181 **New-York Historical Society**
 170 Central Park West
 New York, NY 10024
 (212) 873-3400

No slides available directly from museum. Approximately 500 4-by-5-inch and a few 8-by-10-inch color transparencies rented for publication, however. American historical prints, Audubon watercolors, paintings by the Hudson River School, caricatures, maps, photographs, and advertising ephemera included in the Society's collection. Slides offered of selected items by F. G. Mayer (61) and Sandak (77). Dunlap Society (243) sets include works from this collection.

182 **Newark Museum**
 49 Washington Street
 P.O. Box 540
 Newark, NJ 07101
 (201) 733-6600

No response to questionnaire. Single slides of works in this collection offered by Burstein (30). Museum's holdings also represented in sets produced by the Dunlap Society (243).

183 **North Carolina Museum of Art**
 107 East Morgan Street
 Raleigh, NC 27611
 (919) 733-7568
 attn: Library

Profile: No response to questionnaire. Entry based on fourth edition. Holdings of museum only partially documented in slides. Renaissance and Baroque painting and American art emphasized.
Photography: Slides shot by staff photographer. Paintings removed from frames.
Production: Duplicated on Ektachrome by Kodak laboratory at Rochester or by a local laboratory.
Documentation: List available; full information provided.
Purchasing: Slides sold singly for $0.75 each or $0.50 each for educational institutions. Special photography undertaken with administrative approval.
Evaluation: No information available.

184 **Norton Simon Museum**
 411 West Colorado Boulevard
 Pasadena, CA 91105
 (213) 681-2484
 attn: Director of Marketing Services

Profile: Offers 130 color slide titles of works in the permanent collection, with emphasis on European paintings. New titles occasionally added.
Photography: Four-by-five-inch color transparencies shot by an independent professional photographer.
Production: Produced by Frank Holmes Laboratories, San Fernando, California. Color corrected and contrast controlled. Mounted in cardboard.
Documentation: Mailing list kept. Free slide list. Identifications consist of artist, title, and date. Slides labeled. Orientation marked.
Purchasing: Slides sold singly, $1.25 each. No minimum order. No discounts. Postage added. Prepayment required on overseas orders (from a pro forma invoice). Slides kept in stock and shipped within one week. Rush orders accepted. Slides not sent on approval; no returns accepted. No special photography carried out.
Evaluation: Quality 3, documentation 3, service 3.

185 **Oakland Museum**
 Art Department
 1000 Oak Street
 Oakland, CA 94607
 (415) 273-3402

No response to questionnaire. Single slides of items in this collection offered by Burstein (30), listed in catalog supplement #2. Slides of works by American painters of the West included in catalog Volume 3 of Rosenthal Art Slides (76). The Oakland Museum art collection also represented in sets produced by the Dunlap Society (243).

186 **Oriental Institute**
 University of Chicago
 1155 East 58th Street
 Chicago, IL 60637
 (312) 753-2474
 attn: Gift Shop or Archaeological Archives Photographic Service

Profile: No response to questionnaire. Entry based on fourth edition. A few slides available from gift shop; over 8,200 slides from Archaeological Archives Photographic Service. Art and archaeology of the ancient Near East, Egypt, and Islamic countries featured.
Photography: Slides shot by staff and excavation photographers.
Production: Duplicated by Kodak and other local laboratories.
Documentation: Free list of 71 titles available from gift shop; full identification provided. No list of holdings of the Archaeological Archives. Information supplied with slides from the latter source.
Purchasing: Slides sold singly or in sets. Single slides $0.50 from shop, $2.00 from Archaeological Archives. Educational discount. Prepayment required. Returns accepted for exchange. Special photography undertaken on request.
Rental: Slides may be rented for reproduction in publications.
Other sources: Slides of selected items in this collection also available from Rosenthal Art Slides (76).
Evaluation: Three-star rating in the fourth edition.

187 **Pennsylvania Academy of the Fine Arts**
Broad and Cherry Streets
Philadelphia, PA 19102
(215) 972-7620
attn: Bookstore

Profile: Offers 130 color slide titles of the permanent collection of American art.
Photography: Originals are 4-by-5-inch transparencies.
Documentation: Free list, revised annually. Artist, title, date provided. Slides labeled.
Purchasing: Slides sold singly, $1.50 each. Postage added. No minimum order. Prepayment required. Rush orders accepted. No special photography undertaken. Returns accepted for exchange.
Evaluation: Quality 3 to 4, documentation 3, service 3 to 4. "Slides are a great bargain. . . . Excellent source for eighteenth and nineteenth century U.S. painting" (Nancy Kirkpatrick).

188 **Philadelphia Museum of Art**
Benjamin Franklin Parkway
P.O. Box 7646
Philadelphia, PA 19101-7646
(215) 763-8100

Profile: Slides no longer offered for sale by the museum. Slides formerly available were produced by Visual Media (91) and may possibly be obtained directly from that source. Inquiries now referred to Rosenthal Art Slides (76). As of 1985, slides of 1,025 works in the Philadelphia Museum of Art, including the John Graver Johnson collection and the Rodin Museum, are available. Painting, sculpture, graphics, and decorative arts represented. More slide titles to be added in the future. Another 183 slides offered by Rosenthal of the exhibition "Manifestations of Shiva."
Photography: Slides and larger transparencies shot by museum staff photographers.
Production: Produced by Rosenthal Art Slides (76).
Documentation: See Rosenthal catalog, Volume 3.
Purchasing: Order directly from Rosenthal. On a very limited basis the museum's slide librarian is able to supply other museums with duplicates (made by a commercial laboratory) of slides in the museum's slide collection.
Other sources: Slides of Philadelphia Museum of Art objects offered by Burstein (30), DeMartini Educational Films (35), Dunlap Society (243), and F. G. Mayer (61).
Evaluation: See Rosenthal and other vendors mentioned in Other sources.

189 **Phillips Collection**
1600-1612 21st Street, N.W.
Washington, DC 20009
(202) 387-2151
attn: Museum Shop

Four hundred and sixty-eight color slide titles produced by Rosenthal Art Slides from originals supplied by the museum may be purchased from Rosenthal (76) or the museum shop. Single slides also offered by Burstein (30), and works from the collection included in sets from the Dunlap Society (243).

190 **Pierpont Morgan Library**
29 East 36th Street
New York, NY 10016
(212) 685-0008
attn: Photographic Services

Profile: Duplicate color slides offered of works in the permanent collection. Sets of 1,200 or 200 slides of manuscripts available from Rosenthal Art Slides (76); single slides may be purchased from the smaller set. Larger set produced in 1980-81 to accompany the exhibition "Masterpieces of Mediaeval Painting: The Art

of Illumination"; slide project as well as exhibition partly funded by Exxon Corporation. Set of 1,200 images also available as microfiche.

Photography: Originals photographed by museum.

Production: Produced by Rosenthal. Single slides obtained from museum are Kodak duplicates.

Documentation: Volume 3 of Rosenthal's catalog lists 200 slides; full identifications given. Large set accompanied by extensive documentation.

Purchasing: Order sets from Rosenthal. Cost is $300.00 for 200 slides, $1,500.00 for 1,200 slides. Limited number of large sets remaining. The museum's Photographic Services provides duplicates of existing originals for $1.75. Slides requiring new photography $6.00 each. Normal delivery time three weeks. Surcharge of 50 percent on rush orders.

Other sources: A few single slides also offered by Burstein (30).

Evaluation: Quality 4, documentation 4, service 4 for Rosenthal sets. Insufficient information available to rate duplicates supplied by the museum.

191 Portland Art Association Museum
1219 Southwest Park Avenue
Portland, OR 97205
(503) 226-2811
attn: Slide Library

Profile: Duplicate color slides offered of objects in the permanent collection.

Photography: Slides shot by an independent professional photographer (85 percent) and by staff (15 percent). Ektachrome ASA 64 daylight and ASA 160 tungsten film used for in-house photography, which is carried out on a Polaroid MP-4 copystand with Leica camera.

Production: Duplicated on Ektachrome. Mounted in cardboard or plastic.

Documentation: No list available. Slides labeled to suit customer request. Orientation marked.

Purchasing: Slides sold singly, $0.75 for a duplicate from an existing slide, $5.00 for a duplicate requiring original photography. Postage of $1.00 added in United States, $3.00 foreign. No minimum order. Slides kept in stock; if necessary, duplicated to order. Usually shipped within one to two weeks. No rush orders accepted. Slides not sent on approval. Special photography undertaken on request.

Exchange: Requests for exchange of slides welcomed.

Evaluation: No information available.

192 Portland Museum of Art
111 Hight Street
Portland, ME 04101
(207) 775-6148

Museum offers no slides for sale at present. A few single slides available from Burstein (30).

193 Preservation Society of Newport County
The Breakers
Ochre Point Avenue
Newport, RI 02840
(401) 847-6543
attn: Museum Store

Profile: Offers 111 color slide titles of seven Newport mansions (the Breakers, the Elms, Marble House, Chateau-sur-Mer, Rosecliff, Kingscote, and Hunter House) and of the topiary gardens at Green Animals. New titles occasionally added.

Photography: Four-by-five-inch transparencies shot by an independent professional photographer on Kodak film.

Production: Duplicated on Ektachrome #5071 by World in Color, Elmira, New York.

Documentation: Order sheet provides brief description of views for each house. No information given about architect, date of construction, or furnishings. Slides labeled. Orientation marked.

Purchasing: Slides sold singly or in sets. Priced $0.40 each or three for $1.00. Set prices vary; maximum $7.50 for 26 slides. All 111 slides offered for $30.00. Postage added. Discount of 10 percent for members. Prepayment or purchase order required. Slides kept in stock and shipped within one to two weeks. Rush orders accepted. Slides not sent on approval, and no returns accepted.
Evaluation: Two samples sent, an exterior view and an interior view: murky color, high contrast, very soft definition; rated 2. Documentation minimal.

194 **Princeton University Art Museum**
Princeton, NJ 08544
(609) 452-5204

Profile: More than 550 color slide titles offered of works in the permanent collection. New titles continually added (15-20 in 1984).
Photography: Slides shot by an independent professional photographer on Kodak film.
Production: Duplicated by Kodak.
Documentation: Free list, supplemented annually. Identifications consist of artist, artist's dates, title, date of work, and medium. Orientation not marked.
Purchasing: Slides sold singly, $1.00 each. No minimum order. Postage added. Prepayment required from new customers; purchase orders accepted from institutions. Orders filled within one to two weeks. Slides not sent on approval, but returns accepted for exchange or refund. Special photography undertaken within two months; minimum charge $15.00 per image.
Other sources: Single slides also offered by Burstein (30), and slides of Princeton University Art Museum objects included in sets from the Dunlap Society (243).
Evaluation: No information available.

195 **Rhode Island School of Design**
Museum of Art
224 Benefit Street
Providence, RI 02903
(401) 331-3511, x349
attn: Laura Stevens, Education Department

Profile: Offers 837 color slide titles of the permanent collection. Many slides of drawings, prints, and decorative arts included. New titles continually added.
Photography: Slides shot by staff photographer (50 percent) and independent professional photographers (50 percent). Whenever possible, objects photographed in studio. If objects cannot be moved, scaffolding and/or backgrounds erected in galleries; tripod and lights used.
Production: Duplicated by Kodak on Ektachrome SE duplicating film SO 366. No attempt made to control contrast or correct color. Mounted in cardboard.
Documentation: Free lists (painting, sculpture, graphic arts, decorative arts), revised once or twice annually. Identifications consist of artist, title, date, and museum accession number. Materials and techniques sometimes indicated for decorative arts, usually for graphic arts. Slides labeled and keyed to catalog. Orientation marked.
Purchasing: Slides sold singly, $2.00 each. No minimum order. Quantity discounts given of 25 percent for 50-100 slides, 33 percent for more than 100 slides. Prepayment required. Slides usually duplicated to order. "Only the most popular slides are kept in stock." Orders shipped within three to six weeks, depending on the size of the order. Rush orders filled in seven to ten days; possible surcharge for special processing costs and/or express mail. Slides not sent on approval. Returns for exchange considered if quality of slide is deemed unsatisfactory. Special photography carried out at $12.00 per object, plus $2.00 each for details.
Other sources: Some single slides of objects in this museum's collection also offered by Burstein (30) and included in sets from the Dunlap Society (243).
Evaluation: Quality 3, documentation 3, service 3.

196 **Rodin Museum**
22nd and Benjamin Franklin Parkway
Box 7646
Philadelphia, PA 19101

Branch of the Philadelphia Museum of Art. No response to questionnaire. According to the *American Art Directory*, slides sold by museum shop. A few slides offered by Rosenthal Art Slides (76).

197 **Rose Art Museum**
Brandeis University
415 South Street
Waltham, MA 02154
(617) 647-2404

No response to questionnaire. Single slides offered by Burstein (30).

198 **St. Louis Art Museum**
Forest Park
St. Louis, MO 63110
(314) 721-0067, x66
attn: Resource Center, Department of Education

Profile: No response to questionnaire. Entry based on fourth edition. Approximately 4,000 color slide titles offered for sale.
Photography: Slides shot by both staff and commercial photographers.
Production: Duplicated on Ektachrome #5071 and processed by a local laboratory.
Documentation: Mailing list kept. Free brochure describing services. Catalog $3.00. Full information, except dimensions, supplied in catalog and with slides. Catalog thoroughly indexed. Some sets accompanied by audiocassettes.
Purchasing: Sets of 20 or more slides $15.00 to $25.00. Single slides available by special order, $1.00 each (1981).
Rental: Slides may be borrowed locally for educational use at no charge.
Other sources: Two sets to be released by University of Michigan Slide Distribution (252) in 1985: one hundred and thirty slides of American painting for $149.50 and 170 slides of European painting for $195.50. Slides of objects in this museum also offered by Burstein (30), F. G. Mayer (61), and the Dunlap Society (243).
Evaluation: Quality variable (1 to 3), documentation 3 to 4. "Museum may assume you wish to rent slides unless you make it very clear you wish to purchase them" (Norine Cashman).

199 **San Diego Museum of Art**
Balboa Park
P.O. Box 2107
San Diego, CA 92112
(714) 232-7931
attn: Museum Store

Profile: No response to questionnaire. Entry based on fourth edition. Slides offered of American and European painting, as well as of a few Oriental sculptures.
Photography: Slides shot in the galleries by a volunteer.
Production: Duplicated by a local laboratory. No attempt made to correct color or control contrast.
Documentation: Free list: artist and title only. Further information provided by curatorial department on request.
Purchasing: Slides sold singly, $1.25 each (1981). No returns accepted unless slides are defective.
Other sources: Slides of works in this collection included in Dunlap Society sets (243).
Evaluation: "Slides received in 1981 were poor duplicates, quite out of focus" (Norine Cashman).

200 **San Francisco Museum of Modern Art**
Van Ness Avenue at McAllister Street
San Francisco, CA 94102
(415) 863-2890
attn: Bookshop

Profile: No response to questionnaire. Entry based on fourth edition. Approximately 20 color slide titles offered of twentieth century paintings in the permanent collection.
Photography and production: Slides produced by Sandak (77).
Documentation: Free list; artist, title, and date provided. Slides labeled with full information.
Purchasing: Slides sold singly, $1.25 each. Discount of 20 percent given to libraries. Postage added ($2.00). Prepayment required. Same slides available from Sandak singly or as a set.
Evaluation: See Sandak (77).

201 **Santa Barbara Museum of Art**
1130 State Street
Santa Barbara, CA 93101
(805) 963-4364

No response to questionnaire. A set of 50 slides of the Preston Morton collection of American Art offered by Rosenthal Art Slides (76) for $75.00; single slides may be purchased. Works from this collection also included in sets from the Dunlap Society (243).

202 **Seattle Art Museum**
Volunteer Park
Seattle, WA 98112
(206) 447-4710

No slides sold by museum. Single slides offered by Burstein (30). Approximately 100 Chinese paintings and 500 Japanese paintings recently documented in slides by Asian Art Photographic Distribution (240).

203 **Shelburne Museum**
Route 7
Shelburne, VT 05482
(802) 985-3346
attn: Photographic Services

Profile: Duplicate color slides offered of objects in the permanent collection. American fine art, decorative art, folk art, and utilitarian objects featured. Some slides of architecture available. European fine and decorative arts also represented. New titles continually added.
Photography: Slides and 4-by-5-inch transparencies shot by staff photographer on Ektachrome or sometimes on Kodachrome in a studio.
Production: Duplicated on Kodak slide duplicating film by Lightworks, Burlington, Vermont. Color corrected and contrast controlled. Mounted in cardboard, plastic, or glass.
Documentation: No list available. Information provided with slides as requested.
Purchasing: Slides sold singly, $3.00 each when sold to nonprofit organizations ($4.00 each to others). Postage added ($2.00). No minimum order. Prepayment or purchase order required, unless credit has been established. Some slides kept in stock, others duplicated to order. Orders filled within three weeks. Rush orders accepted with 50 percent surcharge; sent within one to two weeks. Slides sometimes sent on approval by special arrangement. Special photography carried out at $10.00 (two-dimensional) or $15.00 (three-dimensional) per slide for nonprofit organizations. Prices for others $15.00 and $25.00, respectively. Minimum of three weeks required to fill special orders.
Evaluation: No information available.

204 **Smith College Museum of Art**
 Elm Street at Bedford Terrace
 Northampton, MA 01063
 (413) 584-2700, x2770
 attn: Archivist

Single slides offered by Burstein (30). Slides of works in this collection included in sets produced by the Dunlap Society (243). Slides sold directly by the museum on a limited basis as a service to scholars and students. All but serious inquiries are discouraged because the museum's policy is not to promote its slide sales as a "business."

205 **Snite Museum of Art**
 University of Notre Dame
 Notre Dame, IN 46556
 (219) 239-5466

Profile: Color slides (originals and duplicates) offered of works in the permanent collection.
Photography: Slides and 4-by-5-inch transparencies shot by independent professional photographers, usually on Kodak film.
Production: Duplicated by Slidecraft Laboratories. No attempt made to control contrast or correct color. Mounted in plastic.
Documentation: No list available. Slides keyed to information sheet. Orientation not marked.
Purchasing: Slides sold singly, $1.50 for a duplicate, $7.50 for an original. No minimum order. Slides usually shipped within two weeks. Postage added. Rush orders filled within one week. No returns accepted.
Evaluation: No information available.

206 **Spencer Museum of Art**
 University of Kansas
 Lawrence, KS 66045
 (913) 864-4710
 attn: Bookstore

Profile: Offers 76 color slides in two sets: Hiroshige prints of the Tokaido Road (51 slides) and quilts from the permanent collection (25 slides).
Photography: Slides shot by staff photographer on Ektachrome using Nikon camera and soft lights.
Production: Various producers have been used. As of 1984, slides duplicated on Ektachrome #5071. Future duplicates to be made by Reversal Systems Lab, Kansas City, Missouri. Color corrected and contrast controlled. Mounted in cardboard (Hiroshige set) or plastic (quilt set).
Documentation: Mailing list kept. Free brochure, revised annually. Identification sheet supplied with sets. Hiroshige set documented by exhibition catalog *Tokaido I*, sold separately for $8.50. Guidebook to Tokaido also offered for $2.00. List of quilt slides available from Publications Department.
Purchasing: Single slides $1.25 each (quilt set only, apparently). Hiroshige set $40.00, quilt set $25.00. Postage added. Discount of 20 percent given to libraries. Prepayment required from overseas. Duplicates kept in stock and shipped within three to four days. Rush orders filled within hours of receipt. No returns accepted. Special photography handled by curatorial offices.
Evaluation: No information available.

207 **Solomon R. Guggenheim Museum**
 1071 Fifth Avenue
 New York, NY 10028
 (212) 860-1313
 attn: Mail Order Department

Profile: No response to questionnaire. Entry based on fourth edition. Approximately 200 slide titles offered of modern European and American painting and sculpture in the permanent collection.

Photography: Four-by-five-inch transparencies shot by staff photographer, sometimes in studio, sometimes in galleries.

Production: Produced by Sandak (77).

Documentation: Free list; artist, title, date provided. Full information supplied with slides. Orientation marked.

Purchasing: Set of 20 slides sold for $10.00, set of 70 slides for $35.00; smaller set is included in larger set. Most slides in the sets may be purchased singly, and additional singles available. Ten slides of the architecture of the museum offered. Single slides $0.75 each, or $0.60 each for educational institutions. Postage added. Prepayment required. "We accept no returns."

Other sources: List of single slides of the permanent collection and exhibitions available from Sandak (77), including 234 slides of paintings and drawings, 42 of sculpture, 24 of Kandinsky woodcuts and watercolors, and 17 views of the architecture. Forty slides of Kandinsky paintings offered as a set. Another set of 70 slides (also sold singly) documents the 1976 Bicentennial Exhibition "Painting: 1880-1945." Single slides also offered by Burstein (30) and F. G. Mayer (61).

Evaluation: See Sandak (77). "When we ordered the large slide set in 1976, the museum took seven and a half months to fill our order" (Norine Cashman).

208 **Stanford University Art Gallery and Museum of Art**
Museum Way and Lomita Drive
Stanford, CA 94305
(415) 497-4177

Eleven slides offered by Rosenthal Art Slides (76), singly or as a set ($15.00). Titles listed in Volume 3 of catalog. Rosenthal slides sold in museum's bookstore, but no mail orders accepted. The two sets of drawings and prints that were formerly available from the Department of Art, Stanford University, have been discontinued, at least temporarily.

209 **Sterling and Francine Clark Art Institute**
225 South Street
P.O. Box 8
Williamstown, MA 01267
(413) 458-8109
attn: Sales Desk

Profile: No response to questionnaire. Entry based on fourth edition. Approximately 300 color slide titles offered of the permanent collection, which features nineteenth century painting, predominantly French. Some Renaissance and Baroque painting and nineteenth century sculpture included.

Photography: Slides shot by a commercial photographer in the galleries.

Production: Duplicated by World in Color on Ektachrome #5071.

Documentation: Free list; artist and title provided. Slides accompanied by full identifications, except medium and dimensions. Further information supplied on request.

Purchasing: Slides sold singly, $0.75 each. Postage added. Special photography carried out at $12.00 per original slide.

Evaluation: Quality 3, documentation 2, service 4.

210 **Storm King Art Center**
Old Pleasant Hill Road
Mountainville, NY 10953
(914) 534-3115

Sandak (77) offers 47 slides of twentieth century sculpture from the permanent collection. Sandak also offers 31 slides of works included in the 1973 exhibition "The Emerging Real." Both sets may be purchased in their entirety, or single slides may be selected.

211 **Terra Museum of American Art**
 2600 Central Park Avenue
 Evanston, IL 60201
 (312) 328-3400

Rosenthal Art Slides (76) offers 57 slides; listed in Volume 3 of catalog.

212 **Thomas Gilcrease Institute of American History and Art**
 1400 North 25 West Avenue
 Tulsa, OK 74127
 (918) 581-5311
 attn: Sales Desk

Profile: No response to questionnaire. Entry based on fourth edition. Offers 60 color slide titles of sculpture by Remington and paintings by Russell, Remington, and Moran.
Photography: Shot by staff photographer in the galleries.
Production: Produced by a commercial laboratory.
Documentation: Free list; artist and title provided.
Purchasing: Slides sold singly, $0.50 each, three for $1.25. Returns within 10 days accepted for exchange only.
Evaluation: No information available.

213 **Timken Art Gallery**
 Balboa Park
 San Diego, CA 92101
 (714) 239-5548

No response to questionnaire. Set of 38 slides offered by Sandak (77); Renaissance paintings featured.

214 **Toledo Museum of Art**
 Monroe Street at Scottwood Avenue
 P.O. Box 1013
 Toledo, OH 43697
 (419) 255-8000

Profile: Offers 3,000 color slides (mostly duplicates, some originals) of the permanent collection, with emphasis on ancient Greek vases. Slides of works in temporary exhibitions sometimes available for a limited time. New titles continually added (25 in 1984).
Photography: Slides shot by staff photographer on Ektachrome ASA 50 (pushed to 100). Items photographed in the gallery with existing light (skylight and spotlights).
Production: Duplicated by Kodak, Findlay, Ohio. Color corrected and contrast controlled. Mounted in cardboard or in Gepe mounts with anti-Newton ring glass.
Documentation: No general list available. Consult published catalogs of the museum's collections of American paintings, European paintings, and glass. List and addenda offered of slides of Greek, Etruscan, and Roman art. No information provided about subjects depicted on vases, but museum accession number given. Also, no dimensions provided on list. Slides labeled. Orientation marked.
Purchasing: Slides sold singly and in sets. No minimum order. Slides $2.50 postpaid, $3.50 to customers outside the continental United States. Slides kept in stock and shipped within 10 days. Rush orders filled within three days; no surcharge. Slides not sent on approval. No returns accepted. ("We have never had a return.") Slides made to order within two weeks, $2.50 each. Slides produced by Rosenthal Art Slides (76) and the University of Michigan Slide Distribution (252) sold by the museum as well.
Other sources: Rosenthal Art Slides (76) offers 40 slides of painting, sculpture, and decorative arts. Sandak (77) offers 150 slides sold singly or as a set, including 27 slides of glass. Set of 200 slides, including many details, available from the University of Michigan Slide Distribution (252).
Evaluation: Only one advisor able to rate (Sara Jane Pearman): quality 2, documentation 2, service 2.

215 **Triton Museum of Art**
1505 Warburton Avenue
Santa Clara, CA 95050
(408) 247-3754

Profile: Approximately 200 color slide titles offered of the permanent collection and temporary exhibitions. Twentieth century American art and international folk art emphasized. New slides continually added.
Photography: Slides shot by staff photographer on Ektachrome ASA 160.
Production: Duplicated on Ektachrome by Process Techniques.
Documentation: No list available. Slides labeled. Orientation not marked.
Purchasing: Slides sold singly and in sets. Minimum order five slides. Priced $1.00 each. Postage added. Prepayment required. Slides not sent on approval, and no returns accepted. Slides duplicated to order and shipped within one month. No rush orders accepted. No special photography undertaken.
Evaluation: No information available.

216 **University Art Museum**
University of California, Berkeley
2626 Bancroft Way
Berkeley, CA 94720
(415) 642-1207
attn: Registration Office

No response to questionnaire. Entry based on 1980 order. Duplicate slides sold singly at $1.50 each. Postage added. Orders invoiced. List of 48 paintings by Hans Hofmann available, giving full information. "Most of the Hofmann slides purchased by Brown University were of good quality" (Norine Cashman).

217 **University Museum**
University of Pennsylvania
33rd and Spruce Streets
Philadelphia, PA 19104
(215) 898-4040
attn: Shop

Profile: Approximately 500 color slide titles offered of the permanent collection, representing objects that are important artistically or as anthropological or archaeological evidence. Sets available include "Excavations at Hasanlu, Iran: A Ninth Century B.C. Mannaean Fortress" (23 slides), "Tikal" (30 slides), "Art of the Ancient Maya" (objects from the National Museum in Guatemala City—33 slides), and "Islamic Ceramic Art" (33 slides). New slides to be added in the future.
Photography: Slides shot by staff photographers.
Production: Duplicated from duplicates. Mounted in cardboard.
Documentation: Catalog $2.00. Identifications consist of description of items (often including materials), place of origin, and date. Slides labeled. Sets accompanied by lecture notes.
Purchasing: Slides sold singly and in sets. Single slides $0.50 each. Discount of 10 percent given on more than 100 slides. Discount not applicable to set prices. Postage included. Prepayment required. Slides kept in stock and shipped within one week. Rush orders accepted; surcharge of 50 percent. Slides not sent on approval. Returns considered. Special photography handled by Photographic Archives ([215] 898-6720); request brochure with price list.
Other sources: Single slides also offered by Burstein (30).
Evaluation: No information available.

218 **University of Oklahoma Museum of Art**
 410 West Boyd Street
 Norman, OK 73019
 (405) 325-3272

No response to questionnaire. Single slides offered by Burstein (30).

219 **Vassar College Art Gallery**
 Raymond Avenue
 Poughkeepsie, NY 12601
 (914) 452-7000

No response to questionnaire. Entry based on a 1985 order. Single slides available on request, $3.50 each. Prepayment required.

220 **Virginia Museum of Fine Arts**
 Boulevard and Grove Street
 Richmond, VA 23221
 (804) 770-6344
 attn: Council Sales Shop

Profile: No response to questionnaire. Entry based on fourth edition. Museum offers slides.
Purchasing: Slides sold singly, $0.50 each. Postage added.
Other sources: Single slides also offered by Burstein (30).
Evaluation: No information available.

221 **Wadsworth Atheneum**
 600 Main Street
 Hartford, CT 06103
 (203) 278-2670
 attn: Slides

Profile: Offers 71 color slide titles of highlights of the permanent collection. American and European paintings and decorative arts featured. New titles occasionally added.
Photography: Four-by-five-inch transparencies shot on Ektachrome by an independent professional photographer.
Production: Duplicated on Kodachrome by Kew Lab, Norwalk, Connecticut. Color corrected and contrast controlled.
Documentation: Mailing list kept. Free list, annually updated. Identifications consist of artist, title, date, medium, and accession number. Slides keyed to list. Orientation marked.
Purchasing: Slides sold singly, $2.00 each. Discount of 10 percent given to educational institutions, museums, and libraries. Postage of $1.50 added for 10 slides, plus $1.00 for each additional 10 slides. Prepayment required. No minimum order. Slides shipped within four weeks. No rush orders accepted. Slides not sent on approval, and no returns accepted. Special photography undertaken; charge of $15.00 to shoot a new original, $5.00 to make a duplicate from an existing slide.
Other sources: Single slides also offered by Burstein (30) and F. G. Mayer (61).
Evaluation: Based on samples sent: photography of three-dimensional objects excellent; soft definition noted on three slides of paintings. Service slow. "Excellent quality, but information is deficient" (Mark Braunstein).

222 **Walker Art Center**
 Vineland Place
 Minneapolis, MN 55403
 (612) 377-7500
 attn: Slide Library

Profile: No response to questionnaire. Entry based on fourth edition and 1982 brochure. Offers 150 slides of twentieth century European and American sculpture, painting, photography, and graphic arts.
Photography: Slides and large-format transparencies shot by staff photographer on Ektachrome ASA 64 in studio.
Production: Duplicated by a commercial laboratory. Color corrected and contrast controlled.
Documentation: Free list. Artist, title, date, and museum accession number provided. Medium indicated on slide labels. Further information available on request.
Purchasing: Slides sold singly, $1.50 each. Postage added. "Should any slide fail to meet your standards, we will accept its return if sent back within 10 days of receipt."
Evaluation: No information available.

223 **Walters Art Gallery**
600 North Charles Street
Baltimore, MD 21201
(301) 547-9000
attn: Museum Shop

Profile: No response to questionnaire. Entry based on fourth edition. Some 1,000 color slides (originals or duplicates) offered of the permanent collection: sculpture, painting, manuscripts, and decorative arts from the ancient Near East through the nineteenth century, including Oriental art.
Photography: Slides shot by staff photographer in the galleries or a studio.
Production: Some slides produced by Rosenthal Art Slides (76) on Ektachrome #5071. Others duplicated by a local laboratory on Kodachrome.
Documentation: Free lists. Not all items listed are kept in stock. Slides labeled. Further information available on request.
Purchasing: Rosenthal-produced slides may be ordered from Rosenthal or the museum: one hundred slides of jewelry, 46 slides of nineteenth century painting, and 192 slides of Alfred Jacob Miller watercolors. Other slides sold by the museum are $2.50 for an original, $1.00 for a duplicate. Sets also offered. No discounts. Postage added. Prepayment required. No returns accepted. Special photography handled by Photographic Services. Slides in the Education Department's collection may be duplicated to order, each $2.50.
Other sources: Single slides also offered by F. G. Mayer (61).
Evaluation: Four-star rating in the fourth edition. See also Rosenthal Art Slides (76).

224 **Washington University Gallery of Art**
Steinberg Hall
P.O. Box 1189
St. Louis, MO 63130

No response to questionnaire. Single slides available from Burstein (30).

225 **Wellesley College Museum**
Wellesley, MA 02181
(617) 235-0320

No response to questionnaire. Single slides available from Burstein (30).

226 **Whitney Museum of American Art**
945 Madison Avenue
New York, NY 10021
(212) 794-0600
attn: Sales Desk

Profile: No response to questionnaire. Entry based on fourth edition. Offers 81 color slides of works in the permanent collection. Slides of special exhibitions sometimes available.

Photography: Shot by a commercial photographer in the galleries.
Production: Produced by Sandak (77).
Documentation: Free list; artist, title, date, and medium provided. Full information, except artist's dates, included on slide labels. Further information available on request. Orientation marked.
Purchasing: Slides sold singly, $0.75 each. Postage added. Prepayment required on orders totaling less than $25.00. No returns accepted. No special photography undertaken.
Other sources: Many slides offered by Sandak (77). Listed in "Slides From the Permanent Collection and Exhibitions of the Whitney Museum of American Art, New York," available free from Sandak. Slides of works in the annual and biennial exhibitions since 1970 available in sets or singly. Single slides also offered by Burstein (30). Craft exhibitions documented by the American Craft Council (235).
Evaluation: See Sandak (77).

227 **Wichita Art Museum**
 619 Stackman Drive
 Wichita, KS 67203
 (316) 268-4621

No response to questionnaire. According to the fourth edition, 10 Sandak slides sold by the museum of American paintings in the Roland P. Murdock collection. Slides sold singly, $0.50 each. Artist and title provided on list.

228 **Winterthur Museum**
 Route 52
 Winterthur, DE 19735
 (302) 656-8591, x201 or x288
 attn: Photographic Services or Slide Library

Profile: Several thousand color slide titles offered by Photographic Services of exterior views, room installations, museum objects, and two historical houses and their furnishings in Odessa. Color slides (originals and duplicates) also offered by the Slide Library of rare books and manuscripts dealing with architecture and the decorative arts. New slides continually added to Photographic Services offerings (500 in 1985).
Photography: Slides shot by staff photographers. Ektachrome used by Photographic Services, Kodachrome by the Slide Library.
Production: Photographic Services slides duplicated on Ektachrome #5071 by Chan Davies Photo Lab, Wilmington, Delaware, or Visual Media (91); mounted in plastic. Slide Library slides duplicated on Ektachrome by Chan Davies or, occasionally, by Tri Color.
Documentation: No list available of Slide Library slides. "We will take orders for any library material as long as it is not too fragile." Approximately 30 lists available from Photographic Services; a few are free, but $1.00 to $2.00 each charged for most (request price list). Orientation not marked on slides from either source. Photographic Services slides keyed to lists. Captions on Slide Library slides available on request.
Purchasing: Photographic Services slides sold singly and in sets. Slides $2.50 each, plus postage. No minimum order. Prepayment required from customers previously delinquent in paying. Some duplicates kept in stock; others must be made to order. Slides shipped within two weeks. Rush orders accepted if slides are in stock, and slides sent next day; surcharge of $5.00. Slides not sent on approval, and no returns accepted. Special photography undertaken after priority work completed; charge of $15.00 for new slides. Allow six weeks minimum for delivery. Slide Library slides sold singly, $2.50 (original or duplicate) when sold to nonprofit organizations, $1.50 to students. No minimum order. Extra originals kept in stock; duplicates made to order. Time required to fill orders varies; rush orders accepted. Prepayment required. Slides not sent on approval. Returns accepted rarely—only when a mistake was made in filling order.
Exchange: Slide Library is willing to arrange exchanges of originals or duplicates.
Evaluation: Photographic Services slides: quality variable (2 to 4), documentation 3, service 3. Only one advisor able to rate Slide Library slides (Sara Jane Pearman): quality 2, documentation 3, service 3.

229 **Worcester Art Museum**
 55 Salisbury Street
 Worcester, MA 01609-3196
 (617) 799-4406, x230
 attn: Coordinator of Photographic Services

Profile: Offers 60 color slide titles of masterworks in the permanent collection. American and European painting emphasized. Some 50 slides to be added in 1984-85. New titles will be offered of Roman mosaics from Antioch; classical sculpture; Asiatic ceramics, painting, metalwork, and sculpture; American decorative arts; and early French stained glass, ivories, and sculpture. Limited edition set of 16 slides available ($21.00 postpaid) of the 1984 loan exhibition "The Collector's Cabinet: Flemish Paintings from New England Private Collections."

Photography: Originals (mostly 4-by-5-inch transparencies, some 35 mm slides) shot by staff photographer on Ektachrome #6118 professional tungsten film or on Kodachrome #5070 ASA 40. Four-by-five-inch view camera used with quartz lights, polarizers, and color-correction filters when necessary.

Production: Duplicated by Industrial Color Laboratory, Framingham, Massachusetts, on Ektachrome #5071. Color corrected and contrast controlled. Mounted in plastic. Slides not on list duplicated by the Kodak laboratory in Rochester and mounted in cardboard.

Documentation: Mailing list kept. Free list and addenda. Full information given (dates often lacking). Slides labeled. Orientation not marked.

Purchasing: Slides sold singly, $2.00 each. Postage added. No discounts. No minimum order. Prepayment preferred. Sets to be made available in 1985. Slides on list kept in stock and shipped within one week. Rush orders filled within one to two days; no surcharge. Slides not sent on approval. Returns accepted only if slide is defective. Original slides available by special order, $18.00 each; allow two to four weeks for delivery.

Rental: Slides may be rented (*in person only*) from the Slide Library.

Other sources: Single slides also offered by Burstein (30). Set of 43 slides (all paintings) offered by Sandak (77), as a set or singly.

Evaluation: Quality 3, documentation 3 to 4, service 3 to 4. "Marked improvement recently in quality, documentation, and service" (Norine Cashman). "Very helpful when we last ordered" (Helen Chillman).

230 **Yale Center for British Art**
 1080 Chapel Street
 Box 2120 Yale Station
 (203) 436-3920
 attn: Museum Shop

Profile: Offers 100 color slide titles of the permanent collection—British art from the Elizabethan period onward. Also, six slides available of the museum building by Louis Kahn. New slide titles to be added in the future.

Photography: Four-by-five-inch transparencies shot by staff photographer in studio.

Production: Produced by Sandak (77). Mounted in cardboard.

Documentation: Free list; artist's name and title of work provided. Slides labeled with full information. Orientation marked.

Purchasing: Slides sold singly, $1.95 each for up to 10 slides. If more than 11 slides ordered, $1.50 each. Postage added. Architectural slides also sold as a set: six for $5.75. No minimum order. Prepayment required from overseas and from all noninstitutional orderers. Slides kept in stock and shipped within two weeks. Rush orders filled within two days if slides are in stock. Express mail charges added to customer's cost. Slides not sent on approval. Returns accepted only if damaged in shipment. Special photography (original slides or duplicates) handled by Registrar; cost varies.

Other sources: Set (91 slides) offered by Sandak (77) for $160.00.

Evaluation: See Sandak (77).

231 **Yale University Art Gallery**
 1111 Chapel Street
 Box 2006 Yale Station
 New Haven, CT 06520
 (203) 436-0574
 attn: Sales Desk

Profile: Approximately 100 color slide titles offered of selected items (painting, sculpture, decorative arts) from the permanent collection.
Photography: Four-by-five-inch photography (transparencies or negatives) carried out mostly by staff photographer, sometimes by Sandak's photographer. Objects photographed in studio, usually on Ektachrome.
Production: Produced by Sandak (77). Mounted in cardboard.
Documentation: Free list of 83 items; only artist's name and title of work provided. Slides labeled with full information. Orientation marked.
Purchasing: Slides sold singly, $1.00 each. Discount of 20 percent given to educational institutions. Postage added. No minimum order. Prepayment required from new customers. Slides kept in stock and shipped within 24 hours. Slides not sent on approval, and no returns accepted. Special photography handled by Rights and Reproductions Department.
Other sources: Same slides available from Sandak (77), plus 35 more. Cost and time to ship vary. Single slides offered by Burstein (30), and slides of works in this museum included in Dunlap Society (243) sets.
Evaluation: See Sandak (77).

OTHER INSTITUTIONS

232 **American Association for State and Local History**
 708 Berry Road
 Nashville, TN 37204
 (615) 383-5991

Profile: No response to questionnaire. Entry based on catalog issued in summer 1984. Nine slide/tape training programs, oriented toward personnel in historical societies and museums, offered for sale. Titles include "The Victorian House: Identification and Conservation," "Identification of Nineteenth-Century Domestic Lighting," and "Beds, Bedding, and Bed Hangings." Total of 700 slides available.
Documentation: Free brochure. Cassette tape (20 minutes) and script included with each set.
Purchasing: Sets of 70-80 slides $44.50 per set. Price for members of AASLH discounted to $40.00 per set. Rental of programs is no longer possible.
Evaluation: "Victorian House" set recommended by Elizabeth Alley. Otherwise, insufficient information to rate this source.

233 **American Classical League**
 Miami University
 Oxford, OH 45056
 (513) 529-4116

Profile: Four sets (100 color slide titles) offered: "Ancient Rome," "Roman Forum," "Pompeii," and "Ancient Athens."
Photography: Slides shot by William M. Seaman, in whose possession the originals reside.
Production: Duplication handled by William Seaman, who supplies slides to the American Classical League. According to the fourth edition of this guide, slides duplicated by World in Color on Ektachrome #5071.
Documentation: Free catalog, issued annually; set titles listed. Slides labeled.
Purchasing: Each set of 25 slides $13.20, plus shipping via United Parcel Service ($2.70). Prices discounted 10 percent for ACL members if order is prepaid. Sets shipped on day of receipt. Returns accepted for refund if slides are damaged.
Evaluation: No information available.

234 **American Committee for South Asian Art**
 South Asian Studies
 Davidson College
 Davidson, NC 28036
 (704) 892-2000, x352
 attn: Prof. I. Job Thomas, Project Coordinator

 or

 Color Slide Project
 202A Tappan Hall
 University of Michigan
 Ann Arbor, MI 48109
 (313) 763-0517 or 764-5400
 attn: Walter M. Spink, Director

Profile: No response to questionnaire. Entry based on fourth edition plus 1985 ACSAA catalog. Project established in 1974 to document art and architecture of India, Nepal, Tibet, Sri Lanka, Burma, and Indonesia. Production and distribution supported by grants from the National Endowment for the Humanities, Ford Foundation, Asian Cultural Council, Southeast Asia Art Foundation, and individuals. All but five sets still available. Five new sets issued annually.
Photography: Photographic team now led by Dr. Suresh Vasnat of Pune, India. Some original slides available for purchase at no additional cost.
Production: Duplicated from master originals after inventory of originals is depleted.
Documentation: Free catalog, revised annually. Some sets accompanied by booklets. Label information imprinted on mounts (since 1982) or provided on self-adhesive labels. Identification extensively detailed.
Purchasing: Sets of 100 slides $125.00 (United States) or $130.00 (foreign), postpaid. Add $10.00 per set if special handling required on foreign orders. Special discounts given to advance subscribers. Any five sets (or more) from prior years discounted 10 percent. Prepayment or purchase order required. Address orders to North Carolina address. Orders of back issues shipped within two weeks. New sets issued in March. "Any subscriber dissatisfied with the slides may receive a refund upon return of the slides within 60 days."
Evaluation: "On the whole, very good slides, especially considering that some were shot under adverse conditions" (Sara Jane Pearman).

235 **American Craft Council**
 Slide and Film Department
 401 Park Avenue South
 New York, NY 10016
 (212) 869-9422
 attn: Nancy Libas, Manager

Profile: Craft exhibitions documented for 25 years. More than 100 slide sets offered for purchase (not rental) of works in the permanent collection of the American Craft Museum and of special exhibitions there and elsewhere. Craft techniques featured in some sets, work of individual craftsmen in others. New set titles continually added (five to ten in 1984). Also, filmstrips sold and films sold or rented.
Photography: Originals (mostly slides, but some 4-by-5-inch transparencies as well) shot 90 percent by independent professional photographers. Remainder supplied by artists. "Depending on the type of work being photographed and the location of the photo sessions, we use either Kodak 64 professional film EPR with strobes or tungsten professional film 50 ASA with photofloods."
Production: Duplicated on Ektachrome #5071 or printed from negatives on Eastmancolor #5384. In the latter case, ECP-2A processing used. Produced by Color Film Corporation, Boston. Color corrected and contrast controlled. Mounted in cardboard. One set each produced by Van Nostrand Reinhold (Ikat Batik) and the Smithsonian Institution (American Porcelain).
Documentation: Mailing list kept. Free catalog issued annually. Slides keyed to printed descriptive notes accompanying each set. Orientation marked by number placement.
Purchasing: Sets only, usually priced on basis of $1.70 per slide. Subscription offered to slides of works featured on *American Craft* magazine's "Portfolio" pages. These slides issued bimonthly at per-slide cost

of $1.50, totaling 170 slides for $250.00. Prices discounted 10 percent for ACC members. Postage included in prices. Prepayment required on foreign orders and noninstitutional orders. Purchase orders required from institutions. Limited inventory kept. Orders usually shipped within two to four weeks. Rush orders accepted if items in stock; no surcharge unless customer requests shipment by Federal Express. Returns and exchanges usually not permitted unless slides are technically flawed. Sets not sent on approval, but one sample slide per set, plus text, will be sent for examination.

Other sources: Sound filmstrips based on 10 slide kits (oriented toward the junior/senior high school market) distributed by Crystal Productions, Box 12317, Aspen, CO 81612.

Evaluation: Quality 3 to 4, documentation 3 to 4, service 3 to 4. "Prompt, efficient service. Slides of objects are sensitively photographed and accompanied by good documentation" (Nancy Kirkpatrick). "Excellent slides—the original photography is good, the duplicates are good, the selections in sets are good" (Mark Braunstein).

236 **American Institute of Architects**
 1735 New York Avenue, N.W.
 Washington, DC 20006
 (202) 626-7332
 attn: Customer Service

Profile: No response to questionnaire. Entry based on fourth edition, updated by telephone call and recent brochure. Seven sets, comprised of 48-80 slides each, offered on architectural topics: "Adaptive Use," "Celebrating American Architecture," "Environments for People," "How Architecture Speaks," "Reaching for the Sun," "Saving Energy by Design," and "What Do They Have in Common?" (American architecture designed by women).

Documentation: Each set accompanied by lecture text prepared by Public Relations Department.

Purchasing: Slides sold in sets only. Prices range from $18.00 to $22.00. Prepayment required.

Rental: More than 16,000 slides in AIA Slide Library available for rental only, to AIA members only.

Evaluation: No information available.

237 **American Numismatic Association**
 818 North Cascade
 Colorado Springs, CO 80903
 or
 P.O. Box 2366
 Colorado Springs, CO 80901

Profile: Slides available for rental only, to ANA members only, "for use as educational programs at club meetings or for educational presentations to schools and civic groups." Offers 80 sets of various sizes in current catalog. Coins of many countries and time periods represented. New sets announced in *The Numismatist.*

Production: Fifteen sets obtained from B. A. Seaby, Ltd., London, England. Other sets apparently produced by ANA. Slides glass-mounted for circulation.

Documentation: Free catalog: "Visual Education Library List." Sets accompanied by lecture notes with description of each slide.

Rental: Exact date of use must be specified on request. Listing of alternate selections recommended. ANA membership number and club name required on all requests and correspondence. Address requests to post office box listed previously. Slides shipped via United Parcel Service, and return via United Parcel Service preferred. Return slides to street address listed previously.

Evaluation: No information available.

238 **American Numismatic Society**
 Broadway at 155th Street
 New York, NY 10032
 (212) 234-3130

Profile: Questionnaire not returned, but current brochure sent instead. Six slide sets offered of coins in the Americas, ancient Greece, Colonial America, ancient Rome, and Islamic countries, as well as one of medallions in ancient Rome. Byzantine set out of print.

Production: According to the fourth edition, GAF slides (42).

Documentation: Free publications list. Sets accompanied by booklets with commentary and identification for each slide. Audiotape included with two sets.

Purchasing: Priced from $9.95 to $39.00 for sets of 24-41 slides. Discounts offered to libraries. Prepayment required when ordering directly from ANS. Postage of $1.00 added for the first item and $0.25 for each additional item (United States); postage of $1.50 added for the first item, $0.25 for each additional item (other countries).

Evaluation: See GAF (42).

239 **Artpark Publications**
 P.O. Box 371
 Lewiston, NY 14092
 (716) 745-3377

Profile: Sets of duplicate color slides issued annually since around 1974, documenting works by contemporary artists at this New York state park. "The Artpark slide presentations correspond to the Visual Arts Program publications and provide a more in-depth study of each work of art. Process is emphasized wherever possible to allow the student a greater understanding and technical knowledge." Set of 75-100 new slides issued annually.

Photography: Slides shot 50 percent by staff photographer, 50 percent by participating artists. Film types vary.

Production: Duplicated by Kodak. Mounted in cardboard.

Documentation: Mailing list kept. Free brochure, updated each spring. "Printed descriptive notes accompany each set and a copy of the publication for the appropriate year is included." Slides keyed to notes. Identification consists of artist, title, date.

Purchasing: Slides sold in sets only. Set sizes vary (45-90 slides). Prices listed in brochure; per-slide cost roughly $1.40. Postage included in prices. Prepayment required on foreign orders. "All orders must be in writing and include the name, address, and telephone number of a contact person. . . . Institutional orders should include a purchase order and tax exemption number, if applicable. Cancellation of confirmed orders must be received at least one week prior to shipping date. Invoices are payable on receipt." Duplicated to order and shipped within three to four weeks. Rush orders filled in approximately two weeks; no surcharge. Slides not sent on approval. Returns accepted, however, within five days of receipt for exchange or refund.

Rental: Rentals also available within the United States. Terms: "All rental orders should be presented in writing at least one month in advance of the desired use date. When sending orders, customers are requested to list preferred and alternate dates. The rental period will begin with the scheduled use date. Returning presentations should be received by Artpark within 12 days of the scheduled use date. The rental fee will be deducted from a subsequent purchase price, if requested on the purchase order."

Evaluation: Quality 3 to 4, documentation 3, service 3 to 4. "Each work is represented by at least one slide in progress and one completed piece. Catalog accompanies slide set. . . . Dimensions and media need to be gleaned from the script. . . . Catalog includes artists' statements" (Marybeth Koos).

240 **Asian Art Photographic Distribution**
 Department of the History of Art
 University of Michigan
 Ann Arbor, MI 48109-1357
 (313) 764-5555
 attn: Wendy Holden

Profile: Established 1970. Duplicate color slides of Chinese and Japanese art offered. At present, 10 sets comprised of approximately 3,250 slides are available. Many special exhibitions documented, as well as the permanent collection of the National Palace Museum, Taiwan. Private collections (Hobart, Crawford,

Shinenkan, Sanso) also covered. Sets documenting the collections of the Metropolitan Museum in New York and the Seattle Art Museum to be issued in the near future. Cleveland Museum of Art set recently reissued. New titles continually added. Black-and-white photographic prints and larger format color transparencies also offered.

Photography: Majority (85 percent) of slides shot on Ektachrome by Patrick Young, History of Art staff photographer at the University of Michigan, using Nikon camera and lenses on copystand. Other slides (15 percent) shot by scholars or obtained from foreign sources.

Production: Duplicated on Ektachrome #5071, at present by Meteor Photo Company, Troy, Michigan. Color corrected and contrast controlled. New stock mounted in plastic, older stock in cardboard.

Documentation: Mailing list kept. Free catalog (in English), revised annually. Slides keyed to identification list, which includes artist, dates, format, media, and dimensions. Orientation marked on older stock by placement of number. Orientation not marked on new stock.

Purchasing: No minimum order, although slides sold primarily in limited-edition sets at per-slide cost of $1.15. "Payments may be budgeted over a two-year period if arrangements are made at the time of the placement of the order." Within the United States, orders shipped by United Parcel Service at no additional cost. Charge of $5.00 added to Canadian orders, $7.50 to foreign orders (surface mail). Single slides available by special order, $2.50, with quantity discounts to $1.25 per slide. Slides kept in stock until depleted; usually not reissued. Orders shipped one day after receipt. Slides duplicated on request (i.e., by special order) and shipped within one to six weeks, depending on size of order. Telephone placement of special orders preferred. Prepayment required on some foreign orders. Slides not sent on approval. Returns accepted for exchange when there are "obvious defects in the slides due to oversight on the part of our staff." Also, if customer finds any set unsatisfactory, "the slides may be returned for replacement or refund within 60 days of the receipt of the goods."

Evaluation: Quality 3 to 4, documentation 3 to 4, service 3 to 4. Twelve samples sent: dust on original slides clearly visible on several duplicates, but quality otherwise well above average.

241 **Biblical Archaeology Society**
 3111 Rittenhouse Street, N.W.
 Washington, DC 20015

No response to questionnaire. Information supplied by an advisor, who last ordered at the end of 1981. Slides offered of architectural monuments and archaeological sites of the Holy Land.

242 **Columbus Area Chamber of Commerce**
 Visitors' Center
 506 Fifth Street
 Columbus, IN 47201
 attn: Graziela Bush, Director

Profile: No response to questionnaire. Information provided by the manager of ArchiCenter, Chicago. Slides offered for sale in the shop at the Visitors' Center, depicting buildings designed by major architects of the twentieth century.

Photography and production: No data provided other than that these slides were recently produced (1984).

Purchasing: Mail order sales implied but not verified.

Evaluation: No information available.

243 **Dunlap Society**
 Lake Champlain Road
 Essex, NY 12936
 (518) 963-7373
 attn: Isabel Barrett Lowry

Profile: Established 1974 to document American art and architecture, especially to produce materials not previously available such as architectural drawings and architectural details. Funded initially by the National Endowment for the Humanities. Exhibitions of American art covered such as "American Light:

The Luminist Movement" (1980), "American Impressionism" (1980), and "200 Years of American Painting" (1981), among others. "Architecture of Washington, D.C." offered in two volumes, 100 slides each plus microfiche and extensive documentation. As of 1984, 12 sets available (1,050 slides), plus 4,500 from "Architecture of Washington, D.C." Six new sets per year planned from 1985 onward.

Photography: Originals of architecture shot with 4-by-5-inch view camera. Paintings photographed on copystands in museum photographic studios, also in 4-by-5-inch format, with color and gray scales included. All color originals shot on Ektachrome by professional photographers; exhibitions photographed by museum staff photographers.

Production: Color slides produced on Ektachrome #5074, black-and-white on Panatomic-X reversal film at Essex Studios, Essex, New York. Color corrected and contrast controlled. Slides mounted in cardboard.

Documentation: Mailing list kept. Free brochure, revised semiannually. Slides labeled with full identification. Orientation marked.

Purchasing: Set prices listed in brochure, ranging from $50.00 to $150.00; per-slide cost slightly more than $1.00. Postage of $5.00 added per sent. Single slides offered from the architectural series only, $2.00 each. Minimum order $25.00. Prepayment required from individuals. Slides kept in stock, and orders filled promptly. Rush orders filled if slides in stock. Special orders requiring restocking carried out on request, surcharge to be determined by size of order. Orders on approval discouraged, but if necessary will be sent after receipt of $5.00 charge. Returns accepted for exchange or refund if quality is not satisfactory.

Evaluation: Quality 4, documentation 4, service 4. "Low prices for high-quality sets of 'out-of-the-ordinary' American art" (Nancy Kirkpatrick). "These have been among our most frequently used slides" (Elizabeth Alley). "MORE, MORE, MORE!" (Helen Chillman). Reviewed by Ada Louise Huxtable in the *New York Times*, July 20, 1980.

244 **FACSEA**
Society for French American Cultural Services
and Education Aid
972 Fifth Avenue
New York, NY 10021
(212) 570-4400

Profile: No response to questionnaire; entry based on recent brochure. Slide program resumed in 1983-84 after suspension due to budget cuts. Offers 55 sets (992 slide titles) on topics concerning French civilization, including art and architecture.

Production: Slides produced by the Centre National de Documentation Pédagogique, Paris.

Documentation: Free one-page sheet listing set titles in French. Each set accompanied by booklet and some by one or two records as well (presumably in French).

Purchasing: Sets composed of 12-24 slides, priced from $11.00 to $21.00 each.

Evaluation: No information available.

245 **Foundation for Latin American Anthropological Research
(FLAAR)**
6355 Green Valley Circle, #213
Culver City, CA 90230
(213) 649-2613 (evenings or weekends)
attn: Nicholas Hellmuth or Frank Comparato, Manager

Profile: Offers 23,000 color slide titles, mostly originals, of pre-Columbian art and archaeology, with strengths in Maya architecture and funerary ceramic art. Unpublished Maya material from private collections and museums featured. Holdings of major Canadian, United States, British, and European museums represented, and the entire Maya collection of the Museo Popol Vuh, Guatemala City, covered. Photographic prints from negatives of same subjects offered as well. Reproduction rights available for black-and-white and color images. "We are mainly interested in providing special, personalized service, documentation, and photographs to a small number of individuals and institutions who understand and appreciate the Mesoamerican subject matters that we feature." Included among standing-order clients are

National Geographic Society, Dumbarton Oaks, Yale University, Dallas Museum of Fine Arts, University of Texas at San Antonio, University of British Columbia, and Brigham Young University.

Photography: All originals and negatives shot by N. Hellmuth, art historian. Leica equipment with Leitz lenses used for 35 mm work, Hasselblad EL/M with Zeiss close-up lenses for 2¼-by-2¼-inch work, and Linhof camera for 4-by-5-inch work. Kodachrome and Ektachrome professional films used for all color transparencies. "FLAAR has portable studios permanently stationed in Europe, the United States, and Central America." Aerial views of Maya architecture taken with motorized Leica camera mounted on gyroscopic stablilizer in a helicopter.

Production: When stock of originals is exhausted, duplicates made in-house on Kodak film. "We are now in the process of selecting a professional duplication laboratory. . . . Duplicates will be color and contrast controlled." Mounted in cardboard. Glass-mounting optional, at cost of $5.00 per slide.

Documentation: Frequent contact maintained with standing-order clients. Free lists of series titles offered. Slides labeled in English, Spanish, German, or French to suit customer preference. Extent of identification negotiable. "We presume that anyone ordering from FLAAR will already know something about pre-Columbian subjects, or we will be glad to work with them in a training and cataloging program on an individual basis. Such training and personalized attention is provided to any museum, library, or institution that orders a set of the entire archive."

Purchasing: Slides sold until depleted; duplicates may be available thereafter. Slides offered in groups (not rigidly defined sets) at prices ranging from $2.00 to $5.00 each. Minimum order usually $300.00. Aerial views priced $30.00 to $50.00 each. Hasselblad color transparencies (2¼-by-2¼-inches) priced $20.00 to $100.00 each, depending on intended use. Single slides rarely sold, and prices for these reflect search time required. Search time charged at $10.00 per hour on all but very large orders. Postage and insurance added to prices. Prepayment required except from standing-order clients. Orders filled three times annually. "We are slow in order fulfillment because only one individual can search for the particular slides wanted, and that individual is often away on other assignments." Orders for entire archive given special treatment. Requests for rush orders accommodated if possible. Samples personally presented to potential customers considering a large order (more than 1,000 slides). Slides never sent on approval, and returns not accepted unless more than one slide of same view sent by mistake. Visitors to archive welcome by appointment to assist in making selections.

Evaluation: "Excellent quality, exhaustive coverage" (Helen Chillman).

246 Islamic Teaching Materials Project
c/o Prof. Herbert L. Bodman, Jr.
554 Hamilton Hall, 070A
University of North Carolina
Chapel Hill, NC 27514
(919) 962-2115

Profile: A set of 600 duplicate color slides entitled "Islamic Art and Architecture" to be offered for sale in 1985 or 1986. Slides and documentation compiled by Professor Ulku Bates of Hunter College. "The slides are organized along broad historical and regional lines from the earliest Islamic monuments to the present and from southeast Asia to western Africa. Furthermore, there are topical categories of medium, technique, and function to provide the user a substantial degree of flexibility in selection. The choice of monuments to include was determined by representational criteria, availability of supplementary literature, and availability of the original works in U.S. museums. Thus, many of the slides are of objects in the Metropolitan Museum of Art and the Freer Gallery. Breadth of representation was sacrificed to depth in well-known monuments or objects. The set is thus designed for use more by the nonspecialist than the specialist in Islamic art."

Photography: No data provided, except that 600 35 mm slides are assembled and ready for production.

Production: To be determined; perhaps Rosenthal Art Slides (76).

Documentation: Project described among others in a brochure available from Professor Bodman. Slides to be accompanied by full documentation: introductory text, glossary, bibliography, slide-by-slide commentary, and identification labels. Label information is ready for printing, but text is still under revision as of late 1984.

Purchasing: Offered only as a complete set of 600 slides. Advance orders are needed to finance production of the set. Estimated price approximately $800.00, plus shipping.
Evaluation: Not yet possible.

247 **Religion and Ethics Institute**
P.O. Box 664
Evanston, IL 60204
(312) 328-4049
attn: Howard M. Teeple

Profile: Offers 29 sets of duplicate color slides in the following series: "Archaeology," "Mystery Religions," "Old Testament," "New Testament," "Judaism," and "Hero Cults." Works included from many museums in the United States and Europe. A new set on ancient Scandinavian religion to be issued in 1984.
Photography: Most original slides shot on Kodachrome ASA 64 by H. Teeple using Minolta camera with various lenses, including wide-angle and telephoto. Exacta V with bellows attachment employed to photograph drawings, etc. Some slides shot by traveling scholars or purchased from museums.
Production: Produced by World in Color, which, according to Mr. Teeple, sends the slides to a Kodak laboratory for duplication. No attempt made to correct color or control contrast. Slides mounted in cardboard.
Documentation: Mailing list kept. Free lists of set titles available. Lists of set contents sent on request. Each set accompanied by eight-page printed lecture notes. Orientation marked by number placement (upper left corner).
Purchasing: Slides sold in sets only, 15-24 slides each, mostly in color. Prices based on approximately $1.00 per slide, postpaid. Price per set reduced if an entire series is purchased. Duplicates kept in stock and orders filled within two to three days. Rush orders filled same day; no surcharge. Slides not sent on approval, and no returns accepted.
Other sources: "Mystery Religions" series also sold by Bolchazy-Carducci Publishers, Chicago.
Evaluation: Rated by one advisor (Sara Jane Pearman): quality 2, documentation 2, service 2.

248 **Social and Public Arts Resource Center (SPARC)**
685 Venice Boulevard
Venice, CA 90291
(213) 822-9560 or 9783
attn: Media Resource Center

Profile: No response to questionnaire. Entry based on 1982 letter. "Extensive collection" offered of slides of murals in the United States and abroad. No further information available.

249 **Tamarind Institute**
University of New Mexico
108 Cornell Avenue, S.E.
Albuquerque, NM 87106
(505) 277-3901

Profile: Six sets (240 color slides) offered of lithographs by artists associated with the Tamarind Institute or the Tamarind Lithography Workshop, Los Angeles. Sets I, II, and III available as duplicate slides. More recent sets offered as Kodachrome originals.
Photography and production: Slides shot on Kodachrome by University of New Mexico Photo Services. Packaged in plastic sleeves.
Documentation: Mailing list kept. Free list available of artists included in each series. Catalog $10.00. Full identification provided with slides.
Purchasing: Slides sold in sets only, priced on basis of $1.00 per slide for originals, $0.75 per slide for duplicates. Prepayment or purchase order required. Sets kept in stock and orders filled within 10 days. Rush orders accepted.
Evaluation: Four-star rating in the fourth edition.

250 **Trinity College Slide Exchange**
 Austin Arts Center
 Trinity College
 Hartford, CT 06106
 (203) 527-3151, x463
 attn: Trudy Buxton Jacoby

Profile: Approximately 1,000 color slide titles offered of architecture in the United States. New England emphasized, with particular strength in Newport, Rhode Island, buildings. New York, Philadelphia, and Washington, DC, also represented. New slides continually added.
Photography: Slides shot by Trudy Jacoby using all Nikon equipment, including 28 mm perspective-correcting and telephoto lenses. Most slides shot on Kodachrome ASA 64, some on Ektachrome ASA 64.
Production: Duplicated on Ektachrome #5071 by Superior Slides, Dallas, Texas. "Each slide is color and density corrected." Mounted in plastic or cardboard.
Documentation: Single sheet of partial holdings available free. More detailed and extensive list in progress, also to be issued free. Periodic revisions planned. Slides to be keyed to catalog. Identification consists of location, building name, date, and architect. Orientation marked only when not obvious.
Purchasing: Slides sold singly and in sets. Minimum order $15.00. Single slides $1.50 each, postpaid. Quantity discounts. Prepayment required. Duplicated to order and shipped within three to four weeks. Rush orders filled when possible; surcharge to cover local duplication. Slides not sent on approval. Returns accepted for exchange or refund only if slide is defective. Requests also considered for slides shot to order.
Exchange: Exchange of slides for other slides considered.
Evaluation: Based on samples sent. Quality 3, documentation 2.

251 **University of Denver School of Art**
 2121 East Asbury
 Denver, CO 80208
 (303) 871-3277
 attn: Peter Dulan

Profile: Approximately 1,250 slide titles offered in sets covering the following topics: Edward Curtis North American Indian photographs, Daumier prints, and American photography. Both originals and duplicates sold; approximately 80 percent on color film.
Photography: Slides shot on Ektachrome ASA 64 or 180 or on Panatomic-X by Peter Dulan.
Production: Mounted in cardboard or plastic.
Documentation: Mailing list kept. Brochures prepared to announce new sets. No catalog available. Slides keyed to list provided with each set. Identification consists of artist, title, size, date, medium, and (when available) biography of artist. Orientation marked.
Purchasing: Slides usually sold in sets of originals. Per-slide cost in sets less than $1.00. Limited-edition sets offered. Prepayment or purchase order required. Slides not sent on approval, and no returns accepted. Time needed to fill orders varies. "Large sets (300-400 slides—all original) may take up to six months." No rush orders accepted. Slides shot to order for nonprofit institutions at cost of $2.00 each.
Evaluation: Quality 3 based on one sample sent, documentation 3, service 2. "Very slow . . . volunteer labor force" (Marybeth Koos).

252 **University of Michigan Slide Distribution**
 Department of History of Art
 University of Michigan
 Ann Arbor, MI 48109
 (313) 764-5404
 attn: Joy Alexander

Profile: Offers 1,300 color slide titles of major paintings (and some sculpture) from selected U.S. museums (to date Albright-Knox Art Gallery, Buffalo; Carnegie Institute Museum of Art, Pittsburgh; High Museum of Art, Atlanta; Kimbell Art Museum, Fort Worth; Nelson-Atkins Museum, Kansas City; New Orleans Museum of Art; St. Louis Art Museum; and Toledo Museum of Art). Exhibitions also

documented include Frank Stella prints and Thyssen-Bornemisza collection (two parts). Details of each work of art included. New sets continually added.

Photography: Slides shot on color-balanced Ektachrome ASA 50 film by Patrick Young, staff photographer for the University of Michigan History of Art Department. Nikon camera and lenses used.

Production: Duplicated on Ektachrome #5071 by Meteor Photo Company, Troy, Michigan, or Precision Photographics, Ann Arbor, Michigan. Color corrected and contrast controlled. Mounted in plastic.

Documentation: Mailing list kept. Series of lists available free. Identifications consist of artist, title, date, country, and medium. Slides keyed to list. Orientation marked only when not obvious.

Purchasing: Sold in sets only (125-150 slides on average). Sets priced at $1.00 per slide, plus $2.60 university processing fee. Prepayment preferred. Slides sent on approval to new customers. "Any slide found to be of unacceptable quality may be returned for replacement or refund within 60 days of receipt." Slides kept in stock and shipped one day after receipt of order. Postage of $3.00 added on U.S. and Canadian orders, $7.50 on foreign orders.

Other sources: Single slides from the Albright-Knox Art Gallery and Toledo Museum of Art sets available from Rosenthal Art Slides (76).

Evaluation: Quality 3 to 4, documentation 3 to 4, service 3 to 4. "An excellent new source for slides" (Nancy Kirkpatrick). "We are extremely pleased with the quality of slides and composition of details" (Marybeth Koos). "A few minor errors noted in documentation" (Norine Cashman).

253 Woman's Building Slide Library

1727 North Spring Street
Los Angeles, CA 90012
(213) 222-2477
attn: Anne Gauldin

Profile: Offers 7,500 duplicate color slides of works by women artists from the sixteenth century to the present. Paintings, drawings, prints, sculpture, photography, mixed media, performance art, and installations included. Exhibitions in the Woman's Building Gallery documented from 1974 to the present. New slides continually added.

Photography: Slides shot on Kodachrome and Ektachrome by staff photographer.

Production: Duplicated by a professional laboratory. Color corrected and contrast controlled. Mounted in cardboard or plastic.

Documentation: Mailing list kept. Send a self-addressed stamped envelope to receive the free catalog of slide sets and, if desired, a partial listing of individual slides. Catalog revised annually. Slides keyed to information sheet, which provides artist's name, title, date, medium, dimensions, and collection. Orientation marked.

Purchasing: Slides sold in sets or singly. Minimum order five slides. Per-slide cost in sets approximately $1.00; size of sets varies from 5 to 60 slides. Single slides $1.25; for members, $1.00. Prepayment required on orders over $100.00. Some slides kept in stock, some made on order. Shipped within two to three weeks. Rush orders filled in one week; surcharge of 20 percent. Slides not sent on approval; returns accepted for refund if slides are defective.

Rental: A set of 125 slides documenting the history of the Woman's Building (the oldest independent institution dedicated to women's culture) rented for $35.00 plus refundable $50.00 deposit.

Evaluation: No information available.

Part II
ASIA, AUSTRALIA,
BRITAIN, EUROPE,
IRELAND,
and the
MIDDLE EAST

AUSTRALIA

COMMERCIAL VENDORS

254 **Aboriginal Arts and Crafts Pty., Ltd.**
38 Harrington Street
Sydney, New South Wales, 2000

No response to questionnaire. Vendor's name and address provided by an advisor who last ordered in late 1981.

MUSEUMS

255 **Art Gallery of Western Australia**
47 James Street
Perth, Western Australia, 6000
328 72 33
attn: Administration Centre

Profile: Offers 304 color slide titles of items in the permanent collection. New titles continually added (100 in 1984). Australian art and crafts featured; a few sets of British and European art available, including two sets of Art Nouveau. Eleven sets derived from the exhibition "The Colonial Eye," representing the life and landscape of Western Australia from 1798 to 1914.
Photography: Slides shot by staff photographer.
Production: Printed on Eastmancolor #5381 by Custom Colour. No attempt made to correct color or control contrast.
Documentation: Free list, updated annually. Artist, title, and date provided. Slides keyed to list. Three comprehensive illustrated catalogs accompany "The Colonial Eye" set. Orientation not marked.
Purchasing: Slides sold only in sets of eight. Minimum order one set. Price per set $6.50 retail or $5.00 tax exempt (Australian dollars). "The Colonial Eye" exhibition (88 slides) priced $50.00. Postage added. Prepayment required from overseas. Slides kept in stock and shipped within one week. Rush orders filled in one day; no surcharge. Slides not sent on approval, and no returns accepted. No special photography undertaken.
Evaluation: No information available.

256 **National Gallery of Victoria**
180 St. Kilda Road
Melbourne 3004
62 74 11
attn: Gallery Library

Profile: No response to questionnaire. Entry based on fourth edition. Approximately 2,000 color slide titles offered of Australian paintings; costumes; Chinese ceramics, jade, and bronzes; seventeenth to twentieth century European paintings; sculpture; and Greek vases. Slides of special exhibitions sometimes offered.

Photography: Shot by a commercial photographer.

Production: Duplicated by a local laboratory.

Documentation: Mailing list kept. Catalog available, updated annually. Identification consists of artist's surname, initials, and dates; title and date of work; and medium.

Purchasing: Slides sold singly, $1.00 each (Australian dollars). No discounts. Postage added. Special photography undertaken at a charge of $7.50 or more per item. No returns accepted.

Evaluation: No information available.

AUSTRIA

COMMERCIAL VENDORS

257 Ars Nova Medienverlag
A-1090 Vienna
Schlagergasse 5/14
(0222) 42 86 554
attn: Helmut Weihsmann

Profile: Company founded 1980 by H. Weihsmann, architectural historian and critic. Duplicate color slides offered of twentieth century architecture in Europe, the United States, and Latin America. Public art also documented such as outdoor sculpture and street murals. "We present unconventional topics on the contemporary environment, highlighting significant and unusual directions in architecture, urban design, and futuristic experiments of visionaries." Approximately 25 sets available, with more to be produced in the near future. Archive of more than 60,000 slides accumulated since 1977. Postcard editions of black-and-white photographs of fin-de-siècle Vienna architecture also available.

Photography: Slides shot by H. Weihsmann (67 percent) and independent professional photographers (33 percent) on Kodak daylight films — Kodachrome ASA 25 and 64 or Ektachrome ASA 64. Canon equipment used by Mr. Weihsmann, Minolta and Nikon cameras by other photographers.

Production: Duplicated on Ektachrome #5071 by Kodak laboratory in Vienna. Color corrected and contrast controlled. Mounted in cardboard and packaged in clear plastic sleeves.

Documentation: Mailing list kept. Free catalog, brochures, and price list available. Information about new sets issued frequently. Sets accompanied by booklets, some of which are available in English, others only in German. Brief identifications in English provided for all sets. Slides labeled with partial identifications and keyed to full identifications in booklet. Orientation marked by number in upper right corner.

Purchasing: Slides sold in sets of 24. Single slides and originals available by special request. Sets priced $36.00 (United States). Special orders $2.50 to $3.50 per slide. Postage added. Quantity discounts possible. Minimum order $25.00. Prepayment required on first orders from overseas customers. International postal money order or bank draft accepted. Sets kept in stock and shipped within two days. Special orders shot or duplicated to order and shipped within one week. Express shipping charges on rush orders billed to customer. Returns due to faulty production accepted for exchange if sent back within eight days of arrival.

Rental: "Super slide-shows" of 80-100 slides accompanied by text (sometimes a cassette as well) rented for one month at the cost of $36.00 (United States) plus shipping and insurance.

Evaluation: Based on samples sent: quality 2 to 3 and improving in recent productions, documentation 4, service 3 to 4. Extensive documentation provided with images, including plans and related illustrations. Duplication is of high quality — contrast controlled, color usually good, and resolution usually sharp. Original photography marred by perspective distortion, but perspective-correcting lens used on recent sets.

258 **Hofstetter-Dia**
 A-4910 Ried im Innkreis
 Oberachgasse 4a
 07752 2425
 attn: Ina (Hofstetter) Ehrenstorfer

Profile: Several hundred color slides offered of art and architecture in Austria, seventeenth to twentieth centuries. Churches and their art treasures featured. Museum objects also documented. New titles occasionally added. Slides intended for the tourist market.

Photography: Many originals were shot by Kurt Hofstetter, now deceased, who established this company. New slides shot by an independent professional photographer on various films, usually Ektachrome or Agfachrome. Negatives and large-format transparencies also shot.

Production: Produced on Eastmancolor #5383 nonperforated 35 mm film, printed in-house from negatives. Some old stock on Eastmancolor #5381 to be disposed of by 1985. Color corrected and contrast controlled. Mounted in plastic super-slide mounts. Sets packaged in plastic sleeves.

Documentation: Free list, in German. Slides labeled in German. Orientation marked.

Purchasing: Slides sold singly or in sets. No minimum order. Singles 10.00 Austrian schillings, sets of six slides 45.00 Austrian schillings. Postage added. No discounts. Prepayment sometimes required on overseas orders. Payment accepted in Austrian, U.S., or West German currencies. Slides kept in stock or made to order if necessary. According to advisor Dr. W. Krause, slides often out of stock. Shipped within 1-14 days. Rush orders accepted; extra postal costs charged to customer. Slides sent on approval. Returns sometimes accepted for exchange.

Evaluation: Quality 3, documentation 2. Produced on unstable film. See GAF (42) for comments on super-slide format.

259 **Photo Meyer K.G.**
 A-1060 Vienna
 Theobaldgasse 15
 Postanschrift: A-1061, Fach 260
 (0222) 57 52 33 or 57 51 84
 attn: Lutz L. Lindner

Profile: No response to questionnaire. Entry based on fourth edition. Approximately 300 color slides offered of art in museums in Vienna, Graz, Prague, and Budapest. Slides of Austrian architecture also offered. Unlisted slides available: "Based on an agreement with the Austrian Ministry of Science and Research, we specialize in art reproductions and have in stock [more than 50,000] transparencies of the main art objects throughout Austria and can make slides of them upon request." Postcards also sold.

Photography: Original photography by proprietor or staff. Professional equipment used. Special arrangements made to photograph in museums and galleries in Vienna and several other museums.

Production: Produced in-house from negatives. As of 1981, both Eastmancolor and Vericolor films used (*International Bulletin*, 1981, no. 1). No attempt made to correct color or control contrast.

Documentation: Catalog available, in German. Identifications consist of artist, title, and location/owner. For architecture, location, name of building, and view description provided. Slides labeled with same information. Orientation marked.

Purchasing: Slides sold singly, 10.00 Austrian schillings. Twenty sets also offered. Postage added. Prepayment required from new customers and on large orders. Slides kept in stock. Returns accepted only if parcel is refused by customer because of damage in shipment. Special photography undertaken. Slides sold in museum shops in Austria.

Evaluation: Quality 3, documentation 2. "New slides are really fine; the old blue ones are so few now that we may forget them" (Walter Krause).

MUSEUMS

260 **Erzbischöfliches Dom- und Diözesanmuseum**
A-1010 Vienna I
Stephansplatz 6
(0222) 53 25 61

Duplicate color slides made by special order from 67 original slides on file. No list available. Slides labeled in German. Orientation marked.

261 **Gemäldegalerie der Akademie der Bildenden Künste**
A-1010 Vienna
Schillerplatz 3
(0222) 57 95 16

No response to questionnaire. According to advisor Dr. Walter Krause, the museum shop sells only a few slides, "not of consistent good quality." European painting collection documented thoroughly by Saskia (78). Slides also offered by Burstein (30).

262 **Kunsthistorisches Museum**
A-1010 Vienna
Burgring 5
(0222) 93 45 41, x414 or x410
attn: Dr. Georg Kugler

Profile: Selection of commercial slides produced by Photo Meyer (259) sold by museum.
Photography and production: See Photo Meyer (259).
Documentation: List available, in German, of slides sold directly by museum.
Purchasing: Orders filled within one to two weeks. Rush orders accepted.
Other sources: "Virtually complete coverage of all paintings normally exhibited" offered by Saskia (78), as well as "very good coverage of sculpture and minor arts." A few slides of Egyptian sculpture in the Kunsthistorisches Museum offered by Saskia in 1985. A microfiche set of 1,800 Old Master paintings in the museum produced by Chadwyck-Healey from master slides by Saskia; order from Chadwyck-Healey, Inc., 623 Martense Avenue, Teaneck, NJ 07666 or Chadwyck-Healey, Ltd., 20 Newmarket Road, Cambridge CB5 8DT, England.
Evaluation: See producers' entries.

263 **Österreichische Galerie**
A-1037 Vienna
Postfach 134
(0222) 78 41 14 or 78 41 21
attn: Museum Bookshop

Profile: Offers 100 color slide titles of Austrian art from the Middle Ages to the present. Includes 17 slides of the Schloss Belvedere.
Photography: Slides shot by an independent professional photographer.
Production: Duplicated to order from originals. No attempt made to correct color or control contrast. Mounted in plastic.
Documentation: Free list, in German. Artist and title of work provided. Slides labeled in German. Orientation marked.
Purchasing: Slides sold singly or in sets. No minimum order. Single slide 12.00 Austrian schillings. One six-slide set offered of paintings by Klimt, another of paintings by Schiele, 60.00 Austrian schillings per set.

Other sources: Slides of nineteenth century Austrian paintings and some Baroque paintings available from Saskia (78). Slides also offered by Burstein (30).
Evaluation: Based on sample order quality of slides of paintings rated 4, slides of architecture rated 3; soft definition noted on the latter. Documentation 2, service 3.

264 Österreichische Nationalbibliothek

A-1015 Vienna
Josefsplatz 1
(0222) 52 23 08 or 52 71 92
attn: Bild-Archiv und Porträtsammlung

Slides made to order from original Ektachrome transparencies on file, priced approximately 100.00 Austrian schillings each. No returns accepted.

265 Salzburger Museum Carolino Augusteum

A-5010 Salzburg
Postfach 525
(0662) 41134

Profile: Museum collection and objects in the Toy Museum, Burgmuseum, and Volkskundemuseum available as slides. Subjects covered include Roman art; medieval sculpture, painting, and manuscripts; sculpture, painting, and graphic arts of the fifteenth to sixteenth centuries; sculpture, painting, graphic arts, and decorative arts of the seventeenth through nineteenth centuries; and painting and graphic arts of the twentieth century.
Photography: Large-format transparencies shot by staff photographer on Agfachrome.
Production: Duplicated on Agfachrome. Contrast controlled. Mounted in cardboard.
Documentation: No list available.
Purchasing: Slides sold singly or in sets of 10. Price list available on request. Postage added. Payment in Austrian schillings requested. Slides made to order; therefore, they are not sent on approval, and returns are not accepted.
Evaluation: One sample sent: produced by Hofstetter, "super-slide" format.

266 Salzburger Residenzgalerie

A-5010 Salzburg
Postfach 527
(0662) 41561, x2070

Profile: Offers 160 color slide titles of European paintings in the permanent collection.
Photography: Slides shot by staff photographer.
Production: Duplicated in-house.
Documentation: Free list, in German. Artist and title provided. Slides labeled in German with artist and title.
Purchasing: Slides sold singly, priced 7.00 Austrian schillings. No rush orders accepted. No returns accepted.
Evaluation: Rated by only one advisor (Nancy Kirkpatrick): quality 2 to 3, information 1 to 2. "Wide selection, but slide quality varies (some cropped and off-color)." One sample sent: produced by Hofstetter, "super-slide" format.

BELGIUM

COMMERCIAL VENDORS

267 **Cinescopie**
18, rue des Deux-Églises
Brussels

No response to questionnaire for this edition or the fourth edition. Perhaps company does not sell slides retail, or at least not by mail order. Slides still produced by Cinescopie for distribution by Belgian museums and other tourist sites. As of late 1984, film used was still unstable Eastmancolor.

MUSEUMS

268 **Koninklijk Museum voor Schone Kunsten**
Plaatsnijdersstraat 2
2000 Antwerp
(031) 38 78 01

Profile: No response to questionnaire. Entry based on fourth edition and a recent order. Offers 87 color slide titles of paintings—69 Old Masters and 18 modern artists.
Photography: Originals shot by a commercial photographer in the galleries.
Production: Produced by Cinescopie (267) on Eastmancolor film.
Documentation: Free lists, in Dutch. Artist, title, and catalog number given on lists.
Purchasing: Slides sold singly. Prepayment required.
Evaluation: "Film received in late 1984 was neither stable nor fresh" (Norine Cashman).

269 **Musées Royaux des Beaux-Arts de Belgique**
Rue du Musée, 9
1000 Brussels
(02) 513 96 30

No response to questionnaire. Entry based on lists received in 1979. Offers 30 slide titles of works by modern artists, 36 slides of works by Old Masters. Artist's name, title in Dutch and French, and inventory number given on lists. Single slides priced 38 francs each as of 1981. Postage added. Prompt service given

on a 1981 order by Brown University (2½ weeks, including airmail delivery time). Those slides seem to be on stable film. Resolution is good, but contrast is high and color distorted (too yellow). Slides also available from Saskia (78) of sixteenth and seventeenth century Flemish paintings in this museum. See also catalog supplement no. 2 from Burstein (30).

BRITAIN

COMMERCIAL VENDORS

270 **Austin, James**
22 Godesdone Road
Cambridge CB5 8HR
(0223) 359763

Profile: Offers 10,000 slide titles (90 percent black-and-white, 10 percent color) of European architecture from 500 B.C. to the present. Subjects featured in color are nineteenth and twentieth century architecture and sculpture in Paris; subjects featured in black-and-white include medieval architecture and sculpture. New titles continually added (500 slides in 1984).

Photography: Slides and negatives shot by James Austin, MA FIPP. For black-and-white negatives, FP4 film used with various cameras: Sinar 4 by 5 inches, Hasselblad, and Nikon. For color slides, Nikon cameras used with various lenses, including a perspective-correcting lens. Slides now shot on Kodachrome ASA 25, previously on Ektachrome ASA 64 and Agfa 50S. Most photography done in available light. Tripod used.

Production: Duplicated in-house on Kodachrome ASA 25 or, in the case of black-and-white images, produced from negatives on Agfa Dia-Direct film. Color corrected and contrast controlled. Mounted in cardboard.

Documentation: Mailing list kept. Free catalog (not up to date in 1984). Separate catalog available of black-and-white work. Slides keyed to catalog. Identifications complete, except dates for medieval churches. Full descriptions given of views and subjects depicted. Orientation marked.

Purchasing: Slides sold singly or in sets. Minimum order to be invoiced: £5.00. Price per slide 70 pence, with quantity discounts to 60 pence for more than 250 slides. Prepaid orders postpaid; otherwise, postage added. Orders sent surface mail unless airmail requested. Payment in pounds sterling preferred; surcharge of 2 percent for conversion. Slides duplicated to order and shipped within three weeks. Rush orders filled, if possible, within one week; no surcharge. Slides not sent on approval. "No photographs or slides will be sent out unless they meet the high standards set by James Austin. No prints or slides can be returned unless defective in manufacture or damaged in transit. Claims should be made promptly, and all defective or damaged material should be returned, when it will be replaced free of charge." Special photography undertaken at £20.00 per hour plus materials and expenses.

Evaluation: Quality 4, information 3 to 4, service 3.

271 **Capper, Barry**
 52, Hanney Road
 Steventon, near Abingdon
 Oxfordshire OX13 6AL
 Abingdon 831383

Profile: Several hundred color slide titles offered of English architecture and sculpture from Anglo-Saxon times to the early twentieth century. Associated decorative arts included such as stained glass, ironwork, and wall painting. Mr. Capper has graduate degrees in theology (University of Durham) and art history (University of London) and is presently working toward a degree in medieval studies (University of London). He received professional training in photography at Leicester Polytechnic. He has taught students of "pre-University age" for 20 years. New titles continually addd to his holdings.
Photography: Slides shot on Kodachrome ASA 25 or 64 by B. Capper. Some black-and-white negatives also shot on Kodak Panatomic-X. Natural light used as often as possible. Nikon and Leica cameras used with various lenses and tripod.
Production: Duplicated in-house on Kodachrome and processed in a Kodak laboratory in West Germany. Color corrected and contrast controlled. Mounted in plastic.
Documentation: Computer-generated lists to be issued in the near future. Slides labeled. "Scholarly information supports each transparency." Orientation marked.
Purchasing: Originals and duplicates available. Slides sold singly, priced £1.00 to £1.50 each in the United Kingdom, $1.50 to $2.00 each in the United States. Quantity discounts given. Postage and bank charges added. Slides duplicated to order and shipped within two to four weeks. Rush orders accepted. Slides sent on approval. Requests welcomed to photograph on commission.
Evaluation: Ten samples sent (original Kodachromes): quality 4, documentation 3.

272 **Drake Educational Productions, Ltd.**
 St. Fagans Road
 Fairwater, Cardiff CF5 3AE
 (0222) 560333
 attn: R. G. Drake, Managing Director

Profile: Filmstrips, slides, and wallcharts offered on a wide range of general subjects. Listed under "Creative Arts" in catalog are two slide sets of contemporary artists at work, including one of Henry Moore, three sets of nineteenth to twentieth century painting, seven sets of modern design, and two sets of prints by Old Masters. Double-frame filmstrips, which can be mounted as slides, also available on techniques of painting, history of art, ceramics, and architecture.
Documentation: Free catalog/price list. Titles of set listed but not contents. Sets usually accompanied by teacher's notes. Audiocassette included in "Contemporary Artists at Work" sets.
Purchasing: Sold as double-frame filmstrips at £6.50 each or mounted in plastic at 50 pence per frame. Sets of 12 slides priced £6.00. "Contemporary Artists at Work" sets priced £13.00 each. Surcharge of 20 percent added to overseas orders. Postage added. Pro forma invoices issued, and slides shipped within five days of receipt of payment. Slides not sent on approval.
Evaluation: No information available.

273 **Focal Point Audiovisual, Ltd.**
 251, Copnor Road
 Portsmouth, Hants. PO3 5EE
 (0705) 665249
 attn: D. Riley and S. Riley, Directors

Profile: Audiovisual teaching aids, principally filmstrips and slides, available in various subject fields. Duplicate color slides offered of drawing, painting, architecture, decorative arts, sculpture, ceramics, and photography. Five 20-slide sets offered in the University of Sussex Art History slide-texts series, each £9.00, plus audiocassette £3.60. New titles continually added. Distributor for Slide Centre, Ltd., 143 Chatham Road, London SW11 6SR.

Photography: Slides shot on Kodachrome ASA 64 or, occasionally, on Ektachrome ASA 50 by staff photographer, other professional photographers, or traveling scholars. Natural light used when possible; otherwise, floodlights or double flash with reflectors.

Production: Printed on Eastmancolor #5384 by Humphries Film Labs, London; ECP-2A processing used. Contrast controlled. Color corrected on some slides. "Century Series" and "Half-Century Series" packaged as unmounted strips in plastic containers, accompanied by cardboard mounts. Mounting in plastic mounts with or without glass or in cardboard may be requested. Slide books composed of 20, 30, or 40 slides mounted and packaged in a clear plastic wallet within rigid binders (the latter optional).

Documentation: Mailing list kept. Free catalog, updated annually. Slides keyed to booklet; extra copies of booklets may be ordered separately. Many sets accompanied by sound cassettes (in some cases optional). Orientation marked by number placement.

Purchasing: Slides usually sold in sets. Single slides available by special request. Order/preview form included in catalog. Prices vary with size of set; for example, 100 frames for £13.80. Discount of 10 percent given to overseas educational institutions. Quantity discount quoted on request. Actual postage cost charged to customer. Prepayment required from individuals. Payment in pounds sterling preferred. Slides kept in stock and shipped within two days. Rush orders filled at no surcharge. Slides sent on 14-day approval within the United Kingdom only. Returns accepted for exchange "if unsuitable." Special photography carried out by arrangement. "Our U.K. prices are much cheaper than those of our distributors, and our 10 percent discount covers postal costs."

Other sources: Slides distributed by Gould Media (44) and also by Educational Images, Ltd., P.O. Box 367, Lyons Falls, NY 13368 and Carman Educational Association, 146 Riverside Drive, Woodbridge, Ontario, L4L 2L3, Canada.

Evaluation: Sample set from University of Sussex series sent (20 slides): quality 2 to 3, documentation 4. Color muted, definition slightly soft, dust and scratches on masters duplicated on copies.

274 **Lambton Visual Aids**
9, Side
Newcastle-on-Tyne NE1 3JE
(0632) 22000

Profile: Approximately 7,200 color slide titles offered of painting and sculpture, illustration, caricatures and cartoons, advertising, photography, graphic design, industrial design, fashion, architecture, interior design, and garden design. New titles continually added.

Photography: Slides shot by staff photographer on Kodachrome, Ektachrome, and Agfachrome using Nikon camera.

Production: Duplicated on Ektachrome #5071 by Turners, Ltd. Color corrected and contrast controlled. Mounted in glass. Optionally packaged in plastic sleeves.

Documentation: Free catalog (1981) lists set titles only. Catalog revised every three to four years. Slides labeled and accompanied by notes. Orientation not marked.

Purchasing: Slides sold in sets of 24, priced £14.00 per set. Postage added. Orders invoiced. Payment in pounds sterling preferred. Duplicated to order and shipped within three months. Rush orders accepted if possible. Slides not sent on approval. Returns accepted for exchange only.

Evaluation: No information available.

✱ 275 **Miniature Gallery**
2 Birds Hill Rise
Oxshott, Surrey KT22 0SW
037 284 2448
attn: Derek Carver

Profile: No response to questionnaire. Entry based on fourth edition, plus knowledge of editor and advisors acquired from ordering experience. Company in business 25 years. Exhibitions in Britain and Europe covered selectively. Permanent collections of the following museums also represented:

Louvre, Paris "Art Slide News" no. 52 plus Sept. 1984 addenda

Vincent Van Gogh Museum, Amsterdam[†] "Art Slide News" no. 52

Glasgow Art Gallery "Art Slide News" no. 58

Stedelijk Museum, Amsterdam[†] "Art Slide News" no. 62

New titles continually added.

Photography: Miniature Gallery's own productions photographed by Derek Carver. Sets occasionally photographed and produced in joint venture with Scala (421).

Production: Eastmancolor #5381 formerly used. Other films, including Agfachrome, have been tried. Current production is on Ektachrome reversal film with E-6 processing. Production carefully supervised by D. Carver. Color corrected and contrast controlled. Slides mounted in plastic. Miniature Gallery distributes work of other producers as well: currently, Scala ("Art Slide News" nos. 19, 28, 34, 51, and 57) and Centre de Création Industrielle ("Art Slide News" no. 57).

Documentation: No comprehensive catalog available. Mailing list kept, and "Art Slide News" issued irregularly (several times annually) to announce new offerings. Many sets are limited issues that sell out within a few years and may not be available thereafter. As of 1985, slides can still be ordered from "Art Slide News" nos. 19, 28, 34, 47, and 49 onward. ("Not all titles are in stock, but we are prepared to reissue if we feel a demand still exists.") Slides keyed to identification lists. Printed labels sometimes supplied. Identifications usually complete. Medium is oil painting if not otherwise indicated. Errors in identifications corrected in subsequent issues of "Art Slide News" or accompanying memoranda.

Purchasing: Slides sold in sets, from which singles sometimes may be ordered. Prices vary, but in general the slides are inexpensive. Payment accepted in pounds sterling or U.S. dollars at the current exchange rate. Institutions invoiced; interest charged after 30 days. To prepay, add 8 percent to cover second-class airmail shipment. Returns accepted if sent back within seven days accompanied by a letter of explanation. Special photography of exhibitions undertaken (lecture slides only) if permissions are secured in advance by customer. Slides produced by others are usually more expensive when purchased from Miniature Gallery rather than directly from the producer.

Evaluation: Of Miniature Gallery's own productions: quality 3 to 4, information 3 to 4, service 3 to 4. "Extremely prompt service. Good coverage of exhibitions in the United Kingdom and on the continent. Slides occasionally too blue or too high contrast" (Nancy Kirkpatrick). "Extremely good buy. . . . Too many slides (particularly those on Baroque painting) are too dark. Selection, framing, choice of details excellent" (Helen Chillman). "Not the very best slides available but among the best bargains. Service is extraordinarily customized" (Norine Cashman).

276 Trans-Globe Film Distributors, Ltd.
52 Upper Berkeley Street
London W1

Profile: No response to questionnaire. Entry based on fourth edition. Approximately 2,500 color slide titles offered of British historic houses, castles, cathedrals, abbeys, and museums. In addition to views of the architecture, art collections housed in these properties are represented.

Photography: Ektacolor negatives (4 by 5 inches or 35 mm) shot by staff photographers using telephoto, wide-angle, and perspective-correcting lenses as appropriate. Interiors usually shot with tripod and professional lighting. Photography in museums conducted during public hours.

Production: Printed on Eastmancolor film.

Documentation: Catalog available for nominal sum. Brief identification for each image provided. Dates infrequently given. Orientation marked.

Purchasing: Slides sold singly or in sets of five. No current prices available. Postage added. Prepayment required in pounds sterling. Distributed by World Microfilms Publications (279).

Evaluation: Trans-Globe slides received in 1984 from World Microfilms Publications were on unstable film, already turning pink. In general, the original photography appeared to be good to excellent.

[†]Produced by museum.

277 **Visual Publications**
197 Kensington High Street
London W8 6BB
(01) 937 1568

Profile: Producer of materials distributed in Canada by McIntyre Educational Media, Ltd. (6) and in the United States by McIntyre Visual Publications (60). Filmstrips supplied on a variety of art subjects. Selected titles also offered as slide sets, representing painting from the Middle Ages to the present, individual modern painters, modern sculpture, and twentieth century architecture.

Photography and production: No data provided. Presumably the same as for McIntyre Visual Publications (60). Slides sold as double-frame filmstrips. Mounts may be purchased separately.

Documentation: Separate catalog of art subjects available. Sets described, but contents not listed slide by slide. Sets accompanied by handbooks, some by audiocassettes.

Purchasing: Slide sets composed of approximately 35 images. Educational discounts (10 percent to 12½ percent) given within the United Kingdom on most sets. Postage added. Thirty-day preview possible within the United Kingdom only; form included in catalog.

Evaluation: See McIntyre Visual Publications (60).

278 **Woodmansterne, Ltd.**
Watford Business Park
Watford, Herts. WD1 8RD
(0923) 28236
attn: Mrs. J. W. Woodmansterne, Director

Profile: Offers 10,000 color slide titles. Architecture and art subjects offered among others such as opera and ballet, royalty and pageantry, railways and transport, space exploration, and natural history. Cathedrals and historic houses in Britain featured, including their art collections. Properties of the National Trust and the National Trust for Scotland represented. Slides of art and architecture on the continent also offered, as well as some slides of the Holy Land. Selected works from museum collections in Britain and Europe available. New titles continually added (100-200 slides in 1984). Approximately 30,000 images available for reproduction. Contract work also undertaken to produce slides in bulk (more than 250) from original photography supplied by the customer.

Photography: Originals shot 95 percent by staff photographers. Most originals are 120-format color negatives shot on Vericolor III. Occasionally, 35 mm slides shot with Nikon camera or large-format transparencies on Agfachrome R100S 120 or 4-by-5-inch sheet film. Cameras used for medium- and large-format work are the Sinar P, Linhof Technica, and Bronica ETR. "Interiors lit with multiple electronic flash using Bowens and Bron electronic flash units. Interiors carefully lit to look as natural as possible while ensuring best possible definition, colour balance, and detail. Almost all cathedral interiors lit in this way despite scale of operation required."

Production: Slides printed in-house from negatives or internegatives on Eastmancolor #5384; processed by Technicolor using ECP-2A processing. Color corrected. Mounted in cardboard or plastic. Glass-mounted slides available by special order. Stock of Eastmancolor #5381 to be exhausted in 1985.

Documentation: Free catalog and supplementary leaflets on topics of special interest (National Trust Properties, Westminster Abbey, the Holy Land, Europe, and museums and galleries). Brief identification given for each image. Sets accompanied by commentaries. Cassettes included with some larger sets. Slides labeled and keyed to catalog. Orientation marked.

Purchasing: Slides sold singly or in sets. No minimum order. Singles priced 38 pence each; set of three £0.90 or £1.00; set of six £1.80; set of nine £2.60 or £2.90. (Higher prices are for slides of art works in galleries.) Slidebooks of 18, 27, or 36 slides also offered at varying prices up to £13.50. Value-added tax included in prices; therefore, 15 percent subtracted from overseas orders. Otherwise no discounts. Postage added. Orders invoiced. Payment in pounds sterling requested. Slides kept in stock and shipped next day. Rush orders shipped same day; no surcharge except extra postage. Slides not sent on approval, and returns not normally accepted. "Consideration will be given for good reasons—we always try to accommodate."

Other sources: Woodmansterne slides distributed in the United States by Gould Media (44).

Evaluation: Quality 3 to 4, documentation 2 to 3, service 3. "Very useful views, good interiors" (Elizabeth Alley). "Too touristy" (Helen Chillman). "Numbering system causes confusion. Letters of inquiry treated as orders!" (Brenda MacEachern).

279 **World Microfilms Publications, Ltd.**
 62 Queen's Grove
 London NW8 6ER
 (01) 586 3092

Profile: Approximately 600 color slide titles offered of medieval illuminated manuscripts (the Winchester Bible and five manuscripts in the Lambeth Palace Library) and modern architecture (85 sets in the Pidgeon Audio-Visual Series as well as several independent tape/slide sets). Some 2,500 slides of historic houses in Britain and John Soane's Museum distributed for Trans-Globe (276). New titles continually added. A new series of tape/slide sets (Lecon Arts) planned of critics interviewing artists. Series I (eight sets) available 1985.

Photography and production: Slides made on Kodak film by an independent professional photographer (80 percent) and a staff photographer (20 percent) from microfilm originals. Produced by Humphries Film Laboratories or Buck Film Laboratories. Color corrected and contrast controlled. Mounted and packaged in plastic sleeves. Historic houses slides produced by Trans-Globe (276). According to the *International Bulletin*, 1981, no. 1, slides in the Pidgeon Audio-Visual Series are obtained from the speakers or taken/commissioned by Monica Pidgeon. Slides are then printed from an internegative on Fujicolor print film.

Documentation: Mailing list kept. Free brochures. Contents listings for sets available on request. Slides labeled and keyed to accompanying documentation. Lecture notes and audiocassettes provided with some larger sets. Transcripts of audiocassettes sold only to purchasers of the sets. Orientation not marked.

Purchasing: Slides sold in sets. Minimum order one set, except historic houses sets, for which £20.00 is the minimum order. Historic houses slides sold in sets of five, priced £3.00 per set. Manuscript slides sold in small subsets (12 slides each for Lambeth Palace, priced £9.00 per set). Pidgeon Audio-Visual sets composed of audiocassettes, 24 slides, and printed identifications. Price per set $70.00 for series 1 through 7, $80.00 for series 8 through 12. Discount given if entire series is purchased. Discount of 20 percent offered on prepaid orders (within a limited time after a new release). Prices usually listed both in pounds sterling and dollars. Postage added. Prepayment required from individuals and on very large orders. Slides kept in stock and shipped within one week. Rush orders filled immediately if slides are in stock; no surcharge. Slides not sent on approval. No returns accepted. Requests considered to shoot slides to order.

Other sources: Slides distributed in the United States by Clearwater Publishing Co., 1995 Broadway, New York, NY 10023.

Evaluation: See Trans-Globe (276) regarding historic houses slides. Pidgeon Audio-Visual Series rated 3 on quality and 3 on information by one advisor (Nancy Kirkpatrick). Manuscript slides rated 3 on quality by editor. "Service on a 1984 order was only fair—slides were missing from the order, and billing procedures were very confused" (Norine Cashman).

MUSEUMS

280 **Ashmolean Museum**
 Oxford University
 Oxford OX1 2PH
 (0865) 512651
 attn: Publications Department

Profile: Color slides (originals and duplicates) offered of works in the permanent collection, which covers the following subject areas: European art; archaeology of Europe, the Middle East, central Asia, and the Far East; Islamic, Indian, Chinese, and Japanese art; and numismatics of the world. New titles continually added.

Photography: Original transparencies in 35 mm and 4-by-5-inch formats shot by staff photographers. Film used is Agfa 50L daylight film balanced for tungsten lighting. Objects photographed in studio or in galleries with Nikon equipment.

Production: Duplicated in-house on Agfa 50S or 50L. Color corrected and contrast controlled. Mounted in plastic and sleeved in cellophane. Gepe mounts, with or without glass, may be requested on slides made to order. Sets of European and English coins produced by Seaby & Co. of Audley House, 11 Margaret Street, London.

Documentation: Mailing list kept. Free lists available of stocked slides, updated at irregular intervals. Some slides labeled; some slides keyed to list; some slides accompanied by no identification. Sets accompanied by information sheets with full identifications or booklet with scholarly commentaries. Orientation not marked.

Purchasing: Slides sold singly or in sets. No minimum order. Duplicate slides from stock priced 35 pence each. Slides copied to order from transparencies priced 75 pence each. Original slides priced £4.00 each from flat copy, £6.00 each from artifacts. Set prices vary. Prepayment required from new customers. Small stock of slides kept. Orders filled within two weeks. Rush orders accepted; surcharge of approximately £3.00 plus airmail shipping. Slides not sent on approval. Returns accepted for exchange or refund only if slide is faulty or damaged or wrong slide was sent.

Evaluation: Quality variable (2 to 4), documentation variable (2 to 4), service 2 to 3.

281 **Atkinson Art Gallery**
Lord Street, Southport
Merseyside PR8 1DH
(0704) 33133, x129

Profile: Approximately 1,800 color slide titles offered, covering the entire permanent collection of eighteenth and nineteenth century watercolors, Victorian genre painting, and British painting 1900-1940.
Photography: Slides shot by gallery technician on various films.
Production: Duplicated in-house on various films. Mounted in cardboard.
Documentation: No list available. Orientation marked.
Purchasing: Slides sold singly, priced 75 pence each. Postage added. Payment requested in pounds sterling. Slides duplicated to order. Some originals sold. Orders filled within three weeks. Rush orders shipped within 10 days. Slides sent on approval. Returns accepted for exchange or refund "if quality is genuinely inadequate."
Evaluation: No information available.

282 **Birmingham Museum and Art Gallery**
Chamberlain Square
Birmingham B3 3DH
(021) 235 4051
attn: Publications Unit

Profile: Approximately 90 color slide titles offered of fine art and archaeological artifacts from the permanent collection. New titles infrequently added.
Photography: Large-format transparencies shot by an independent professional photographer.
Production: Duplicated from originals. Film now used is not Eastmancolor. Color corrected and contrast controlled.
Documentation: Free list. Slides labeled.
Purchasing: Slides sold singly, 30 pence each. Postage added. Minimum order 20 slides. Prepayment required in pounds sterling. Slides shipped within two weeks. Rush orders filled within one week. No special photography undertaken. Slides not sent on approval, and no returns accepted.
Evaluation: Numerous samples sent: quality variable, documentation variable. Some slides on unstable film, already pink. Some others (new production?) good to excellent quality and labeled with full information.

283 **Bodleian Library**
Clarendon Building
Oxford OX1 3BG
(0865) 244675, x305
attn: Publications Officer

Profile: Duplicate color slides offered of the library's collection, some Oxford College manuscripts, and exhibitions held at the Bodleian between 1968 and 1981. More than 1,000 filmstrips currently available

(20,000 frames). Medieval illuminated manuscripts featured, but early printed books, bindings, maps, and printed ephemera also represented. New titles continually added (in 1984, five or six filmstrips [100-200 images]). Large-format transparencies, black-and-white prints, and microfilm also available.

Photography: Originals are negatives on Eastmancolor #5247, shot by staff photographers. Books, manuscripts, and other documents photographed flat under a vertical fixed Nikon camera, lit by photo pearl lights. Older materials (nos. 1-200) were made on other equipment that is no longer used.

Production: Produced by Filmstrip Services, Ltd., Borehamwood, Herts. Color corrected and contrast controlled. Stock on Eastmancolor #5381 to be sold until summer 1986. Meanwhile, all slides may be made to order on low-fade Eastmancolor film on request. Processing is ECP-41, not the recommended ECP-2A. Slides sold unmounted as filmstrips, also in professionally mounted heat-sealed cardboard mounts. Glassless plastic mounts available for some items.

Documentation: Catalog £3.00 (£5.00 airmail), deductible from first order "at present." Catalog indexed by shelfmark and subject. Supplements issued every two to three years. Filmstrips and slide sets accompanied by identification lists. Orientation marked on some slides but not all. Classified list of single slides in preparation. Meanwhile, list of 1,300 items available (unclassified).

Purchasing: Slides sold chiefly in sets or filmstrip format. Some singles offered as well, but sets cannot be broken up. Minimum handling charge £2.00; otherwise, no minimuim order. Unmounted filmstrips priced £.00 for 10 frames, plus 15 pence per additional frame (old film) or £3.00 for 10 frames plus 25 pence per additional frame (low-fade film). Mounted slides priced 35 pence each (old film) or 60 pence each (low-fade film). Pro forma invoice sent on receipt of order; slides shipped within one week of receipt of payment. Payment in pounds sterling or U.S. dollars accepted. Slides kept in stock or made to order on low-fade film if requested. Four to five-week wait for slides made to order on new film. Slides not sent on approval. "Even on the low-fade film, accuracy or permanency of colour cannot be guaranteed." Returns accepted for exchange or refund "only where there is a mistake or fault on our part." Special photography carried out by the Bodleian Photographic Studio, usually within six weeks of receipt of payment.

Other sources: Set of nine sixteenth century portraits offered by Woodmansterne (278).

Evaluation: Only one advisor able to rate (Sara Jane Pearman): quality 3, documentation 3, service 3. "Tendency to be too contrasty."

284 British Library, Reference Division
Great Russell Street
London WC1B 3DG
(01) 636 1544, x326
attn: Photographic Service

Profile: Black-and-white and color slides made to order, on request, of items in the library's collection, which includes illuminated manuscripts and early printed books. Reference Division composed of Printed Books, Manuscripts, and Oriental Manuscripts and Printed Books.

Photography: Slides, negatives, and large-format transparencies shot by staff photographers. Nikon equipment and Ektachrome ASA 64 used for 35 mm slides, with lighting by electronic flash.

Production: Duplicated in-house on Ektachrome #5071. Contrast controlled. Color corrected "as far as possible." Mounted in plastic.

Documentation: No list available. Identification on slide consists of the library shelfmark. Orientation not marked.

Purchasing: Slides made to order. If an original slide exists, it is duplicated. If not, originals are shot and the customer receives an original slide. No minimum order. Originals priced £5.60 each, duplicates £3.20 each (same prices whether black-and-white or color). Postage added. Prepayment required. Slides shipped within four weeks of receipt of payment. Rush orders filled within one week; surcharge of 100 percent or more. Defective slides replaced; otherwise, no returns accepted. Slides not sent on approval.

Evaluation: Quality 4, documentation 2, service 2.

285 **British Museum**
46 Bloomsbury Street
London SC1B 3QQ
(01) 323 1234
attn: British Museum Publications

Profile: Approximately 900 color slide titles offered by British Museum Publications, a company publishing for the trustees of the British Museum. Fine art and archaeological artifacts in the permanent collection represented.
Photography: Slides shot by staff photographers of the British Museum, in studio when possible.
Production: Produced in a German laboratory, presumably on Eastmancolor film. Mounted in plastic. Sets packaged in plastic sleeves.
Documentation: Free catalog, revised every five years. Artist, title, and date provided. Slides labeled, and sets accompanied by booklets including scholarly commentaries and full identifications. Orientation marked.
Purchasing: Slides sold singly and in sets (60 sets of 12, one set of 36, and one set of six). Single slides priced 35 pence each. Sets of 12 priced £4.00 per set. Discount of 25 percent. Postage added. Pro forma invoice issued; payment required before goods are shipped. Slides kept in stock and shipped within six to eight weeks, "subject to availability." No rush orders accepted. Slides not sent on approval, and no returns accepted. Slides not available from Publications may be ordered from the British Museum's Photographic Department, Great Russell Street. Each department of the museum will send, on request, a list of slides from which duplicates can be ordered.
Other sources: Some British Museum slides distributed by Audio-Visual Library Services, Powdrake Road, Grangemouth, Stirlingshire FK3 9UT, Scotland. A 50-slide set of British Museum objects offered by Dick Blick Co. (36).
Evaluation: Quality 3, documentation 3, service 3.

286 **Christ Church Picture Gallery**
Christ Church
Oxford OX1 1DP
(0865) 242102

Profile: Duplicate color slides offered of selected works from the permanent collection of European paintings and drawings of the fourteenth through eighteenth centuries.
Photography: Slides shot on Ektachrome or Agfachrome by an independent professional photographer.
Production: Duplicated on Agfachrome by Ashmolean Museum Photographic Department. Color corrected and contrast controlled. Mounted in plastic or in Gepe mounts with anti-Newton ring glass.
Documentation: List priced 20 pence. No additional information provided. Orientation not marked.
Purchasing: Slides sold singly and in sets. No minimum order. Set of 50 drawings available. Prepayment in pounds sterling requested. Slides kept in stock and shipped within two to three weeks. Rush orders filled within one to two days. Slides not sent on approval. Returns accepted for exchange or refund within one month. Special photography undertaken; orders filled within one month and customer charged 60 percent of actual cost.
Evaluation: Quality 3 to 4, documentation 3, service 3.

287 **Colchester and Essex Museum**
The Castle, High Street
Colchester
(0206) 744 75

Thirty-four slides available from Woodmansterne (278).

288 **Courtauld Institute Galleries**
 Woburn Square
 London WC1H 0AB
 (01) 580 1015 or 636 2095

Profile: No response to questionnaire. Entry based on fourth edition. Offers 111 slides of European painting, Renaissance through modern, with emphasis on nineteenth century French.
Documentation: Free list. Artist and title provided.
Purchasing: Original slides sold singly, priced 40 pence each.
Evaluation: Three-star rating in the fourth edition. "Slides often out of stock, and back orders very slow. Identification poorly keyed to some slides" (Nancy DeLaurier).

289 **Dulwich Picture Gallery**
 College Road
 London SE21 7AD
 (01) 693 5254

Profile: Approximately 70 color slide titles offered of works in the permanent collection of seventeenth and eighteenth century European painting. New titles occasionally added.
Photography: Slides shot by an independent professional photographer.
Production: Produced by Woodmansterne (278) on Eastmancolor #5384.
Documentation: Free list, revised biennially. Artist's surname and title of work provided. Slides labeled. Orientation marked.
Purchasing: Slides sold singly, 40 pence each. No minimum order. No discounts. Postage added. Payment requested in pounds sterling. Orders shipped within two to three days. Rush orders filled same day; no surcharge. Special photography undertaken by freelance photographer at an average price of £3.00 per slide. Special orders delivered within four weeks.
Evaluation: Quality 3 to 4, documentation 3, service 3.

290 **Fitzwilliam Museum**
 Trumpington Street
 Cambridge CB2 1RB
 (0223) 69501 or 69789
 attn: Manager, Museum Shop

Profile: Offers 77 color slide titles of works in the permanent collection: fine arts, decorative arts, antiquities, manuscripts, coins, and medals. New titles occasionally added.
Photography: Slides shot by the museum's photographer.
Production: Produced by Woodmansterne (278). Mounted in cardboard.
Documentation: Free list. Artist and title given. Slides labeled. Orientation marked.
Purchasing: Slides sold singly, 40 pence each. No minimum order. No discounts. Postage added. Prepayment requested in pounds sterling or by international money order. Slides kept in stock and shipped within one to four weeks. Rush orders filled as quickly as possible; no surcharge. Slides not sent on approval, and no returns accepted. Special photography undertaken on request.
Other sources: Same slides available from Woodmansterne (278), singly or in sets of three or nine.
Evaluation: Quality 3, documentation 2, service 2.

291 **Glasgow Museums and Art Galleries**
 Argyll Street
 Glasgow, Scotland

No response to questionnaire. As of 1979, 87 slide titles offered of paintings and decorative arts. Title and artist of paintings provided on list. Medium and dates supplied as well for decorative arts. Slides sold singly, 18 pence each. Slides available from Miniature Gallery (275) as a set of 209, subsets, or singles (see "Art Slide News" no. 58).

292 **Hunterian Art Gallery**
University of Glasgow
Glasgow, Scotland G12 8QQ
(041) 339 8855, x7431

Profile: Offers 148 color slide titles of the Mackintosh collection, the Mackintosh House, Whistler paintings, and paintings in the general collection (Old Masters and Scottish painters).
Photography: Slides shot by university's photographer on Ektachrome ASA 50.
Production: Duplicated on Ektachrome by the university photographic unit. Color corrected and contrast controlled. Mounted in plastic.
Documentation: Free list. Artist and title provided. Medium supplied for some items, dates only for the Mackintosh collection. Slides keyed to list. Orientation not marked.
Purchasing: Slides sold singly or in sets. No minimum order. Singles 75 pence each. Quantity discount of 10 percent given on orders of more than 100 slides. Postage added. Prepayment required in pounds sterling. Slides shipped within two weeks. Rush orders filled within two days of payment. Slides not sent on approval. Returns accepted for exchange. Special photography undertaken at £2.50 per item; orders filled within four weeks.
Evaluation: Quality 3, documentation 3, service 2 to 3.

293 **Iveagh Bequest**
Kenwood, Hampstead Lane
London NW3 7JR
(01) 348 1286
attn: Publications Officer

Profile: Offers 63 color slide titles of seventeenth to eighteenth century paintings in the permanent collection, as well as views of the architecture of Kenwood and the gardens.
Photography: Color negatives shot by an independent professional photographer.
Production: Produced by Woodmansterne (278). Mounted in cardboard.
Documentation: List available. Slides labeled. Orientation marked.
Purchasing: Slides sold singly for 35 pence each or in sets of three for £1.00. No minimum order. Orders by educational institutions sent postpaid (in lieu of discount). Postage added to other orders. Payment in pounds sterling preferred. Slides kept in stock and shipped within one to two days. Rush orders filled same day. Slides not sent on approval. Returns accepted for exchange only. No special photography undertaken.
Other sources: Three sets of nine slides available directly from Woodmansterne (278).
Evaluation: Four samples sent, two of architecture and two of painting: quality 3, documentation 3. Soft definition noted on architecture slides.

294 **Lambeth Palace Library**
London

Slides of five manuscripts (nos. 3-4, 6, 209, 563, and 1370) offered complete on color microfilm or in selections on color slides by World Microfilms Publications (279). Offers 248 slide titles in sets of 12. Prices based on 75 pence per slide, with quantity discounts given. Identification sheet included with each set, to which slides are keyed. Sample slides of good quality.

295 **Manchester City Art Galleries**
City Art Gallery
Mosley Street
Manchester M2 3JL
(061) 236 9422

Profile: Duplicate color slides offered of objects in the City Art Gallery, the Gallery of Modern Art, the Athenaeum, the Gallery of English Costume, Wythenshawe Hall, and Heaton Hall. British painting of the seventeenth through twentieth centuries featured. European painting of the eighteenth century also represented.

Photography: Slides and large-format transparencies shot on Ektachrome by staff photographers. Nikon camera used for 35 mm work.
Production: Duplicated on Ektachrome. Contrast controlled. Mounted in cardboard.
Documentation: No list available.
Purchasing: Slides sold in sets or singly. Price per slide £2.50. Postage added. Payment in pounds sterling preferred. Prepayment required on overseas orders. Duplicates kept in stock and shipped within one week. No rush orders accepted. Slides not sent on approval, and no returns accepted.
Evaluation: Rated by one advisor (Sara Jane Pearman): quality 3, documentation 3, service 3.

296 **Merseyside County Museum**
William Brown Street
Liverpool L3 8EN
(051) 207 0001
attn: Photographic Services

Profile: Entry based on 1981 brochure. Color slides, black-and-white prints, and color prints offered for sale of objects in the museum's collections and of "the human and natural environment of Merseyside and the surrounding area with a particular emphasis on Liverpool."
Photography and production: No information available, except that slides are mounted in cardboard and are of "projection quality."
Documentation: No list available. Card indexes may be consulted on the premises.
Purchasing: Slides sold singly, £2.40 each. Prepayment required. Slides duplicated within four weeks. New photography carried out within 10 weeks. Order form provided.
Evaluation: No information available.

297 **Museum of London**
London Wall
London EC2Y 5HN
(01) 600 3699

Six sets of nine slides and one set of three slides available from Woodmansterne (278).

298 **National Galleries of Scotland**
17 Ainslie Place
Edinburgh, Scotland EH3 6AU
(031) 556 8921
attn: Postal Sales

Profile: No response to questionnaire. Entry based on fourth edition. More than 500 color slide titles (originals) offered of works in the National Gallery of Scotland, the Scottish National Portrait Gallery, and the Scottish National Gallery of Modern Art. Paintings and drawings of the fifteenth through twentieth centuries and sculpture of the twentieth century represented.
Photography: Shot by a commercial photographer.
Production: Processed by a commercial laboratory. Mounted.
Documentation: Free lists. Only artist's name and title of work supplied on list and with slides. Further information available in published catalogs.
Purchasing: Original slides sold singly, 34 pence each within the United Kingdom, 32 pence each abroad. Educational and quantity discounts given. Postage added. Prepayment required. Returns accepted for exchange only.
Evaluation: Three-star rating in the fourth edition.

299 **National Gallery**
 Trafalgar Square
 London WC2N 5DN
 (01) 839 1912
 attn: Publications Department

Profile: Offers 1,400 color slides (originals and duplicates) of European paintings of the thirteenth to twentieth centuries in the permanent collection. A few slides available of works on loan. New titles occasionally added. Color and black-and-white photographic prints also supplied.
Photography: Slides shot by staff photographers on Agfachrome 50L tungsten film. Schackman automatic camera used with two banks of tungsten halogen lights and color-correction filters. Originals for duplication are 8-by-10-inch transparencies.
Production: Duplicated on various films manufactured by Kodak, Agfa, and Fuji. Color corrected and contrast controlled. Newer production plastic-mounted. Older originals mounted in cardboard.
Documentation: Free catalog and supplements. Artist and title given. Further information available in published catalogs. New slides imprinted on mount, old slides keyed to catalog. Orientation marked on duplicates.
Purchasing: Order form supplied. Originals and duplicates sold singly, 30 pence each. Eleven 12-slide sets also available. No minimum order. Discount of 10 percent given on orders exceeding £50.00 (excluding handling charges). Postage added. Prepayment or purchase order required. Payment accepted in pounds sterling or U.S. dollars; $5.00 bank charge added if payment made in dollars. Slides kept in stock. Orders shipped within one to two weeks of receipt of payment. Rush orders filled within one to three days. Slides not sent on approval. Returns accepted "only in exceptional circumstances." No special photography undertaken.
Evaluation: Quality 3 to 4, documentation 3, service variable (2 to 4).

300 **National Museum of Wales**
 Cathays Park
 Cardiff, Wales CF1 3NP
 (0222) 397951
 attn: Bookshop Manager

Profile: Offers 69 color slide titles of the permanent collection: twenty-four of archaeological artifacts, 39 of art, and six of industry from the Quarrying Museum.
Photography and production: No data provided except that duplicates are made from originals shot by staff photographers. Mounted in plastic.
Documentation: Free list. Full identifications given in most cases for archaeological slides. Artist and title provided for art. Orientation marked.
Purchasing: Slides sold singly, 25 pence each. Postage added. Prepayment in pounds sterling required on overseas orders; pro forma invoices issued. Slides kept in stock and shipped within three to four days. Slides not sent on approval, and returns usually not accepted. Special photography undertaken on request.
Evaluation: One sample slide: quality 3, documentation 3. Color appears too brown.

301 **National Portrait Gallery**
 2 St. Martin's Place
 London WC2H 0HE
 (01) 930 1552
 attn: Publications Department

Profile: Offers 450 slide titles (95 percent color duplicates) of portraits in the permanent collection. British portraits from the fifteenth through twentieth centuries featured. New titles occasionally added.
Photography: Large-format transparencies shot on Kodak film by an independent professional photographer.
Production: Duplicated by a commercial laboratory; processed in West Germany. (According to the fourth edition, produced from negatives by Walter Scott Laboratories.)

Documentation: Mailing list kept. Free list, arranged alphabetically by sitter. Title (sitter) and artist provided on list. Slides labeled with sitter's name, sitter's dates, artist, and date of work. Orientation marked.

Purchasing: Order form provided. Slides sold singly and in sets. Single slides 35 pence each. Minimum order £1.00 or $3.00. Sets of nine slides priced £2.75 per set. "Portraits of Monarchy" (36 slides) priced £10.00. No discounts. Postage added. Prepayment required in pounds sterling or U.S. dollars. Slides kept in stock and shipped within three days. Slides not sent on approval, but sample will be sent on request. Returns accepted only if slides are faulty. Special photography carried out within approximately 12 days; slides priced £6.00 each.

Evaluation: Quality 3 to 4, documentation 3, service 2 to 3.

302 Royal Collection
The Queen's Gallery
Windsor Castle
Windsor
attn: Surveyor of the Queen's Pictures and Works of Art

Profile: No response to questionnaire. Entry based on fourth edition. Offers 72 color slide titles of fifteenth through nineteenth century European paintings and decorative arts. Slides sometimes available of special exhibitions.

Photography: Original transparencies shot in 8-by-10-inch format by a commercial photographer. Works of art photographed in situ.

Production: Produced by Walter Scott Laboratories. Color corrected and contrast controlled.

Documentation: List available.

Purchasing: Slides sold in sets of four, priced 61 pence per set. No discounts. Prepayment required. No returns accepted. Special photography undertaken on request.

Evaluation: Two-star rating in fourth edition.

303 Royal Institute of British Architects
66 Portland Place
London W1N 4AD
(01) 580 5533
attn: Drawings Collection, British Architectural Library

No response to questionnaire. Entry based on a recent order. Original slides offered by special order. No list available. Photographed by Geremy Butler Photographer, London. Slides priced £4.00 each. Service charge of 20 percent added, plus postage and bank charge of £5.00. Prepayment required; pro forma invoice issued by photographer. Quality 4, documentation 2, service 2.

304 Sir John Soane's Museum
13 Lincoln's Inn Fields
London WC1
(01) 405 2107

No response to questionnaire. Three sets of five slides available from Trans-Globe (276) or World Micro-films Publications (279).

305 Southampton Art Gallery
Civic Centre, Commercial Road
Southampton SO9 4XF
(0705) 23855

Profile: Offers 43 color slide titles of paintings in the permanent collection. New titles occasionally added.

Photography: Four-by-five-inch transparencies shot by an independent professional photographer.

Production: Produced by Walter Scott Laboratories. Mounted in plastic.

Documentation: Free list. Artist's surname and title of work given. Slides labeled. Orientation marked.
Purchasing: Slides sold singly. Minimum overseas order 20 slides. Price per slide 45 pence. No discounts. Postage added. Orders invoiced. Payment in pounds sterling preferred. Slides kept in stock and shipped same or next day. Slides not sent on approval. Returns accepted for exchange only. No special photography undertaken.
Evaluation: No information available.

306 **Tate Gallery**
 Millbank
 London SW1P 4RG
 (01) 834 5651
 attn: Publications Department

Profile: Approximately 700 color slide titles offered of works in the permanent collection. British painting and twentieth century art featured. Slides of drawings and sculpture included. New titles occasionally added.
Photography: Eight-by-ten-inch color transparencies shot by staff photographer and an independent professional photographer.
Production: Produced from internegatives in Germany via an English agent. Color corrected and contrast controlled. Mounted in plastic.
Documentation: Free catalog, updated biennially. Artist, title, and date given. Slides labeled. Orientation marked.
Purchasing: Slides sold singly, 30 pence each. No minimum order. Order form included in catalog. No discounts. Postage added. Payment in pounds sterling requested. Prepayment required from individuals. Slides kept in stock and shipped within a few days. Slides not sent on approval, and no returns accepted.
Other sources: Slides of works in the Tate Gallery are no longer available from Sandak. In 1983, Miniature Gallery (275) offered a set of "New Art" from an exhibition at the Tate. Special photography not carried out as a general rule.
Evaluation: Quality 3 to 4, documentation 3 to 4, service variable.

307 **Victoria and Albert Museum**
 South Kensington
 London SW7 2RL
 (01) 589 6371

No response to questionnaire. Slides formerly offered by Miniature Gallery are no longer available. Set of nine Constable paintings offered by Woodmansterne (278). Two 36-slide sets available from Scala (80 or 421): one on William Morris, the other on English furniture.

308 **Walker Art Gallery**
 William Brown Street
 Liverpool L3 8EL
 (051) 227 5234, x2074
 attn: Publications Officer

Profile: Offers 58 color slide titles of major works in the Walker Art Gallery, the Lady Lever Art Gallery at Port Sunlight, and the Sudley Art Gallery. British and European paintings featured.
Photography: Originals are color transparencies.
Production: Duplicated on Ektachrome EPD film without the use of internegatives by Gilchrist Studios, Ltd. Color corrected. Gepe glass mounts (37 slides); others (21 slides) mounted in cardboard.
Documentation: Free list. Artist, artist's dates, title, and date given. Slides labeled. Orientation not marked.
Purchasing: Gepe-mounted slides sold singly at £1.00 each. Cardboard-mounted slides 30 pence each. Postage added. Prepayment required in pounds sterling.
Evaluation: Quality 3, documentation 3, service 2.

309 **Wallace Collection**
Manchester Square
London W1M 6BN
(01) 935 0687

Profile: Offers 231 color slide titles of paintings in the permanent collection. Also, 44 color slide titles available of decorative arts (Sèvres, furniture, armor, majolica, and snuff boxes).
Photography: Large-format transparencies shot by Derek Carver of Miniature Gallery (275).
Production: Slides of paintings produced by Miniature Gallery (275). No information available about production of other slides.
Documentation: Free list. Artist and title provided for paintings. Brief description of object given for decorative arts and date if known.
Purchasing: Slides sold singly, 40 pence each. No minimum order. No discounts. Postage added. Orders filled immediately on receipt of payment in pounds sterling. Slides not sent on approval, and no returns accepted. No special photography undertaken.
Other sources: Slides also may be purchased directly from Miniature Gallery (275).
Evaluation: Quality 3, documentation 3, service 2 to 3.

310 **Wellington Museum**
Apsley House
London

Thirty-six slides offered by Woodmansterne (278), 40 slides by Trans-Globe (276).

311 **William Morris Gallery**
Walthamstow
London

Thirty slides offered by Woodmansterne (278).

312 **York City Art Gallery**
Exhibition Square
York
(0904) 23839

No response to questionnaire. Thirty-six slides offered by Woodmansterne (278).

313 **Yorkshire Museum**
Museum Street
York YO1 2DR
(0904) 29745

Twenty-five slides offered by Woodmansterne (278) of Roman and Viking objects.

OTHER INSTITUTIONS

314 **Arts Council of Great Britain**
105 Piccadilly
London W1V 0AU
(01) 629 9495
attn: Publications

Slide sets issued in conjunction with exhibitions at the Hayward Gallery, London. For instance, in 1984 a set of 12 color slides was selected from the audiovisual program on English Romanesque architecture

associated with the 1066 exhibition. Photography of that set carried out by Triangle Audio-Visual Partnership. Set sold for £3.95, plus 50 pence postage. Introductory essay supplied with set. An earlier exhibition, "In the Image of Man," documented by six slide sets on the Indian vision of the universe from the Ann and Bury Peerless Picture Library. Each set composed of 12 slides plus notes, priced £5.00, plus 60 pence postage.

315 **Centre for Study of Cartoons and Caricature**
The Library
University of Kent
Canterbury CT2 7NU
(0227) 66822, x573

Profile: Eleven sets of black-and-white slides offered of British twentieth century cartoons.
Photography: Negatives shot by staff photographer.
Production: Slides produced in-house. Mounted in Gepe mounts with anti-Newton ring glass.
Documentation: Free list. Sets accompanied by notes. Slides keyed to booklet.
Purchasing: Slides sold in sets. Single slides may be requested. Nine sets of 30 slides each priced £20.00. Two more recent sets priced £28.00 each. Postage of £2.00 added. Prepayment in pounds sterling required on overseas orders. Slides kept in stock and shipped within two to four weeks. No rush orders accepted. Slides sent on approval for £2.00 to cover postage. No returns accepted. No special photography undertaken.
Evaluation: "Perfectly adequate in quality" (*International Bulletin*, 1982, no. 3).

316 **Commonwealth Association of Architects**
The Building Centre
26 Stone Street
London WC1E 7BT
attn: Projects Unit

Profile: No response to questionnaire. Entry based on fourth edition and "Slide Market News" in the *International Bulletin*, 1982, no. 4, and 1983, no. 3. Some 750 slides offered on topics such as environmental design, landscape architecture, building conservation, and building techniques. Sets intended for training architects.
Documentation: Catalog of set listings issued biennially. Sets accompanied by audiocassettes and tapescripts.
Purchasing: Slides sold in sets of 24, priced £20.00.
Other sources: Distributed in the United States by Projected Learning Programs, Inc., P.O. Box 2002, Chico, CA 95927.
Evaluation: No information available.

317 **Design Council**
28 Haymarket
London SW1Y 4SU
attn: Slide Library

Profile: No response to questionnaire. Entry based on fourth edition. Offers 25,000 color slide titles of twentieth century design (and some historical material as well). Architecture, crafts, consumer goods, and textiles included.
Photography: Some originals shot by staff photographer. Other master slides obtained from museums, archives, manufacturers, and other slide libraries.
Production: Duplicated by Kodak on Ektachrome film.
Documentation: Mailing list kept. Catalog available. Slides labeled with catalog information. For architecture, location, building name, architect, and date provided. For products, name, designer, nationality, date, and sometimes manufacturer given. Further information supplied on request.

Purchasing: Slides sold singly and in sets. Singles priced £1.00 each. Sets of 12 slides priced £3.60. Prepayment required. No returns accepted.
Rental: Slides also loaned.
Evaluation: No information available.

318 **National Trust**
 36 Queen Anne's Gate
 London SW1H 9AS
 (01) 222 9251

The National Trust's own slide collection intended for exclusive use of its volunteer lecturers in England and Wales. Commercial slides offered of National Trust properties by Woodmansterne (278) and Trans-Globe (276).

319 **Percival David Foundation of Chinese Art**
 53 Gordon Square
 London WC1H 0PD

Profile: No response to questionnaire. Entry based on fourth edition. Duplicate color slides offered of Chinese ceramics.
Photography: Slides shot by staff photographer on Kodachrome.
Production: Duplicated in-house on Ektachrome. Color corrected and contrast controlled.
Documentation: No catalog available. Lists, issued irregularly, sent on request. Full information supplied on lists. Partial identification (lacking medium and dimensions) given on slide labels.
Purchasing: Slides sold singly, 60 pence each. No discounts. No returns accepted.
Evaluation: Four-star rating in fourth edition.

320 **Trinity College Library**
 Cambridge CB2 1TQ
 (0223) 358201
 attn: Librarian

Profile: "We can provide slides of almost any of our holdings of medieval (and modern) manuscripts."
Photography: Slides, negatives, and large-format transparencies shot by professional photographers at the main university library.
Production: Duplicates made from originals. Color corrected and contrast controlled. Mounted in cardboard.
Documentation: No list available. *Catalogue of Western Manuscripts in Trinity College* by M. R. James (Cambridge, 1901-04) may be consulted. Slides keyed to identifications provided.
Purchasing: Originals and duplicates supplied singly, £2.00 each. No minimum order. Postage added. Prepayment required in pounds sterling. Slides shot or duplicated to order within eight weeks. Rush orders filled in one week; surcharge variable. Slides not sent on approval. Returns accepted "only if mistake is ours."
Evaluation: No information available.

321 **University Colour Slide Scheme**
 Courtauld Institute of Art
 20 Portman Square
 London W1H 0BE
 (01) 935 9292
 attn: Anna Whitworth, U.C.S.S. Librarian

Profile: Duplicate color slides offered by subscription of works exhibited temporarily at museums, galleries, and dealers, mostly in London. European and American painting, drawing, and sculpture featured. Offers 570 new titles annually. "We do not sell slides to order, nor do we duplicate our existing

collection." Suggestions of exhibitions to photograph welcomed, however. Note that the U.C.S.S. is entirely separate from the Courtauld Institute Galleries.

Photography: Slides shot on Agfachrome 50S by the U.C.S.S. librarian or a staff photographer. Objects lit by flash. Master slides occasionally obtained from museums.

Production: Duplicated in-house on Agfachrome 50S. Processed at an Agfa laboratory. Color checked and contrast controlled. Mounted in Agfa plastic mounts.

Documentation: Mailing list kept of subscribers. Identification lists sent with slides. Number keys on slides and lists are the catalog numbers from the exhibition. Artist, title, medium, dimensions, and location/owner supplied. Orientation marked by number placement.

Purchasing: New subscribers being accepted during 1985. Subscription year runs from August 1 to July 31. Slides sold only in groups of 135 slides for £80.00, 270 slides for £160.00, or 560 slides for £315.00 (per annum). Surface postage included. Airmail, if requested, £15.00 extra. Prepayment in pounds sterling requested. Lists of new offerings mailed quarterly to subscribers. Orders filled within four to eight weeks. Rush orders accepted if possible. Slides not sent on approval. Returns accepted only if faulty. "All subscribers are required to sign a copyright declaration, undertaking to use the slides for educational purposes only, and not to have them copied or used by other than authorised staff."

Evaluation: "I would rate them excellent" (Helen Chillman).

322 **University of Edinburgh**
 Department of Fine Art
 16-30 George Square
 Edinburgh EH8 9JZ
 (031) 667 1011

Profile: Entry based on 1983 letter. Two small sets of original color slides offered: five slides of Raeburn paintings and six slides of miscellaneous paintings and sculpture.

Photography: Slides shot by the department photographer.

Documentation: Slide sets accompanied by information card. Artist, subject, date (if known), medium, and dimensions given.

Purchasing: Slides sold in sets only. Raeburn set £3.00. Miscellaneous set £3.60. No discounts given.

Evaluation: Sample set sent: quality 3, documentation 3.

DENMARK

323 **Thorvaldsens Museum**
Porthusgade 2
1213 K Copenhagen
(01) 121532

Profile: Offers 24 color slides (originals and duplicates) of works in the permanent collection: ten of sculpture by Thorvaldsen, eight of paintings by Danish artists, three of the architecture of the museum, and two miscellaneous. No new titles to be added.
Photography: Slides shot on Kodachrome by an independent professional photographer.
Production: Duplicated from originals. No attempt made to correct color.
Documentation: Free list. Slides labeled in English.
Purchasing: Both originals and duplicates sold singly or in sets. Single slides 4.00 kroner each. Twelve slides 40.00 kroner. Postage added. Slides kept in stock and shipped within one week. Slides sent on approval. Special photography undertaken for 150.00 kroner per item.
Other sources: Slides also offered by Saskia (78).
Evaluation: No information available.

EGYPT

COMMERCIAL VENDORS

324 **Ramses Color**
Studio 7
208, El Ahram Street
Cairo
855338

No response to questionnaire. Information supplied by an advisor, who last ordered in mid-1983. Slides offered of Egyptian art, including objects in the Egyptian Museum, Cairo.

FINLAND

MUSEUMS

325 **Suomen Rakennustaiteen Museo**
(Museum of Finnish Architecture)
Puistokatu 4
0140 Helsinki 14

Profile: No response to questionnaire. Entry based on fourth edition and "Slide Market News" in the *International Bulletin*, 1980, no. 1. Twentieth century Finnish architecture documented by 10,000 original slides, from which duplicates can be ordered. Black-and-white slides and prints also offered.
Photography: Photographed mainly by commercial photographers, also by architects and students.
Production: Duplicated by a local laboratory.
Documentation: No list available. Slides labeled, in Finnish, with architect's name, name of building, and date. No further information can be supplied.
Purchasing: Slides sold singly, 13.00 markkaa. No discounts. Duplicates made to order. No returns accepted.
Other sources: Slides also offered by Saskia (78) of some architectural renderings of works by Eliel Saarinen.
Evaluation: No current information available.

326 **Suomen Taideaketemia**
(Finnish Art Academy)
Kaivokatu 2-4
Helsinki

Profile: No response to questionnaire. Entry based on "Slide Market News" in the *International Bulletin*, 1980, no. 1. Offers 150 slides of Finnish painting and some sculpture from the early nineteenth century to the 1940s.
Photography and production: No information available, except that slides are sold in Gepe glass mounts.
Documentation: List in Finnish. Slides labeled.
Purchasing: Slides sold singly or as a set. Price per slide 5.00 markkaa.
Evaluation: No current information available.

FRANCE

COMMERCIAL VENDORS

327 Diapofilm
1, rue Villaret-de-Joyeuse
75854 Paris
(01) 622 17 83 or 754 15 52 or 754 26 72

Profile: No response to questionnaire. Entry based on fourth edition and "Slide Market News" in the *International Bulletin*, 1981, no. 4, and 1982, no. 1. Slides and filmstrips offered for school use, documenting many subjects in addition to art and architecture history. Many French buildings represented.
Photography and production: Shot by staff photographers or obtained from agencies. Printed on Eastmancolor film; eventual change to low-fade film announced in 1982.
Documentation: Free catalog, in French, issued annually. Sets described briefly in catalog, but individual slides not listed. Further information about contents of sets available on request. Sets accompanied by a booklet of commentaries on the slides.
Purchasing: Slides sold in sets of 12, 20, 24, or 30. Per-slide cost 4.50 francs (1981). Quantity discount. Order form provided. Prepayment required. Airmail postage included in prices. Slides kept in stock and shipped within three days.
Other sources: Distributed by Gould Media (44).
Evaluation: No current information available.

328 Documentation Photographique de la Réunion des Musées Nationaux
89, avenue Victor-Hugo
75116 Paris
(01) 500 75 57

Profile: Commercial slides sold by Services Techniques et Commerciaux photographed and edited by the Documentation Photographique de la Réunion des Musées Nationaux. In addition, single duplicate slides made to order of objects in the collections of member museums. Ten thousand original color slides on file may be duplicated. New titles continually added. Subjects covered include prehistoric objects; ancient art of the Near East, Egypt, Greece, Etruria, and the Roman Empire; early Christian and Byzantine art; medieval art; Western art of the fifteenth through twentieth centuries; Islamic art; Oriental art; African art; Oceanic art; and art of Central and South America. Complete list of member museums available on request. Among those included are the following:

Musée National des Arts Africains et Océaniens, Paris

Musée National des Arts et Traditions Populaires, Paris

Musée Guimet, Paris

Musée du Louvre, Paris

Musée d'Orsay, Galerie du Jeu de Paume, Paris

Galeries Nationales du Grand Palais, Paris

Orangerie des Tuileries, Paris

Musée des Monuments Français, Paris

Musée National Eugène Delacroix, Paris

Musée Gustave Moreau, Paris

Musée Auguste Rodin, Paris

Musée des Thermes et de l'Hôtel de Cluny, Paris

Musée National du Château de Fontainebleau

Musée National du Château de Versailles

Photography: Large-format transparencies shot on Ektachrome #6117 by staff photographers. Sinar 5-by-7-inch camera used with electronic flash.

Production: Duplicated in-house on Ektachrome #5071. Color corrected and contrast controlled.

Documentation: Catalog 50 francs; price to increase in 1985. Written in French, updated every eight years. Slides labeled in French. Orientation marked.

Purchasing: Order form provided. Slides sold singly, 20.00 francs each. No minimum order. Postage added. Prepayment required in French francs; pro forma invoice sent. Slides duplicated to order and shipped within 10 days of receipt of payment. Rush orders not accepted. Slides not sent on approval, and no returns accepted.

Evaluation: Quality 3, documentation 2 to 3, service 3.

329 **Gaud, Georges**
 11, rue Brulard
 Moisenay-le-Petit
 77950 Maincy
 438 94 60

Profile: No response to questionnaire. Entry based on fourth edition and 1981 correspondence. Color slides offered of French art and architecture from prehistory to the eighteenth century.

Photography: Shot by G. Gaud "in the best possible conditions with the equipment best suited for circumstances."

Production: As of 1981, printed on Eastmancolor #5381; no intention at that time to change to low-fade film.

Documentation: Free list of set titles.

Evaluation: "Good original photography reproduced on unstable film. No response to a 1982 order we sent" (Norine Cashman).

330 **La Bibliovision-Rencontre**
 73, rue Albert
 75013 Paris

Profile: No response to questionnaire. Entry based on fourth edition. Slides offered of general art history, with emphasis on French art and architecture.

Photography and production: No information available; possibly on Eastmancolor film.

Documentation: Catalog available.

Purchasing: Slides sold in sets.

Evaluation: No information available.

331 **La Goelette**
 10, rue Jean Dolfuss
 75018 Paris

Profile: No response to questionnaire for this edition or fourth edition. Slides of French architecture and art offered to tourists in France. Mail orders perhaps not accepted.
Photography and production: No information available; possibly on Eastmancolor film.
Evaluation: Quality 3 when new; film unstable.

332 **Publications Filmées d'Art et d'Histoire**
 9-15, rue Carvès
 92120 Montrouge

Profile: No response to questionnaire. Entry based on fourth edition and 1984 correspondence. Subsidiary of Hamelle Laboratories, probably the largest photographic processing company in Paris. Includes Publislides. Sets of color slide titles offered of collections and exhibitions in French museums and of French architectural monuments.
Photography: Shot by staff photographers.
Production: Printed on Eastmancolor #5381. Although change to low-fade Eastmancolor film for new production has been announced, slides presently available are on unstable film. At this time (1984), production of old titles on low-fade film is not planned. Mounted in cardboard.
Documentation: Free catalogs, in French. Set titles listed. Lists of contents of sets available on request. Slides briefly labeled in French. Orientation marked. Some sets accompanied by booklets; English translations available.
Purchasing: Slides sold in sets of 24 or 36 slides only.
Other sources: Distributed in the United States by Prothmann (74).
Evaluation: Quality 3 when film is fresh, documentation 3.

333 **Quenneville, Michel**
 61, rue des Trois Frères
 75018 Paris
 (01) 259 62 08

No response to questionnaire. Entry based on 1983 information. Independent photographer will shoot slides to order for institutions or individuals. He has photographed in the Bibliothèque Nationale, Paris, and other museums. Samples sent on request.

334 **Services Techniques et Commerciaux de la Réunion**
 des Musées Nationaux
 10, rue de l'Abbaye
 75006 Paris
 (01) 329 21 45
 attn: Monsieur le Directeur

Profile: No response to questionnaire. Entry based on fourth edition and 1984 catalog. Also known as DiaLouvre and Louvre Audiovisuel. Slides offered in addition to videocassettes, super 8 films, and microfiche. Works in the Louvre and other French national museums represented. Temporary exhibitions documented in sets classified as "séries variées." Large-format transparencies rented for reproduction.
Photography: Thirteen-by-eighteen-centimeter color transparencies shot on Ektachrome by photographers employed by the Réunion des Musées Nationaux.
Production: Printed from internegatives on low-fade Eastmancolor film (since 1981). Mounted in cardboard. Versailles and Fontainebleau sets produced elsewhere.
Documentation: Mailing list kept of customers interested in exhibition coverage. Free catalog, revised 1984. Artist and title listed. Slides labeled. Since January 1983, label information consists of artist, artist's dates if necessary, title, date if known, location, dimensions, and materials. "Diafiche" sets of 10 slides

accompanied by text in French, English, German, and Spanish. Front of slides indicated by printed name of museum.

Purchasing: Slides sold singly or in sets. Some slides available only in sets. Single slides offered only of objects in the Louvre, the Musée d'Orsay (Jeu de Paume), and the Orangerie des Tuileries. Prices for overseas customers: 3.75 francs each for single slides, 11.25 francs for a set of six slides, 23.22 francs for "Diafiche" sets of ten slides. Large sets (18, 30, 42 slides) also offered. Minimum order 54.00 francs. Airmail postage added. Prepayment required in traveler's checks, money order, or check.

Evaluation: Quality 3, documentation 3, service 2.

MUSEUMS

335 Centre Hospitalier de Beaune
Avenue Guigone de Salins
21206 Beaune
(80) 22 53 53
attn: Régisseur d'Avances

Profile: No response to questionnaire. Entry based on 1984 order. Two sets of color slide titles offered of Rogier van der Weyden's polyptych in the Hôtel-Dieu. One set of the architecture of the Hôtel-Dieu also available.

Photography and production: Produced by La Goelette (331), apparently on Eastmancolor #5381.

Documentation: Slides labeled in French.

Purchasing: Slides sold in sets of six (11.00 francs), ten (17.00 francs), or thirty (50.00 francs). Largest and smallest sets are of the polyptych. Postage added. Prepayment required.

Evaluation: Quality 3, documentation 3, service 1.

336 Galeries Nationales du Grand Palais
Avenue de Selves
75008 Paris

Exhibitions documented by Services Techniques et Commerciaux. As of 1984, three sets of 16 color slides offered: "Le Siècle de Charles V," "Fantin-Latour," and "Édouard Manet." These sets co-produced by the Réunion des Musées Nationaux and the Centre National de Documentation Pédagogique. Booklets of 16-20 pages included. Sets priced 65.00 francs each when ordered from Services Techniques et Commerciaux (334).

337 Musée Bonnat
5, rue Jacques-Laffitte
Bayonne
(59) 08 52
attn: Librairie

Profile: Set of 12 color slides offered of paintings in the museum's collection.

Photography: Shot by a photographer from the Centre Régional de Documentation Pédagogique de Bordeaux.

Production: No data provided, except that this set is newly produced (mid-1984).

Documentation: Free list; artist and title given. Set accompanied by a booklet.

Purchasing: Set of 12 slides sold for 25.00 francs plus postage.

Evaluation: No information available.

338 **Musée Conacq-Jay**
 25, boulevard des Capucines
 75002 Paris
 (01) 742 94 71

No response to questionnaire. A few single slides offered by Burstein (30).

339 **Musée de Cluny**
 6, place Paul Painlevé
 75005 Paris
 (01) 325 62 00

Two sets offered by Services Techniques et Commerciaux (334): ten slides of the Unicorn Tapestries and six slides of art objects of the twelfth to fifteenth centuries. Single slides duplicated to order by the Documentation Photographique de la Réunion des Musées Nationaux (328). Two sets of 20 slides offered by Publications Filmées d'Art et d'Histoire (332): one of medieval tapestries and one of enamels, miniatures, and stained glass.

340 **Musée des Antiquités Nationals**
 Château de Saint-Germain-en-Laye
 78100 Saint-Germain-en-Laye
 (1) 451 53 65

Set of 10 slides offered by Services Techniques et Commerciaux (334) of Celtic art in Gaul.

341 **Musée National des Arts Africains et Océaniens**
 293, avenue Daumesnil
 75012 Paris
 (01) 343 14 54

Three sets of six slides offered by Services Techniques et Commerciaux (334). Single slides duplicated to order by the Documentation Photographique de la Réunion des Musées Nationaux (328).

342 **Musée National des Arts et Traditions Populaires**
 6, route du Mahatma Gandhi
 75116 Paris
 (01) 747 69 80

Two sets of six slides offered by Services Techniques et Commerciaux (334). Single slides duplicated to order by the Documentation Photographique de la Réunion des Musées Nationaux (328).

343 **Musée des Beaux-Arts**
 Palais Longchamp
 13004 Marseille
 (91) 622 117

A small selection of single slides offered by Burstein (30).

344 **Musée des Beaux-Arts**
 20, quai Emile Zola
 35100 Rennes
 (99) 30 83 87

Profile: Color slides (originals and duplicates) offered of the permanent collection. Twenty-four paintings listed, Renaissance to twentieth century. New titles occasionally added.

Photography: Transparencies (35 mm and large format) shot by staff photographer on Ektachrome using electronic flash. Cameras employed include a Mamiya 6 by 7 inches, Linhof 4 by 5 inches, and Contax 35 mm.

Production: Duplicated on Ektachrome #5071 by L.C.B., Rennes. Color corrected and contrast controlled. Mounted in plastic.

Documentation: Free list, in French, revised biennially. Four sets of six slides listed; artist, artist's dates, and title given. Slides labeled in French. Orientation marked.

Purchasing: Originals and duplicates sold singly or in sets. Limited edition sets available. No minimum order. Price per slide 5.60 francs plus postage. Set of six slides priced 11.30 francs plus postage. Slides shot or duplicated to order. No rush orders accepted. Slides not sent on approval. Returns accepted for exchange only.

Other sources: Single slides also offered by Burstein (30).

Evaluation: Rated by one advisor (Sara Jane Pearman): quality 1, documentation 2, service 1.

345 Musée des Beaux-Arts et de la Céramique
26 bis, rue Thiers
76000 Rouen
(35) 71 28 40

No response to questionnaire. Single slides available from Burstein (30).

346 Musée d'Orsay
Galerie du Jeu de Paume
Place de la Concorde
75001 Paris

No response to questionnaire. Slide sets (nine sets of 10 slides, 16 sets of six slides, one set of 42) offered by Services Techniques et Commerciaux (334) of Impressionist paintings. Single slides (187) also offered. Single slides duplicated to order by the Documentation Photographique de la Réunion des Musées Nationaux (328). Set of 100 slides also available from Aguilar (469).

347 Musée du Louvre
Palais du Louvre
Place de Carrousel
75001 Paris

Profile: No response to questionnaire. No mail order slides sold directly by museum. Slides offered by Services Techniques et Commerciaux (334): fifteen sets of 10 slides of paintings, seven sets of six slides of paintings, approximately 275 single slides of paintings, nine sets of six slides of Egyptian antiquities, seven sets of six slides of Greek and Roman antiquities, one set of six slides of Near Eastern antiquities, one set of six slides of art objects of the ninth through nineteenth centuries, two sets of six slides of sculpture, and four sets of 42 slides. Sets may not be broken, but many slides in sets are also offered as singles. Single slides duplicated to order by the Documentation Photographique de la Réunion des Musées Nationaux (328).

Other sources:

Aguilar (469) — two sets of 100 slides

Burstein (30) — miscellaneous single slides

Dick Blick Co. (36) — set of 50 slides

F. G. Mayer (61) — miscellaneous single slides

Miniature Gallery (275) — 246 French paintings listed in "Art Slide News" no. 52, available singly (minimum 20 slides). Thirty-eight slides of Dutch and Flemish paintings offered as a set (September 1984 list)

Sandak (77) — set of 59 slides of paintings offered, also available singly

Saskia (78)—subjects documented include Greek sculpture, Renaissance sculpture, early Flemish paintings, works by Rubens and Rembrandt, and seventeenth to nineteenth century French painting

Stoedtner (373)—various slides available in sets or singly

Wolfe Worldwide Films (93)—22 slides

348 Musée Fabré
13, rue Montpellieret
34000 Montpellier
(67) 66 06 34

No response to questionnaire. Single slides offered by Burstein (30).

349 Musée Guimet
6, place d'Iena, avenue d'Iena
75016 Paris
(01) 723 61 65

No response to questionnaire. Two sets of six slides of Indian art offered by Services Techniques et Commerciaux (334). Single slides duplicated to order by the Documentation Photographique de la Réunion des Musées Nationaux (328).

350 Musée Marmottan
2, rue Louis Boilly
75016 Paris
(01) 224 07 02 or 224 07 03

No response to questionnaire. Entry based on 1984 correspondence and order. Offers 29 color slides of works in the permanent collection, sold in sets of five or six. List available on request; artist and title given. Artists represented are Monet, Morisot, Pissarro, and Renoir. Also one set of six slides offered of paintings in the Wildenstein collection (fifteenth century works). Set of six slides 20.00 francs. Prepayment required. "Color rather garish" (Norine Cashman).

351 Musée National d'Art Moderne
Centre National d'Art et de Culture G. Pompidou
Place Beaubourg, rue St.-Merri
75191 Paris
(01) 277 12 33
attn: Service de Documentation Diathèque

Entry based on recent brochure. Approximately 15 color slide sets offered on individual modern artists. Sets of 24 slides priced from 35.00 to 70.00 francs (reflecting, presumably, increasing production costs). Commentaries in French provided. Set produced in 1984 to document the Bonnard exhibition; good slides accompanied by full identifications.

352 Musée National du Château de Fontainebleau
77300 Fontainebleau
(1) 422 27 40

No response to questionnaire. Set of 30 slides offered by Services Techniques et Commerciaux (334). Single slides made to order by the Documentation Photographique de la Réunion des Musées Nationaux (328). Three sets of 20-21 slides available from Publications Filmées (332).

353 **Musée National du Château de Versailles**
 7800 Versailles
 (1) 950 58 32

No response to questionnaire. Two sets of 30 slides offered by Services Techniques et Commerciaux (334). Single slides duplicated to order by the Documentation Photographique de la Réunion des Musées Nationaux (328). Four sets of 21-22 slides available from Publications Filmées (332). Five sets totaling 95 slides offered by Haeseler Art Publishers (46). Set of 85 original slides sold by Hartill Art Associates (4), also available singly as duplicates. Single slides listed in Rosenthal Art Slides (76) catalog.

354 **Musée National Message Biblique**
 Marc Chagall
 06000 Nice

Four sets of six slides offered by Services Techniques et Commerciaux (334). Single slides duplicated to order by the Documentation Photographique de la Réunion des Musées Nationaux (328); few titles available.

355 **Musée Picasso**
 Paris

Six sets of six slides offered by Services Techniques et Commerciaux (334), including one set of slides of paintings from the Picasso Donation by Matisse, Degas, Renoir, Modigliani, and H. Rousseau. Also, 160 slides of works by Picasso exhibited at the Museum of Modern Art in New York during 1980, including many from the Musée Picasso, offered by Sandak (77) as a set; most slides in the set sold singly as well.

356 **Musée Rolin**
 3, rue des Bancs
 71400 Autun
 (85) 52 09 76

Profile: Offers 30 color slides of Gallo-Roman antiquities, medieval sculpture, and fifteenth to sixteenth century art. New titles continually added (10 in 1984).
Photography and production: Photographed and produced by "Atelier du Regard," Orsay. Color corrected and contrast controlled. Mounted in cardboard.
Documentation: Free list, in French. Orientation marked.
Purchasing: Slides sold singly or in sets. No minimum order. Price per slide 1.50 francs. Postage added. Orders filled within one month. Returns accepted for exchange only. Slides made to order for 2.00 francs each.
Evaluation: No information available.

357 **Musée d'Unterlinden**
 1, place d'Unterlinden
 68000 Colmar
 (89) 41 89 23

A few single slides offered by Burstein (30). Set of slides of the Isenheim Altarpiece listed in "Art Slide News" no. 50 of Miniature Gallery (275).

358 **Orangerie des Tuileries**
 Place de la Concorde
 75001 Paris

Slides offered by Services Techniques et Commerciaux (334). One set of 10 slides of Monet's waterlilies available. The collection of Jean Walter and Paul Guillaume documented by one set of 10 slides, one set of

18 slides, one set of 42 slides, and approximately 140 single slides. Single slides also duplicated to order by the Documentation Photographique de la Réunion des Musées Nationaux (328).

OTHER INSTITUTIONS

359 Bibliothèque Nationale
58, rue de Richelieu
75084 Paris
(01) 261 82 83
attn: Service photographique

Profile: Duplicate color slides offered of the library's holdings, including illuminated manuscripts, coins and medals, jewelry, etc.
Documentation: No catalog. Slide sets listed on publications list: two sets of nine slides offered of medical manuscripts, and 33 sets of six or nine slides offered of objects in the Cabinet des Médailles.
Purchasing: Ready-made slides sold in sets of six for 30.00 francs or nine for 43.00 francs (postpaid). Single slides (black-and-white) duplicated to order for 12.00 francs each (minimum 30.00 francs), and single slides (color) duplicated to order for 17.00 francs each (minimum 52.00 francs). Prepayment required; pro forma invoice issued.
Other sources: Ten sets of 20 slides offered by Publications Filmées (332) on unstable film. Selected single slides available from Burstein (30). See also M. Quenneville (333).
Evaluation: Single slides: quality 3, documentation 2, service 2 to 3. "A 1983 order of 13 slides took four months to fill, but the slides were worth waiting for" (Norine Cashman).

360 Bibliothèque Publique d'Information
Centre Georges Pompidou
(01) 277 12 33
attn: Service Diffusion

Profile: At present, one set of 24 slides offered, entitled "Places d'Europe," documenting the 1984 exhibition at the library. Public squares in Europe from the sixteenth to twentieth centuries represented. Most slides in color; several black-and-white included.
Photography: Shot by independent professional photographers.
Production: Duplicated by Publimod, Paris, on Ektachrome #5071. Color corrected. Black-and-white slides produced on Kodak film #5302. Mounted in cardboard.
Documentation: Set accompanied by brief commentary on each slide, in French, and a bibliography.
Purchasing: Slides sold as a set, priced 70.00 francs.
Evaluation: Quality 3, documentation 3.

361 Centre de Création Industrielle
Centre Georges Pompidou
75191 Paris
attn: Audio-Visual Publications

Profile: No response to questionnaire. Entry based on Miniature Gallery's "Art Slide News" no. 57 and a 1984 brochure from the Centre Georges Pompidou. Thirteen slide sets (each 24 slides) offered by C.C.I. and also distributed by Miniature Gallery (275). Three sets offered of French posters, eight of architecture and urbanism, one of color theory, and one entitled "Design: 1925."
Photography and production: Some slides produced with an image larger than the standard 35 mm format.
Documentation: Sets accompanied by text in French and English. Color theory set documentation also available in French/German.
Purchasing: From C.C.I., sets priced 60.00 to 70.00 francs. From Miniature Gallery, sets priced £10.80 each (as of November 1982).
Evaluation: Quality 3, documentation 3 to 4, service 3. Oversized slides require mounts with a larger aperture.

362 **Centre National de Documentation Pédagogique**
 29, rue d'Ulm
 75005 Paris
 attn: Département Promotion et Vente

No response to questionnaire. Slides offered covering the history of art. Catalog available. Three sets documenting exhibitions at the Galeries du Grand Palais co-produced with Services Techniques et Commerciaux (334). Distributed in the United States by FACSEA (244).

363 **Imago**
 Centre de Documentation sur l'Art Engagé
 4, passage Sainte Avoie
 75003 Paris
 or
 162, boulevard du Montparnasse
 75014 Paris

No response to questionnaire. Information supplied by an advisor. Slides offered of modern art. Dada featured.

GERMANY (EAST)

COMMERCIAL VENDORS

364 **VEB DEFA Kopierwerke Berlin**
1058 Berlin
Milastrasse 2
West Germany
attn: Aussenhändel

Profile: East German company with office in West Berlin, to which orders from Western countries should be directed. No response to questionnaire. Entry based on a 1984 order and 1981-82 brochure. Duplicate color slides offered of architecture in Eastern Europe. Several sets available of art in museums, notably those in East Berlin and Dresden.
Documentation: Information booklet and prospectus available for 0.10 marks and 0.30 marks, respectively (in postal coupons). Sets accompanied by commentaries in German. Artist, artist's dates and places of birth and death, title of work, materials, dimensions, and museum accession number provided. For architecture, only building name given; other information must be extracted from text.
Purchasing: Slides sold in sets. Ninety-seven sets of 25 slides available, priced 12.50 marks per set. Also, 184 sets of 9-12 slides offered (no price stated). Prepayment required.
Evaluation: Based on sample order quality 1 to 2, documentation 2 to 3, service 1.

365 **VEB IMAGO Strahlbild Radebeul**
8122 Radebeul 2
Postschliessfach 57

Entry based on brochure sent by advisor Dr. W. Krause. Color slides offered of art and architecture in East Germany. Slides sold in sets of 6 or 12. Sets of six priced 4.50 marks per set. According to Dr. Krause, produced on film manufactured by ORWO; slides fade quickly. Brochure lists set titles in German.

MUSEUMS

366 **Staatliche Kunstsammlungen Dresden**
8012 Dresden
Georg-Treu Platz 1
Albertinum, Postfach 450
(051) 4 46 11

No response to questionnaire. Set of 12 slides of paintings by Old Masters offered by VEB DEFA (364). Slides also available singly or included in sets from Stoedtner (373). Slides of paintings in Dresden no longer supplied by Blauel.

367 **Staatliche Museen zu Berlin**
 1020 Berlin
 Bodestrasse 1-3
 (02) 220 03 81
 attn: Generaldirektion

No response to questionnaire. Three sets of 25 slides offered by VEB DEFA (364): one each of the Antikensammlung, the Ägyptisches Museum, and the Vorderasiatisches Museum. A set of 12 slides devoted exclusively to the Pergamon Altar available. Works in the Gemäldegalerie, the Nationalgalerie, and the Kunstgewerbemuseum Köpenick represented by one set of 12 slides per museum. Selected slides of the Staatliche Museen collections, particularly the Pergamon Altar, also offered by DeMarco (34).

GERMANY (WEST)

COMMERCIAL VENDORS

368 **Blauel Kunst-Dias**
D-8033 Planegg bei München
Egenhofenstrasse 8
Postfach 1105
(089) 9 59 64 41
attn: Jürgen Hinrichs

Profile: Offers 700 color slide titles of European painting. Collections in Munich documented including the Alte Pinakothek, Neue Pinakothek, Staatsgalerie Moderner Kunst, and Schack-galerie. Slides also available of works in the Städelsches Kunstinstitut, Frankfurt-am-Main, and the Staatliche Kunsthalle Karlsruhe. Slides of paintings by Emil Nolde also offered. Few new titles to be added. Slides formerly available of paintings in other museums are not being restocked.
Photography: Color negatives (9 by 12 cm) shot by a professional photographer on Kodak Vericolor II professional film #4108, ASA 100. Sinar camera with Aponar lenses used with lighting by tungsten lamps.
Production: Printed on Kodak Vericolor slide film #5072. Process C41 used with 10-minute second water wash. Color corrected. Contrast controlled "if necessary." Slides bound in 2-by-2-inch glass (lighter weight plastic-and-glass mounts to be phased in).
Documentation: Free catalog, in German, infrequently revised. Slides labeled in German with full information.
Purchasing: Slides sold singly, priced 3.00 Deutsche Mark each (3.50 Deutsche Mark for Nolde slides). No minimum order. Postage and bank charges added. Slides kept in stock, and orders shipped immediately. Rush orders accepted; no surcharge. Slides not sent on approval, and no returns accepted.
Other sources: Distributed by Mini-Aids (65).
Evaluation: Quality 3 to 4, documentation 3, service variable (2 to 4).

369 **Film & Bild / F. Heinze-von Hippel**
D-1000 Berlin 20
Charlottenburger Chaussee 51-55
(030) 305 11 14
attn: H. Heinze

Profile: No response to questionnaire. Entry based on form letter and list received in 1984. Offers 113 color slide titles of paintings in the Gemäldegalerie of the Staatliche Museen Preussischer Kulturbesitz, Berlin. Seven sets of six slides of items in the Antikenmuseums also offered. New titles to be added. In addition to slides, other audiovisual products sold by this company.

Photography and production: No information available.
Documentation: Free list, in German. For the Gemäldegalerie, artist and title provided, plus museum inventory number. For the Antikenmuseums, complete identifications given, except dimensions.
Purchasing: Slides sold singly, priced 1.50 Deutsche Mark. Postage added. Quantity discount: more than 100 slides 1.00 Deutsche Mark each. Unlisted slides available for 19.00 Deutsche Mark each. Prepayment required.
Evaluation: Based on sample order quality 3, documentation 2, service 3.

370 **Jünger Audio-Visuell**
 D-6050 Offenbach/Main
 Schumannstrasse 161
 Postfach 580
 (0611) 83 30 03

Profile: No response to questionnaire. Entry based on fourth edition and 1978-79 catalog. Slides sold among other audiovisual materials, including super-8 films and videocassettes. Art history is one of many subjects covered. Slides available of ancient art, European architecture from the early Christian era to the Baroque, and European painting from the tenth to twentieth centuries.
Photography and production: Slides produced from 6-by-9-inch color negatives. Mounted in plastic and glass. Shipped in plastic boxes.
Documentation: Lavish general catalog, in German, 262 pages (of which five are devoted to art history slides). Sets briefly described, but contents not listed slide by slide. Sets accompanied by German text. At extra cost, tapes optionally available with some sets. Orientation marked.
Purchasing: Art history slides sold in sets ranging in size from 20 to 80 slides. Smallest set priced 41.00 Deutsche Mark, largest 104.00 Deutsche Mark. Discount of 10 percent given on purchase of an entire series.
Other sources: Distributed by Mini-Aids (65).
Evaluation: No current information available. "Slides we purchased in the late 1970s were on unstable film, and the quality of the slides was fair at best even when they were new" (Norine Cashman).

371 **Postel, Elsa**
 Diapositiv-Verlag
 D-1000 Berlin 10
 Postfach 100527

No response to questionnaire. Free lists, in German, received from the Staatliche Museen Preussischer Kulturbezitz, Berlin. Slides offered of selected items in the following departments of the state museums:

 Museum für Deutsche Volkskunde

 Museum für Indische Kunst

 Museum für Islamische Kunst

 Museum für Ostasiatische Kunst

 Museum für Vor- und Frühgeschichte

 Nationalgalerie

 Skulpturengalerie

Completeness of identifications on lists varies. Most slides offered in series of six; some listed as single slides.

372 **Praun Dia**
 D-8000 Munich 71
 Walliserstrasse 22

Profile: No response to questionnaire for this edition or the fourth edition. Entry based on catalog received in late 1978. Color slides of works in German museums offered, as well as of architectural monuments in

Germany. Praun Dia slides sold in museum shop of the Antikensammlungen und Glyptothek in Munich (1983).

Photography and production: No information available on film type. Glass-mounted on request.

Documentation: Free catalog, in German. Each slide briefly identified in catalog; for paintings, artist and title given and sometimes date. Artist's name and dates, title of work, date, dimensions, and materials provided with slides.

Purchasing: Slides sold in 80 sets of six. Approximately 700 single slides also offered. Sets 6.00 Deutsche Mark each; single slides 1.30 Deutsche Mark each or 1.50 Deutsche Mark each, for glass-mounted slides.

Evaluation: No current information available.

373 **Stoedtner, Dr. Franz**
 D-4000 Düsseldorf 1
 Feuerbachstrasse 12-14
 Postfach 25 0162
 (0211) 31 41 56
 attn: Heinz Klemm

Profile: No response to questionnaire. Entry based on fourth edition, a catalog from the late 1970s, and a leaflet dated January 1985. Company founded 1895. Also known as Stoe-Dia and Institut für Wissenschaftliche Projektion. History of art and architecture extensively covered in black-and-white and color slides. German art and architecture featured.

Photography and production: Kodak film used, type unknown. Color slides mounted in plastic, black-and-white slides in cardboard. Slides mounted in glass on request.

Documentation: General catalog, in German (1981). Each slide listed in catalog, arranged in sets. Identifications vary in completeness. Sets accompanied by one to two pages of text in German. Color slides labeled in German.

Purchasing: Slides sold in sets. Single slides from sets may be ordered as noted in catalog. Price per slide in sets 2.15 Deutsche Mark for color, 1.40 Deutsche Mark for black-and-white. Single slides 2.60 Deutsche Mark for color, 1.90 Deutsche Mark for black-and-white. Quantity discounts given on orders of whole sets of 5 percent on 250.00 Deutsche Mark worth of goods. Postage added to orders totaling less than 250.00 Deutsche Mark. Extra charge applied to orders of fewer than 20 slides and orders that do not furnish catalog numbers. Prepayment from pro forma invoice required. Whole sets of color slides sent on approval; at least 50 percent must be purchased. Single slides not sent on approval.

Evaluation: Two-star rating in the fourth edition. "Color slides purchased on several occasions were marred by small purple spots. High contrast and soft resolution were also noted" (Norine Cashman).

374 **Vista Point Verlag**
 D-5000 Cologne 1
 Gereonshof 30
 (0221) 13 34 02
 attn: Andreas Schulz

Profile: No response to questionnaire. Entry based on "Slide Market News" in the International Bulletin, 1983, no. 1. Offers 6,000 slides, possibly including some black-and-white, of medieval church architecture; art and architecture of the Third Reich; murals in the United States, Mexico, and Europe; architecture of the southwest American Indians; contemporary art; and photography. New titles continually added. Books and postcard series published by this firm as well.

Photography: Sixty percent of slides shot by Dr. Horst Schmidt-Brümmer, editor.

Production: Duplicated and processed by a commercial laboratory on Ektachrome or Kodachrome.

Documentation: Free catalog available, in German. Full identifications given in catalog. Slides labeled with artist and title or with location, building name, and architect. Sets accompanied by text in German. Caption sheet in English provided on request.

Purchasing: Slides sold in sets of 12 or 24. Set of 24 slides 56.00 Deutsche Mark. Slides kept in stock and shipped immediately.

Other sources: Distributed in the United States by Mini-Aids (65).

Evaluation: "Very good quality" (Nancy Kirkpatrick).

MUSEUMS

375 **Ägyptische Museum**
D-1000 Berlin 19 (Charlottenburg)
Schlossstrasse 70
(030) 3201 261
attn: Mail Order Department

Profile: No response to questionnaire. Entry based on fourth edition and a December 1984 letter. New set of color slides to be offered in 1985 of works in the permanent collection.
Photography: Negatives shot by staff photographer in studio and in the galleries.
Production: No information available.
Documentation: Free list in English or German. Full identifications supplied. Slides labeled in German.
Purchasing: Slides sold as a set only. No returns accepted.
Evaluation: Rated by one advisor (Nancy DeLaurier): quality 3.

376 **Alte Pinakothek**
D-8000 Munich 40
Barerstrasse 27
(089) 28 61 05

No response to questionnaire. Slides offered by Blauel (368), F. G. Mayer (61), Praun Dia (372), and Stoedtner (373).

377 **Germanisches Nationalmuseum**
D-8500 Nuremberg
Kartäusergasse 1
(0911) 20 39 71

No response to questionnaire. Two sets of six slides offered by Praun Dia (372), as well as 70 single slides. Slides available from Saskia (78) of sixteenth to eighteenth century European painting and sculpture.

378 **Hamburger Kunsthalle**
D-2000 Hamburg 1
Glockengiesserwall
(040) 24 82 51

No response to questionnaire. Slides no longer supplied by Blauel. Some slides included in sets from Stoedtner (373).

379 **Herzog Anton Ulrich-Museum**
D-3300 Brunswick
Museumstrasse 1
(0531) 49589 or 49378

No response to questionnaire. Free list, in German, received 1979. Offers 30 color slides singly at 1.50 Deutsche Mark each. One set of six slides sold by Praun Dia (372), and slides also included in sets by Stoedtner (373).

380 **Hessisches Landesmuseum**
 D-6100 Darmstadt
 Friedensplatz 1
 (06151) 12 54 34

No response to questionnaire. Slides included in sets available from Stoedtner (373).

381 **Kunsthalle Bremen**
 D-2800 Bremen
 Am Wall 207
 (0421) 32 47 85

No response to questionnaire. Offers 134 color slides on list received in 1975. Twenty slides available from Praun Dia (372). Slides also included in sets sold by Stoedtner (373).

382 **Kunstsammlung Nordrhein-Westfalen**
 D-4000 Düsseldorf 1
 Grabbeplatz 5 (or Jacobistrasse 2)
 (0211) 36 20 10 or 36 20 19

Profile: Offers 96 color slide titles of the permanent collection of twentieth century art. Of special interest is the Paul Klee Collection.
Photography: Slides shot by an independent professional photographer.
Production: Produced by a commercial laboratory. Color corrected. Mounted in glass.
Documentation: Free list, in German. Artist, title, and date provided. Slides labeled in German. Orientation marked.
Purchasing: Slides sold singly, 2.50 Deutsche Mark each. No minimum order. Postage added. Prepayment required on large orders from abroad. Slides kept in stock and shipped within two to three days. Rush orders filled same day; no surcharge. Slides not sent on approval, and no returns accepted. No special photography undertaken.
Evaluation: No information available.

383 **Liebieghaus (Museum Alter Plastik)**
 D-6000 Frankfurt/Main 70
 Schaumainkai 71
 (0611) 63 89 07

No response to questionnaire. Slides of medieval sculpture offered by Saskia (78).

384 **Museum Folkwang**
 D-4300 Essen
 Bismarckstrasse 64-66
 (0201) 77 47 83 or 78 24 49

No response to questionnaire. Offers 50 slides on undated list, 1.00 Deutsche Mark each or 40.00 Deutsche Mark for the set. Nineteenth and twentieth century paintings represented. Artist and German title provided on list. Slides also available from Burstein (30) (see catalog supplement no. 2) and Stoedtner (373).

385 **Museum für Ostasiatische Kunst**
 D-5000 Cologne 1
 Marspfortengasse 6 (or Universitätstrasse 100)
 (0221) 2212375
 attn: Verwaltung der Museen

Profile: Offers 96 color slide titles of works in the permanent collection: Chinese, Japanese, and Korean art. No additions to offerings planned.
Photography: Slides shot by an independent professional photographer.
Production: Color corrected. Four sets of six slides of masterpieces mounted. Other sets unmounted.
Documentation: No list available. Slides labeled in German. Orientation marked.
Purchasing: Slides sold in sets: four sets of six slides of masterpieces of the collection, priced 6.00 Deutsche Mark the set; eighteen masterpieces from China, Japan, and Korea, priced 10.00 Deutsche Mark the set; eighteen slides of Buddhist sculpture, priced 10.00 Deutsche Mark the set; and 36 slides of Japanese screens, priced 18.00 Deutsche Mark the set. Prepayment required on overseas orders. Slides kept in stock and shipped promptly after receipt of payment. Two sets of six slides also offered by Praun Dia (372).
Evaluation: No information available.

386 Neue Pinakothek
D-8000 Munich 40

No response to questionnaire. Single slides offered by Blauel (368). Early twentieth century French painting documented by Saskia (78). Slides also available from F. G. Mayer (61).

387 Niedersächsisches Landesmuseum
D-3000 Hannover
Am Maschpark 5
(0511) 88 30 51

No response to questionnaire. Slides of fifteenth century German painting offered by Saskia (78).

388 Nolde-Museum
D-2261 Seebüll bei Niebüll
(04664) 3 64

No response to questionnaire. Single slides offered by Blauel (368).

389 Residenzmuseum
D-8000 Munich
Max-Joseph-Platz 3
(089) 22 46 41

Five sets of six slides and 72 single slides offered by Praun Dia (372).

390 Rheinisches Landesmuseum Bonn
D-5300 Bonn
Colmantstrasse 14-16
(0228) 63 21 58

No response to questionnaire. Four sets of six slides offered by Praun Dia (372). Slides of works in this museum also included in sets available from Stoedtner (373).

391 Schloss Charlottenburg
D-1000 Berlin 19
Luisenplatz
(030) 32011
attn: Verwaltung, Staatliche Schlösser und Gärten

No response to questionnaire. Slides of eighteenth century French and nineteenth century German paintings offered by Saskia (78).

392 **Staatliche Antikensammlungen und Glyptothek**
D-8000 Munich 2
Meiserstrasse 10
(089) 5591 551

Profile: Approximately 300 slides offered of ancient vases, terracottas, bronzes, jewelry, and sculpture. New titles continually added (100 in 1984).
Photography: Slides shot 95 percent in color, 5 percent in black-and-white by staff photographer (80 percent) and an independent professional photographer (20 percent). Slides shot on Ektachrome 50 or Agfachrome 50L in studio, with lights and polarizing filters. Black-and-white negatives and large-format Ektachromes also shot.
Production: Slides produced by Foto Kohlroser, Munich, on Agfa film. Color not corrected. Contrast controlled. Sold in strips or mounted in cardboard.
Documentation: No list available. Slides labeled in German. Orientation marked.
Purchasing: Slides sold singly. Minimum order 10 slides. Actual costs charged (variable). No discounts. Prepayment required. Slides duplicated to order and shipped within three weeks. Rush orders filled in three days; no surcharge. Original slides may be requested by special order. Slides shot to order priced 20.00 Deutsche Mark each. Slides not sent on approval, and no returns accepted. However, if the quality is unacceptable, the order may be canceled.
Other sources: Slides also available from Blauel (368) and Praun Dia (372).
Evaluation: No information available.

393 **Staatliche Kunsthalle Karlsruhe**
D-7500 Karlsruhe
Hans-Thoma-Strasse 2-6
(0721) 135 33 55

Profile: No response to questionnaire. Entry based on fourth edition. Offers 22 color slides (1979) of European painting from the Renaissance to the twentieth century.
Photography: Large-format Ektachromes shot by a commercial photographer in a studio.
Production: Produced by a commercial laboratory.
Documentation: Free list, in German. Slides labeled in German. Full identifications supplied on request.
Purchasing: Sold in sets or singly, priced 2.50 and 3.50 Deutsche Mark (1979). No discounts. Prepayment required. No returns accepted from overseas. Special photography undertaken for 5.00 Deutsche Mark per slide.
Other sources: Twenty-six slides offered by Praun Dia (372) and 20 offered by Blauel (368). Slides also included in sets available from Stoedtner (373).
Evaluation: Three-star rating in fourth edition.

394 **Staatliche Kunstsammlungen Kassel**
D-3500 Kassel
Schloss Wilhelmshöhe
(0561) 36011

No response to questionnaire. Slides offered by Praun Dia (372) and Stoedtner (373).

395 **Staatliche Museen Preussischer Kulturbesitz**
D-1000 Berlin 30
Stauffenbergstrasse 41
(030) 2 66 26 28

Slides may be purchased in person at the museum, but mail orders are referred to Film & Bild (369) and Postel (371). Other sources of slides include Praun Dia (372), which offers six sets of six slides of ancient art; Saskia (78), which offers slides of European painting and sculpture, and F. G. Mayer (61). Works from Berlin included in the 260-slide set of central Asian art exhibited at the New York Metropolitan Museum in 1982 available from Asian Art Photographic Distribution (240).

396 **Staatsgalerie Moderner Kunst**
 D-8000 Munich
 Prinzregentenstrasse 1
 (089) 29 27 10

No response to questionnaire. Thirty slides available from Blauel (368).

397 **Staatsgalerie Stuttgart**
 D-7000 Stuttgart
 Konrad-Adenauer-Strasse 32
 (0711) 212 5108

No response to questionnaire. One slide recently acquired by special request, priced 10.00 Deutsche Mark. Fifteenth to twentieth century European painting documented by Saskia (78), including all the paintings by Burne-Jones. Slides also available from Stoedtner (373).

398 **Städelsches Kunstinstitut und Städtische Galerie**
 D-6000 Frankfurt/Main 70
 Schaumainkai 63
 (0611) 61 70 92

No response to questionnaire. One hundred and fifteen slides offered by Blauel (368). Nineteenth century German painting documented by Saskia (78).

399 **Suermondt-Ludwig-Museum**
 D-5100 Aachen
 Wilhelmstrasse 18
 (0241) 432 4400

No response to questionnaire. Slides offered by Saskia (78) of northern medieval and early Renaissance sculpture.

400 **Von der Heydt Museum**
 D-5600 Wuppertal-Elberfeld
 Turmhof 8
 (0202) 563 62 31

Slides included in sets offered by Stoedtner (373).

401 **Wallraf-Richartz-Museum**
 D-5000 Cologne 1
 An der Rechtschule
 (0221) 221 23 72

Profile: No response to questionnaire. Entry based on fourth edition and list received in 1979. Approximately 430 slides offered of paintings and sculpture in the permanent collection (medieval to contemporary).
Photography and production: No information available; perhaps produced by Stoedtner (373).
Documentation: Free list, in German. Artist and title provided.
Purchasing: Slides sold singly, priced 2.00 Deutsche Mark each.
Other sources: Seventeenth to nineteenth century painting documented by Saskia (78). Slides also available from Praun Dia (372) and Stoedtner (373).
Evaluation: Two-star rating in fourth edition.

OTHER INSTITUTIONS

402 Bildarchiv Foto Marburg
D-3550 Marburg
Postfach 1460
(06421) 28 3600

Profile: Black-and-white slides duplicated to order from an archive of 900,000 negatives representing art and architecture in Europe. Approximately 5 percent of holdings are large-format color transparencies, from which color slides can be made. Archives purchased by the University of Marburg include Stoedtner, Osthaus, Aufsberg, Hege, and others.
Photography: Negatives and transparencies shot by staff photographers and traveling scholars on various low-speed films. Leica, Rollei, Hasselblad, and Linhof cameras used. Majority of negatives on file are glass.
Production: Black-and-white slides produced in-house on Agfa pan 5 or Kodak technical film. Mounted in plastic and glass.
Documentation: No list available. Microfiche sets, the *Marburger Index* and *Index Photographique de l'Art en France*, may be used as catalogs for items located in Germany or France. Slides labeled in German. Orientation marked by label position.
Purchasing: Slides sold singly, priced 6.00 Deutsche Mark each. No minimum order. No discounts. Slides made to order and shipped within three days. Rush orders filled in 24 hours. Slides not sent on approval. To date, no returns received. Subscription series available. Special photography sometimes undertaken.
Evaluation: Quality 3 to 4, documentation 3 to 4, service 2 to 3.

GREECE

COMMERCIAL VENDORS

403 **Hannibal**
11 Arkadias Street
Halandri 152-34
Athens
(021) 681 70 28
attn: Constantine Tryfides

Profile: Offers 630 color slide titles of ancient Greek art and architecture. All museums in Greece represented.
Photography: Slides and large-format transparencies shot on Kodak film by Hannibal Stamatopoulos, owner of the company.
Production: Produced by Herrmann & Kraemer, Garmisch, West Germany. Printed from internegatives on Eastmancolor #5384. Recommended ECP-2A processing used. Color corrected and contrast controlled. Mounted in cardboard.
Documentation: Free list of set titles, in English and Greek. (Former English catalog provided brief description of each slide.) Identification list included with set, printed in Greek, English, French, and German. Orientation marked.
Purchasing: Slides sold in sets of 10, priced $7.00 (United States) per set. Airmail postage added. Slides restocked annually. Stating alternate choices is recommended in case desired sets are out of stock. No refunds given.
Evaluation: Quality 2 to 3, documentation 2, service 1 to 2. Many sets have been out of stock during the change to stable film. New stock is to be ready in 1985. As noted in fourth edition, removal of the film from its cardboard mount is extraordinarily difficult.

MUSEUMS

404 **Acropolis Museum**
Acropolis
Athens
(021) 3236 665

Slides available from TAP Service (410), Hannibal (403), and Saskia (78).

405 **Archaeological Museum**
 Delphi
 (0265) 82313

Slides available from TAP Service (410), Hannibal (403), and Saskia (78).

406 **Archaeological Museum**
 Heraklion, Crete

Slides available from Hannibal (403) and Pictures of Record (73).

407 **Archaeological Museum**
 Olympia

Slides available from TAP Service (410) and Hannibal (403).

408 **Archaeological Museum**
 Thessaloniki

Three sets, each six slides, of a special exhibition of Macedonian metalwork offered by TAP Service (410).

409 **National Archaeological Museum**
 1, Tositsa Street
 Athens
 (021) 82 17 717

Slides offered by TAP Service (410), Hannibal (403), Saskia (78), and Architectural Color Slides (21).

OTHER INSTITUTIONS

410 **Archaeological Receipts Fund**
 (TAP Service)
 Ministry of Culture and Science
 57, Panepistimiou Street
 GR 105 64 Athens
 (021) 32 20 468 or 3253901-6

Profile: Offers 408 color slide titles of objects in Greek museums. A few slides of archaeological sites included. Museums in Athens, Olympia, Delphi, and Thessaloniki represented. New titles continually added. Postcards also sold, and large-format color transparencies of museum objects rented for reproduction.
Photography: Large-format transparencies shot by staff photographer (30 percent) or an independent professional photographer (70 percent).
Production: No information provided on film type. Mounted in cardboard.
Documentation: Mailing list kept. Free list, in Greek or English. Slides labeled in four languages: Greek, English, French, and German. Orientation marked.
Purchasing: Slides sold in set of six, priced 100.00 drachmas per set. Postage added. Prepayment required in Greek or U.S. currency. Slides duplicated to order and shipped within 10 days of receipt of payment. Rush orders filled as quickly as possible; no surcharge. Special photography undertaken for objects in Athens museums only. Price and time to carry out order vary.
Evaluation: No information available.

HUNGARY

411 Dr. Marosi Ernö doc.
Gellérthegy utca 5/1
H-1016 Budapest

Dr. Marosi does not supply slides for sale, but he is willing to provide up-to-date information on slides available from Hungarian museums and other institutions.

412 Magyar Nemzeti Galéria
(Hungarian National Gallery)
H-1250 Budapest PF.31
160 170 or 160 100
attn: Artfotó VGMK

Profile: Slides offered of works in the permanent collection, representing Hungarian art from the eleventh century to the present.
Photography: Six-by-seven-centimeter black-and-white negatives (90 percent) and 6-by-7-centimeter and 6-by-9-centimeter color transparencies (10 percent) shot by staff photographer on Kodak and Agfa films. Mamiya camera used.
Production: Color corrected and contrast controlled.
Documentation: No list available. Slides labeled in Hungarian or English. Orientation marked.
Purchasing: Slides sold singly. Minimum order five slides. Orders filled within six days. Special photography undertaken for $15.00 per slide.
Evaluation: No information available.

IRELAND

MUSEUMS

413 **National Gallery of Ireland**
Merrion Square West
Dublin 2
(01) 767571
attn: Photographic Department

Profile: Offers 140 color slide titles of paintings, watercolors, drawings, and sculpture in the permanent collection. New slides continually added (80 in 1984).
Photography: Slides shot by staff photographers on Ektachrome ASA 50 using Nikon camera and tungsten lighting.
Production: Original slides processed by Professional Colour, Dublin. Color corrected and contrast controlled. Mounted in plastic or cardboard.
Documentation: Mailing list kept. Free list, in English, updated annually. Artist and title provided on list. Slides labeled in English with artist, date, and title. Front of slide indicated by label; otherwise, orientation not marked.
Purchasing: Original slides sold singly, priced 0.45 pence (Irish). No minimum order. Slides shot to order and shipped within one week. Rush orders filled if possible; no surcharge. Orders invoiced. Slides not sent on approval. Special photography carried out for IR£25.00 to IR£30.00 (Irish pounds) plus charge for slide; orders filled within two weeks.
Rental: Slides may be borrowed temporarily for a particular lecture.
Evaluation: Quality 3, documentation 3, service 3.

414 **National Museum of Ireland**
Kildare Street
Dublin 2
(01) 76 55 21
attn: Sales Office

Profile: Offers 170 color slide titles of works in the permanent collection: archaeological artifacts, early Christian metalwork, traditional crafts, fine art, and natural history. No additions to slide holdings planned.
Photography: Slides shot on low-speed Ektachrome by staff photographers. Tungsten lighting used.
Production: Duplicated on Kodak Ektachrome duplicating film by GBS, Ltd., Bray, Co. Wicklow, Ireland. Contrast controlled. Mounted in cardboard and packaged in plastic sleeves. Three percent of slides are black-and-white.

159

Documentation: Free list, in English, revised 1984. Title, date, and provenance given, as well as artist, if known. Slides labeled in English.

Purchasing: Slides sold in small sets or singly. Current prices sent on request. No discounts. Postage added. Slides kept in stock. Rush orders filled immediately. No special photography undertaken. Slides not sent on approval. Returns accepted for exchange only.

Evaluation: Quality 2, documentation 2 to 3, service 2.

OTHER INSTITUTIONS

415 **Trinity College Library**
College Street
Dublin 2
(01) 772941, x1757
attn: Library Shop

Profile: No response to questionnaire. Entry based on fourth edition and a recent order. Three sets of six slides offered, two of the *Book of Kells* and one of the *Book of Durrow*.

Photography: Shot by a commercial photographer.

Production: Produced on Kodak film by a commercial laboratory.

Documentation: Free brochure, listing slides among other publications.

Purchasing: Order form included in brochure. Set of six slides priced IR£2.85 in the United Kingdom, IR£3.00 in Europe and the United States. Postage included. Prepayment required in Irish pounds, pounds sterling, or U.S. dollars, by credit card, personal check, or bank draft. Orders sent by surface mail and delivered within five to nine weeks to the United States and Canada, within 10 days to Europe.

Evaluation: Quality 2, documentation 3, service 2.

ISRAEL

416 Holy Views, Ltd.
P.O. Box 2497
Jerusalem

No response to questionnaire. Entry based on information from the Cleveland Museum of Art Slide Library, which received an order from this source in 1977. Several hundred slide titles offered of sites in the Holy Land.

417 Israel Museum
Hakirya, P.O. Box 1299
91000 Jerusalem
(02) 636 231

No response to questionnaire. Slides available from Pictures of Record (73).

ITALY

COMMERCIAL VENDORS

418 **Böhm, Osvaldo**
San Moisè 1349-50
30124 Venice

Profile: No response to questionnaire. Entry based on a letter of March 1984. Archive of 30,000 black-and-white negatives accumulated since the 1860s of Venetian art and architecture from the Byzantine era through the nineteenth century. New titles (300 to 400) added annually. Permanent collections and exhibitions in Venetian museums documented. Photographic prints also offered and a few large-format color transparencies for publication.
Photography: Shot mostly with large-format cameras.
Production: Black-and-white slides produced from negatives.
Documentation: Series of catalogs in publication, approximately one volume per year. Volume 1 (1983) contains subjects in the churches and scuole, except San Marco. Volume 1 priced 5,000.00 lire plus 4,000.00 lire postage.
Purchasing: Slides sold singly, priced 8,000.00 lire each.
Evaluation: No information on slides; photographic prints are of good quality.

419 **Colorvald S.A.S.**
Zona Industriale 23
36078 Valdagno
(0445) 40 11 55
attn: Alberto Fornasa

Profile: Approximately 3,000 color slide titles offered of art and architecture: prehistoric, ancient, early Christian and Byzantine, medieval, European from the fifteenth to twentieth centuries, Islamic, and Oriental.
Photography: Large-format transparencies shot by staff photographer (30 percent) or independent professional photographers (70 percent). Ten percent of originals are 35 mm slides. Ektachrome film used, ASA 64 to 200.
Production: Produced in-house. Film type unspecified but apparently Eastmancolor. Color corrected and contrast controlled. Mounted in cardboard, plastic of various thicknesses, or plastic with glass.
Documentation: No list available. Sets accompanied by texts.
Purchasing: Slides sold in sets. Prices vary depending on quantity per subject. (A large portion of this company's business is producing slides in bulk for other vendors.) Slides produced to order and shipped

within three to four weeks. Payment accepted in West German or U.S. currency. Sets sent on approval for a fee of $3.00 each. No returns accepted.

Other sources: Distributed by Gould Media (44).

Evaluation: Based on sample order quality 1 to 2. Film unstable; some slides already pink on receipt.

420 **Loffredo, Christopher**
Piazza San Giovanni 1
Florence
(055) 261 289

Profile: Slides shot to order of monuments in Florence. Slides of objects in other locations may be obtained by special arrangement. Slides shot from books on request.

Photography: Slides shot by C. Loffredo, an experienced photographer who has studied art history in the United States and Italy. Film types subject to customer request: Ektachrome or Fujichrome ASA 100, Kodachrome ASA 25 or 64, Ektachrome 64 professional film, or black-and-white Ilford FP4 film. Six-by-six-centimeter slides shot on request. No special lighting or scaffolding available, and photography requiring permits cannot be undertaken.

Production: Kodachrome and Ektachrome 64 processed by a professional laboratory. Slides mounted in plastic or cardboard unless glass mounts are requested ($0.50 each, including masking).

Documentation: None.

Purchasing: Prices depend on film chosen and quantity ordered, ranging from $1.95 to $3.00 each. Minimum order 10-15 slides. Quantity discounts. Postage added. Slides shot to order and shipped within ten days to three weeks. Rush orders of black-and-white slides or Ektachrome (E-6) filled within three working days; surcharge of $0.25 per slide, plus express mail costs. Prepayment of 50 percent required on all orders. "If not fully satisfied with the results, you will be reimbursed except for the mailing costs; simply send back the slides and state the reason for your complaint."

Evaluation: No information available.

✱ 421 **Scala**
Via Chiantigiana, Ponte a Niccheri
50011 Antella (Florence)

Profile: Offers 8,200 color slide titles in 385 sets. Art history of all periods covered, with emphasis on works in Italian collections. Scala is "the largest single source of large-format color transparencies on the arts. Scala is the official photographer for major European collections, including the Vatican Museums. Scala also publishes its own award-winning art books and museum catalogs and is therefore very aware of the needs of picture researchers and publishers." Masterpieces of at least 14 European museums offered as sets. European churches documented in 55 eight-slide sets. Italian painting surveyed in 122 12-slide sets. New sets continually produced from an archive of more than 80,000 transparencies. Series of sets surveying the history of architecture in preparation.

Photography: Original transparencies shot by professional staff photographers on Kodak film in several formats (4 by 5 inches, 5 by 7 inches, 8 by 10 inches) using Sinar view cameras.

Production: Duplicated on Eastmancolor #5384 film at Scala Istituto Fotografico Editoriale, Florence. Color corrected and contrast controlled. Mounted in cardboard. Packaged in plastic sleeves.

Documentation: Mailing list kept. New catalog (1985) in English, listing set titles. Slide-by-slide identifications not given, but for reissues of old sets this information can be obtained from old catalogs. Slides labeled in Italian and keyed to information sheet or booklet accompanying set. Texts often multilingual (English, Italian, French, German) or sometimes available in selected languages. Images thoroughly identified in most cases. Orientation marked. List of slide sets in preparation also available.

Purchasing: Slides sold in sets only; single slides no longer available. Holdings listed in former single-slide catalog to be partially reissued as sets. Sets composed of 6, 12, 18, 24, 36, 60, 64, 80, 96, 112, 120, or 240 slides. U.S. orders not handled directly by Italian office; orders must be channeled through Art Resource, Inc., in New York (80). Requests considered for slides shot to order; partial advance payment required.

Evaluation: Quality 3, information 3, service 2 to 3. "Views well chosen and original photography usually excellent, but duplication is only fair" (Norine Cashman). "Slides of same item may vary in exposure. Data

for obscure works can be minimal. Very long shipment time. New listings often not available or cancelled" (Brenda MacEachern). "A reliable standby, especially for Italian materials. Slide longevity is improving of late" (Nancy Kirkpatrick).

MUSEUMS

422 Castello Sforzesco
20121 Milan

One set of 18 slides of paintings offered by Scala (80 and 421).

423 Galleria Borghese
Piazzale Scipione Borghese 5
00197 Rome
(06) 85 85 77

A general set of 36 slides offered by Scala (80 and 421), as well as nine other sets totaling 106 slides. Slides of Italian Baroque painting and sculpture by Bernini available from Saskia (78).

424 Galleria degli Uffizi
Piazza degli Uffizi
50100 Florence
(019) 21 83 41

No response to questionnaire. A set of 12 slides offered by Scala (80 and 421); slides of works in the Uffizi also included in many other Scala sets. Major paintings and important works of Greek sculpture available from Saskia (78). The Uffizi collection also documented by F. G. Mayer (61) and Stoedtner (373).

425 Galleria di Palazzo Rosso
Via Garibaldi 18
16100 Genoa
(010) 28 26 41

Italian Renaissance and northern Baroque painting photographed by Saskia (78).

426 Galleria Nazionale d'Arte Antica
Palazzo Barberini
Via delle Quattro Fontane 13
00184 Rome
(06) 47 45 91

Slides of Italian Baroque art offered by Saskia (78).

427 Galleria Palatina
Palazzo Pitti
Piazza Pitti 1
50125 Florence
(019) 26 06 95 or 21 03 23

No response to questionnaire. Slides of works in this collection included in many sets by Scala (80 and 421). Paintings, including all by Raphael and Rubens, represented in slides from Saskia (78).

428 **Galleria Spada**
Piazza Capodiferro 13
00100 Rome
(06) 65 61 158

Slides of Italian Baroque art offered by Saskia (78).

429 **Gallerie dell'Accademia**
Campo della Carità
30100 Venice
(041) 222 47

Set of 36 slides offered by Scala (80 and 421). Slides of paintings (early Venetians, Giorgione, and Liss, among others) available from Saskia (78). Slides also sold by F. G. Mayer (61).

430 **Monumenti, Musei, e Gallerie Pontificie**
00120 Vatican City
(06) 698 33 32

No response to questionnaire. Seven sets of 36 slides offered by Scala (80 and 421); many slides of works in the Vatican collections included in other sets.

431 **Museo Archeologico de Firenze**
Via della Colonna 38
50121 Florence
(055) 22 52 70

Four sets totaling 42 slides offered by Scala (80 and 421).

432 **Museo Archeologico Nazionale**
Via Museo 19
80135 Naples
(081) 294 502

Greek and Roman sculpture and Roman mosaics documented by Saskia (78). Slides of works in this museum also included in sets by Scala (80 and 421).

433 **Museo Civico Revoltella**
Via Diaz 27
34123 Trieste
(040) 75 04 36

Set of 12 slides offered by Scala (80 and 421).

434 **Museo dell'Opera della Metropolitana**
Piazza del Duomo
53100 Siena
(0577) 28 30 48

Slides of paintings and some sculpture offered by Saskia (78).

435 **Museo di San Marco**
Piazza San Marco
50100 Florence

One set of 80 slides and one set of 36 slides offered by Scala (80 and 421) of paintings by Fra Angelico.

436 **Museo e Gallerie Nazionali di Capodimonte**
Palazzo di Capodimonte
80100 Naples
(081) 74 10 801

No response to questionnaire. Italian and Flemish paintings photographed by Saskia (78). Many slides also included in sets offered by Scala (80 and 421).

437 **Museo Internazionale delle Ceramiche**
Viale Baccarini 19
48018 Faenza

No response to questionnaire. Two sets of 24 slides each offered by Scala (80 and 421).

438 **Museo Nazionale del Bargello**
Via del Proconsolo 4
50122 Florence
(055) 21 08 01

Slides of the most important works offered by Saskia (78), including the sculpture of Donatello and Michelangelo. Slides of works in this museum included in sets by Scala (80 and 421).

439 **Museo Nazionale di Villa Giulia**
Piazzale di Villa Giulia 9
00100 Rome
(06) 35 07 19 or 38 64 80

One set of 24 slides of Etruscan art offered by Scala (80 and 421).

440 **Museo Poldi Pezzoli**
Via Manzoni 12
20121 Milan
(02) 79 48 89

Three sets offered by Scala (80 and 421): twelve slides of paintings, 12 slides of decorative arts, and 12 slides of tapestries and armor.

441 **Pinacoteca di Brera**
Via Brera 28
20121 Milan
(02) 80 09 85

Five sets totaling 132 slides of paintings offered by Scala (80 and 421). Slides of Italian Renaissance painting and northern Baroque painting available from Saskia (78).

442 **Pinacoteca Nazionale di Siena**
 Via San Pietro 31
 53100 Siena
 (0577) 28 11 61

Slides of thirteenth through sixteenth century Italian painting available from Saskia (78).

OTHER INSTITUTIONS

443 **Centro Internazionale di Studi de Architettura**
 "A. Palladio"
 Domus Comestabilis Basilica
 36100 Vicenza

Profile: No response to questionnaire. Set of 60 slides offered of architecture designed by Palladio.
Production: Produced by Colorvald (419) on unstable film.
Documentation: Identifications provided with slides.
Purchasing: Distributed in the United States by Baluster Books, Inc., 340 West Huron Street, Chicago, IL 60610. Set priced approximately $50.00.
Evaluation: Quality 1 to 2, documentation 2.

444 **Commune di Ferrara**
 Direzione Musei Civici d'Arte Antica
 Palazzo Schifanoia
 Via Scandiana 23
 44100 Ferrara

Information provided by an advisor. Slides offered of ancient, Renaissance, and modern art in Ferrara.

JAPAN

COMMERCIAL VENDORS

445 Mitsumori Color Printing Co.
New Kokusai Building
Marunouchi, Tokyo
(216) 2801, x3

No response to questionnaire. Information supplied by an advisor. Color slides offered of sites in Japan.

446 SK Color Co.
2-1-2 Higashi
Nakano, Nakano-ku, Tokyo 164

Profile: No response to questionnaire. Apparently still in business because slides were obtained in Japan in 1984 by a traveling scholar. Entry based on 1978 update to the 1976 *Slide Buyers Guide*. Color slides offered of art and architecture in Japan, produced for the tourist trade.
Production: Printed from Kodak color negatives on Fujicolor positive film. Produced in-house.
Documentation: Free list.
Purchasing: Slides sold in sets of 10 for 600 yen. Prepayment required.
Evaluation: Sample set (1978): quality 4. Samples viewed by editor in 1984: quality 2 to 3.

MUSEUMS

447 Kokuritsu Seiyo Bijutsukan
(National Museum of Western Art)
Ueno Park, Taito-ku, Tokyo
(03) 828 5131

No response to questionnaire. Slides sold on site as of 1980. A few slides offered by Burstein (30).

OTHER INSTITUTIONS

448 **International Society for Educational Information**
Kikue Building, No. 7-8
Shintomi 2, Chane Chao-ku, Tokyo
(03) 552 9481 or 552 9482

No response to questionnaire. In business as of late 1981. Slides offered of Japanese art and architecture.

JORDAN

MUSEUMS

449 **Amman Archaeological Museum**
P.O. Box 88
Amman
Slides available from Pictures of Record (73).

LIECHTENSTEIN

MUSEUMS

450 **Sammlungen des Regierenden Fürsten von Liechtenstein**
Schloss
9490 Vaduz
(075) 2 12 12

No response to questionnaire. Slides offered by Stoedtner (373).

_____NETHERLANDS_____

MUSEUMS

451 Centraal Museum der Gemeente Utrecht
Agnietenstraat 1, 3512 XA Utrecht
 or
P.O. Box 2106, 3500 GC Utrecht
(030) 31 55 41

No response to questionnaire. Slides offered by Saskia (78) of paintings by seventeenth century Utrecht painters influenced by Caravaggio.

452 Frans Halsmuseum
Groot Heiligland 62
2011 ES Haarlem
(023) 31 91 80

Profile: Offers 23 color slide titles of works in the permanent collection. New titles occasionally added.
Photography: Slides shot by an independent professional photographer.
Production: Produced by A.N.C. Productions. No attempt made to correct color or control contrast.
Documentation: Free list, in Dutch, English, German, and French. Artist, artist's dates and places of birth and death, title of work, and date of work provided. Slides labeled in English.
Purchasing: Slides sold singly, priced 1.50 guilders each. No minimum order. No discounts. Postage added. Slides kept in stock and shipped within two weeks. Rush orders filled within three days if slides are in stock. Slides not sent on approval, and no returns accepted.
Evaluation: Quality 2 to 3, documentation 3, service 3.

453 Haags Gemeentemuseum
Stadhouderslaan 41
2517 HV The Hague
(070) 51 41 81

Profile: Approximately 250 color slide titles offered of items in the Gemeentemuseum, the Museum Bredius (12 slides), and the Kostuummuseum (11 slides). Subjects covered include modern art (of special interest, the work of Mondrian and M. C. Escher), nineteenth century art, history of the Hague, costumes, and musical instruments. New titles occasionally added.
Photography: Large-format transparencies shot by a staff photographer.

Production: Produced by Fotoburo Niestadt, Panningen. Color corrected and contrast controlled.
Documentation: Free list, in Dutch, revised annually. Artist, title, and date provided. Slides labeled in Dutch.
Purchasing: Slides sold singly, 1.75 guilders each. No minimum order. Discount of 10 percent given on 10 slides or more. Set of 35 slides of M. C. Escher's work, 29.50 guilders. Orders filled within three weeks. No rush orders accepted. Slides not sent on approval, and no returns accepted. Special photography undertaken within four weeks at 7.50 guilders per slide.
Evaluation: Quality 3 to 4, documentation 2 to 3, service 2 to 3. Film is stable.

454 **Mauritshuis**
Korte Vijverberg 8
2513 AB The Hague
(070) 46 92 44

No response to questionnaire. Offers 27 slide titles on list received in 1979. Slides priced 1.80 guilders each. Prepayment required. Artist and title (in English) provided on list. Slides also available from F. G. Mayer (61).

455 **Museum Boymans-van Beuningen**
Mathenesserlaan 18-20, 3015 CK Rotterdam
 or
P.O. Box 2277, 3000 CG Rotterdam
(010) 36 05 00
attn: Administration

Profile: No response to questionnaire. Entry based on list received in 1982. Offers 58 color slide titles of works in the permanent collection.
Documentation: Free list. Artist, artist's dates, and title (in Dutch and English) provided.
Purchasing: Slides sold singly, 1.75 guilders each. Postage and bank charges added.
Other sources: Slides also available from F. G. Mayer (61).
Evaluation: No information available.

456 **Museum het Rembrandthuis**
Jodenbreestraat 4-6
1011 NK Amsterdam
(020) 24 94 86

Profile: No response to questionnaire. Entry based on fourth edition. Offers 94 slide titles of Rembrandt's etchings and a few paintings by artists of the Rembrandt School.
Photography: Shot by a commercial photographer in a studio.
Production: Printed from negatives by Polyvisie.
Documentation: Free list, arranged according to Bartsch. Full identifications, except dimensions, provided. Slides keyed to list by Bartsch numbers.
Purchasing: Slides sold singly or as a complete set. Singles 0.60 guilders each for black-and-white, 1.20 guilders each for color. Set 50.00 guilders. No discounts. Prepayment required. Returns accepted only if slides damaged by museum staff.
Evaluation: "Excellent" (Mark Braunstein).

457 **Rijksmuseum-Foundation**
Hobbemastraat 21
1071 XZ Amsterdam
attn: Department of Reproductions

Profile: No response to questionnaire. Entry based on 1983 catalog and 1984 order. Offers 107 color slide titles of works in the permanent collection, chiefly Dutch paintings. Postcards and reproductions also available.

Photography and production: Produced by Scala (421).

Documentation: Free catalog of reproductions, slides, and books. Slides identified in catalog by artist and English title. Slides labeled with same information, plus date when known and dimensions. Orientation marked.

Purchasing: Slides sold singly, 1.50 guilders each. Postage added. Prepayment required.

Other sources: Set of 12 slides available directly from Scala (80 and 421).

Evaluation: Quality 3, documentation 3, service 2 to 3. Limited selection.

458 **Rijksmuseum Kröller-Müller**
 P.O. Box 1
 6730 AA Otterlo
 (08382) 2 41

Profile: Offers 41 color slide titles of works in the permanent collection: nineteenth and twentieth century painting and twentieth century sculpture. No additions to slide holdings planned.

Photography: Slides shot by staff photographer.

Production: Produced by Scala (421). Color corrected and contrast controlled.

Documentation: Free list. Identifications consist of artist, title (in Dutch and English), and date. Slides labeled in Dutch and English.

Purchasing: Slides sold singly, 1.75 guilders each. No minimum order. Postage added. Prepayment required in guilders or U.S. dollars. Orders shipped within 10 days of receipt of payment. No rush orders accepted. No returns accepted. No special photography undertaken.

Other sources: Forty-two single slides and a slidebook of 36 slides offered by Woodmansterne (278). Slides also available from F. G. Mayer (61), Rosenthal Art Slides (76), and Stoedtner (373).

Evaluation: No information available.

459 **Stedelijk Museum**
 P.O. Box 5082
 1007 AB Amsterdam
 (020) 73 21 66
 attn: Reproduction Department

Profile: Offers 450 color slide titles of selected works in the collections of the Stedelijk Museum (250 slides), the Rijksmuseum Vincent van Gogh (130 slides), and the Amsterdams Historisch Museum (70 slides). New titles occasionally added.

Photography: Large-format transparencies shot by staff photographer on Agfa film 100S.

Production: Printed from internegatives on low-fade Eastmancolor (formerly Eastmancolor #5381) by Hermann & Kraemer, Garmisch, West Germany. Fujicolor film now used and will be used in future production. Color corrected and contrast controlled. Mounted in plastic.

Documentation: Free list for each museum, in Dutch and English. Artist and title provided on list. Slides labeled in English. Orientation marked with an arrow only if necessary.

Purchasing: Slides sold singly except for one set of 12 slides from the Vincent van Gogh Museum. No minimum order. Single slide priced 1.75 guilders each. Quantity discount: ten slides for 15.00 guilders. Prepayment required on overseas orders; pro forma invoice sent. Slides shipped within one week of receipt of payment. Rush orders filled within two days; no surcharge. Slides not sent on approval, and no returns accepted. Special photography undertaken within four weeks at 25.00 guilders per item.

Other sources: Slides distributed by Miniature Gallery (275), available singly, as listed in "Art Slide News" no. 52 (60 slides from the Vincent van Gogh Museum) and no. 62 (187 slides from the Stedelijk Museum). Single slides also offered by Burstein (30).

Evaluation: Quality 3 to 4, documentation 3, service 3.

460 **Stedelijk Museum "de Lakenhal"**
P.O. Box 2044
2301 CA Leiden
(071) 25 46 20

Profile: Approximately 60 color slide titles offered of works by artists who were born or lived in Leiden. Slides of painting of the fifteenth through nineteenth centuries, decorative arts of the seventeenth through nineteenth centuries, and some seventeenth and eighteenth century architectural interiors included.

Photography and production: A few slides shot by a staff photographer on Ektachrome ASA 50 and produced by the University of Leiden. Majority of slides photographed by a commercial photographer and produced by Polyvisie. Copies sometimes produced from duplicates rather than originals. Color corrected. No attempt made to control contrast.

Documentation: No list available. Slides labeled in English. Orientation not marked.

Purchasing: Slides sold in sets, 25.00 guilders for six slides. Slides kept in stock and shipped within two weeks. Slides not sent on approval, and no returns accepted.

Evaluation: Quality 2, documentation 2. "Polyvisie slides purchased in the past have all faded to pink" (Norine Cashman).

461 **Teylers Museum**
Spaarne 16
2011 CH Haarlem
(023) 31 68 51

Profile: Offers 21 color slide titles of museum interiors, fossils, minerals, physical instruments, and art collections. Included in the latter are three drawings by Rembrandt, three drawings by Michelangelo, and three Dutch paintings.

Photography: Slides, negatives, and large-format transparencies shot by staff photographer on Kodak film.

Production: Commercial slides produced by an outside firm.

Documentation: Free list, in English. Artist and title provided.

Purchasing: Slides sold in sets of three, 3.25 guilders per set. Six-by-six-centimeter slides made to order of other objects. Quotations supplied on request for special photography.

Evaluation: No information available.

NORWAY

MUSEUMS

462 **Nasjonalgalleriet**
(National Gallery)
Universitetsgaten 13
P.O. Box 8157
Oslo 1
(02) 20 04 04

No response to questionnaire. Nineteenth and twentieth century Norwegian painting, including all paintings by Munch, photographed by Saskia (78). Slides also offered by Burstein (30) and Stoedtner (373). See also Statens Filmsentral (464).

463 **Oslo Kommunes Kunstsamlinger/Munch-Museet**
(City of Oslo Art Collection/Munch Museum)
Toyengaten 53
P.O. Box 2812, Kampen 5
Oslo
(02) 67 37 74

Profile: No response to questionnaire. Entry based on 1981 list. Offers 58 color slide titles of paintings by Edvard Munch.
Photography and production: No information provided on film types. Mounted in plastic.
Documentation: Free list, in English and Norwegian. Title and date provided for each painting.
Purchasing: Slides sold in sets of six, or singly. Price per slide 3.00 Norwegian kroner. Orders invoiced.
Other sources: Slides also offered by Burstein (30) and Statens Filmsentral (464).
Evaluation: No current information available. "Slides we purchased in the 1970s were on unstable film" (Norine Cashman).

OTHER INSTITUTIONS

464 **Statens Filmsentral**
P.O. Box 2655, St. Hanshaugen
0131 Oslo 1
(02) 60 20 90
attn: Anne Lise Rabben, c/o Nasjonalgalleriet

Profile: Project in progress, 1985-1987, to offer 26 slide sets totaling 780 color slide titles. Norwegian art systematically documented, with sets representing a variety of media and historical periods. Painting, sculpture, graphic arts, tapestries included. Most Norwegian museums are contributing to the project. Set of Munch paintings to be ready by fall 1985.

Photography: Large-format transparencies shot by museum photographers and a staff photographer on Agfachrome or Ektachrome.

Production: Produced by an in-house laboratory and Laboratorie-Service, Oslo. Printed on Kodak Vericolor #5072 from internegatives on Kodak Vericolor #6011 (35 mm). Color corrected and contrast controlled. Mounted in plastic and glass.

Documentation: Free brochure, in Norwegian. Each set accompanied by booklet containing identifications and commentary by an art historian, in Norwegian. Slides labeled with artist and title.

Purchasing: Slides sold in sets of 30. Entire series offered by subscription (150.00 Norwegian kroner per set). Minimum order one set, priced 180.00 Norwegian kroner.

Evaluation: One sample sent: quality 3.

POLAND

COMMERCIAL VENDORS

465 **Ars Polona**
Krakowskie Przedmiescie 7
00-068 Warsaw
26 12 01

Profile: Approximately 100 slide titles offered of works in the Muzeum Narodowe (National Museum), Warsaw. Ancient art, medieval art, Polish art, European art, and contemporary paintings and drawings represented. No additions to slide holdings planned.
Photography and production: Shot by an independent professional photographer and produced by KAW, Wilcra Str. 46, 00-679 Warsaw.
Documentation: Free list, in French. Artist, title, and date provided. Slides labeled in Polish. Back of slide mount white; otherwise, orientation not marked.
Purchasing: Slides sold singly or in sets. Orders shipped within one month. Special photography undertaken by KAW (see Photography and production). Payment accepted in U.S. dollars. Returns accepted for exchange only.
Evaluation: No information available.

MUSEUMS

466 **Museum Narodowe**
(National Museum)
Al. Jerozolimskie 3
00-495 Warsaw
21 10 31

Responded to questionnaire with reference to Ars Polona (465), the only Polish agency authorized to sell slides abroad.

PORTUGAL

MUSEUMS

467 Fundação Calouste Gulbenkian, Museu
Avenue de Berna, 45-A
Lisbon 1
(019) 76 50 61

No response to questionnaire. Offers 146 slide titles according to list received in 1975. Fine art and decorative arts represented, both Western and Oriental. Full identifications provided on list, except dimensions. "Slides we requested in 1974 and 1975 were sent gratis and were of excellent quality" (Norine Cashman).

468 Museu Nacional de Arte Antiga
Rua das Janelas Verdes
1293 Lisbon
(019) 66 41 51
attn: Curator

No response to questionnaire. "We obtained several commercially produced slides from the museum in 1975 that were of good quality and on stable film" (Norine Cashman).

SPAIN

COMMERCIAL VENDORS

469 **Aguilar S.A. de Ediciones**
Juan Bravo 38
28006 Madrid

No response to questionnaire. Slide sets offered of works in the Prado (two sets), Louvre, Musée d'Orsay in Paris, Accademia in Venice, and National Gallery in Washington. Two sets on Picasso also available. Sets priced approximately $50.00 (United States) for 100 slides. "Good slides" (Sara Jane Pearman).

470 **Ampliaciones y Reproducciones MAS**
(Arxiu Mas)
Frenería, 5, 3° D.
08002 Barcelona
(93) 315 27 06
attn: Dr. Montserrat Blanch

Profile: No response to questionnaire. Entry based on 1981 letter. Black-and-white slides offered of art and architecture in Spain, made to order from an extensive archive of black-and-white negatives. Photographic prints also may be ordered.
Documentation: No comprehensive catalog. Lists, in Spanish, available on request of particular subjects. Slides keyed to lists. All correspondence in Spanish.
Purchasing: Slides sold singly, 375.00 pesetas each. Quantity discount possible. Postage and bank charges added. Prepayment required from pro forma invoice.
Evaluation: "We have ordered only photographic prints, which I would rate 2 to 3 on quality. Identifications are minimal and in Spanish. This is a valuable source, however, for images unobtainable elsewhere. Service is reasonably prompt and extremely courteous" (Norine Cashman).

471 **Ancora, Producciones**
Consejo de Ciento, 160, 2° D.
08015 Barcelona
(93) 254 09 04

No response to questionnaire for this edition or the fourth edition. Color slide sets offered of art and architecture in Spain, of all periods. Order received in 1984; slides produced on unstable film, already pink on receipt. Documentation in Spanish, English, French, and German. Service slow. Orders invoiced, and payment in U.S. dollars requested.

472 **Iriscolor**
 Via Layetana 4, 4° D.
 08003 Barcelona
 (93) 310 44 43
 attn: Albert Mila

Profile: Offers 2,500 color slide titles of Spanish monuments and works of art, intended for the tourist market. Some slides available of museum objects from the Prado and several other collections. No new titles to be added.
Photography: Slides and negatives shot on Kodak film by staff photographer or independent professional photographer.
Production: Produced by J. Vilafranca laboratory on Agfa film #4687. Color corrected. No attempt made to control contrast.
Documentation: No current list available. General catalog dated 1966, in Spanish, lists each slide with very brief identification. Slides labeled in Spanish. Orientation marked.
Purchasing: Slides sold singly or in sets. No minimum order, although price per slide is much higher (200.00 pesetas for one slide) on small orders. Ten slides 80.00 pesetas each, 20 slides 50.00 pesetas each, 50 slides 35.00 pesetas each, 100 slides 20.00 pesetas each, etc. Small number of copies kept in stock; copied to order if necessary. Slides shipped within 15 days of receipt of payment, in Spanish or U.S. currency, or a letter of credit. Slides sent on approval. No returns accepted. Slides distributed for ARTICOR, Rua da Prata 71, Lisbon.
Evaluation: Based on three samples and rating by one advisor: quality 1 to 2, documentation 2. Film appears to be unstable. Other faults noted on samples: garish color, poor focus, distortion, cropping, glare, and scratches.

473 **Sanz Vega**
 Fotografía de Arte e Historia
 Concha Espina, 11
 28016 Madrid
 (91) 259 58 34
 attn: Prof. B. Sanz Vega

Profile: Questionnaire not completed due to difficulty communicating in English. Entry based on fourth edition, catalog, and recent orders. Offers 7,500 color slide titles of art and architecture in Spain. Museum collections extensively represented. Many details of paintings and sculptures included. Several exhibitions from 1960 to 1964 documented.
Production: Printed on Eastmancolor #5381 in the company's own laboratory.
Documentation: General catalog issued 1965, bound together with two supplements (1969 and 1972). Each slide briefly identified in Spanish. Slides labeled with artist and title, in Spanish, and keyed to catalog.
Purchasing: Slides sold singly, priced $0.85 each (United States). Several sets offered as well, at a 20 percent discount from the single-slide price: Spanish architecture (180 slides), Spanish sculpture (150 slides), and Spanish painting (234 slides). Orders invoiced; payment in U.S. dollars requested. Postage added.
Evaluation: Quality 2 to 3, documentation 2 to 3, service 3. Film unstable.

474 **Silex, Ediciones**
 Calle Cid, 4
 28001 Madrid
 (91) 435 55 34

Profile: Offers 347 color slide titles of art and archaeological artifacts in Spanish museums. New titles occasionally added.
Photography: Color transparencies (18 by 24 cm) shot on Ektachrome by staff photographers.
Production: Produced by Dinasa Laboratory. Contrast controlled. According to catalog, Ektachrome film used for copies. Mounted in cardboard.

Documentation: Free 17-page catalog available, in English or Spanish. Catalog revised annually; mailing list kept. Brief identifications provided for each slide (for painting, artist and title only). One large Prado set and four small sets accompanied by commentaries in English, Spanish, French, or German. Slides labeled in Spanish. Orientation marked.

Purchasing: Slides sold singly or in sets of 6, 10, or 12 slides. Single slides 35.00 pesetas. Minimum order $30.00. Set of 120 slides of masterpieces in the Prado 4,200.00 pesetas. Postage (by surface) added. Pro forma invoice issued. Slides kept in stock and shipped within one week of receipt of payment. Rush orders accepted; no surcharge.

Evaluation: Quality variable (1 to 3), documentation 2, service variable (1 to 3). One sample sent of a cave painting: good quality. "Some images cropped" (Nancy DeLaurier).

MUSEUMS

475 **Casa y Museo del Greco**
 Calle Samuel Levi
 Toledo
 (925) 22 40 46

No response to questionnaire. Many slides offered by Sanz Vega (473). Twenty-five slides available from Iriscolor (472) and 12 slides from Silex (474).

476 **Colecciones del Real Monasterio**
 El Escorial

No response to questionnaire. Slides offered by Sanz Vega (473).

477 **Museo Arqueológico Artistico Episcopal**
 Vich

Slides available from Sanz Vega (473).

478 **Museo Arqueológico de Barcelona**
 Parque de Montjuich
 08004 Barcelona
 (93) 223 21 49 or 223 56 01

No response to questionnaire. Slides offered by Sanz Vega (473).

479 **Museo Cerralbo**
 Ventura Rodrigues, 17
 28008 Madrid

No response to questionnaire. Slides offered by Sanz Vega (473).

480 **Museo de Arqueologia Nacional**
 Calle de Serrano, 13
 Madrid
 (91) 226 68 40

Seventy-two slides available from Silex (474).

481 **Museo de Arte de Cataluña**
 Parque de Montjuich
 Palacio Nacional
 Barcelona
 (93) 2 23 18 24

No response to questionnaire. Slides available from Sanz Vega (473) and Haeseler (46).

482 **Museo de Arte Moderno**
 Paseo de Calvo Sotelo, 30
 Madrid

Slides available from Sanz Vega (473).

483 **Museo de Bellas Artes**
 Parque de Doña Casilda de Iturriza
 Bilbao

Slides offered by Sanz Vega (473).

484 **Museo de Bellas Artes**
 Plaza del Museo, 9
 Seville
 (954) 22 18 29 or 22 07 90

Slides available from Sanz Vega (473), Iriscolor (472), and Haeseler (46).

485 **Museo de Bellas Artes de Granada**
 Palacio de Carlos V, Alhambra
 Granada

Slides offered by Sanz Vega (473).

486 **Museo de la Real Academia de Bellas Artes**
 de San Fernando
 Alcalá 13
 Madrid

Slides available from Sanz Vega (473).

487 **Museo de Santa Cruz Cervantes**
 Toledo
 (925) 22 14 02

Slides available from Sanz Vega (473) and Haeseler (46).

488 **Museo del Prado**
 Paseo del Prado
 Madrid
 (91) 468 09 50
 attn: Servicio de Fotografías y Publicaciones

No response to questionnaire. Slides sold by museum are produced by Silex (474) and Sanz Vega (473).
Other sources of slides of works in this museum are as follows:

Aguilar (469)

Ancora (471)

Editorial Patrimonio Nacional (497)

Haeseler (46)

Iriscolor (472)—40 slides

Mayer (61)

Sandak (77)—set of 63 slides, also sold singly

Sanz Vega (473)

Silex (474)—237 slides

Wolfe Worldwide Films (91)—54 slides

489 **Museo Español de Arte Contemporaneo**
 Avda. Calvo Sotelo, 20
 28001 Madrid
 (91) 2 76 03 34

Slides offered by Sanz Vega (473), Silex (474), and Editorial Patrimonio Nacional (497).

490 **Museo "Lazaro Galdiano"**
 Calle de Serrano, 122
 Madrid

Slides available from Sanz Vega (473).

491 **Museo Nacional de Esculturas**
 Cadenas de San Gregorio, 1
 Valladolid

Slides offered by Sanz Vega (473).

492 **Museo Provincial de Bellas Artes**
 San Agustin 6
 Malaga

Slides available from Sanz Vega (473).

493 **Museo Provincial de Bellas Artes**
 San Pio V, 9
 Valencia 10
 (96) 360 5793

Slides offered by Sanz Vega (473).

494 **Museo Provincial de Cádiz**
 Plaza de Mina
 Cádiz
 (956) 21 43 00

Slides offered by Sanz Vega (473).

495 **Museo Salvador Dali**
 Figueras

Thirty slides available from Iriscolor (472).

496 **Panteón de Goya**
 Ermita de San Antonio de la Florida
 Paseo de San Antonio de la Florida
 Madrid

Slides offered by Sanz Vega (473).

OTHER INSTITUTIONS

497 **Editorial Patrimonio Nacional**
 Ministry of Culture
 Palacio de Oriente
 Bailén num. 10
 28013 Madrid

No response to questionnaire. Entry based on fourth edition and newer information from an advisor. Offers 50 slide titles in five sets of 10, covering the Royal Palace in Madrid (two sets), the Escorial, Goya tapestries, and the Casita del Principe. Sets now offered documenting works in the Prado and the Museo Español de Arte Contemporaneo, as well as the art of Picasso. Sets accompanied by identifications and commentaries in English. Priced $3.00 (United States) per set.

SWEDEN

MUSEUMS

498 **Göteborgs Konstmuseum**
(Gothenburg Art Gallery)
Götaplatsen
41256 Gothenburg
(031) 18 95 37 or 16 22 91

Profile: No response to questionnaire. Entry based on fourth edition. Offers 103 slide titles of works in the permanent collection.
Photography: Shot by commercial photographers in studio.
Production: Copies made by a local laboratory on Kodak film.
Documentation: Free list, in Swedish. Artist's name and dates, title and date of work supplied with slides. Slides labeled in Swedish. Further information available on request.
Purchasing: Slides sold singly, 2.50 Swedish kronor each. Educational discount given. No returns accepted. Special photography undertaken at 50.00 Swedish kronor per original slide; charge of 10.00 Swedish kronor for a duplicate.
Other sources: Many of the important works in this collection photographed by Saskia (78). Some slides available from Stoedtner (373).
Evaluation: No information available.

499 **Nationalmuseum**
P.O. Box 16176
S-103 24 Stockholm
(08) 24 42 00
attn: Museum Shop

Profile: Questionnaire not returned, but 1984 list sent. Approximately 250 color slide titles offered, mostly of European paintings. A few sculptures, icons, portraits, and works of decorative art included.
Documentation: Free list, in Swedish and English. Artist and title provided.
Purchasing: Slides sold singly, 4.00 Swedish kronor each. Postage added: minimum 10.00 Swedish kronor per order.
Other sources: Slides of seventeenth and eighteenth century European painting and Swedish paintings offered by Saskia (78).
Evaluation: Quality 3 to 4, documentation 3, service 3.

500 **Statens Historiska Museum**
(Museum of National Antiquities)
Storgatan 41
P.O. Box 5405
S-114 84 Stockholm
(08) 783 94 77
attn: Curator (Carin G. M. Orrling)

Profile: Offers 24 color slides of Viking artifacts from the excavation on Helgeansholmen (Old Stock-holm). Offers 16 color slides to illustrate the saga of Thor's visit to Utgardaloke.
Photography: Slides shot by staff photographer.
Production: Duplicated on Kodachrome by Fotolabor. Mounted in plastic and glass.
Documentation: Slides labeled in Swedish and accompanied by text. Orientation not marked.
Purchasing: Slides sold in sets. Postage included in prices. Slides kept in stock. Rush orders filled in one day. Slides sent on approval. No returns accepted.
Evaluation: Rated by one advisor (Sara Jane Pearman): quality 4, documentation 3, service 3.

501 **Uppsala Universitets Konstsamling**
Domkyrkoplan 7
75220 Uppsala
(018) 15 54 00

Highlights of the collection photographed by Saskia (78).

SWITZERLAND

MUSEUMS

502 **Kunsthaus Zürich**
Heimplatz 1, P.O. Box 8024
8001 Zürich
(01) 251 67 65

No response to questionnaire. Slides offered by Stoedtner (373).

503 **Kunstmuseum Bern**
Hodlerstrasse 12
3011 Bern
(031) 22 09 44

No response to questionnaire. Selected slides available from Burstein (30) and Stoedtner (373).

504 **Öffentliche Kunstsammlung-Kunstmuseum Basel**
St. Alban-Graben 16
4010 Basel
(061) 22 08 28

Profile: Questionnaire not completed, but list sent (dated March 1983). Offers 120 slide titles of European painting.
Documentation: Free list. Identifications consist of artist, title (in the original language), and date when known.
Purchasing: Slides sold singly, priced 2.00 francs each. Postage added: minimum (for one to ten slides) 5.00 francs.
Evaluation: Quality 4, documentation 3, service 3.

505 **Sammlung Oskar Reinhart**
"Am Römerholz"
Haldenstrasse 95
8400 Winterthur
(052) 23 41 21

Profile: No response to questionnaire. Entry based on fourth edition. Offers 51 slide titles of works in the collection, chiefly nineteenth century French painting.
Photography: Large-format originals shot by commercial photographer in the galleries.
Production: Copies made by a commercial laboratory.
Documentation: Free list, in German. Artist and title provided, plus date when known.
Purchasing: Slides sold singly, priced 1.50 francs each. Prepayment required. Special photography carried out at same price.
Other sources: Slides of selected works available from Stoedtner (373).
Evaluation: Three-star rating in fourth edition.

506　**Schweizerisches Landesmuseum**
　　　(Swiss National Museum)
　　　Postfach 2760
　　　8023 Zürich
　　　(01) 221 10 10

Profile: Approximately 100 color slide titles offered of architecture, fine arts, decorative arts, historical objects, and excavations. Archive of 13,000 registered slides available for duplication.
Photography: Slides shot by staff photographer using Nikon camera on Kodak 64 daylight EPT 135 or Kodak 160 tungsten EPR 135.
Production: Copies made by Photo Studio 13, Zürich. No attempt made to correct color or control contrast. No film type specified. Mounted without glass.
Documentation: No list available. Slides labeled in German with artist, title, and date. Orientation not marked.
Purchasing: Slides sold singly or in sets. No minimum order. Stocked slides 1.00 franc each; orders shipped next day. Slides duplicated to order 2.00 to 6.00 francs each; orders shipped within one to two weeks. Original slides shot to order 50.00 francs for one slide, 70.00 francs for two slides (of two different objects), 80.00 francs for three slides, and each additional slide 10.00 francs; orders shipped within one month. Rush orders filled as soon as possible. Prepayment required from new customers on orders over 100.00 francs. Slides not sent on approval, and no returns accepted.
Evaluation: Four samples sent: quality 2 to 3, documentation 3. Definition good, color fair. Purplish tinge possibly indicates unstable film.

507　**Thyssen-Bornemisza Collection**
　　　Villa Favorita
　　　Castagnola
　　　6900 Lugano

Two sets, 130 slides each, offered by University of Michigan Slide Distribution (252): one of twentieth century painting, the other of nineteenth century American painting. A set of 153 slides available from Miniature Gallery (275), documenting the 1984-85 exhibition of "Modern Masters." Slides of selected works in this collection also sold by F. G. Mayer (61) and Stoedtner (373).

TAIWAN

MUSEUMS

508 **National Palace Museum**
Wai-Shuang-Hsi, Shih-Lin
Taipei
881 20 21
attn: Mail Order Division, or Curator (Chou Feng-sen)

Profile: Offers 1,000 color slide titles of works in the permanent collection. Additional slides available from the Curator (14 sets). New titles continually added. Black-and-white photographic prints and color transparencies also available from curator.

Photography: Slides shot on Kodak film by a staff photographer.

Production: Copies made in-house on Kodak film. Duplicates sometimes used as masters for producing copies. Color corrected. Mounted in plastic.

Documentation: Free catalog (April 1983), in English. Artist, title, and dynasty provided. No list available of slides offered by curator. Slides keyed to catalog or information sheet in English and Chinese. Orientation not marked.

Purchasing: Slides from catalog sold in sets of eight, priced 180.00 New Taiwan Dollars per set. Single slides and sets offered by curator 190.00 New Taiwan Dollars each; some are originals. Minimum order from curator 10 slides. Postage added (airmail or surface, as requested). Prepayment in U.S. funds requested. Slides kept in stock and shipped within two weeks. Slides sent on approval. Returns accepted for exchange only and only if mistake was made by museum.

Other sources: Slides offered by Asian Art Photographic Distribution (240).

Evaluation: Rated by one advisor (Sara Jane Pearman): quality 2, documentation 3, service 3. Unstable film noted in fourth edition. Slides ordered from curator may be of superior quality in comparison to slides available from catalog.

TURKEY

MUSEUMS

509 **Topkapi Saray Museum**
Sultanahmed
Istanbul

No response to questionnaire. Fifty slides offered by Islamic Perspectives (53).

YUGOSLAVIA

MUSEUMS

510 **Narodna Galerija**
(National Gallery)
Prezhova 1, PP 432
6100 Ljubljana
(061) 219 716

Profile: Two sets of color slides offered of works in the permanent collection: one of Slovene art of the eighteenth and nineteenth centuries and one of Slovene Impressionist painting. No new titles to be added.
Photography: Shot by an independent professional photographer on Agfa or Kodak film.
Production: Copies made in a laboratory in Zagreb. No attempt made to correct color.
Documentation: No list available. Slides labeled in English. Orientation marked.
Purchasing: Slides sold in sets of six. Slides kept in stock and shipped within one month.
Evaluation: No information available.

Part III
APPENDIXES

Appendix 1
Respondents Offering No Slides

The following companies and institutions did not have slides for sale at the time they received our questionnaire. This appendix is arranged according to the same scheme that is used in the body of the guide, that is, by country and then by type (commercial vendors, museums, institutions). Items in the following list are numbered and included in the name index.

CANADA

511 **Canada Council Art Bank**
P.O. Box 1047
Ottawa, Ontario K1P 5V8

512 **Musée d'Art Contemporain**
Cité du Havre
Montréal, Québec H3C 3R4

UNITED STATES

513 **Elk, John III**
583 Weldon
Oakland, CA 94610

514 **Light Impressions**
P.O. Box 3012
Rochester, NY 14614
(slide program has been reinstituted in 1985)

515 **McGraw-Hill**
Professional and Reference Book Division
1221 Avenue of the Americas
New York, NY 10020

516 **University Prints**
 21 East Street
 P.O. Box 485
 Winchester, MA 01890

517 **Amherst College Art Museum**
 Mead Art Building
 Amherst, MA 01002

518 **Parrish Art Museum**
 25 Jobs Lane
 Southampton, NY 11968

519 **Vanderbilt University Art Gallery**
 Department of Fine Arts
 West End Avenue at 23rd
 P.O. Box 1801B
 Nashville, TN 37235

520 **Archaeological Institute of America**
 260 West Broadway
 New York, NY 10013

521 **Pittsburgh History and Landmarks Foundation**
 One Landmarks Square
 Pittsburgh, PA 15212

AUSTRIA

522 **Landesmuseum Joanneum**
 A-8010 Graz
 Raubergasse 10

BRITAIN

523 **Plymouth City Museum and Art Gallery**
 Drake Circus
 Plymouth PL4 8AJ

FRANCE

524 **Photographie Giraudon**
 92, rue de Richelieu
 75002 Paris

GERMANY (WEST)

525 **Hirmer Verlag**
 D-8000 Munich 19
 Marees-strasse 15

ITALY

526 **Alinari**
Via Nazionale 6
50123 Florence
(according to the U.S. distributor, Art Resource, Inc.)

U.S.S.R.

527 **Pushkin Museum**
Bolchonka Street 12
Moscow

Appendix 2
Vendors Not Responding to the Questionnaire

The following companies and institutions did not respond to the questionnaire. Parenthetical remarks are included when the questionnaire was returned as undeliverable or when there was other evidence that the vendor was out of business or had moved. This appendix is arranged according to the same scheme used in the body of the guide, that is, by country and then by type (commercial vendors, museums, institutions). Items in the following list are numbered and included in the name index.

CANADA

528 **Amerindian Art**
A. H. Publishing
P.O. Box 833, Postal Station Q
Toronto, Ontario M4L 1T0
(apparently out of business)

529 **Martin, J. Edward**
1360 Fir Street, Suite 306
White Rock, B.C. V4B 4B2

530 **SECAS/ADIMEC**
5275, rue Berri
Montréal, Québec H2J 2S7

531 **British Columbia Provincial Museum**
601 Belleville Street
Victoria, B.C. V8W 1A1

532 **Glenbow Museum**
Ninth Avenue and First Street, S.E.
Calgary, Alberta T2G 0P3

533 **Isaacs Gallery**
832 Yonge Street
Toronto, Ontario M4W 2H1

534 **McCord Museum**
McGill University
690 Sherbrooke Street, W.
Montréal, Québec H3A 1E9

535 **McMichael Canadian Collection**
Kleinburg, Ontario L0J 1C0

536 **Musée de Québec**
Parc des Champs de Bataille
Québec, Québec G1S 1C8

537 **Vancouver Art Gallery**
750 Hornby Street
Vancouver, B.C. V6Z 2H7

UNITED STATES

538 **American Visual Communications Bank**
P.O. Box 26392
Tucson, AZ 85726

539 **Art Council Aids**
P.O. Box 641
Beverly Hills, CA 90213

540 **Asia Photos**
820 East Ann Street
Ann Arbor, MI 48104
(questionnaire returned as undeliverable)

541 **Beaux-Arts Slides**
P.O. Box 307
Princeton, NJ 08540
(apparently out of business)

542 **Becker, Norma S.**
371 Amsterdam Avenue, #3
New York, NY 10024

543 **Collins, Joseph W.**
840 Pacheco Street
P.O. Box 16403
San Francisco, CA 94116

544 **Environmental Communications**
64 Windward Avenue
Venice, CA 90491
(apparently out of business as of 1985)

545 **Four Continent Book Corporation**
149 Fifth Avenue
New York, NY 10010
(apparently out of business)

546 **Gonzales, Dr. Elsa**
2326 Lincoln Park, W., #3C
Chicago, IL 60614

547 **Harper & Row Publishers, Inc.**
Audio-Visual Department
10 East 53rd Street
New York, NY 10022
(questionnaire returned as undeliverable)

548 **Huey, Mary Paige**
4203 Farhills Drive
Austin, TX 78731
(apparently out of business)

549 **Interbook, Inc.**
13 East 16th Street
New York, NY 10003
(apparently out of business)

550 **Keller Color**
P.O. Box 1061
Clifton, NJ 07014

551 **Krausche, Mrs. Kenneth K.**
1250 Dorchester Drive, #202
Alexandria, LA 71301

552 **Landfall Press**
215 West Superior Street
Chicago, IL 60610

553 **Lillys, William**
29 Commonwealth Avenue
Boston, MA 02116

554 **Mortimer, Harvey J.**
109 Alexander Avenue
Montclair, NJ 07043

555 **Photo Lab, Inc.**
3825 Georgia Avenue, N.W.
Washington, DC 20011
(apparently out of business)

556 **Scholarly Audio-Visual Corporation**
177 Main Street, Suite 300A
Ft. Lee, NJ 07024

557 **Society for Visual Education, Inc.**
(Singer, Educational Division)
1345 Diversey Parkway
Chicago, IL 60614

558 **Spectra Photographics**
 1509 Murray Lane
 Austin, TX 78701

559 **Unipub**
 P.O. Box 433, Murray Hill Station
 New York, NY 10016
 or
 345 Park Avenue South
 New York, NY 10010
 (apparently out of business)

560 **Zhanie Book Store**
 5237 Geary Boulevard
 San Francisco, CA 94118

561 **Akron Art Institute**
 69 East Market Street
 Akron, OH 44308

562 **Brandywine River Museum**
 P.O. Box 141
 Chadds Ford, PA 19317

563 **Chicago Historical Society**
 Clark Street at North Avenue
 Chicago, IL 60614

564 **Crocker Art Museum**
 216 O Street
 Sacramento, CA 95814

565 **Dayton Art Institute**
 Forest and Riverview Avenue
 P.O. Box 941
 Dayton, OH 45401

566 **Duke University Museum of Art**
 6877 College Station
 Durham, NC 27708

567 **Everson Museum of Art**
 401 Harrison Street
 Syracuse, NY 13202

568 **J. B. Speed Art Museum**
 2035 South Third Street
 P.O. Box 8345
 Louisville, KY 40208

569 **J. Paul Getty Museum**
 17985 Pacific Coast Highway
 Malibu, CA 90265

570 **Los Angeles Institute of Contemporary Art**
 2020 South Robertson Boulevard
 Los Angeles, CA 90034

571 **Lyman Allyn Museum**
 625 Williams Street
 New London, CT 06320

572 **Montclair Art Museum**
 3 South Mountain Avenue
 P.O. Box X
 Montclair, NJ 07042

573 **Museum of American Folk Art**
 49 West 53rd Street
 New York, NY 10019

574 **Museum of Fine Arts**
 49 Chestnut Street
 Springfield, MA 01103

575 **Museums at Stony Brook**
 Route 25A
 Stony Brook, NY 11790

576 **Newark Museum**
 49 Washington Street
 P.O. Box 540
 Newark, NJ 07101

577 **Philbrook Art Center**
 2727 South Rockford Road
 P.O. Box 52510
 Tulsa, OK 74152

578 **Taft Museum**
 316 Pike Street
 Cincinnati, OH 45202

579 **University of Oregon Museum of Art**
 Eugene, OR 97403

580 **Wellesley College Museum**
 Wellesley, MA 02181

581 **Williams College Museum of Art**
 Main Street
 Williamstown, MA 01267

582 **Ethnic-American Art Slide Library**
 Arts and Sciences
 University of Southern Alabama
 Mobile, AL 36688

583 **Library of Congress**
 Prints and Photographs Division
 First Street near Independence Avenue
 Washington, DC 20540

584 **National Center of Afro-American Artists**
 300 Walnut Avenue
 Boston, MA 02119

585 **New York Public Library**
 Fifth Avenue at 42nd Street
 New York, NY 10018

586 **Yale University Divinity School**
 Visual Education Service
 409 Prospect Street
 New Haven, CT 06511

ARGENTINA

587 **Museo Nacional de Bellas Artes**
 Avda. Libertador 1473
 Buenos Aires

AUSTRALIA

588 **Educational Technology Centre**
 81 Flinders Street
 Adelaide, S.A. 5000

589 **Art Gallery of New South Wales**
 Art Gallery Road
 Domain, Sydney, N.S.W. 2000

590 **Art Gallery of South Australia**
 North Terrace
 Adelaide, S.A. 5000

591 **Queensland Art Gallery**
 Fifth Floor, Mim Building
 160 Anne Street
 Brisbane, Queensland 4000

592 **Crafts Council of Australia**
 27-29 King Street
 Sydney, N.S.W. 2000

AUSTRIA

593 **Graphische Sammlung Albertina**
 A-1010 Vienna
 Augustinerstrasse 1

594 **Kupferstichkabinett der**
 Akademie der Bildenden Künste
 A-1010 Vienna
 Schillerplatz 3

BELGIUM

595 **IVAC**
 Chaussée de Mons 691
 1070 Brussels
 (questionnaire returned as undeliverable)

596 **Bylokemuseum**
 Godhuizenlaan 2
 9000 Ghent

597 **Musée des Beaux-Arts de Tournai**
 Enclos St. Martin 8
 7500 Tournai

598 **Musées Royaux des Beaux-Arts de Belgique**
 9, rue du Musée
 1000 Brussels

599 **Museum Mayer van den Bergh**
 Lange Gasthuisstraat 19
 2000 Antwerp

600 **Museum voor Schone Kunsten**
 Citadelpark
 9000 Ghent

601 **Abbaye de St.-Bavon**
 Gandastraat 7
 9000 Ghent

602 **Bibliothèque Royale**
 4, blvd. de l'Empereur
 1000 Brussels

BRAZIL

603 **Museu Nacional de Belas Artes**
 Avda. Rio Branco 199
 20000 Rio de Janeiro

BRITAIN

604 **Collett's Russian Bookshop**
 39 Museum Street
 London WC1
 (questionnaire returned as undeliverable)

605 **Colour Centre Slides, Ltd.**
 Hilltop, Hedgerley Hill
 Hedgerley Slough SL2 3RJ
 (apparently out of business)

606 **E.S.M. Colour Documentations Archives**
 69 Elsham Road
 London
 (apparently out of business)

607 **Pictorial Colour Slides**
 242 Langley Way
 West Wickham, Kent

608 **Slide Centre, Ltd.**
 143 Chatham Road
 London SW11 6SR

609 **Barber Institute**
 University of Birmingham
 Birmingham B15 2TS

610 **Bristol City Art Gallery**
 Queen's Road, Clifton
 Bristol BS8 1RL

611 **Duke of Devonshire Collection**
 Chatsworth

612 **Guildhall Art Gallery**
 King Street
 London EC2P 2EJ

613 **Leeds City Art Gallery**
 The Headrow
 Leeds

614 **Leicestershire Museum and Art Gallery**
 96 New Walk
 Leicester LE1 6TD

615 **Royal Pavilion Art Gallery and Museum**
 Church Street
 Brighton BN1 1UE

616 **Sheffield City Museum**
 Weston Park
 Sheffield S10 2TP

617 **Tyne and Wear County Council Museums**
 Laing Art Gallery and Museum
 Higham Place
 Newcastle-upon-Tyne NE1 8AG

618 **Whitworth Art Gallery**
University of Manchester
Whitworth Park, 1 Oxford Road
Manchester M15 6ER

CHILE

619 **Museo Nacional de Bellas Artes**
Universidad de Chile
Parque Forestan s/n
Casilla 3209
Santiago

CYPRUS

620 **Cyprus Museum**
Museum Avenue
P.O. Box 2024
Nicosia

CZECHOSLOVAKIA

621 **Národni Galeri v Praze**
(National Gallery)
Hradcanské Námesti 15(1)
Hradcany
Prague

DENMARK

622 **Nationalmuseet**
Frederiksholms Kanal 12
1220 Copenhagen

623 **Ny Carlsberg Glyptothek**
Dantes Plads
1556 Copenhagen

624 **Statens Museum for Kunst**
Sölvgade
1307 Copenhagen

EGYPT

625 **Lehnert and Landrock**
44 Sherif Street
P.O. Box 1013
Cairo

626 **Egyptian Museum**
Midan-el-Tahrir
Kasr-el-Nil
Cairo

FRANCE

627 **Diafrance**
37, rue Chanzy
75011 Paris
(questionnaire returned as undeliverable)

628 **Europart**
Abbaye St. Martin
86240 Ligugé, Vienne

629 **Galerie Maeght**
06570 St.-Paul

630 **Musée, Bibliothèque, et Archives
de l'École Nationale Supérieure
des Beaux-Arts**
17, quai Malaquais
75272 Paris

631 **Musée Calvet**
65, rue Joseph-Vernet
84000 Avignon

632 **Musée Carnavalet**
23, rue de Sévigne
75003 Paris

633 **Musée Condé**
Château de Chantilly
60500 Chantilly

634 **Musée Réattu**
Rue du Grand Prieuré
13200 Arles

635 **Musée de l'Oeuvre Notre Dame**
3, place du Château
67000 Strasbourg

636 **Musée des Arts Décoratifs**
107, rue de Rivoli
Palais du Louvre, pavillon de Marsan
75001 Paris

637 **Musée des Augustins**
2, rue Alsace-Lorraine
31000 Toulouse

638 **Musée des Beaux-Arts**
 10, rue de Musée
 49000 Angers

639 **Musée des Beaux-Arts**
 Place de la Sainte-Chapelle
 21000 Dijon

640 **Musée des Beaux-Arts**
 Palais Saint-Pierre
 20, place des Terreaux
 69001 Lyon

641 **Musée des Beaux-Arts**
 3, place Stanislas
 54000 Nancy

642 **Musée des Beaux-Arts**
 Château des Rohan
 2, place du Château
 67000 Strasbourg

643 **Musée des Beaux-Arts**
 18, place François Sicard
 37000 Tours

644 **Musée du Petit Palais**
 Avenue Winston Churchill
 75008 Paris

645 **Musée Granet**
 Place St.-Jean de Malte
 13100 Aix-en-Provence

646 **Musée Gustave Moreau**
 14, rue de la Rochefoucauld
 75009 Paris

647 **Musée Jacquemart-André**
 158, blvd. Haussmann
 75008 Paris

648 **Musée National des Monuments Français**
 Palais de Chaillot, Place du Trocadero
 75116 Paris

649 **Musée Ochier**
 Palais Jean de Bourbon
 71250 Cluny

650 **Musées de Reims**
 8, rue Chanzy
 51100 Reims

651 **Caisse National des Monuments Historiques**
 Hotel de Sully
 62, rue St. Antoine
 75004 Paris

652 **Centre Régional de Documentation Pédagogique**
 Centre Universitaire Montmuzard
 B.P. 490
 21013 Dijon

GERMANY (WEST)

653 **Badisches Landesmuseum**
 D-7500 Karlsruhe
 75 Karlsruhe Schloss

654 **Bayerisches Nationalmuseum**
 D-8000 Munich 22
 Prinzregentenstrasse 3

655 **Mittelrheinisches Landesmuseum Mainz**
 D-6500 Mainz
 Grosse Bleiche 49-51

656 **Rheinisches Landesmuseum Trier**
 D-5500 Trier
 Ostallee 44

657 **Römisch-Germanisches Museum**
 D-5000 Cologne
 Roncalliplatz 4

658 **Römisch-Germanishes Zentralmuseum**
 D-6500 Mainz
 Ernst-Ludwig-Platz 2

659 **Schnütgen-Museum**
 D-5000 Cologne
 Cäcilienstrasse 29

660 **Staatliche Graphische Sammlung**
 D-8000 Munich 2
 Meiserstrasse 10

661 **Städtische Kunsthalle Düsseldorf**
 D-4000 Düsseldorf
 Grabbeplatz 4, Postfach 1120

662 **Stadtisches Kunstmuseum Bonn**
 D-5300 Bonn
 Rathausgasse 7

663 **Württembergisches Landesmuseum**
D-7000 Stuttgart
Altes Schloss
Schillerplatz 6

664 **Bauhaus-Archiv**
Museum für Gestaltung
D-1000 Berlin 30
Klingelhöferstrasse 13-14

INDIA

665 **Asutosh Museum of Indian Art**
University of Calcutta
Central Building, College Street
Calcutta

666 **National Museum of India**
Janpath 11
New Delhi

667 **American Institute of Indian Studies**
Center for Art and Archaeology
Court House, Ramnager
Varanasi, U.P.

IRELAND

668 **Archive Colour Slides, Ltd.**
41 Palmerston Road
Dublin 6

ISRAEL

669 **Tel Aviv Museum**
25-27 Shaul Hamelech Blvd.
Tel Aviv

ITALY

670 **Biblioteca Apostolica Vaticana**
Vatican City

JAPAN

671 **Bijutsu Shuppan-sha**
15 Ichigaya, Honmura-cho
Shinjuku-ku
Tokyo 162

672 **Gakken Co.**
40-5, 4-Chome, Kami-Ikedai
Ohta-ku
Tokyo 145
(possibly out of business)

673 **Sun Slide Co., Ltd.**
59 Yaraicho
Shinjuku
Tokyo
(questionnaire returned as undeliverable)

674 **Toyo Slides**
Sakamoto Photo Lab
28-2 Matsubara
4-Chome, Setagaya-ku
Tokyo

675 **Bridgestone Bijutsukan**
10-1, 1-Chome
Kyobashi Chuo-ku
Tokyo

676 **Kyoto Kokuritsu Kindai Bijutsukan**
Enshoji-cho, Okazaki, Sakyo-ku
Kyoto

677 **Osaka Shiritsu Bijutsukan**
Tennoji-ku
Osaka

678 **Tokyo Kokuritsu Kindai Bijutsukan**
3 Kitanomaru Koen
Chiyoda-ku
Tokyo 102

KOREA

679 **National Museum of Korea**
Kyong Bok Palace
1 Sejongro, Chongro-ku
Seoul

MALTA

680 **National Museum of Fine Arts**
South Street
Valletta

MEXICO

681 **Museo de Arte Moderno**
Chapultepec Paseo de la Reforma y Ghandhi, 5
Mexico City

682 **Museo Nacional de Antropologia**
Ave. Paseo de la Reforma y Ghandhi s/n
Mexico City

NETHERLANDS

683 **Polyvisie**
N.V. Cinecentrum
Postbus 508
s'Gravelandseweg 80
Hilversum

684 **Dordrechts Museum**
Museumstraat 40
3400 Dordrecht

685 **Groningen Museum voor Stad en Land**
Praediniussingel 59
9711 AG Groningen

686 **Museum Bredius**
Prinsegracht 6, P.O. Box 72
2501 CB The Hague

687 **Rijksbureau voor Kunsthistorische Documentatie**
Korte Vijverberg 7
2000 The Hague

NEW ZEALAND

688 **Auckland City Art Gallery**
Kitchener Street
P.O. Box 5449
Auckland

689 **National Art Gallery of New Zealand**
Buckle Street
Wellington

NORWAY

690 **Historisk Museum**
Universitete i Bergen
P.O. Box 25
Bergen 5000

PERU

691 **Museo de Arte**
Paseo Colon 125
Lima

POLAND

692 **Muzeum Narodowe w Krakowie**
 (National Museum)
 ul. Manifestu Lipcowego 12
 31-110 Cracow

693 **Muzeum Narodowe we Wroclawiu**
 (National Museum)
 Place Powstanc
ów Warszawy 5
 50-153 Wroclaw

694 **Ministry of Culture and Art**
 Bernardynska Nr. 5
 Wroclaw

REPUBLIC OF SOUTH AFRICA

695 **Johannesburg Art Gallery**
 Joubert Park
 Johannesburg, Transvaal 2001

696 **South African National Gallery**
 Government Avenue
 P.O. Box 2420
 Cape Town, Cape Province 8000

SYRIA

697 **National Museum of Damascus**
 Reda Saeed Street
 Damascus

TAIWAN

698 **Y.V.A. Studio**
 251 Roosevelt Road, 2nd floor
 Section 3
 Taipei
 (questionnaire returned as undeliverable)

TUNISIA

699 **Musée National du Bardo**
 Le Bardo
 Tunis

TURKEY

700 **Istanbul Arkeoloji Müzeleri**
 (Archaeological Museums)
 Sultanahmet
 Istanbul

701 **Türk ve Islam Eserleri Müzesi**
 (Museum of Turkish and Islamic Art)
 Suleymaniye
 6 Sifahane Street
 Istanbul

SWITZERLAND

702 **Kunsthalle Basel**
 Steinenberg 7, Klostergasse 5
 Sekretariat
 4051 Basel

U.S.S.R.

703 **Hermitage Museum**
 v/o "Mezhdunarodnaya Kniga"
 Sadovaya-Sennaya 32/34
 Moscow 121211

VENEZUELA

704 **Museo de Bellas Artes**
 Parque Sucre, los Caobos 105
 Caracas

YUGOSLAVIA

705 **Arheološki Muzej**
 (Archaeological Museum)
 Zrinsko Frankopanska 25
 P.P. 15
 58000 Split

706 **Galerija Suvremene Umjetnosti**
 (Gallery of Modern Art)
 Katarinin trg 2
 P.O. Box 233
 41000 Zagreb

707 **Muzej Suvremene Umjetnosti**
 (Museum of Modern Art)
 Novi Beograd Kod ušća
 11071 Belgrade

708 **Narodni Muzej**
 (National Museum)
 Trg Republike 1A
 11000 Belgrade

Appendix 3
Sources of Slides Coordinated with Texts

The vendors of slides coordinated with text are listed below each text citation. The number in parentheses is the entry number for the vendor in this guide. When no edition is specified in the vendor's catalog, the citation consists of author and title only. This list is selective; smaller slide sets related to less well-known texts are also available.

Arnason, H. Harvard. *History of Modern Art: Painting, Sculpture, Architecture*. New York: Abrams, 1968.

 American Library Color Slide Co. (19)
 Rosenthal Art Slides (76)
 Universal Color Slide Co. (89)

Arnason, H. Harvard. *History of Modern Art: Painting, Sculpture, Architecture*. 2d ed. New York: Abrams, 1977.

 Dick Blick Co. (36)
 Heaton-Sessions (48)

Brommer, Gerald F. *Discovering Art History*. Worcester, MA: Davis Publications, 1981.

 Sandak (77)

Brown, Milton Wolf, et al. *American Art: Painting, Sculpture, Architecture, Decorative Arts, Photography*. New York: Abrams [1979].

 Heaton-Sessions (48)

Canaday, John Edwin. *Mainstreams of Modern Art*. New York: Simon & Schuster, 1959.

 American Library Color Slide Co. (19)

Canaday, John Edwin. *Mainstreams of Modern Art*. 2d ed. New York: Holt, Rinehart and Winston, 1981.

 Heaton-Sessions (48)

Canaday, John Edwin. *What Is Art? An Introduction to Painting, Sculpture, and Architecture.* New York: Knopf, 1980.
> Heaton-Sessions (48)

Clark, Kenneth. *Civilisation: A Personal View.* New York: Harper & Row, 1970.
> American Library Color Slide Co. (19)

Clark, Kenneth. *The Nude: A Study in Ideal Form.*
> American Library Color Slide Co. (19)

Cleaver, Dale G. *Art: An Introduction.* 3d ed. New York: Harcourt Brace Jovanovich, 1977.
> Heaton-Sessions (48)
> Rosenthal Art Slides (76)

Cooke, Hereward Lester. *Painting Techniques of the Masters.*
> Dick Blick Co. (36)
> Universal Color Slide Co. (89)

Dudley, Louise, and Austin Faricy. *The Humanities: Applied Aesthetics.*
> American Library Color Slide Co. (19)

Elsen, Albert Edward. *Purposes of Art: An Introduction to the History and Appreciation of Art.*
> American Library Color Slide Co. (19)

Feldman, Edmund Burke. *Art As Image and Idea.* Englewood Cliffs, NJ: Prentice-Hall, 1967.
> Sandak (77)

Fleming, William. *Arts and Ideas.* 3d ed. New York: Holt, Rinehart and Winston, 1968.
> Rosenthal Art Slides (76)

Fleming, William. *Arts and Ideas.* 6th ed. New York: Holt, Rinehart and Winston, 1980.
> American Library Color Slide Co. (19)
> Saskia, Ltd. (78)

Fleming, William. *Arts and Ideas, New and Brief.* New York: Holt, Rinehart and Winston, [1974].
> Heaton-Sessions (48)

Gardner, Helen. *Art through the Ages.*
> Sandak (77)

Gardner, Helen. *Gardner's Art through the Ages.* 6th ed. New York: Harcourt Brace Jovanovich, 1975.
> American Library Color Slide Co. (19)
> Rosenthal Art Slides (76)

Gardner, Helen. *Gardner's Art through the Ages.* 7th ed. New York: Harcourt Brace Jovanovich, 1980.
> American Library Color Slide Co. (19)
> Heaton-Sessions (48)
> Saskia (78)

Gombrich, Ernst Hans. *The Story of Art*.
 American Library Color Slide Co. (19)

Gombrich, Ernst Hans. *The Story of Art*. 11th ed. London: Phaidon, 1967.
 Rosenthal Art Slides (76)

Gombrich, Ernst Hans. *The Story of Art*. 13th ed. Englewood Cliffs, NJ: Prentice-Hall, 1983.
 Heaton-Sessions (48)

Hale, Robert Beverly. *Drawing Lessons from the Great Masters*. New York: Watson-Guptill, [1964].
 Dick Blick Co. (36)
 Universal Color Slide Co. (89)

Hamilton, George Heard. *Nineteenth and Twentieth Century Art: Painting, Sculpture, and Architecture*. New York: Abrams, 1970 and Englewood Cliffs, NJ: Prentice-Hall, 1972.
 Heaton-Sessions (48)
 Rosenthal Art Slides (76)

Hartt, Frederick. *Art: A History of Painting, Sculpture, and Architecture*. 2 vols. New York: Abrams, 1976.
 American Library Color Slide Co. (19)
 Dick Blick Co. (36)
 Heaton-Sessions (48)
 Saskia (78)
 Universal Color Slide Co. (89)

Hobbs, Jack A. *Art in Context*. New York: n.p., 1975.
 Rosenthal Art Slides (76)

Honour, Hugh, and John Fleming. *The Visual Arts: A History*. 1st ed. Englewood Cliffs, NJ: Prentice-Hall, 1982.
 American Library Color Slide Co. (19)
 Sandak (77)

Hunter, Sam, and John Jacobus. *American Art of the Twentieth Century: Painting, Sculpture, Architecture*. 1st ed. New York: Abrams, 1973.
 Dick Blick Co. (36)
 Heaton-Sessions (48)
 Universal Color Slide Co. (89)

Janson, H. W. *History of Art*.
 Sandak (77)

Janson, H. W. *History of Art*. 1st ed. New York: Abrams, 1962.
 American Library Color Slide Co. (19)
 F. G. Mayer (61)
 Rosenthal Art Slides (76)
 Saskia (78)

Janson, H. W. *History of Art*. 2d ed. New York: Abrams, 1977.

 American Library Color Slide Co. (19)
 Dick Blick Co. (36)
 Heaton-Sessions (48)
 Universal Color Slide Co. (89)

Janson, H. W. *History of Art for Young People*.

 American Library Color Slide Co. (19)

Janson, H. W. *Story of Painting for Young People*. New York: Abrams, 1952.

 American Library Color Slide Co. (19)
 Dick Blick Co. (36)

Janson, H. W., and Samuel Cauman. *A Basic History of Art*. 2d ed. New York: Abrams, 1981 and Englewood Cliffs, NJ: Prentice-Hall, 1981.

 Heaton-Sessions (48)

Janson, H. W., and Samuel Cauman. *History of Art for Young People*. New York: Abrams, 1971.

 American Library Color Slide Co. (19)
 Dick Blick Co. (36)
 Heaton-Sessions (48)
 Universal Color Slide Co. (89)

Janson, H. W., and Dora Jane Janson. *The Story of Painting*. New York: Abrams, 1966.

 Universal Color Slide Co. (89)

Janson, H. W., Joseph Kerman, and Dora Jane Janson. *History of Art and Music*. Englewood Cliffs, NJ: Prentice-Hall, 1968.

 American Library Color Slide Co. (19)

Knobler, Nathan. *The Visual Dialogue*.

 American Library Color Slide Co. (19)
 Sandak (77)

Myers, Bernard Samuel. *Art and Civilization*.

 American Library Color Slide Co. (19)

Myers, Bernard Samuel. *Understanding the Arts*. New York: Holt, Rinehart and Winston, [c1958].

 American Library Color Slide Co. (19)

Stoddard, Whitney S. *Monastery and Cathedral in France*. Middletown, CT: Wesleyan University Press, 1966.

 Sandak (77)

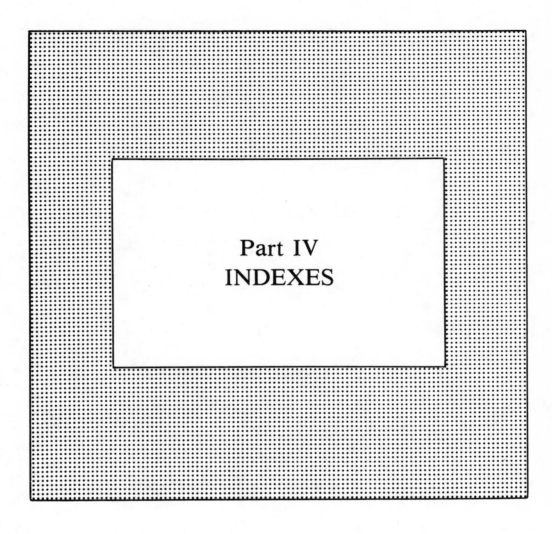

Part IV
INDEXES

Name Index

Names of slide vendors, including alternatives to the name by which a vendor is listed in the guide, are indexed below. Personal names are included only when they are better known than the names of the slide vending companies with which they are associated.

References are to entry numbers. A boldface number indicates the entry that is devoted entirely to a vendor. Other numbers refer to entries in which the vendor is mentioned. Numbers greater than 510 refer to entries in the appendixes—respondents offering no slides and vendors not responding to the questionnaire.

Subject Index†

References here are to entry number.

Where a vendor's set or category of slides totals twenty-five or more, its code number is entered under an appropriate subject heading. Where the slides total 250 or more, the code number is printed in boldface. Three vendors—American Library Color Slide Co., Dick Blick Co., and Universal Color Slide Co.—are not indexed here for two reasons. First, their scopes are so vast that they would have appeared in almost every category. For the second reason, please consult the vendors' evaluations within this guide. Please also note that the arts of Europe, the Americas, China, and Japan are indexed not under Art but under Drawing, Painting, Prints, Sculpture, and so forth.

Many museum painting lists are arranged strictly alphabetically by artist rather than chronologically and geographically. These earn indexing here for only the predominant countries. Unfortunately, this perpetuates the obscurity of nationalities scattered across pages like migrants across maps. Likewise, many commercial architecture catalogs are divided only by country but not by century. These too are indexed accordingly. In short, few headings are entered in the index that do not already clearly exist in the catalogs. Where I could not discern a subject easily, I assumed neither would you.

The most fruitful catalogs often are those of Hartill, Rosenthal, Sandak, Saskia, and Scala—so long as one is seeking the arts or architecture of North America or Europe. If one's subject is further afield, the search becomes increasingly difficult. This index purports to ease the search.

ABSTRACT EXPRESSIONISM, 24, 37, 38
ADVERTISING ART, 77, 274, 283. *See also*
 Trademarks
ALTARPIECES, 65
ARCHITECTURAL DESIGN, 44, **71**, 274, 316, 317
ARCHITECTURAL DRAWING, 22, 77, 119, 243
ARCHITECTURAL MODELS, 22
ARCHITECTURAL TECHNIQUE, 71, 316
ARCHITECTURAL TERMINOLOGY, 44

ARCHITECTURE. *See also* Art Deco; Art Nouveau;
 Bauhaus; Beaux Arts style; Bridges; Building
 materials; City planning; Engineering; Farm
 buildings; Greek Revival style; Housing;
 Museums; Schools; Shopping centers & malls;
 Solar buildings; Theaters; Utopias; Women
 architects; World's Fairs
ARCHITECTURE, Afghan, 47, 75
ARCHITECTURE, African, 33, 75
ARCHITECTURE, Algerian, 21, 75

†Sincere thanks are due to the Rhode Island School of Design and its Faculty Development Fund for granting me release time in order to complete this subject index. Special thanks go also to Norine Cashman for her kind criticisms and edifying editing. I hope this index is worthy of the very definitive *Slide Buyers' Guide* to which it points. As the whole does not equal more than the sum of its parts, the true worth of both the guide and its index is measured by the hundreds of dealers and their lists and catalogs. Yet the slides are more important than the catalogs, and the artworks more important than the slides. Because a slide stands to art as art stands to life. Mark Mathew Braunstein